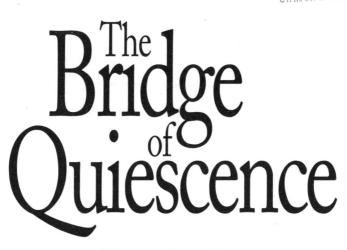

The
Bridge
of
Quiescence

Experiencing
Tibetan Buddhist
Meditation

B. Alan Wallace

Foreword by H.H. the Dalai Lama

D0369251

OPEN COURT
Chicago and La Salle, Illinois

Library of Congress Cataloging-in-Publication Data

Wallace, B. Alan
 The bridge of quiescence : experiencing Tibetan Buddhist
meditation / B. Alan Wallace.
 p. cm.
 Includes the text of Tsoṅ-kha-pa Blo-bzaṅ-grags-pa's text of Byang
chub lam gyi rim pa chung ba.
 Includes bibliographical references and index
 ISBN 0-8126-9360-4 (cloth : alk. paper). — ISBN 0-8126-9361-2
(pbk. : alk. paper)
 1. Tsoṅ-kha-pa Blo-bzaṅ-grags-pa, 1357–1419. Byaṅ chub lam gyi
rim pa chuṅ ba. 2. Lam-rim. 3. Meditation—Buddhism. I. Tsoṅ-kha
-pa Blo-bzaṅ-grags-pa, 1357–1419. Byaṅ chub lam gyi rim pa chuṅ ba.
II. Title.
BQ7950.T754B9338 1998
294.3'4435—dc21 97–41697
 CIP

Brief Table of Contents

Detailed Table of Contents

Chapter 3
An Analysis of Quiescence

Foreword
by H.H. the Dalai Lama

In recent years Western scientists and philosophers have shown increasing interest in the nature of consciousness. While modern science, including psychology, has gained significant knowledge about a wide range of objects of consciousness, it has achieved little understanding of the origins, characteristics, and function of consciousness itself. On the other hand, for more than two thousand years, living experience of Buddhist meditation has given its practitioners a profound knowledge of the workings and nature of the mind. This is an inner science that complements modern objective investigation.

Psychologists and neuroscientists have been keen to understand the nature of attention. They have learned a great deal about the characteristics and types of attention. However, many questions remain, to which they seek scientific answers.

Alan Wallace has experience of both scientific investigation and the practice of meditation. In this useful book he explains the significance of training the attention within the context of Buddhist theory and practice as a whole. He translates and explains a classic presentation of the way to train the attention composed by the reknowned fifteenth century Tibetan Buddhist scholar Tsongkhapa. This work provides a detailed and authoritative account of methods for cultivating meditative quiescence, in which stability and clarity of attention are enhanced to a very high degree.

The Buddhist world has much to learn from all branches of Western science. However, scholars and scientists from the West may also benefit from Buddhist understanding, especially of the nature of the mind and its functions. I am confident that this

book will be of value to scholars and scientists concerned with the workings of the mind, who wish to understand what can be learned through the path of Buddhist meditation.

H.H. THE DALAI LAMA
NOVEMBER 13, 1997

Preface
Overview

This work largely consists of three chapters. Before Chapter 1, there is a discussion of methodologies in the field of Buddhist Studies, especially as they pertain to scholarly treatments of Buddhist meditation. The emphasis of this discussion is on the importance of bringing traditional Buddhist theories about consciousness, attention, and introspection into dialogue with modern scientific and philosophical discussions of these topics.

The main body of Chapter 1 is a presentation of the Buddhist Four Noble Truths as these are expounded in the writings of the Tibetan Buddhist scholar and contemplative Tsongkhapa (Tsong kha pa) (1357–1419). Tsongkhapa's views are frequently brought into juxtaposition with assertions by major figures in the history of Christianity, and Western philosophy and science. The purpose of such references to Western thinkers is to highlight areas of common concern and to promote deeper cross-cultural and interdisciplinary dialogue between modern Western culture and Indo-Tibetan Buddhism.

Chapter 2 gives a translation of Tsongkhapa's own presentation of the cultivation of quiescence in his *Small Exposition of the Stages of the Path to Enlightenment (Byang chub lam gyi rim pa chung ba).* This translation from the original Tibetan is accompanied by my own commentary, presented from the perspective of the Prāsaṅgika Madhyamaka view as propounded in the Gelugpa (dGe lugs pa) order founded by Tsongkhapa. The translation and commentary are extensively annotated with references to the original Sanskrit Buddhist sources from which Tsongkhapa draws, and to analogous writings in the Theravāda Buddhist tradition.

Chapter 3 includes a detailed analysis of the nature of introspection in terms of modern philosophy of mind and cognitive psychology, and the Prāsaṅgika Madhyamaka view promoted by

Tsongkhapa. This section concludes with a presentation of the role of introspection *(samprajnya)* and mindfulness *(smṛti)* in the cultivation of meditative quiescence *(śamatha)* in Indo-Tibetan Buddhism. This discussion draws from both the writings of Tsongkhapa and the Mahāmudrā and Atiyoga Buddhist traditions, showing the complementarity of these approaches for the contemplative cultivation of sustained voluntary attention. Finally, I offer a comparative analysis of quiescence in the Theravāda and Indo-Tibetan Buddhist traditions.

Tsongkhapa

Tsongkhapa (1357–1419), the Tibetan Buddhist scholar and contemplative who is the author of the presentation on the cultivation of quiescence translated in this work, is renowned in Tibet as one of the greatest sages in the entire history of Indo-Tibetan Buddhism. As a religious reformer, he has been likened to Luther by Western Buddhologists; but as a religious scholar he is regarded in his own culture as a genius whose status more closely parallels that of Aquinas in Western Christianity. For Tsongkhapa created his own unique interpretation of Buddhist systematics and hermeneutics, in which he synthesized themes from all the Tibetan Buddhist traditions of his era. For these reasons he was praised by the Eighth Karmapa as Tibet's chief exponent of ultimate truth, who revived the Buddha's doctrine at a time when the teachings of all the four major Tibetan Buddhist lineages were in decline.[1]

[1] The Eighth Karmapa, Gyalwa Mikyö Dorje (rGyal ba mi bskyod rdo rje) (1507–1554), lauded Tsongkhapa in this manner in his poem "In Praise of the Incomparable Tsongkhapa." *Life and Teachings of Tsong Khapa*, ed. Prof. R. Thurman (Dharamsala: Library of Tibetan Works and Archives, 1982), pp. 243–45.

Born in the eastern region of Amdo, near the Chinese border, Tsongkhapa was early recognized as a child prodigy; and at the age of three he was given the Buddhist layman's vows by the Fourth Karmapa, Rölpay Dorje.[2] Four years later he began his monastic career by taking the vows of a novice, and he was also initiated into the esoteric practices of Buddhist Tantra, or Vajrayāna.

Throughout his youth and adulthood, he studied under many of the most accomplished Tibetan Buddhist scholars and contemplatives of his day, who represented all the major lineages that flourished in Tibet at that time. Even before he was out of his teens, his reputation as a prodigious and insightful scholar was spreading throughout Tibet, and he was eventually invited by the Emperor of China to serve as his Imperial Tutor, an honor that Tsongkhapa respectfully declined.

Tsongkhapa's studies covered the entire corpus of the Buddhist *sūtras* and *tantras* preserved in the New Translation School,[3] as well as numerous classic Indian Buddhist treatises on soteriology, dialectics, epistemology, psychology, ontology, ethics, phenomenology, medicine, and of course the entire range of exoteric and esoteric contemplative practices. The extent of his learning was reflected in the numerous lecture series he delivered over the course of his life to thousands of students, and in the eighteen large volumes of his collected works.

In Tibetan Buddhist society it is often assumed that an individual who has excelled in erudition, lecturing, and writing is bound to have succumbed to the pitfall of barren intellectualism. But Tsongkhapa emphasized in his life and writings that erudition is meaningful only if one distills the pragmatic import of one's knowledge and puts it into practice. Thus, he did his utmost to exemplify the Buddhist ideals of the monastic way of life of a

[2] Rol pa'i rdo rje

[3] This school, initiated by the Tibetan translator Rinchen Zangpo (Rin chen bzang po) (958–1055), is given its name in comparison to the "Old Translation School," begun in the eighth century under the guidance of the Indian Mahāsiddha Padmasambhava. Cf. Gos lo tsva ba gzon nu dpal, *The Blue Annals*, trans. George Roerich (Delhi: Motilal Banarsidass, 1988), pp. 68–69.

Bodhisattva. Moreover, from the time he was in his thirties, he devoted years on end to intensive contemplative retreats, the first of these lasting for four years, in which he engaged in practices drawn from both the *sūtras* and *tantras*. During a later one-year retreat, having already apparently achieved quiescence, it is reported that he went on to achieve the integration of quiescence and intuitive insight into emptiness.

It was after this retreat, as a seasoned scholar, author, teacher, and contemplative, that he composed *The Small Exposition of the Stages of the Path*,[4] from which our presentation of quiescence is drawn. Tsongkhapa passed away in his sixty-second year while sitting in meditation, having set an example in his life and teachings of how to integrate vast erudition with deep contemplative practice.[5]

The Cultivation of Quiescence

The subject of quiescence is one that has received relatively little attention by either Asian or modern Western Buddhist scholars and contemplatives. Within the Tibetan Buddhist tradition strong emphasis is placed on the cultivation of insight by means of the more advanced theories and practices of Madhyamaka, Mahāmudrā, and Atiyoga as well as the other esoteric branches of the Vajrayāna. And yet in the *sūtras*, *tantras*, and other authoritative Indian and Tibetan Buddhist treatises on these subjects, quiescence is widely acknowledged as an indispensable prerequisite for the cultivation of insight.

[4] Lam rim chung ngu

[5] For a fuller account of Tsongkhapa's life and works, see *Life and Teachings of Tsong Khapa*, ed. Thurman, Ch. 1.

This insistence is not simply a dogmatic adherence to tradition, but rather stems from deep contemplative experience. The implication here is one not often emphasized in modern works on contemplation and mysticism: before seeking transcendent insight, one is advised to achieve a heightened degree of cognitive and mental health. As we shall see in the following pages, the subject of mental health is central to the threefold Buddhist training in ethics, meditation, and insight.

Among the Buddhist *sūtras* and Indian and Tibetan Buddhist classics on meditation there are many excellent, authoritative explanations of methods for developing sustained voluntary attention that is central to the cultivation of quiescence. Among these, Tsongkhapa's discussion in his *Small Exposition of the Stages of the Path* is remarkably thorough and yet concise, erudite and yet practical, and is marked with a high degree of philosophical and psychological sophistication. Drawing on his own wealth of learning and contemplative experience, his exposition well represents the Indo-Tibetan Buddhist tradition concerning the psychological and soteriological significance of quiescence. This training is presented as a profoundly religious practice, honed with philosophical insight, and imbued with an emphasis on precise observation and testing with personal experience. As such, it challenges modern Western reified notions of the boundaries demarcating religion, philosophy, and science.

Acknowledgments

I would like to thank first of all Professor Carl Bielefeldt of the Religious Studies Department at Stanford University for his help in seeing this work to its completion. I am also grateful to Professor Anne Klein, of the Department of Religious Studies at Rice University, and Professor Hester Gelber, of the Religious Studies Department at Stanford University, for their stimulating

and challenging comments and suggestions for this text. I would also like to thank Dr. William Ames, Dr. Robert Kantor, Clinical Professor of Psychology at Stanford Medical School, and Dr. Gregory Simpson, of the Department of Neurology at Albert Einstein College of Medicine, for their helpful comments on Part Three of this work. I am also grateful to Professor Lee Yearley for introducing me to the brilliant writings of William James, which inspired Chapter 1 of this book.

I was first introduced to the Indo-Tibetan practices for cultivating quiescence in 1972 by Geshe Ngawang Dhargye, then teaching in the Library of Tibetan Works and Archives in Dharamsala, India; and I later received further instruction on this training from H.H. the Dalai Lama, Geshe Rabten, Gen Lamrimpa, and Gyatrul Rinpoche. I am deeply grateful to them all for so selflessly sharing their knowledge and wisdom with me. I would also especially like to thank David Ramsay Steele of Open Court for his conscientious editing of this work.

Finally, I would like to expess my heartfelt gratitude to my parents and to my wife, Dr. Vesna A. Wallace, for their constant support, assistance, and affection.

An Approach to Quiescence

The Study of Consciousness and of Buddhist Meditation

This present work is motivated by an interest in Buddhist contemplative practices as a means to gaining greater understanding of the mind, and particularly the nature of consciousness. For people brought up and educated in America and Europe, it would be quite reasonable to look first to modern Western science for answers to questions about this subject; and indeed, in recent years there has been a surge of scientific interest in a wide array of issues surrounding consciousness. One assumption underlying this work is that Indo-Tibetan Buddhist literature on the cultivation of sustained, voluntary attention may contribute to our modern understanding of the nature and potentials of attention, introspection, and consciousness. Despite four hundred years of expanding knowledge in the fields of the physical sciences, life sciences, and cognitive sciences, there is presently no scientific or philosophical consensus concerning the origins, nature, causal efficacy, or fate of consciousness. Scientists have yet to discover the manner in which consciousness arises, either in primitive organisms or in humans. The general assumption is that consciousness arises as an emergent property of matter and energy, but scientists do not yet know what it is about certain configurations of matter and energy that enable them to produce consciousness. Thus, the origins of consciousness remain a mystery.

The nature of consciousness also eludes the natural sciences. There are no scientific means of detecting the presence or absence of consciousness, either in primitive organisms, such as a hydra,

1

or in a developing human fetus. If such scientific knowledge were available, there would be much more clarity and less dogma, for example, in the ongoing debates about abortion. Moreover, there is no consensus among cognitive scientists as to whether consciousness is a state, a content, a process, or a system. Is it *identical* to certain functions of the nervous system, or is it a distinct phenomenon that is *produced* by certain—as yet unidentified— neurological processes? If it is in fact a natural phenomenon distinct from the brain, what are its own unique characteristics? The nature of consciousness remains an open question.

Subjective experience clearly indicates that states of consciousness causally influence other mental and physical processes, as evidenced by the placebo effect, and the influences of both unintentional and intentional mental processes, such as the opening of capillaries in the face as a result of embarrassment, and the intentional movements of the body. This very assertion, however, is held suspect in contemporary cognitive science, which tends to attribute all such causal efficacy to brain functions alone. If subjectively experienced conscious states do in fact have causal efficacy, the mechanisms of their influence remain unknown to modern science. Even without accepting Cartesian dualism regarding the body and mind, it seems that some scientific explanation should be sought to account for the fact that our mental states at least seem to influence the body and mind; but the nature of that causal efficacy remains a mystery.

Finally, although there is widespread scientific consensus that consciousness disappears at death, this is a necessary implication of the premise that consciousness is an emergent property of a properly functioning nervous system. But given our lack of scientific knowledge about the origins and nature of consciousness, both in terms of evolution and human embryology, it is hard to avoid the conclusion that we are equally ignorant about the fate of consciousness at death.

In short, although modern science is presently ignorant of the origins, nature, causal efficacy, and fate of consciousness, the extent of our ignorance about consciousness is often overlooked. This ignorance is, as it were, a retinal "blind spot" in the scientific

view of the world: it is a deficit in our vision of reality, a deficit of which our civilization seems largely unaware. Thus, volumes on cosmogony, evolution, embryology, and psychology are written with hardly a mention of consciousness; and when it is addressed, it tends to be presented not in terms of its own distinctive, experiential qualities, but in terms of other phenomena with which scientists are well familiar, such as computer systems,[1] brain functions,[2] and even quantum mechanics.[3] Although the nature of consciousness was long overlooked in Western science, over roughly the past ten years there has been a rapid surge of interest in this subject not only in the field of cognitive science, but in the life sciences and physical sciences as well. Moreover, a growing number of these scientists are demonstrating an unprecedented openness to insights from the world's contemplative traditions, of both the East and the West.[4]

Although there is certainly a comparable diversity of speculative theories of consciousness among Eastern philosophers and theologians, there are also many phenomenological accounts reported by contemplatives on the basis of their own personal experience. The Indo-Tibetan Buddhist contemplative tradition has produced an especially rich body of such literature. Not only does it give accounts of the origins, nature, causal efficacy, and fate of consciousness, it also provides specific instructions on

[1] Howard Gardner expresses the view of many contemporary cognitive scientists when he comments that the computer model is "central to any understanding of the human mind." Howard Gardner, *The Mind's New Science* (New York: Basic Books, 1985), p. 6.

[2] Cf. F.H.C. Crick, *The Astonishing Hypothesis: The Scientific Search for the Soul* (London: Simon and Schuster, 1994).

[3] Cf. Roger Penrose, *Shadows of the Mind: A Search for the Missing Science of Consciousness* (Oxford: Oxford University Press, 1994); Bernard Baars, "Roger Penrose and the Quest for the Quantum Soul," Journal of Consciousness Studies: Controversies in Science and the Humanities. 1, 2 (1994), pp. 261–63; Stuart Hameroff, "Quantum Coherence in Microtubules: A Neural Basis for Emergent Consciousness?" *Journal of Consciousness Studies* 1, 1 (1994), pp. 91–118.

[4] I would especially draw the reader's attention to the new *Journal of Consciousness Studies: Controversies in Science and the Humanities*, an international multi-disciplinary journal, which provides a forum for a broad range of views concerning this subject.

ways of testing these theories experientially. While Western cognitive science has largely dismissed introspection as a means of exploring conscious states, the Buddhist tradition not only uses it, but explains in detail techniques for making this a more reliable and penetrating mode of observation. In particular, it asserts that the qualities of attentional stability and clarity are indispensable keys to the introspective exploration of conscious states. To take a modern analog, if one wishes to observe a specimen under an optical microscope, one should first see that this instrument is firmly mounted and that its lenses are clean and polished to ensure high resolution.

The very notion of taking from Buddhism theories of consciousness and techniques for developing sustained, voluntary attention and presenting them as possibly true and useful runs against much of the grain of the Western academic study of Buddhism. One reason for this is that Buddhism is widely regarded as a religion, and such theories and practices are simply components of the doctrine and rituals of that religion. Thus, the only acceptable way to present these topics is to report them as elements of the Buddhist tradition; they are not to be submitted as descriptions of the actual nature of consciousness or as means of actually refining one's introspective faculties.[5] In the words of William Christian, a distinguished philosopher of religion, as long as one is reporting on a religion, speakers can be informative "when they define or explain doctrines of their traditions, but not when they are asserting them."[6] Although scientists are obviously granted the right to assert the truth of their theories, a different standard is required for proponents of religion, for "the central doctrines of the major traditions are not scientific theories, that is to say exact formulations of uniformities said to hold in the apparent world, or explanations and predictions derived from these laws of nature."[7]

[5] William A. Christian, *Oppositions of Religious Doctrines: A Study in the Logic of Dialogue among Religions* (London: Macmillan, 1972), p. 24.

[6] Ibid., p. 88.

[7] Ibid., p. 30.

What are we to make, then, of Buddhist contemplatives' exact formulations of uniformities said to hold true of states of consciousness and the means they describe for testing those theories in experience? William Christian comments:

> Though conceivably a religious tradition might include among its subsidiary doctrines some scientific claim (or something purporting to be a scientific claim), oppositions of such doctrines drawn from different religions are even less likely than opposed historical claims . . . [8]

Some reasons for this are that

> (i) all the major religions took shape in pre-scientific eras and (ii) when they have had to assimilate modern science they have learned (more or less, sometimes by bitter experience) how to avoid introducing scientific theories into their doctrinal schemes. But as with historical claims the main reason is that religious doctrines deal with a different range of problems than scientific theories do . . . [9]

This statement certainly holds true with regard to many problems that clearly fall within the separate domains of theology or natural science, but these two disciplines are bound for a head-on collision when it comes to the nature of consciousness; for they both have a great stake in their doctrines, and neither is inclined to sacrifice its beliefs to the other. Although it is obviously true that Buddhism has taken shape in pre-scientific eras, the past four hundred years of natural science have produced no consensus concerning the fundamental issues around consciousness. Buddhism raises real questions concerning the origins, nature, causal efficacy, and fate of consciousness; and it suggests means of enhancing attentional stability and clarity, and of then using these abilities in the introspective examination of conscious states to pursue the fundamental issues concerning consciousness itself. Its theoretical and practical hypotheses are either true or false, and if they can be tested in part by modern scientific methods,

[8] Ibid.

[9] Ibid.

this can only be seen as an advantage by Buddhists who are genuinely concerned with the nature and means of exploring consciousness.

William Christian does allow for one exception to his guidelines for making religious statements: in the course of supporting them, adherents of a religion may make informative utterances about their own experiences "if they are relevant."[10] Thus, this leaves open the possibility that contemplatives, Buddhist or otherwise, may speak informatively of their own experiences; and such reports may be taken seriously by others.

[10] Ibid., pp. 88–89.

Approaches to the Study
of Buddhist Meditation

On the whole, the Western academic study of Buddhism has adhered to the guidelines laid out by William Christian, and its treatment of Indo-Tibetan Buddhist techniques for developing sustained, voluntary attention is no exception. For example, in his book *Calming the Mind and Discerning the Real: Buddhist Meditation and the Middle View*,[1] Alex Wayman has produced an English translation of Tsongkhapa's most extensive discussion of meditative quiescence. The introduction, translation and extensive annotations are standard examples of the philological, historical, text-critical model of Buddhology. As C.W. Huntington points out, this model "is accorded the greatest prestige—due, no doubt, to its close association with what is taken to be the scientific method—but it is also subject to frequent criticism on the grounds that it has become altogether too abstract and sterile in its refusal to give sustained attention to the problem of meaning."[2]

While this model may rightly be called *scientific* with respect to the texts under investigation, it is purely *scholastic* in that it ignores whatever experiential basis may underlie those texts. Moreover, the truth or falsity of the theoretical and practical assertions of the texts is never even addressed. For instance, in his introduction Wayman gives a summary of various paranormal abilities that are said to be achievable once one has attained quiescence. These include flying, physically moving through solid objects, the psychic manipulation of matter, the psychic creation of physical illusions, recollections of previous lives, clairaudience, and clairvoyance.[3] To most modern Western readers, all such

[1]Alex Wayman, *Calming the Mind and Discerning the Real: Buddhist Meditation and the Middle View* (New York: Columbia University Press, 1978).

[2]C.W. Huntington, *The Emptiness of Emptiness: An Introduction to Early Indian Mādhyamika* with Geshé Namgyal Wangchen (Honolulu: University of Hawaii Press, 1989), pp. 6–7.

[3]Wayman, *Calming the Mind and Discerning the Real*, pp. 38–43.

claims must appear preposterous, but nowhere does he offer any evaluative comment whatsoever. Do Buddhists take these claims seriously? Are there accounts of people actually achieving any of these abilities? Is it possible to attain quiescence, which is said to be an indispensable prerequisite to those paranormal abilities? Is it possible to attain any of the nine attentional states leading up to the achievement of quiescence? None of these issues are even raised by Wayman, which may be seen as an indication of his refusal to look beyond the meaning of the words to the philosophical, scientific, and religious import of the text.[4]

This way of treating literature from non-Western cultures conforms well with the current intellectual orthodoxy in the Western academic disciplines of philosophy, anthropology, sociology, and history of religion, in which cultural relativism and deconstruction are very much in vogue. Huntington, for instance, approvingly cites Gadamer's claim that

> The text that is understood historically is forced to abandon its claim that it is uttering something true. We think we understand when we see the past from a historical perspective, i.e. place ourselves in the historical situation and seek to reconstruct the historical horizon. In fact, however, we have given up the claim to find, in the past, any truth valid and intelligible for ourselves. Thus this acknowledgment of the otherness of the other, which makes him the object of objective knowledge, involves the fundamental suspension of his claim to truth.[5]

[4] For further discussion of Wayman's book, see Geshe Sopa, "Some Comments on Tsong kha pa's *Lam rim chen mo* and Professor Wayman's *Calming the Mind and Discerning the Real* and "Geshe Sopa Replies to Alex Wayman" in *Journal of the International Association of Buddhist Studies*, 3 (1980), pp. 68–92 and 98–100; Alex Wayman, "Alex Wayman Replies to Geshe Sopa" in *Journal of the International Association of Buddhist Studies* 3 (1980), pp. 93–97; Alex Wayman, "Introduction to Tsoṅ kha pa's Lam rim chen mo". *Phi Theta Annual*, Vol. 3 (Berkeley, 1952), pp. 51–82; Robert Kritzer, "Review of Alex Wayman, *Calming the Mind and Discerning the Real: Buddhist Meditation and the Middle View*" in *Philosophy East and West* 31 (1981), pp. 380–82. Also note Elizabeth Napper, *Dependent-Arising and Emptiness* (Boston: Wisdom, 1989), pp. 441–473, for her comments on Wayman's translation of the insight section of Tsongkhapa's *Lam rim chen mo*.

[5] H. Gadamer, *Truth and Method*. Garrett Barden and John Cumming, trans. (New York. Reprint, 1988), p. 270. Cited in C.W. Huntington, *The Emptiness of Emptiness: An Introduction to Early Indian Mādhyamika*, p. 13.

In describing his methodology for his introduction, translation, and annotations to Candrakīrti's classic *Madhyamakāvatāra*, Huntington comments that his own approach takes for granted the insights of Gadamer's concept of effective history.[6] The frequently noted limitation of Gadamer's historical treatment of texts, however, is that his own works are written in "disappearing ink": that is, as soon as his hermeneutical criteria are applied by others to his writings, his own texts are forced to abandon their claim to utter anything that is true. On the other hand, if advocates of his viewpoint wish to claim a privileged perspective, superior to and unlike all others, they must stand at the end of a long line of earlier proponents of all manner of religious, philosophical, and scientific theories who make the same claim.

In a refreshing departure from this "self-erasing" methodology, Paul Griffiths suggests that, contrary to the assumptions of our contemporary intellectual climate, rational discourse is a phenomenon which operates by recognizably similar rules and with effectively identical goals cross-culturally, and is thus a tool available in a relatively straightforward manner for cross-cultural communication and assessment. In his learned volume *On Being Mindless: Buddhist Meditation and the Mind-Body Problem* he uses as his working hypothesis the theory that "philosophy is a transcultural human activity, which in all essentials operates within the same conventions and by the same norms in all cultures."[7] Whether or not this large claim can be accepted without qualifying it in important respects, Griffiths rightly criticizes Western Buddhologists who refuse to take Buddhist thought seriously; and he comments, "We do the tradition a disservice if we refuse to move beyond the exegetical mode of academic discourse to the normative, the judgmental."[8]

Among the wide variety of Indian Buddhist literature on meditation—ranging from highly experiential to highly scholastic

[6] Huntington, *The Emptiness of Emptiness*, p. 13.

[7] Paul J. Griffiths, *On Being Mindless: Buddhist Meditation and the Mind-Body Problem* (La Salle: Open Court, 1986), p. xvii.

[8] Ibid., p. xix.

treatments—Griffiths focuses on systematic philosophical texts of Indian scholastic Buddhism, and treats them as "large-scale and sophisticated conceptual systems."[9] While he acknowledges that the "results of meditative practice inform the philosophical views of practicing Buddhists with new ways in which the philosophical system can be modified and developed," in terms of his own methodology, he refuses to address whether or not there actually are or were virtuoso practitioners who claim to be able to enter the meditative state called "the attainment of cessation,"* which is the major topic of his work.[10] Moreover, this approach may easily give rise to the impression that Buddhists meditate in order to devise sophisticated conceptual systems about meditation. According to the Buddhist contemplative tradition, however, the reverse holds true: conceptual systems about meditation are designed to guide contemplatives to states of experience that transcend all conceptual systems. In effect, Griffiths treats the topic of Buddhist meditation as if it is a dead (or never even living) tradition entombed in ancient books, a methodology long familiar to Western Buddhologists at least since the Victorian era, in which the modern "scientific" study of Buddhism began.[11] This approach may be just as much a disservice to the tradition as a purely exegetical mode of academic discourse.

On the basis of his erudite, text-critical analysis of the attainment of cessation, Griffiths concludes that this meditative state is analogous to "some kind of profound cataleptic trance, the kind of condition manifested by some psychotic patients and by long-term coma patients."[12] If this is in fact the case, what is the appeal of this soteriological goal for practicing Buddhists? If this is regarded as a temporary state of mindlessness, why would Buddhist contemplatives subject themselves to the arduous, sustained mental discipline culminating in a state that could much

[9] Ibid., p. xx.

[10] Ibid., p. 5. All terms marked with an asterisk are to be found in the Glossary on p. 303, with their Tibetan and Sanskrit counterparts.

[11] Cf. Philip C. Almond, *The British Discovery of Buddhism* (Cambridge: Cambridge University Press, 1988).

[12] Griffiths, *On Being Mindless*, p. 11.

more swiftly and straightforwardly be achieved by means of a well-aimed blow to the head with a heavy object? On the other hand, if this is regarded as a salvific state that lasts for eternity, it is hard to imagine a more impoverished notion of salvation than this, which Griffiths has attributed to the Buddhist tradition. Are there any Buddhist contemplatives today who actually aspire to such a goal? If one feels that the texts compel one to draw this conclusion about the nature of the attainment of cessation, it would seem worthwhile to check with living members of this tradition to see if it corresponds to their own contemplative goals. Although Griffiths does indeed take the meaning of these scholastic texts seriously, he displays no comparable respect for the experiences of living Buddhist contemplatives. Thus, while he seeks to distance himself from the condescending perspective of some of the early Western pioneers of Buddhology, such as Louis de La Vallée Poussin,[13] the distance may not be as great as he desires.

Regarding the general topic of the relationship between quiescence and insight practices in Indian Buddhism, Griffiths sees this as "an excellent example of the uneasy bringing together of two radically different sets of soteriological methods and two radically different soteriological goals."[14] If one sets aside for the moment the lofty (or simply vegetative?) attainment of cessation and focuses on the basic training in quiescence presented by Tsongkhapa, it should be swiftly apparent that this discipline is a reasonable preparation for the cultivation of contemplative insight. Indo-Tibetan Buddhism regards the ordinary, untrained

[13] Griffiths specifically rejects Poussin's judgment of Indian "'philosophumena' as being concocted by ascetic . . . men exhausted by a severe diet and often stupefied by the practice of ecstasy." [Louis de La Vallée Poussin, The way to *Nirvāṇa: Six Lectures on Ancient Buddhism as a Discipline of Salvation* (Cambridge: Cambridge University Press, 1917), pp. 110–12]; Griffiths, *On Being Mindless*, p. xiii. See also Paul J. Griffiths, "Buddhist Hybrid English: Some Notes on Philology and Hermeneutics for Buddhologists". *Journal of the International Association of Buddhist Studies* 4 (1981), pp. 17–32.

[14] Griffiths, *On Being Mindless*, p. 23. A far more insightful discussion of the relationship between quiescence and insight in Theravāda Buddhist practice is found in Winston L. King's *Theravāda Meditation: The Buddhist Transformation of Yoga* (University Park: Pennsylvania State University Press, 1980), pp. 108–115.

mind as "dysfunctional"* insofar as it is dominated by alternating states of laxity, lethargy, and drowsiness on the one hand and excitation and attentional scattering on the other. The cultivation of quiescence is designed to counteract these hindrances and cultivate the qualities of attentional stability and clarity, which are then applied to the training in insight. Thus, the assertion that quiescence is incompatible with insight at this early stage is tantamount to arguing that a mind dominated by laxity and excitation is more suitable for the cultivation of insight than is a mind imbued with attentional stability and clarity.

In her essay "Mental Concentration and the Unconditioned: A Buddhist Case for Unmediated Experience," Anne Klein, drawing from more than twenty years of close collaboration with Tibetan Buddhist contemplatives and scholars, discusses the stages of Buddhist meditation from a Gelugpa Madhyamaka perspective. There she asserts that at some early stages of the path to enlightenment, concentration and insight are indeed antithetical; but in the more advanced stages the relationship between them becomes "complementary—meaning that the increase of one fits with and engenders development in the other."[15] At least implicitly in response to Griffiths characterization of the attainment of cessation as a state of complete mindlessness, Klein comments, " . . . it is only those who do not understand the extent of calm or the full potential of the internally engendered energy associated with consciousness who are susceptible to misinterpreting the cessation of coarse minds as cessation of consciousness."[16]

It may be that the Theravāda, Vaibhāṣika, and Yogācāra traditions, which Griffiths analyzes, simply disagree with the Madhyamaka interpretation of the attainment of cessation. Or it may be that by focusing on scholastic accounts of meditation and ignoring the fact that the Buddhist contemplative tradition has

[15]Anne C. Klein, "Mental Concentration and the Unconditioned: A Buddhist Case for Unmediated Experience" in Robert E. Buswell, Jr. and Robert M. Gimello, ed. *Paths to Liberation: The Mārga and Its Transformations in Buddhist Thought* (Honolulu: University of Hawaii Press, 1992) (Studies in East Asian Buddhism 7), p. 281.

[16]Ibid., p. 290.

ever been a living tradition, Griffiths, for all his impressive erudi-
tion and philosophical acumen, has produced a fundamentally
misleading interpretation of the attainment of cessation and the
relationship between quiescence and insight.[17] An increasing
number of Buddhologists are coming to recognize the shortcom-
ings of ignoring the contemporary Buddhist tradition. For exam-
ple, J.W. de Jong, a highly respected scholar of philology and
textual criticism, writes, "The most important task for the student
of Buddhism today is the study of the Buddhist mentality. That is
why contact with present-day Buddhism is so important . . . "[18]

Since 1959, when over 100,000 Tibetans fled from their home-
land, which had been brutally occupied since 1950 by the Chinese
Communists, an increasing number of Tibetan Buddhist scholars
and contemplatives have visited and taught in the West; and many
from the Gelugpa order have expounded on the cultivation of qui-
escence. Geshe Sopa, for instance offers a cursory overview of this
discipline in his essay *"Śamathavipaśyanāyuganaddha:* The Two
Leading Principles of Buddhist Meditation."[19] Lati Rinbochay
gives a similar, somewhat more extensive account in the discus-
sion of "Calm Abiding" in *Meditative States in Tibetan Buddhism:
The Concentrations and Formless Absorptions.*[20] And Geshe Gedün
Lodrö gives an even more detailed, highly erudite account in
Walking Through Walls: A Presentation of Tibetan Meditation,[21] in

[17]When trying to assess contemplative experiences that are said to be beyond the
scope of the intellect, it is well to bear in mind Nāgārjuna's injunction: "What
words can express comes to a stop when the domain of the mind comes to a stop."
(*"nivṛttam abhidhātavya· nivṛtte cittagocare," Mūlamadhyama-kakārikā* 18.7a).
Cited in Frits Staal, *Exploring Mysticism: A Methodological Essay* (Berkeley:
University of California Press, 1975), p. 45.

[18]J.W. de Jong (1974) "The study of Buddhism: Problems and Perspectives."
Studies in Indo-Asian Art and Culture 4 *(Vira Commemorative Volume),* p. 26.

[19]Included in the volume *Mahāyāna Buddhist Meditation: Theory and Practice,*
Minoru Kiyota, ed. (Honolulu: University of Hawaii Press, 1978), pp. 46–65.

[20]Lati and Lochö Rinbochays, L. Zahler, and J. Hopkins, *Meditative States in
Tibetan Buddhism: The Concentrations and Formless Absorptions.* (London:
Wisdom, 1983,) pp. 52–91.

[21]Geshe Gedün Lodrö, *Walking Through Walls: A Presentation of Tibetan Meditation.*
trans. and ed. Jeffrey Hopkins (Ithaca: Snow Lion, 1992).

which he demonstrates his extensive knowledge not only of early Indian Buddhist literature, but later Gelugpa scholasticism as well. Jeffrey Hopkins, whom we have to thank for the above two volumes, has also given his own presentation of the development of quiescence in the "Calm Abiding" chapter of his *Meditation on Emptiness;* and his discussion is of precisely the same genre as the above mentioned texts.[22]

All these presentations by erudite Tibetan scholars of Buddhism pattern themselves closely after Tsongkhapa's discussions of this topic in his two major expositions of the stages of the path to enlightenment;[23] and all of them are delivered within the context of Western academia. It seems safe to assume that all the above Tibetan scholars—trained in the Tibetan monastic tradition and not in "Buddhist Studies" in the Western academic tradition—take seriously both the texts on quiescence as well as the experiential accounts of the development and attainment of quiescence. Huntington characterizes this traditional approach to Buddhist literature as "proselytic," and he disparages this methodology as constituting a violation of the very texts that are studied.[24] In light of the fact that Buddhists have been transmitting knowledge of their tradition in this manner for more than two millennia, it seems somewhat harsh to judge them all as violating the very texts they hold sacred. And Huntington's approach of refusing to look in such texts for any truth valid and intelligible for ourselves seems an unpromising alternative.

The chief limitation of the previously mentioned Tibetan scholars' methodology is that while they take Buddhist texts and contemplative experience seriously, in presenting this material they do not apparently take into account the cultural backgrounds of their audience. It is as if their lectures on Buddhism are sent to us in envelopes marked "Occupant," anonymously directed to whatever audience might receive them, regardless of time or place. With no regard for modern Western views concerning the

[22] Jeffrey Hopkins, *Meditation on Emptiness* (London: Wisdom, 1983), pp. 67–90.

[23] *Byang chub lam rim che ba.* (Collected Works, Vol. Pa) and *Byang chub lam gyi rim pa chung ba.* (Collected Works, Vol. Pha).

[24] Huntington, *The Emptiness of Emptiness*, p. 8.

mind, attention, the role of consciousness in the universe, or any of the natural sciences, these Tibetan teachers describe the nature of quiescence and the means of achieving paranormal abilities and extrasensory perception. The vast chasm between their assertions, which they present as uncontested facts, and the prevailing Western views on these subjects is never even acknowledged. Thus, while Western Buddhologists commonly fail to take Buddhist literature and experience seriously, Tibetan teachers commonly fail to take the Western world view seriously. Allowance for this oversight must be made for senior Tibetan scholars and contemplatives who visit the West with little or no knowledge of Western languages and culture. But it is to be hoped that younger generations of Tibetans and Western scholars who adopt their approach will take on the difficult challenge of bringing the Buddhist tradition into meaningful, informed dialogue with the modern West.

All the above treatments of quiescence are presented within the context of the modern Western academic world. But Buddhism is also being taught in Buddhist "Dharma centers" and monasteries around the world; and here the emphasis is on seeking not only theoretical understanding but personal experience. It was in this context, in a Buddhist monastery in Switzerland, that the late, distinguished Tibetan Buddhist scholar and contemplative Geshe Rabten taught quiescence to a group of Westerner monks and lay students in his lectures published in the book *Echoes of Voidness*.[25] Likewise, after living as a Buddhist contemplative recluse in the Himalayas for roughly twenty years, the Tibetan monk Gen Lamrimpa delivered a series of lectures on the cultivation of quiescence to a group of Western students as they were about to begin a one-year contemplative retreat under his guidance in the United States. These lectures, which appeared as his book *Śamatha Meditation*,[26] were followed by his individual guidance to each of those in retreat as they applied themselves to

[25] Geshe Rabten, *Echoes of Voidness*, Stephen Batchelor, trans. and ed. (London: Wisdom, 1986), pp. 113–128.

[26] Gen Lamrimpa, *Śamatha Meditation*. B. Alan Wallace, trans. (Ithaca: Snow Lion, 1992).

this training over the next year. Among the range of treatments of quiescence cited above, this approach may be deemed the least scientific with respect to Buddhist literature, but the most scientific with respect to Buddhist meditative experience; for the participants in this project actually put the Buddhist theories concerning attentional development to the test of experience.[27] The working hypothesis for this project was that not only philosophy, but meditation is, to use Griffiths words, "a trans-cultural human activity, which in all essentials operates within the same conventions and by the same norms in all cultures."[28]

[27] When Herbert Benson, a Harvard physician with an interest in meditation, offered to conduct objective scientific research on the participants in this one-year retreat, Gen Lamrimpa respectfully declined on the grounds that such research might interfere with the meditators' own training. He proposed instead that such research be conducted during some comparable future retreat; then by comparing the two, one might ascertain the extent of interference experienced due to such scientific research.

[28] Gen Lamrimpa commented to me at the end of this year that before he began leading this retreat, he had little hope that these Western students would be able to progress significantly in this training; but after collaborating with them over the course of the year, he was impressed at the progress many of them had made. At the conclusion of this project, the majority of the participants told me that, for all its difficulties and challenges, this had been the most meaningful year of their life.

Buddhology and the Modern World

For all the variety of discussions of quiescence in Indo-Tibetan Buddhism by Western and Tibetan scholars alike, their impact on modern philosophical and scientific understanding of attention, introspection, and consciousness remains negligible. For example, more than a century ago, William James, founder of the first psychology laboratory in the United States, concluded on the basis of the best available scientific research that voluntary attention cannot be sustained for more than a few seconds at a time. The last fifty years of scientific research on attention have relied primarily on measures of performance, that is, on the effects of attention on some type of behavior. Following this approach, the quality and duration of attention can be inferred only indirectly from behavior. This method is particularly problematic when it comes to assessing scientifically the kind of attention developed in the training in quiescence, which is not directly linked to behavior.

Gregory Simpson, a contemporary neuroscientist who has specialized in the study of attention, comments that it may be accurate to say that the effects of the highest levels of attention on outwardly manifested performance are not typically sustained for more than one to three seconds.[1] Although focused attention may be enhanced for only one to three seconds without additional stimuli or other external assistance, relatively high levels of attention may be sustained for many tens of minutes.[2] Due to the lack of engagement between scientists and Buddhist contemplatives, it is not clear whether the kind of attention cultivated in the training in quiescence is of the "highest level," which, according to

[1] Personal correspondence, June 4, 1995.

[2] Cf. N.H. Mackworth, Medical Research Council Special Report no. 268 (London: H.M. Stationary Office, 1950); J.F. Mackworth, *Vigilance and Attention* (Penguin Books, 1970); A.F. Sanders, ed., *Attention and Performance I* (Amsterdam: North-Holland, 1970).

scientific research can be maintained for only a few seconds, or whether it is the kind that can commonly be sustained for much longer periods. What can be said is that experiments that have measured transient, focused attention on the basis of the performance of simple sensory tasks indicate that this transient, high level of focused attention lasts between one and three seconds,[3] which agrees with James's claim more than a century ago.

James also assumed that one's attentional faculties cannot be significantly refined by any type of discipline. Rather, the degree of one's attentional stability is most likely a fixed characteristic of the individual.[4] Since he made this claim, very little scientific research has been conducted to test this theory, and the present attitude among cognitive scientists remains very close to James's. In contrast, a central claim of all Indo-Buddhist discussions of quiescence is that with training the attention can be voluntarily sustained for many hours in succession, without the slightest interference by laxity or excitation. These discussions also assert that one's introspective faculties can also be enhanced to a high degree, resulting in exceptional states of cognitive and emotional balance. If there is any truth to the Buddhist claims concerning these issues, they have not been demonstrated to scientists who study the nature, functioning, and potentials of human attention, introspection, or consciousness.

This situation is typical of the relationship between the academic study of Buddhism and the rest of the academic and scientific world. Huntington rightly points out that this insularity of the

[3] M.I. Posner, *Chronometric Exploration of Mind* (Hove, U.K.: Erlbaum, 1978).

[4] William James, *Talks to Teachers: On Psychology; and to Students on Some of Life's Ideals,* Intro. by Paul Woodring (New York: Norton, 1899/1958), p. 84. James also claims, *"There can be no improvement of the general or elementary faculty of memory: there can only be improvement of our memory for special systems of associated things;* and this latter improvement is due to the way in which the things in question are woven into association with each other in the mind." (Ibid., pp. 90–91.) In light of the fact that the same term, *smṛti,* is used in Buddhism for both mindfulness and memory, it would also be interesting to determine scientifically whether Buddhist techniques for developing *smṛti,* do in fact enhance either mindfulness or memory.

academic field of Buddhology "is supposed to preserve the integrity of the discipline as a legitimate, autonomous *Fach,* but by now it has become clear that both the concept of an isolated discipline and the techniques used to define it (the guarantors of purity) are no longer necessary or desirable."[5] A great strength of the natural sciences is their cross-fertilization from one discipline to another, but the study of religion and the study of science are separated by a vast chasm of silence, each one insulated from the other, apparently by mutual consent.

A remedy for this dysfunctional relationship was long ago proposed by William James, who was trained as a scientist and also wrote major works in the fields of philosophy and religious studies. James was a premier example of a man of science who refused to adhere to the articles of faith of scientific naturalism, and a deeply religious man who rejected religious dogma.[6] His approach was to take a genuinely scientific interest in the precise, open-minded investigation of the entire range of human experience, including religious experience.[7]

James proposed a science of religion that would differ from philosophical theology by drawing inferences and devising imperatives based on a scrutiny of "the immediate content of religious consciousness."[8] He envisioned this as an empirical, rather than a scholastic, rationalistic approach, that was to focus on religious experience rather than religious doctrines and institutions. He elaborates on this point:

[5] Huntington, *The Emptiness of Emptiness,* p. 5.

[6] Cf. Bennett Ramsey, *Submitting to Freedom* (New York: Oxford University Press, 1993). Throughout this work, I am using the term "scientific naturalism" to denote a creed that identifies itself with natural science and that adheres to the metaphysical principles of physicalism, reductionism, and the closure principle (the assertion that there are no causal influences on physical events besides other physical events). Natural science, in contrast, is a body of knowledge acquired by means of empirical testing of hypotheses through observation and experiment, and as such, it is not inextricably tied with any one metaphysical belief system.

[7] Cf. Henry Samuel Levinson, *The Religious Investigations of William James* (Chapel Hill: University of North Carolina Press, 1981).

[8] William James, *The Varieties of Religious Experience: A Study in Human Nature* (New York: Penguin, 1902/1982), p. 12.

Let empiricism once become associated with religion, as hitherto, through some strange misunderstanding, it has been associated with irreligion, and I believe that a new era of religion as well as philosophy will be ready to begin. . . . I fully believe that such an empiricism is a more natural ally than dialectics ever were, or can be, of the religious life.[9]

Such a science of religions, he suggests, "can offer mediation between different believers, and help to bring about consensus of opinion";[10] and he pondered whether such a science might even command public adherence comparable to that presently granted to the physical sciences.[11]

With a return to empiricism as opposed to dogmatic religious and scientific rationalism, James's perspective on the future interface between science and religion was optimistic:

Evidently, then, the science and the religion are both of them genuine keys for unlocking the world's treasure-house to him who can use either of them practically. Just as evidently neither is exhaustive or conclusive of the other's simultaneous use.[12]

James's proposal for an empirically scientific study of religion has itself been a subject of academic study, but it has hardly been adopted as a methodology in the field of religious studies. One scholar who has challenged this trend is the Indologist Frits Staal. In his book *Exploring Mysticism: A Methodological Essay* he declares that the study of the phenomenology and history of religion is always unsatisfactory and insufficient because it does not investigate the validity of the phenomena it studies, and often wrong because of incorrect implicit evaluation.[13] Staal proposes

[9] William James, *A Pluralistic Universe* (Cambridge: Harvard University Press, 1909/1977), p. 142; Cf. William James, "Pluralism and Religion," *Hibbert Journal*, (1908) 6, pp. 721–28.

[10] James, *Varieties of Religious Experience*, p. 456.

[11] Ibid.

[12] Ibid., pp. 122–23.

[13] Frits Staal, *Exploring Mysticism: A Methodological Essay* (Berkeley: University of California Press, 1975), p. 92.

two parts to the scientific study of mysticism: the study of mystical experiences and their validity, and the study of the interpretations mystics and others have offered to account for these experiences. A rational, theoretical and experimental approach to mysticism is necessary, he says, if mysticism is ever to become a serious subject of investigation.

It is Staal's interest in mystical experience that draws him to the study of meditation, which, he says, stands most in need of experiential, or subjective, study. While various meditative experiences certainly may be deemed mystical in nature, one disadvantage of classifying meditation as mystical practice is that one thereby tends to ignore aspects of meditative experience that are not mystical. For example, the entire Buddhist training in quiescence consists of theories and practices concerning the nature of attention, introspection, and consciousness; and none of these phenomena are intrinsically mystical. Such practice may be deemed "pre-mystical," and yet it forms a crucial element of Indo-Tibetan Buddhist meditation.

Perhaps due to this too narrow assessment of meditation, Staal dismisses physiological research into this subject as providing insignificant results about unexplained, physical side effects, without detecting the effects of meditation on the mind.[14] At present, the psychological study of mysticism, he says, is in an even more unsatisfactory state than its physiological study; but he regards the outlook for the future as very promising. While Staal is probably right in his evaluation of physiological research into mystical experience, it may, nevertheless, yield significant insights into the psycho-physiological transformations that take place during the more basic, non-mystical training in quiescence. Yet even here, he is right in asserting that the methodologies of cognitive psychology are likely to provide a clearer evaluation of such meditation practice.

In proposing his methodology for studying meditation scientifically, Staal draws a strict distinction between (1) followers of a *guru*, adherents of a particular sect, or people in search of *nirvāna, mokṣa,* or salvation and (2) genuine students of

[14] Ibid., p. 110.

mysticism: "While both have to share certain attitudes, the student has sooner or later to resume a critical outlook so that he can obtain understanding and make it available to others."[15] The uncharitable, and not entirely justified, assumption underlying this distinction is that religious people who practice meditation are incapable of resuming (or ever adopting) a critical outlook on such practice and are therefore incapable of obtaining understanding and making it available to others. The student of meditation, he proposes, can learn the necessary techniques of meditation only by initially accepting them uncritically. However, once those methods have been learned, the critical student must "be prepared to question and check what the teacher says, and introduce new variables and experimental variation."[16] With keen insight, he points out:

> The doubts which we entertain with respect to very unfamiliar events are largely the outcome of prejudices shaped by our experiences with more familiar events. Too much doubt at the outset will accordingly hold us back and prevent us from entering a new domain. Therefore we should suspend doubt if we wish to learn something new. But if we do not resort to analysis and critical evaluation at a later stage, we move into the new domain like sleep-walkers, without gaining any knowledge or understanding.[17]

What he fails to note, however, is that a similar view is advocated in traditional Buddhist discussions of religious practice as a whole,[18] and it may well be that this approach is encouraged in other contemplative traditions as well. Although the *types* of critical analysis of the practice applied to the practice may differ between aspiring mystics and students of mysticism, it is certainly unfair to characterize the former as sleep-walkers devoid of knowledge or understanding.

[15] Ibid., p. 130.

[16] Ibid., p. 146.

[17] Ibid., p. 134.

[18] See the discussion of these three phases of practice in the following discussion of Tsongkhapa's methodology.

Staal claims that it is the task of students of mysticism, rather than mystics, to evolve the best theories about mysticism;[19] and it is the former who must explore whether the latter have actually attained the goals they think they have.[20] Such claims may be nothing more than an expression of his bias against religious mysticism, for one of the expressed aims of his book is to show that mysticism need not necessarily be regarded as a part of religion.

While Staal provides in the first part of his book excellent critiques of earlier comparative studies of mysticism, showing how they fail due to their dogmatic biases, the methodology he proposes seems to fall under the same sword. The dogma that underlies his approach is one that is dismissive of the relevance of religion, philosophy, and ethics to mystical experience. It is the task of his idealized student of mysticism to distinguish between "valid instruction into a practice, such as meditation, which cannot be learned in any other way, and the religious or philosophical superstructure which is added and which is often meaningless if not worthless."[21] Moreover, he cautions that many of the required or recommended methods are likely to be irrelevant, "because they are religious or moral paraphernalia."[22] Staal asserts his dogmatic bias most distinctly when he says of such "superstructure" that since "they generally involve religious or philosophical considerations, differences between them need not reflect differences in mystical experience."[23] Thus, he declares, "a good teacher will emphasize practice, a bad teacher will expound theories."[24]

The simple truth that is ignored in this dogma is one that Griffiths rightly identifies: while the results of meditative practice influence philosophical and religious theories, it is also true that "philosophical beliefs shape meditative techniques, provide

[19] Ibid., p. 63.

[20] Ibid., p. 148.

[21] Ibid., p. 147.

[22] Ibid., p. 135.

[23] Ibid., p. 173.

[24] Ibid., p. 149.

specific expectations, and thus have a formative influence on the kinds of experience which are actually produced . . . "[25]

The root of Staal's aversion to religion may be traced to his perception of institutionalized religions as being chiefly concerned not with the religious or mystical experience of individuals, but "with society, ethics, morality, and the continuation of the *status quo*."[26] This fundamental sympathy with mystical experience, coupled with antipathy towards the religious and philosophical theories about mysticism, is an attitude shared with William James. James comments that in writing his *The Varieties of Religious Experience,* he had two aims: first, to defend "experience" against "philosophy" as being the real backbone of the world's religious life, and second, "to make the hearer or reader believe, what I myself do invincibly believe, that, although all the special manifestations of religion may have been absurd (I mean its creeds and theories), yet the life of it as a whole is mankind's most important function."[27] Staal and James seem to differ, however, in that James places a high value on the religious practices of ethics, prayer, worship, and so on, whereas Staal apparently dismisses these as aspects of the useless superstructure around mysticism.

The opposition that Staal sets up between traditional meditators and modern students of mysticism raises fundamental questions concerning the degree of difference that separates the religious from the scientific mentality. Although this is far too vast a topic to treat adequately in the present context, it may be worthwhile, before bringing this discussion to a close, to note James's perspective on this matter. In his provocative essay entitled "Faith

[25] Griffiths, *On Being Mindless*, p. xiv.

[26] Staal, *Exploring Mysticism*, p. 165.

[27] *The Letters of William James*, ed. by Henry James, Jr. (Boston: Atlantic Monthly Press, 1920), Vol. II, p. 127. Cf. "[Experience and Religion: A Comment]" in *The Writings of William James: A Comprehensive Edition*, John J. McDermott, ed. (Chicago: University of Chicago Press, 1977), pp. 740–41.

[28] William James, "Faith and the Right to Believe," in *Some Problems of Philosophy* (New York: Longman's, Green, 1948 (1911). Posthumous. ed. by Henry James, Jr., pp. 221–231. Also in *The Writings of William James: A Comprehensive Edition*, pp. 735–740.

and the Right to Believe,"[28] James challenges what he calls "intellectualism," defined as "the belief that our mind comes upon a world complete in itself, and has the duty of ascertaining its contents; but has no power of re-determining its character, for that is already given." He identifies two kinds of intellectualists: rational intellectualists who "lay stress on deductive and 'dialectic' arguments, making large use of abstract concepts and pure logic (Hegel, Bradley, Taylor, Royce); and empiricist intellectualists who "are more 'scientific,' and think that the character of the world must be sought in our sensible experiences, and found in hypotheses based exclusively thereon (Clifford, Pearson)."[29] In this light, Staal's student of mysticism seems to bear all the earmarks of an empiricist intellectualist, while more traditional Buddhologists, such as Griffiths, appear to be rational intellectualists.

Intellectualism, James says, asserts that knowledge of the pre-given universe "is best gained by a passively receptive mind, with no native sense of probability, or good-will towards any special result."[30] Moreover, it assumes that "our beliefs and our acts based thereupon . . . [are] such mere externalities as not to alter in any way the significance of the rest of the world when they are added to it."[31] Here is the classic "disinterested" perspective that is widely deemed necessary on the part of all scientific researchers, whether they are examining texts or experience. James acknowledges that the postulates of intellectualism work well as long as the issues under investigation are of no pressing importance and that by believing nothing, we can escape error while we wait. It is a different matter, however, when the subject is of pressing importance. In such cases, he writes,

> . . . we often cannot wait but must act, somehow; so we act on the most *probable* hypothesis, trusting that the event prove us wise.

[29] Ibid., p. 735. In this essay James is specifically targeting the views of William K. Clifford expressed in the essay "The Ethics of Belief" in *Lectures and Essays* (1879); Cf. William Kingdom Clifford, *Lectures and Essays by the Late William Kingdom Cliffored, F.R.S.* (London: Macmillan, 1901).

[30] Ibid., p. 736.

[31] Ibid.

Moreover, not to act on one belief, is often equivalent to acting as if the opposite belief were true, so inaction would not always be as "passive" as the intellectualists assume. It is one attitude of will.[32]

Philosophy and religion address issues that many regard as urgently important, and for these, he suggests, the intellectualist postulates may not obtain. As an expression of his pluralistic philosophy, James proposes,

> The character of the world's results may in part depend upon our acts. Our acts may depend on our religion,—on our not-resisting our faith-tendencies, or on our sustaining them in spite of "evidence" being incomplete. These faith-tendencies in turn are but expressions of our good-will towards certain forms of result.[33]

From this perspective, intellectualists' condemnation of religious faith is itself nothing more than an act of faith in the intellectualists' theory of the constitution of the universe.

In terms of James's distinction between intellectualism and pluralism, it is evident that advocates of religion as well as advocates of science may be either intellectualists or pluralists. Likewise, while one adheres to articles of a religious creed, the other may just as tenaciously adhere to the metaphysical principles of scientific naturalism. James acknowledges faith as one of the inalienable birthrights of our minds, but he cautions,

> Of course it must remain practical, and not a dogmatic attitude. It must go with toleration of other faiths, with the search for the most probable, and with the full consciousness of responsibilities and risks.
> It may be regarded as a formative factor in the universe, if we be integral parts thereof, and co-determinants, by our behavior, of what its total character may be.[34]

All of us are presently endowed with consciousness, but for most of us, at least, the origins, nature, causal efficacy, and fate of

[32] Ibid.

[33] Ibid.

[34] Ibid., p. 737.

this phenomenon, so central to our very existence, remain a mystery. Is it possible to explore these features of consciousness by means of introspection? If so, is it possible to enhance our attentional and introspection faculties so that such research may provide reliable and incisive results? Given the centrality of consciousness to our whole existence, and given the brief and uncertain span of human life, the fundamental questions about consciousness may well be regarded as ones of pressing importance.

The following work, then, is written for those who share this sense of the importance and urgency of discovering the nature and potentials of consciousness. They may include Western philosophers and cognitive scientists concerned with attention, introspection, and consciousness, historians of religion interested in the connections between quiescence and analogous techniques taught and practiced in other traditions, professional Buddhologists, and practicing contemplatives interested in implementing Tsongkhapa's instructions on the cultivation of quiescence. Finally, I hope that this work may encourage the growth of the community of scientists and contemplatives willing to join their efforts in probing the nature of consciousness by drawing on and integrating the methods and wisdom of the East and the West, the ancient and the modern.

Tsongkhapa's Vision of Reality

Seeking Tsongkhapa's Vision

> We need, then, not only to have good knowledge of the religious values of other cultures but above all to strive to see ourselves as they see us . . .
>
> [It is] only after a pious journey in a distant region, in a new land, that the meaning of that inner voice guiding us on our search can make itself understood by us. And to this strange and persistent fact is added another: that he who reveals to us the meaning of our mysterious inward pilgrimage must himself be a stranger, of another belief and another race.[1]
>
> Mircea Eliade

The attempt to portray another person's vision of reality is a challenging one even if this person is a contemporary member of one's own culture. The task is more difficult if this person lived in an earlier era of one's own civilization, and even more demanding if he or she was raised and educated long ago in an alien culture. Finally, if this person is an accomplished contemplative* whose vision of reality purportedly transcends societal conventions and norms, the challenge of presenting his or her vision of reality may appear simply insurmountable.

Tsongkhapa certainly fits into this final category, and though I can in no way claim to have penetrated the core of his vision, I shall attempt to sketch some of the central themes of his view of the world as he sets them forth in his own writings. In so doing, I shall not go into the details of the progression of his thought during the course of his life, nor shall I try to validate my assertions about his views with quotes from his writings; but I shall cite the textual bases in the eighteen volumes of his collected works for the major themes that are addressed here. Tsongkhapa asks fundamental questions of existence that have been posed by people

[1] Mircea Eliade, *Myths, Dreams, and Mysteries: The Encounter Between Contemporary Faiths and Archaic Realities.* trans. Philip Mairet (New York: Harper Torchbooks, 1957), pp. 233, 245.

31

the world over, but his Buddhist theoretical and empirical methods for seeking answers to these questions are often without analog in Western civilization. Moreover, many of the discoveries claimed by Buddhist contemplatives, if true, would shake the very foundations of our Western beliefs concerning the nature of consciousness and its role in the natural world.

While passing through some of the salient features of his world view, I shall occasionally rub them against some distinctly Western beliefs, particularly those of Christianity and scientific naturalism. Although there are certainly many diverse belief systems that have sprung up in our civilization, none are more dominant than these two; and both continue to exert powerful (and not always incompatible) influences on our society today. Thus, I shall make references to three world views: (1) Christianity; (2) scientific naturalism, which branched off from Christianity and still intermingles with it on occasion; and (3) Indo-Tibetan Buddhism as represented by Tsongkhapa, which shares few, if any, common origins with either of the other two world views, and has barely begun to interact with them.

In the course of this discussion, I shall also make frequent references to the writings of William James, though I stop short of a full-scale comparative analysis of his writings and those of Tsongkhapa. The reason for my emphasis on James is that, given his wide interests in the fields of psychology, philosophy, and religion, and his brilliant contributions in the fields of introspective psychology, pragmatism, empiricism, and the philosophy of religion, there are many points of contact between his writings and the literature of Indo-Tibetan Buddhism. I hope that this highlighting of points of contact will encourage more detailed comparative studies on the part of Jamesian and Buddhist scholars alike.

In citing Western views in relation to those of Tsongkhapa, I shall not attempt any thorough or definitive comparative analyses. Rather, I shall confine myself to the more modest task of pointing out areas in which such comparative studies might eventually be pursued, possibly to the enrichment of our understanding of both Western and Buddhist traditions. Even this task,

however, has its pitfalls, for if the cited views are not representative of the traditions in question, then their juxtaposition will be of little value to anyone. Thus, while my references to Western views must of necessity be cursory in nature, I shall do my best to choose those that are truly representative, and not distort them in the telling.

Tsongkhapa's Methodology

In accordance with the Indo-Tibetan Buddhist tradition as a whole, Tsongkhapa is chiefly concerned with recognizing the nature and extent of suffering, identifying its most fundamental causes, adopting the working hypothesis that those causes are not intrinsic to sentient existence, then determining and applying means for irreversibly eliminating those causes.

Given this basic agenda, it is not immediately apparent whether this project should be regarded as a religion or a science. Van Harvey observes that in deeming something religious we ordinarily mean a perspective expressing a dominating interest in certain universal and elemental features of human existence as those features bear on the human desire for liberation and authentic existence.[1] In this sense of the term, Tsongkhapa's perspective is indubitably religious.

On the other hand, Clifford Geertz maintains that the central problem of religion is "how to make of physical pain, personal loss, worldly defeat, or the helpless contemplation of others' agony something bearable, supportable—something, as we say, sufferable."[2] Religion, he points out, accepts divine authority as a basis for escaping from adversity through the use of ritual and belief in the supernatural; and it has as its defining concern not action upon wider realities but acceptance of them and faith in them. So defined, the task of religion would be one totally alien to Tsongkhapa's basic agenda, and it would be one in which he would not have the slightest interest.[3]

[1] Van Harvey elaborates on this theme in Ch. 8 of his *The Historian and the Believer* (Philadelphia: Westminster Press, 1981).

[2] Clifford Geertz, *The Interpretation of Cultures* (New York: Basic Books, 1973), p. 104.

[3] While Tsongkhapa certainly does rely in part upon divine authority, this is done as a means of escaping from suffering through the cultivation of insight, not ritual and belief in the supernatural alone. And while he accepts the Buddhist doctrine of *karma*, he views this as something requiring engaged action, not simply faithful submission.

To the contrary, if science embodies the diagnostic and critical dimension of a culture, as Geertz suggests,[4] then Tsongkhapa would deem the challenge of Buddhism to be emphatically scientific and not religious in nature. Moreover, if a scientific theory is characterized by its explicit concern with determining exact formulations of uniformities of experience, and with deriving explanations and predictions from these laws of nature,[5] then Tsongkhapa's agenda is clearly scientific. But this, too, is an unsatisfactory conclusion, for Tsongkhapa begins his investigation into the nature and sources of suffering by relying on the authoritative treatises of the Buddhist tradition. The scientific spirit, in contrast, has been characterized by its unwillingness to admit any starting point for research, or any source of knowledge, other than experience.[6]

The simple reason why Tsongkhapa's views do not simply conform to either our criteria for religion or science is that he is not from our culture, and he did not formulate his fundamental questions or his way of responding to them according to any Western paradigm. The distinctions between religion and science, which seem so natural to us in the West, are not found in traditional Tibetan culture; and efforts to impose these stereotypes on Tibetan Buddhism are misplaced.

While it is true that Tsongkhapa insists on the importance of rational and experiential verification of the nature of suffering, its sources, and the effective ways of eliminating them, he also clearly places great emphasis on reliance upon the teachings of the Buddha and later authorities in the Buddhist tradition. But this reliance is not an uncritical acceptance of the literal truth of the entire Buddhist doctrine. On the contrary, he quotes the Buddha's own admonition to his followers: "Monks, just as the wise accept gold after testing it by heating, cutting, and rubbing

[4] Ibid. p. 231.

[5] William A. Christian, *Oppositions of Religious Doctrines: A Study in the Logic of Dialogue among Religions* (London: Macmillan, 1972), p. 30.

[6] Émile Boutroux, *Science and Religion in Contemporary Philosophy*, trans. Jonathan Nield (New York: Macmillan, 1911), p. 352.

it, so are my words to be accepted after examining them, but not out of respect [for me]."[7]

The main reason that Tsongkhapa cites for the necessity of critically examining all the theses of the Buddha's doctrine is that the literal meanings of many of these teachings do not stand up to critical analysis. Indeed, he maintains that all Buddhist theories that explicitly describe or explain conventional truths* must be regarded as provisional;* only those that pertain directly to ultimate truth* are definitive*. The former are invariably contextual, while the latter point to a universal, invariable truth, regardless of one's conceptual framework. This is to say that Buddhist teachings concerning the conventional, phenomenal world, including the path to liberation, are taught according to the predispositions of those hearing the teachings. Tsongkhapa regards as definitive only those teachings that pertain explicitly to ultimate reality; but if one conceptually reifies the referent of those teachings, one commits the grievous error of "turning medicine into poison."[8]

Tsongkhapa also adopts a traditionally Buddhist approach to knowledge that goes beyond a purely rational analysis of texts. The first step is to acquire an initial level of conceptual understanding simply by learning a theory. Such knowledge is traditionally gained by hearing instruction from a teacher, and this requires simply that one attend closely to the lectures and

[7] This verse, often quoted in Tibetan Buddhist literature, is cited from the *Vimalaprabhā* commentary on the *Kālacakra*, although it appears in the Pāli Canon as well. The Sanskrit occurs as a quotation in *Tattvasaṃgraha*, ed. D. Shastri (Varanasi: Bauddhabharati, 1968), k. 3587. Cf. *Tsong Khapa's Speech of Gold in the Essence of True Eloquence: Reason and Enlightenment in the Central Philosophy of Tibet*, trans. Robert A.F. Thurman (Princeton: Princeton University Press, 1984), p. 190. The text translated by Thurman, entitled *The Essence of True Eloquence: A Treatise on Differentiating Interpretative and Definitive Meanings* [*Drang ba dang nges pa'i don rnam par phe ba'i bstan bcos legs bshad snying po* (Collected Works, Vol. Pha)] is Tsongkhapa's classic work on Buddhist hermeneutics.

[8] There is an interesting parallel in the Pāli Buddhist canon in which the Buddha states: "There are these two who misrepresent the Tathāgata. Which two? He who represents a Sutta of indirect meaning *(neyyattha)* as a Sutta of direct meaning *(nītattha)* and he who represents a Sutta of direct meaning as a Sutta of indirect meaning." [*Aṅguttara Nikāya*, I:60, trans. K.N. Jayatilleke, in *Early Buddhist*

remembers their content without distortion. The second, more demanding level of understanding is achieved by examining what one has learned in light of one's perceptual experience and conceptual understanding of reality. This phase of inquiry includes both theoretical analysis as well as empirical investigation; that is, it deals not only with the ideas acquired through learning, but with the experienced realities that purportedly correspond to those ideas. If a thesis stands up to such analysis, one then seeks the third, and most challenging, level of comprehension, which is achieved by focusing one's mind repeatedly on the reality that is the referent of the teachings first heard and then tested. Such wisdom is said to occur only while one's mind is in a state of meditative equipoise,* which, as we shall see, begins with the attainment of quiescence.*[9]

Buddhist doctrine includes, of course, a wide variety of theories. Some of these pertain to phenomena that are immediately accessible to observation. Many, though by no means all, of the Buddhist accounts of the reality of suffering are assertions of this type. The veracity of those statements does not need to be tested with reason or be simply accepted as an article of faith, but can be examined with one's powers of perception,* which are to be honed as finely as possible.

Another class of theories concerns phenomena that are not initially accessible to observation but can be verified by means of logical inference.* Tsongkhapa maintains that the Buddhist

Theory of Knowledge (London: Allen and Unwin, 1963), p. 361]. Jayatilleke comments on p. 362 of the same text that no examples of these two kinds of suttas are given in the Pāli canon.

Note also: "The Perfectly Enlightened One, the best of teachers, spoke of two truths, viz. conventional and absolute—one does not come across a third; a conventional statement is true because of convention and an absolute statement is true as (disclosing) the true characteristics of things." [Jayatilleke, p. 364, translating from the standard commentary on the Kathāvatthu (34) and the standard commentary on the Aṅguttara Nikāya (I:95)].

[9] These three phases of understanding correspond to the traditional Buddhist threefold cultivation of wisdom, namely: the wisdom arising from hearing *(thos byung shes rab, srutamayīprajñā),* the wisdom arising from thinking *(bsam byung shes rab, cintāmayīprajñā),* and the wisdom arising from meditation *(bsgom byung shes rab, bhāvanāmayīprajñā).*

assertion of the continuity of an individual's stream of conscious-
ness before conception and after death is a theory of this type.
Without going into the details of his argument, suffice it to say for
the time being that such inference depends on perceptual knowl-
edge of the nature of consciousness and the manner in which the
stream of consciousness is normally produced during the course
of an individual's life. Inference based on perceptually verified
facts is called *cogent inference,** and such reasoning ability is
developed by training in dialectics.

A third and final class of Buddhist assertions cannot be veri-
fied or refuted either perceptually or by means of cogent infer-
ence. Examples of this are some of the Buddha's statements
concerning the specific acts in previous lives in the distant past
that led to specific conditions and events in an individual's present
life. Tsongkhapa insists that it is possible in principle to verify
even such statements. The initial challenge here is to determine by
cogent inference that the Buddha had the ability to make such
valid observations, then to infer, on the basis of his authority, that
his specific claims are true. This is called *inference* by *authority.**[10]

It is of course far easier for devout Buddhists simply to accept
such claims by the Buddha out of faith, and the majority of tradi-
tional Buddhists do just that. To draw an analogy, most people
nowadays who believe in science would accept out of faith the
statements of astrophysicists concerning the composition of the
surface of the planet Mars. But an atomic physicist well versed in
spectral analysis could reasonably infer that such statements by
astrophysicists were correct, even without seeing their data. This
would be a case of inference by authority. The astrophysicists
making such claims may know the composition of Mars by means
of cogent inference; and if astronauts were to travel to Mars, it
should be possible for them to perceive the composition of the
surface of that planet. It would be extremely awkward for scien-
tific knowledge to advance if scientists in different fields were not
to rely on the work of their fellow scientists in other fields and on

[10] For a detailed account of these three types of knowledge see Lati Rinbochay,
Mind in Tibetan Buddhism, trans. and ed. by Elizabeth Napper (Valois:
Gabriel/Snow Lion, 1981), pp. 75–84.

the work of their predecessors. Much of their knowledge of the natural world as a whole is based on inference by authority.

According to Tsongkhapa, there are three types of phenomena associated with the above three modes of knowledge: (1) evident phenomena accessible to immediate observation; (2) concealed phenomena accessible to cogent inference; and (3) very concealed phenomena accessible to inference by authority.[11] All of these classifications are made in relation to specific modes of knowledge, and are not categories intrinsic to the phenomena themselves. For example, the composition of the surface of Mars may be very concealed for an atomic physicist, concealed for an astrophysicist, and evident for an astronaut. Or, to take another example closer to home: while speaking on the telephone with John, I may see a boy outside fall off his bicycle. Seeing the boy getting up slowly, I tell John that the boy must be in pain and that I must go outside to see if he is all right. In this scenario, the boy's pain is directly perceived by himself; I know it by cogent inference; and John knows it by inference by authority (I being that authority).

Tsongkhapa's fundamental premise is that anything verifiable by means of cogent inference or inference by authority is in principle verifiable by means of direct observation, or perception. For all sentient beings have the capacity to become Buddhas themselves, at which point they can see for themselves the extent of a Buddha's powers of observation. Indeed, Tsongkhapa accepts many of the accounts of individuals having attained the enlightenment of a Buddha since the time of Buddha Śākyamuni.

While Tsongkhapa places a strong emphasis on the roles of perception, cogent inference, and inference by authority, he also acknowledges the epistemic and soteriological importance of faith. Tsongkhapa acknowledges three types of faith. The first of these is the faith of belief, which for a Buddhist entails an unwavering conviction in the most fundamental principles of the Buddhist teachings, such as the qualities of enlightenment, the relationships among actions and their results, and the possibility

[11] These three are respectively (1) *mngon gyur, abhimukhi;* (2) *lkog gyur, parokṣa;* and (3) *shin tu lkog gyur, atyartha-parokṣa.*

of freedom from suffering and its source. Secondly, the faith of admiration entails seeing the excellent qualities of the object of one's faith with a sense of appreciation or even adoration. Such faith for a Buddhist is especially focused on the qualities of the achievement of liberation and enlightenment, and adoration is felt towards those who embody these attainments. Finally, the faith of yearning entails the conviction that it is possible to realize in oneself the excellent qualities that one admires, and with such faith one aspires to do so.[12]

It is faith that gladdens the heart in one's quest for liberation and enlightenment, and faith is regarded as the wellspring of all virtues, including the virtue of insight. Thus, Tsongkhapa sees faith as a necessary prerequisite for deeper understanding and insight, a theme commonly found in Christian writings. While religion as a whole is frequently characterized by its emphasis on the importance of unwavering belief, science is commonly characterized by unrelenting skepticism towards even its most firmly established conclusions. The chasm between these two perspectives appears, at least at first glance, to be unbridgeable; and insofar as Tsongkhapa endorses the faith of belief, his methodology seems to land on the side of religion.

The characterization of religion as entailing an utter commitment to an ideology in contrast to science as a form of empirical skepticism certainly bears an element of truth. This simple dichotomy, however, may obscure the commitment to metaphysical beliefs that underlies the actual practice of science. The dominant metaphysical system for modern science is called scientific naturalism. Four principles lie at the core of this ideology; and, according to many of its proponents, natural science is inconceivable without them. The principle of reductionism asserts that macro-phenomena, such as the behavior of human beings, are the

[12]The nature and significance of faith *(dad pa, śraddhā)* is discussed in Śāntideva's *Śikṣā-samuccaya,* trans. Cecil Bendall and W.H.D. Rouse (Delhi: Motilal Banarsidass, 1981), pp. 3–8. The above threefold classification of faith is discussed in Geshe Rabten's *The Mind and Its Functions,* trans. Stephen Batchelor (Mont Pèlerin: Tharpa Choeling, 1979), pp. 66–67. The Tibetan terms for the three types of faith are respectively: *yid ches kyi dad pa, dang ba'i dad pa,* and *mngon 'dod kyi dad pa.*

causal results of micro-phenomena, such as human cells and ulti-
mately the behavior of the atoms which constitute the cells. The
closure principle asserts that the physical world is "causally
closed"—that is, there are no causal influences on physical events
besides other physical events. The principle of physicalism asserts
that the only things that exist are ultimately physical. A fourth
principle is that the natural world explored, described, and
explained by science exists independently of the human concepts
and yet is intelligible in terms of the scientific conceptual frame-
work.

Such pre-eminent scientists as Albert Einstein and Richard
Feynman well represent the scientific tradition in their religious-
like commitment to the principles of scientific naturalism; and in
fact very few scientists show any skepticism towards them at all.
Indeed, Einstein goes so far as to claim that "in this materialistic
age of ours the serious scientific workers are the only profoundly
religious people."[13]

In short, the claim that scientists routinely question even their
most fundamental assumptions is a dubious one, and it is not at
all evident that such a methodology would be a useful one, either
in science or religion. On the other hand, when the adherence to
an ideology becomes thoroughly uncritical and complacent, the
result in the realm of science is scientism; and in the realm of reli-
gion it is fundamentalism. These two ideological stances, regard-
less of the disparity of their views, appear to be manifestations of
one and the same mentality.

In Tsongkhapa's view, uncritical grasping onto dogmas is
deluded, while extreme skepticism is simply another mental afflic-
tion. The middle way that he advocates for a Buddhist is to place
one's faith and trust in the enlightenment of the Buddha, and yet
to continue to question one's own understanding of the Buddha's
teachings. Without faith, there would be no inspiration to enter
the path to liberation; but without using one's critical faculties, it
would be impossible to progress along that path. For while the

[13]Albert Einstein, *Ideas and Opinions*, trans. and rev. by Sonya Bangmann (New
York: Crown, 1954), p. 40.

enlightenment of the historical Buddha took place in the past, one's own enlightenment lies in the future.

The above sketch of Tsongkhapa's methodology certainly bears some traits in common with religion as it is conceived in the modern West, and yet in some important respects it profoundly diverges from our model of religion. On the other hand, certain elements of his approach appear to be scientific; and yet the disparities between his methodologies and those of modern natural science are enormous. While the empirical element of Tsongkhapa's methodology is largely contemplative and introspective, science is dominantly mechanistic and extraspective. Finally, Tsongkhapa would regard as highly questionable all of the above-mentioned principles of scientific naturalism, which are said to provide the necessary foundation and structure for scientific research.

The Reality of Suffering

Tsongkhapa lays a great emphasis on exploring the nature and extent of suffering to which we as sentient beings are subject. All sentient beings, he insists, wish to be forever free of suffering and to experience lasting, true happiness; but despite the fact that we are continually striving to fulfill these aims, our efforts are far from successful. Only by recognizing the full scope of suffering is one in a position to fathom the fundamental causes of all suffering; and only if those causes are discovered is it possible to know whether they may be eliminated completely.

Most elaborately in his *Great Exposition of the Stages of the Path to Enlightenment*,[1] Tsongkhapa discusses the many types of suffering to which humans and other living beings are exposed. He describes, for example, the suffering involved in the processes of birth, aging, sickness, and death, much of which is accessible to direct observation. Generally this type of unhappiness and pain becomes evident in times of adversity. But Tsongkhapa goes further in suggesting that even our experiences of pleasure and satisfaction in times of felicity are simply another, less obvious type of suffering. Pleasurable feelings of this sort are experienced as such simply due to a temporary alleviation of prior suffering; but they are not genuine happiness. Thus, the transitory pleasures derived from material gain, from contact with agreeable sensory and intellectual objects, from being praised, and from acquiring fame and the acknowledgment of others are all included within the spectrum of suffering.

If such stimulus-dependent pleasures were truly of the nature of happiness, he reasons, repeated contact with such pleasurable stimuli would invariably give rise to happiness; and the degree of happiness should increase in proportion to the intensity of the stimulus. This is evidently not the case. Thus, Tsongkhapa, like the Indo-Tibetan Buddhist tradition as a whole, would agree with Freud's observation that "We are so made that we can derive

[1]*Byang chub lam rim chen mo* (Collected Works, Vol. Pa)

intense enjoyment only from a contrast and very little from a state
of things . . . Unhappiness is much less difficult to experience."[2]

For Tsongkhapa the realities of suffering and happiness are not
confined to human existence. For example, like all Tibetan
Buddhists, he would utterly reject Aquinas's premise that only
beings endowed with reason, not including animals, desire happi-
ness;[3] and he would similarly reject Descartes's depiction of ani-
mals as mindless automatons. Moreover, the full implications of
Tsongkhapa's view of the extent of suffering can be appreciated
only in light of his assertion of the continuity of consciousness
preceding and following an individual human's life span. In short,
the suffering that a person has experienced did not begin while in
the womb or at birth, nor does it cease at death.

This view stands in stark contrast to the belief promoted in sci-
entific naturalism that death entails the utter, irreversible cessa-
tion of individual consciousness. The basis of this view is, of
course, the assertion that human consciousness is solely a prod-
uct, or epiphenomenon, of the brain, and that when the brain
ceases functioning, consciousness vanishes without a trace. Let us
see how Tsongkhapa might respond to this claim. First of all, the
assertion that consciousness is *solely* a product of the brain can be
reasonably adopted only if *all* the causes of consciousness have
been identified, and they are all found to be in the brain. At first
glance, this proposition seems simply absurd, for the brain cannot
operate in isolation from the other vital organs. So the more accu-
rate premise here would be that the brain functioning in conjunc-
tion with the rest of the body is solely responsible for the
production of consciousness. Yet more accurately, since the vari-
ous types of sensory consciousness do not normally arise in the
absence of external physical stimuli, the materialist hypothesis
should best be stated as: consciousness is normally produced
solely by the brain functioning in conjunction with the rest of the
body and in interaction with the physical environment.

[2] Sigmund Freud, *Civilization and Its Discontents,* trans. and ed. by James Strachey
(New York: Norton, 1961), pp. 23–24.

[3] *Summa contra Gentiles* 3, 27.

Having stated the materialist hypothesis as succinctly as possible, we are now in a position to ask: has modern neurophysiology discovered all the causes necessary for the production of consciousness? John Searle, a distinguished cognitive scientist and philosopher of mind, answers, "We would . . . need a much richer neurobiological theory of consciousness than anything we can now imagine to suppose that we could isolate necessary conditions of consciousness."[4] It is remarkable that Searle feels competent to claim that "consciousness is entirely caused by the behavior of lower-level biological phenomena," while in the next breath acknowledging that "we are at present very far from having an adequate theory of the neurophysiology of consciousness . . ."[5]

If modern science is still very far from being able to isolate the necessary conditions of consciousness, it naturally follows that it does not know all those conditions. And if that is the case, it would reasonably follow that science does not know whether some of those conditions might be nonphysical. Under the mandate of the closure principle, however, immaterial causes are not even to be contemplated.[6] Searle apparently justifies his materialist conclusions concerning the origination of consciousness by drawing on his faith in the future progress of neurophysiology: "If we had an adequate science of the brain, an account of the brain that would give causal explanations of consciousness in all its forms and varieties, and if we overcame our conceptual mistakes, no mind-body problem would remain."[7] Such unquestioning faith that is based on so little actual knowledge is a trait more commonly associated with religion than with science; yet it is a faith that many adherents of scientific naturalism today apparently share.

[4] John R. Searle, *The Rediscovery of the Mind* (Cambridge, Mass.: MIT Press, 1994), pp. 76-7. Cf. David Hodgson, "Why Searle Has Not Rediscovered the Mind," *Journal of Consciousness Studies*, 1, No. 2 (1994), pp. 264–274.

[5] Ibid. pp. 91, 92.

[6] Peter Smith and O.R. Jones, *The Philosophy of Mind: An Introduction* (Cambridge: Cambridge University Press, 1988), p. 252.

[7] Searle, *Rediscovery of the Mind,* p. 100.

The real basis of the materialist assumption of the extinction of consciousness at death is the belief that human consciousness is possible only in a living human body. This is an assertion that Tsongkhapa, too, would accept. But Tsongkhapa goes on to assert the existence of a subtle continuum of consciousness throughout the course of a human life that is *not distinctly human* and is therefore *not a derivative of the human body*. This subtle consciousness can be experientially ascertained by well-trained contemplatives, as will be explained in the following text by Tsongkhapa. It is this consciousness, he claims, and not the human body, that is the fundamental source of human consciousness. All forms of specifically human consciousness, including our sensory and intellectual faculties, are conditioned by the human body; but the consciousness that is so conditioned is not fundamentally human. Neurophysiology has no objective means of directly observing the presence of any kind of consciousness in an organism, so of course it has no knowledge of the subtle consciousness posited by Tsongkhapa.

In the Tibetan Buddhist view, adopted by Tsongkhapa, it is this subtle continuum of consciousness, and not *human* consciousness, that precedes and continues on after this life. Although the individual human dies, there is still a continuity of experience through the dying process and beyond; so even though the human personality is not immortal, the individual continuum of experience is. Tsongkhapa is chiefly concerned in his writings with the theoretical understanding of the continuity of consciousness, but this emphasis is not for want of empirical evidence. In the history of Tibet there have been numerous contemplatives who have claimed to perceive this continuity by means of extrasensory perception;[*8] and over the past nine hundred years there has been a

[8] A premier example of such a contemplative in the history of Tibetan Buddhism is Padmasambhava, whose biography is presented in Yeshe Tsogyal, *The Lotus-Born: The Life Story of Padmasambhava*, trans. Erik Pema Kunsang (Boston: Shambhala, 1993). See also the life story of Tibet's most renowned contemplative, Milarepa, in Lobsang Lhalungpa trans., *The Life of Milarepa* (Boulder: Shambhala, 1984) For examples of such realized contemplatives in the Gelugpa order see Janice D. Willis, *Enlightened Beings: Life Stories from the Ganden Oral Tradition* (Boston: Wisdom, 1995).

widespread tradition among Tibetans of seeking out and identifying the reincarnations of highly realized contemplatives. At times such people would report in advance where they would be reborn and to which parents. The past sixteen incarnations of the Karmapa Lama were all believed to have left behind a written testimony of the details of their next rebirth in order to facilitate the discovery of their next incarnation.

Far from taking the continuity of consciousness as a source of solace, Tsongkhapa accepts this theory as the basis for judging the enormity of the problem of suffering. Thus, from his perspective, out of their faith in the future discoveries of neurophysiology, and their ignorance of the existence of subtle consciousness, the adherents of scientific naturalism take false comfort in their belief that death will bring each of them final release from all sorrow and pain. Death, he asserts, brings an end to a person's life, but not to the reality of an individual's suffering.

The Reality of the Source of Suffering

For Tsongkhapa the assertion of the continuity of experience beyond death in no way diminishes the significance of a single human life. On the contrary, as he explains at length in his *Great Exposition of the Stages of the Path to Enlightenment,* within the broad range of sentient existence, human life is extraordinarily rare and precious; for with human intelligence we have the ability to discern the true causes of suffering and of genuine happiness and to live accordingly.

Tsongkhapa recognizes two types of suffering: mental and physical. First taking into account the entire range of mental suffering—from a mild sense of malaise and anxiety to overwhelming anguish and terror—he presents the Buddhist hypothesis that the principle causes of all such suffering are mental afflictions.* A mental affliction is a mental factor, or impulse, that disrupts the equilibrium of the mind, specifically due to the influence of ignorance, attachment, or hatred.*[1] Thus, even such a disruption in the mind that is apparently due to an upsurge of compassion or a passionate response to injustice is in fact due to the mental afflictions that take on the guise of compassion or other virtuous mental processes. This does not imply that if the equilibrium of the mind is not disturbed, one's actions would necessarily also be peaceful and soothing. As will be discussed later on, pacifying action is only one of four types of responses that might flow from a thoroughly virtuous, unafflicted mental state.

Tsongkhapa certainly acknowledges there are external factors that contribute to our joys and sorrows, and these are not to be dismissed or ignored. But they are to a great extent beyond our control. Our mastery of aging, sickness, and death, for example, is limited at best, and in the end they are utterly beyond our control.

[1]The three primary afflictions, known as the "three poisons," are respectively *ma riga pa, avidyā; 'dod chags, rāga, and zhe sdang, dveṣa.*

The mental causes of sorrow are like seeds, while other influences (including the body and the environment) are like the soil and weather conditions. If the seeds of suffering are destroyed, the soil and weather can no longer produce the harvest of misery. It is the afflictions of our own minds that lie at the root of our mental troubles, not the material world, not other people, not our bodies, not intangible spirits or demons, and not God.

All three of the basic afflictions of the mind distort our awareness of reality. Attachment does so by superimposing attractive qualities upon an object of desire and ignoring its unappealing qualities, while hatred superimposes disagreeable qualities upon an object of aversion and ignores its good qualities. Attachment disrupts the equilibrium of the mind by filling it with craving and dissatisfaction, while hatred does so by agitating it with hostility and aggression. It is important to recognize that desire does not necessarily disrupt the balance of the mind; and if it does not, it is not an affliction. For example, Tsongkhapa asserts that the most highly enlightened beings feel compassion, desiring that all sentient beings be free of suffering, and loving kindness, desiring that all may experience genuine happiness.

Both attachment and hatred are regarded by Tsongkhapa as derivative of the most fundamental mental affliction, ignorance. One type of ignorance is passive, for it entails a simple lack of acuity in one's perceptions of reality. The second type of ignorance actively misconstrues the contents of experience and thereby acts as the source of all other mental afflictions. The relationship between these two is likened to seeing a striped rope indistinctly due to insufficient light, then taking it to be a snake.

As an advocate of the Prāsaṅgika Madhyamaka view,[2]

[2]Tsongkhapa lays out his interpretation of the Prāsaṅgika Madhyamaka view most definitively in two treatises, *The Clear Intention: An Explanation of the* Madhyamakāvatāra [*dBu ma 'jug pa'i rnam bshad dgongs pa rab gsal* (Collected Works, Vol. Ma)] and *Ocean of Reasoning: An Explanation of the* Mūlamadhya-makakārikā [*dBu ma rtsa ba'i tshig le'ur byas pa'i rnam bshad rigs pa'i rgya mtsho* (Collected Works, Vol. Ba)]. Jeffrey Hopkins has translated part of the former work in his *Compassion in Tibetan Buddhism* (Ithaca: Snow Lion, 1980). In his *Calming the Mind and Discerning the Real*, Wayman translates the quiescence and insight sections of Tsongkhapa's *Great Exposition of the Stages of the Path to*

Tsongkhapa identifies the second type of ignorance as the activity of reification, in the sense of apprehending objects as existing independently of conceptual designations and as bearing their own intrinsic identities,* or inherent natures.* By first conceptually grasping onto one's own intrinsic personal identity, a reified division is made between self and others, and one then grasps onto the inherently existent personal identities of others. Identifying in this way with one's own body, feelings, desires, and so on, attachment arises for oneself and all that is seen as being conducive to one's own welfare. Hatred then arises towards objects that are seen as obstructing one's own happiness or contributing to one's suffering. In this way all attachment and hatred arise out of the ignorance of reification, which operates within the context of indistinct perceptions of reality.

In making this claim about the source of mental afflictions, Tsongkhapa is obviously making a broader assertion about the nature of reality. In denying that any phenomenon exists independently of conceptual designations, he is not suggesting that nothing exists independently of human conceptual constructs. But he is stating that any object conceived or designated by the human mind does not exist independently of our conceptual frameworks. Thus, in his view the question, "What exists independently of human percepts and concepts?" is internally problematic; for our very notion of existence is a human concept that we set in opposition to our concept of *non-existence.* Moreover, all such terms as *existence, non-existence, object,* and *subject* have multiple usages within the contexts of difference conceptual

Enlightenment. Unfortunately, his translation is so deeply flawed and often simply unintelligible that its usefulness is very limited, though his bibliographical references are valuable. One should rather look to Elizabeth Napper's *Dependent-Arising and Emptiness* (Boston: Wisdom, 1989), which includes a translation of a discussion of the Madhyamaka view in Tsongkhapa's *Great Exposition of the Stages of the Path to Enlightenment.* Also see José Cabezón, *A Dose of Emptiness* (Albany: SUNY, 1992), in which he translates a major Madhyamaka treatise by Tsongkhapa's disciple mKhas grub dGe legs dpal bzang; Anne Klein, *Path to the Middle* (Albany: SUNY, 1994); E. Steinkellner and H. Tauscher, (eds), *Contributions of Tibetan and Buddhist Religion and Philosophy: Proceedings of the Csoma de Koros Symposium* (Vienna: Arbeitskreis für Tibetologie und Buddhistische Studien Universität Wien, 1981).

frameworks. They are not self-defining or drawn from some absolute reality independent of human percepts and concepts. In other words, as the contemporary philosopher Hilary Putnam states, our definitions, including those of scientific terms, are not "metaphysically privileged."[3]

Tsongkhapa's assertion that all known entities exist in dependence upon their conceptual designations does not imply that genuine discovery is impossible. It does suggest, however, that all our discoveries that are made within the context of conceptual frameworks do not exist independently of those frameworks. Even our very definitions of objective knowledge are made by human subjects.

The innate ignorance* of reifying ourselves and the rest of the world is regarded by Tsongkhapa as the source of all other mental afflictions. Moreover, under the influence of this innate ignorance, people may compound their mental distress with contrived ignorance.* Let us see how Tsongkhapa might regard the physicalist and dualistic premises of scientific naturalism as expressions of contrived ignorance.

The process of reification causes us to regard conceptually designated objects as real substances; and the more unlike these substances are, the more difficult it becomes to conceive how they might causally interact. Thus, if one reifies the world into objective matter and subjective consciousness, as Descartes does, there arises an insoluble problem of how the mind influences matter and how matter influences the mind.

Even if one tries to solve that problem by acknowledging the substantial, real existence of the objective world alone, the same problem of causal interaction appears in that world wherever there are conceived to be unlike substances, such as fields and particles, waves and particles, living and non-living entities.

[3]This theme is developed by Hilary Putnam in his philosophy of pragmatic realism, which he sets forth with great clarity in his *The Many Faces of Realism* (La Salle: Open Court, 1987) and *Realism with a Human Face*, ed. James Conant (Cambridge, Mass.: Harvard University Press, 1990). This philosophy seems to bear a remarkable "family resemblance" to Tsongkhapa's Prāsaṅgika Madhyamaka view.

To overcome this problem, we may try to fit all material phenomena into a single category, that is, to devise a grand unified theory that presents the entire universe as a manifestation of a single type of physical entity, be it atoms, fields, or waves. But such attempts are problematic, for radically diverse modes of observation often reveal radically diverse types of objective phenomena.

In the meantime, the fixation on the objective world inevitably allows no place for subjectivity—including the entire range of mental states—so it must be banished from the real world altogether. The fact that this rationalistic approach violates experience leaves open two options: thoroughly reject the validity of subjective, conscious experience, or reject the principle of materialism and return to experience. Since the first option can be taken only by a conscious subject refuting his or her existence and ability to act as an agent, this option is self-annihilating.

Reification of subject-object dualism is like seeing the world with two eyes that operate independently so that the worlds they see never fuse into a single, coherent view of reality. Reification of the objective world to the exclusion of the subjective is like solving the above problem by plucking out one eye. The same is true if one tries to solve that problem by reifying subjective states of consciousness and ignoring the objective world. At first one may be troubled by trying to explain how objective phenomena influence mental states; and when one gets sufficiently frustrated with this endeavor, one may "solve" the problem simply by denying that there are any external, non-mental influences on perception.

The entire range of experience of the phenomenal world consists of subjective and objective events, in some cases the subjective being more dominant and in others, the objective. But nowhere in experience can we identify anything that is *purely* objective, devoid of any subjective influence, or purely subjective, without relation to anything objective. According to Tsongkhapa, there are no objective phenomena that exist independently of conceptual designation; and there is no subject without an object. Thus, the two poles of absolute objectivity and subjectivity are vacuous. Devoid of any inherent existence, the duality between subject and object is said to be conceptually contrived, not absolutely real.

Even appearances themselves, or qualia, are conceptually designated, for the distinct identity of qualia, as differentiated from other events—for example, realities that are assumed to underlie appearances, and the consciousness of the appearances—is determined within the context of a conceptual framework. Finally, any process of conceptual designation, too, is designated within the context of a conceptual framework and therefore lacks any intrinsic existence. For such reasons Tsongkhapa rejects what he deems to be the philosophical extremes of materialism, mentalism, and absolute dualism.

In short, in Tsongkhapa's view, not only are we subject to misery and anxiety due to our bodies and the surrounding environment, but we may also suffer due to the mistaken ideas that we acquire through the course of our lives. None of these mistaken notions is more ubiquitous than our reification of the duality of subject and object. Fundamental to all these factors that may contribute to suffering is innate ignorance, which is present at birth and continues on in the stream of consciousness after death. Moreover, this ongoing mind-stream also carries with it innumerable imprints, habits, or latent propensities* that have been accumulated during one's individual past. Thus, within the framework of his own Buddhist view, Tsongkhapa would accept Freud's premise that "in mental life nothing which has once been formed can perish . . . everything is somehow preserved and . . . in suitable circumstances . . . it can once more be brought to light."[4]

Tsongkhapa and Freud, however, fundamentally differ in their views concerning the genuine sources of suffering. Freud acknowledges three sources from which our suffering comes: "the superior power of nature, the feebleness of our own bodies and the inadequacy of the regulations which adjust the mutual relationships of human beings in the family, the state and society."[5] Concerning the first two, he encourages "becoming a member of the human community, and, with the help of a technique guided by science, going over to the attack against nature and subjecting

[4] Freud, *Civilization and Its Discontents*, p. 16.

[5] Ibid., p. 33.

her to the human will."[6] But finally, he adds, we must submit to the inevitable, and we may even be forced to acknowledge the third source of suffering as a piece of unconquerable nature, which is to say "a piece of our own psychical constitution."[7]

The Buddhist theory advocated by Tsongkhapa implies that ignoring the external conditions that contribute to suffering may lead to a kind of apathy with respect to one's social and natural environment. But ignoring the inner sources of suffering leads to another kind of apathy, in which one assumes that human nature is essentially inalterable and that suffering is innate to human existence. Ironically, when hope in an inner source of well-being vanishes, one may become all the more fixated on manipulating the environment to protect one from suffering and bring one joy; and this in turn can easily lead to the destruction of the very environment one is trying to control.

[6] Ibid., pp. 24–25.

[7] Ibid., p. 33.

The Reality of the
Cessation of Suffering

In accord with the Buddhist tradition as a whole, Tsongkhapa asserts that the mental afflictions that lie at the root of suffering are not intrinsic to the nature of the mind. Rather, the nature of the mind is likened to clear light, and the afflictions are regarded as adventitious obscurations* of the mind's luminous nature.[1] It is this primordially pure mind that causes every sentient being to seek utter freedom from suffering.[2] As long as the mind is subject to these adventitious afflictions,* one is compelled to continue in the cycle of rebirth. *Saṃsāra* is the name given to this type of existence and also to the universe as it is experienced by such an individual. *Nirvāṇa* is freedom from *saṃsāra*, it is the ultimate reality that transcends all conceptual frameworks; and were it not for *nirvāṇa*, there would be no phenomenal world.[3] Thus, *nirvāṇa* is a primordial reality, which is not dependent upon being known or achieved.

One who has achieved *nirvāṇa* is known as an Arhat, and such an individual experiences the innate joy that is of the nature of the mind freed from obscurations.[4] Arhats living on as human beings after their attainment of *nirvāṇa* are said to have achieved "residual *nirvāṇa*,"* for they retain the "residue" of their human consciousness, feelings, concepts, body, and so on. Such people lead a dual life. At times they dwell in a state of meditative equipoise in which the unconditioned reality of *nirvāṇa* is experienced

[1]Cf. *Aṅguttara-Nikāya*, I, 10.

[2]*Uttaratantra*, 40. Cf. Jikido Takasaki, *A Study of the Ratnagotravibhāga* (Rome: Istituto Italiano Per Il Medio ed Estremo Oriente, 1966). p. 221.

[3]Cf. Itivuttaka 37.

[4]Tsongkhapa describes the four stages by which one becomes an Arhat is his treatise *The Stairway Taken by Those of Clear Intelligence: A Presentation of the Great Beings Who Have Attained the Stages of Entering and Abiding* [*Zhugs pa dang gnas pa'i skyes bu chen po rnams kyi rnam par bzhag pa blo gsal bgrod pa'i them skas* (Collected Works, Vol. Tsha)].

without mediation by any conceptual frameworks, and with no sense of a subject/object duality. In this state they experience no vestige of their human psycho-physical aggregates.* Moreover, this *nirvāṇic* consciousness is timeless for it entails no sense of past, present, or future;[5] it is boundless, radiant, and free of all appearances of the phenomenal world.[6]

At other times, when such Arhats are not in meditative equipoise and are conscious of the phenomenal world, they do not retain their non-dual experience of *nirvāṇa*. But they are free of all mental afflictions, they experience no mental suffering or fear, and they do no evil. In the meantime, they are still subject to physical pain; but it is experienced in quite a different way from beings who still identify with their bodies. Instead of grasping onto the pain as intrinsically "mine," and responding to it with misery and anxiety, an Arhat simply experiences it as a transient event and responds to it as needed.

While the unmediated realization of *nirvāṇa* is inconceivable and inexpressible, metaphorical and philosophical attempts are still made to describe it. Tsongkhapa emphasizes that the *nirvāṇa* that is discussed in terms of conceptual frameworks does not ultimately exist, that is, *it does not exist independently of those frameworks*. And yet *nirvāṇa* as it is realized without the mediation of concepts is ultimate reality. The non-dual realization of *nirvāṇa* is undifferentiated: it is not internally regarded as existent or nonexistent, as subjective or objective, as permanent or impermanent. *Nirvāṇa* is ascertained, and yet it is not identified conceptually. This realization, Tsongkhapa maintains, is unique, and it is this alone that irreversibly removes all the adventitious obscurations from the mind.

When a human Arhat dies, one's human body and mind are left behind, and one is not compelled to take on another existence as a human being or any other kind of sentient being. This is the achievement of non-residual *nirvāṇa*,* devoid of both mental and physical suffering, a state in which the consciousness of an Arhat

[5] Cf. *Dhammasaṅgani* 1416.

[6] Cf. *Dīgha-Nikāya* I, 223.

is unsupported, like a ray of sunlight that comes in contact with no physical object and does not "alight" anywhere.[7] Thus, while the mind and body are transcended, the individual continuum of consciousness of an Arhat does not cease.[8]

Within the framework of Tsongkhapa's Madhyamaka view, *nirvāṇa* is regarded as the object of an Arhat's ultimate realization;[9] while within the framework of many other Indian and Tibetan Buddhist treatises, the innately pure mind of clear light is said to be *nirvāṇa*.[10] Thus, different conceptual frameworks are brought to bear on a realization in which all differentiations of subject and object have disappeared. Finally all such accounts must be deemed *prescriptive* rather than formally *descriptive*, that is, they are intended as means to bring people to their own experience of *nirvāṇa*. Otherwise, the assertion that the unmediated experience of *nirvāṇa* is inconceivable and inexpressible would be meaningless.

Since Tsongkhapa denies the existence of an immutable, self-existent, personal identity, he also rejects the notion that such an ego is destroyed when an Arhat achieves non-residual *nirvāṇa*. For that which never existed in the first place can never be destroyed. What an Arhat has abandoned is the innate *grasping* onto an intrinsically existent personal identity. Such deluded conceptual grasping exists in an ordinary being, but not its referent.

[7] Cf. *Saṃyutta-Nikāya* I, 122; II, 103; III, 53-4, 124. For an illuminating discussion of this issue in Pāli Buddhist literature see Peter Harvey, "Consciousness Mysticism in the Discourses of The Buddha," in *The Yogi and the Mystic: Studies in Indian and Comparative Mysticism*, ed. Karel Werner (London: Curzon Press, 1989), pp. 82–102.

[8] Cf. *Udāna*, 80.

[9] Cf. *Paṭisambhidā-magga* II.143–45.

[10] Cf. Jikido Takasaki, *A Study of the Ratnagotravibhāga*, pp. 258, 261. Buddhaghosa's views on this matter correspond closely with Tsongkhapa's (cf. *Dīgha-Nikāya Commentary* II, 393–94), whereas Peter Harvey makes a case for interpreting *nirvāṇa* as the objectless consciousness of an Arhat. Cf. "Consciousness Mysticism in the Discourses of The Buddha," in *The Yogi and the Mystic: Studies in Indian and Comparative Mysticism*, and "The Mind-Body Relationship in Pāli Buddhism: A Philosophical Investigation," in *Asian Philosophy*, Vol. 3 (1992), no. 1, pp. 29–41.

When the ignorance of reifying oneself and other phenomena has been totally eliminated, one is also freed from every other kind of mental affliction that stems from such ignorance. However, if love and joy are included in the category of *passions*, then it must be said that Arhats are not free of all passions, for they experience the joy of *nirvāṇa*, and this experience is also said to open their hearts in love and compassion for all beings. Similarly, unless all instincts are considered to be of the nature of mental afflictions, the attainment of *nirvāṇa* does not entail "killing off the instincts," an ideal that Freud deems typical of the "worldly wisdom of the East."[11]

Tsongkhapa's views may come into clearer focus by juxtaposing them with some of the principle tenets of Western Christian mysticism. Augustine asserts that the two real causes of the miseries of this life are "the profundity of ignorance" and the "love of things vain and noxious," and all moral failure is due to the principle of evil within us. Within his own Buddhist context, Tsongkhapa would agree with the first of these statements, but he would question the nature of the "principle of evil within us," and he would reject Augustine's assertion of the indivisible unity of the self that is the same from one day to the next.

Augustine describes the ultimate reality of God as the non-composite, Changeless Light, the realization of which is the goal of the contemplative life; and Tsongkhapa describes the unmediated experience of ultimate reality in similar terms. However, from the time of Augustine, Western mystics have testified to the transient nature of the act of Christian contemplation, and assert

[11] Freud, *Civilization and Its Discontents*, p. 26.

[12] *Tract. in Ioan.* cxxiv. 5. According to the Christian theologian John Burnaby, Neo-Platonism encouraged Augustine to hope that by a stripping off of what was mutable in himself he might attain here and now to the Immutable. Moreover, "The Catholic orthodoxy of the time, so far from conflicting with this hope, offered him its confirmation in the monastic ideal. When he wrote the *De Quantitate Animae*, he saw no reason why the soul, having attained the 'tranquillity' of complete purification through the practice of virtue, should not advance from the 'beginnings' *(ingressio)* of momentary intuition of the divine to a secure 'abiding' *(mansio)* of contemplative fruition, of full and unshakable apprehension of the truth of God." [*De Quant. An.* 76] [Burnaby, John. *Amor Dei: A Study of the Religion of St.*

with Augustine, "Contemplation is only begun in this life, to be perfected in the next."[12] On the basis of his own experience and that of earlier Buddhist contemplatives, Tsongkhapa asserts that the highest Buddhist contemplation* may be maintained for long periods and can be perfected in this life. While Aquinas declares that "In the present life perfect happiness cannot be,"[13] Tsongkhapa asserts that since the human mind is not intrinsically evil or deluded, perfect happiness can indeed be experienced in this life.

Augustine's mystical vision retains the distinction between subject and object, and he asserts that the human soul must look outside itself for perfection. In contrast, according to Tsongkhapa, the unmediated experience of ultimate reality is undifferentiated in terms of subject and object, and perfection is to be found within the continuum of one's own consciousness. Finally, Gregory, regarded by many as the greatest of all the Popes, declares that man may apprehend the Eternal Being only by way of His co-eternal image.[14] Tsongkhapa, on the other hand, maintains that ultimate reality can eventually be known directly, without mediation by any ideas or images.

At first glance, Tsongkhapa's and Augustine's accounts of the contemplative experience of ultimate reality appear to be compatible in some respects and utterly incompatible in others. A critical comparison of the two would need to ask such questions as: Are Western Christian and Tibetan Buddhist contemplative experiences of ultimate reality fundamentally different or alike? Do the religious images, beliefs, symbols, and rituals of these two traditions define, in advance, what experiences they want and eventually have, as the modern scholar Steven Katz suggests? Or, despite these differences, might Christian and Buddhist contemplative

Augustine (Norwich: the Canterbury Press, 1991; first pub. 1938), p. 52.] Thus, it appears that the orthodox Christian insistence on the impossibility of abiding at length in the highest contemplative state traces back to, but not before, Augustine.

[13] *Commentary on Aristotle's Nicomachean Ethics* I, 10; no. 129.

[14] Dom Cuthbert Butler, *Western Mysticism: The Teaching of Augustine, Gregory and Bernard on Contemplation and the Contemplative Life.* 3rd ed., with "Afterthoughts" by David Knowles (London: Constable, 1967), p. 89.

practices lead to realizations of an ultimate reality that transcends the practices themselves? Finally, might the same reality be experienced with different degrees of clarity and immediacy?

Katz claims *"There are NO pure (i.e. unmediated) experiences,"*[15] and despite the claims of many Buddhist and non-Buddhist contemplatives to the contrary, he insists there are no grounds for believing any type of mystical experience to be unmediated. That is, Katz claims that all human experience is invariably structured by conceptual frameworks, in which are embedded one's memories, desires, and expectations; while contemplatives from diverse religious traditions claim to have entered into mystical experiences that transcend all conceptual conditioning. While it is certainly true that critical scholarship cannot accept all mystical claims at face value, it seems equally obvious that if one simply disregards contemplatives' own accounts of their experiences, there can be no study of mysticism. Katz evidently has his own reason for utterly dismissing contemplatives' claims of unmediated experience, and in fact his reason is clearly stated. Although he claims he has no "particular dogmatic position to defend in this discussion,"[16] his fundamental reason for rejecting the notion of unmediated experience is "because of the sorts of beings we are, even with regard to the experiences of those ultimate objects of concern with which mystics have intercourse, e.g. God, Being, *nirvāṇa*, etc."[17] He elaborates on his position by explaining "the kinds of beings we are require that experience be not only instantaneous and discontinuous, but that it also involve memory, apprehension, expectation, language, accumulation of prior experience, concepts, and expectations, with each experience being built on the back of all these elements and being shaped anew by each fresh experience."[18]

Tsongkhapa would fully endorse Katz's basic plea for a recognition of the differences among mystical experiences, for he

[15] Katz, Steven T., ed. Mysticism and Philosophical Analysis (New York: Oxford University Press, 1978) p. 33.

[16] Ibid., p. 65.

[17] Ibid., p. 26.

[18] Ibid., p. 59.

strongly emphasizes the wide range of contemplative experiences even within the context of Tibetan Buddhism alone. Moreover, Tsongkhapa also discusses at length various states of meditative equipoise that may easily be mistaken for the realization of *nirvāṇa;* and he shows how one should go about differentiating between the highest realization and its counterfeits. However, he would insist that while Katz's account of "the kinds of beings we are" well describes the whole range of conventional human experience, it fails to address the possibility that human consciousness may not ultimately be limited to this mode of dualistic experience. And in denying that any veridical propositions can be generated on the basis of contemplative experience, Katz protects his dogmatic position against the very people who claim to know otherwise. Indeed, he goes so far as to claim that mystics themselves do not have a privileged position when it comes to understanding the nature of mystical experience.[19] Mystics and scholars alike, he says, can take only mystics' accounts of their experience as their data for the study and analysis of mysticism. Katz's dismissal of the possibility of contemplative knowledge is representative of the more comprehensive taboo against subjectivity that is typical of modern scientific naturalism; and it is a stance that is contrary to the Buddhist and Christian contemplative traditions alike.

Arhats have often described *nirvāṇa* in terms of negation, such as the cessation of suffering, the unborn, the deathless, the unconditioned, the timeless, and as emptiness,* which Tsongkhapa interprets as the emptiness of an intrinsic identity of all phenomena.[20] In positive terms they commonly refer to it as ultimate peace, truth, and purity, and as the highest bliss. Christian contemplatives have described the contemplation of God as the culmination of all good actions, everlasting rest, and enduring joy. Freud counters that such contemplative goals entail giving up all other activities and sacrificing one's very life for the sake of achieving only the happiness of quietness.[21]

[19] Steven T. Katz, "The 'Conservative' Character of Mystical Experience" in *Mysticism and Religious Traditions*, ed. Steven T. Katz (Oxford: Oxford University Press, 1983), p. 5.

[20] Cf. *Paṭisambhidā-magga* I.92 and *Majjhima-Nikāya* I. 297–99.

[21] Freud, *Civilization and Its Discontents*, p. 26.

Tsongkhapa does not lightly dismiss this kind of criticism. Indeed, while identifying *saṃsāra* existence as one extreme, which is suffused with suffering, he regards *nirvāṇa* as the opposite extreme: the extreme of quietism. An Arhat's passage to the farther shore of non-residual *nirvāṇa* is a marvelous accomplishment for that single individual, but in the meantime all other sentient beings are left behind in the ocean of suffering. In light of this inadequacy, Tsongkhapa embraces the ultimate ideal of the perfect enlightenment* of a Buddha.[22] While all Arhats are alike in terms of their freedom from mental afflictions, they vary in terms of their virtues of knowledge, compassion, and power. Only in a Buddha are these three virtues brought to their infinite perfection, thereby enabling a Buddha to be of maximum effectiveness in serving the needs of sentient beings. Moreover, Tsongkhapa asserts that even after a Buddha's death, such a being continues to manifest in innumerable ways in the phenomenal world in order to guide individuals along the path to enlightenment. A Buddha's service to the world does not cease until all sentient beings are brought to enlightenment. Thus, due to the greater inner virtues and greater capacity for service of a Buddha, the means of achieving this state are called the Mahāyāna, or "Great Vehicle"; while the means of achieving individual liberation are called the Hīnayāna, or "Lesser Vehicle."

While a living Arhat alternately experiences the phenomenal world and the ultimate reality of *nirvāṇa*, Tsongkhapa asserts that a Buddha continuously experiences both conventional and ultimate realities, and knows them to be of the same nature. That is, *nirvāṇa* is in reality the ultimate nature of the phenomenal world. While sentient beings still subject to mental afflictions abide in *saṃsāra*, and Arhats after death abide in non-residual *nirvāṇa*,

[22] Tsongkhapa discusses in great detail the successive paths culminating in the liberation of an Arhat and the enlightenment of a Buddha and the differences between these states in his two-volume treatise *A Golden Rosary of Eloquence: An Extensive Explanation of* Abhisamayālaṃkāra, *a Treatise on the Practical Instructions in the Perfection of Wisdom, Together With Its Commentaries* [*Shes rab kyi pha rol tu phyin pa'i man ngag gi bstan bcos mngon par rtogs pa'i rgyan 'grel pa dang bcas pa'i rgya cher bshad pa'i legs bshad gser gyi phreng ba* (Collected Works, Vols. Tsa and Tsha)].

the enlightenment of a Buddha is said to be "non-abiding." That is, while the infinite mind of a Buddha, known as the Dharmakāya, or embodiment of truth, is indivisible from *nirvāna*, the physical embodiments of a Buddha, known as Rūpakāyas, continue to appear in the worlds of sentient beings. While the virtues of all Buddhas are identical, in that all have been brought to perfection, all Buddhas retain their own individual mind-streams, each with its own unique history. From the Dharmakāya of each Buddha there is emanated a sublime embodiment of perfect rapture, or Sambhogakāya, which remains until all sentient beings have been brought to enlightenment. And each Sambhogakāya is the source of innumerable emanated embodiments, or Nirmānakāyas, which directly serve the needs of sentient beings in every conceivable way. These three embodiments of the Dharmakāya, Sambhogakāya, and Nirmānakāyas are said to be of the same nature; that is, a Nirmānakāya has no existence independent of the Sambhogakāya from which it originates; and a Sambhogakāya, does not exist independently of the Dharmakāya from which it is appears.

Tsongkhapa maintains that all sentient beings have the capacity to become Buddhas, and this perfect enlightenment alone is the ultimate goal of Buddhist practice. Thus, even those who have achieved non-residual *nirvāna*, he maintains, are eventually aroused from this extreme of quietism to appear again in the world and to strive for perfect enlightenment until it is achieved.

While the virtues of sentient beings are finite and those of Buddhas are infinite, in Tsongkhapa's view there is no unbridgeable chasm separating sentient beings from Buddhas. For the Buddhas manifest, for example, as human beings, with whom ordinary people may interact; and every sentient being has the potential for the infinite wisdom, compassion, and power of a Buddha. Although Tsongkhapa frequently refers to the necessity of accumulating spiritual power*23 and knowledge* as means to

23 *Punya* is widely regarded in Buddhism as something accumulated in one's mind-stream as a result of virtuous activity, and diminished by non-virtuous deeds such as an act of malice. It is the source of well-being within *samsāra*, and its accumulation is a necessary element in the pursuit of *nirvāna*. Thus, I have

achieve enlightenment, sentient beings do not acquire infinite
virtues by accumulating finite virtues. Rather, accumulated spiri-
tual power and knowledge are needed to dispel the finite, adven-
titious obscurations* that conceal sentient beings' infinite, innate
capacity for virtue. These obscurations are of two kinds: afflictive
and cognitive obscurations.* The former, which constitute the
source of suffering, are eliminated in the process of becoming an
Arhat; and the latter, which obstruct the innate potential for infi-
nite consciousness, are dispelled as one approaches the perfect
enlightenment of a Buddha.

chosen to render this term as "spiritual power," rather than the more common
"merit," which has the more abstract connotation of a quality, value, or excellence.

The Reality of the Path to Enlightenment

The Cultivation of Contemplative Insight

As an advocate of the Prāsaṇgika Madhyamaka view, Tsongkhapa asserts that the antidote to the ignorance that lies at the root of suffering is insight* into the absence of an intrinsic nature of all phenomena.[1] Thus, the path to the unconditioned reality of *nirvāṇa* is followed by investigating the nature of the conditioned reality of the phenomenal world. The issue here is, on the one hand, to examine the manner in which phenomena appear to our minds and physical senses, then to observe introspectively the manner in which we conceptually designate them and reify them. Tsongkhapa maintains that all phenomena appear to us as if they existed in their own right, independent of any conceptual framework. The innate tendency of the mind is to grasp onto them as if they do indeed exist in the way they appear, that is, as inherently existent.

The empirical observation required in Tsongkhapa's method for developing insight is largely introspective in nature, entailing the first-person observation of the states of one's own body and mind. Moreover, since one's sense of personal identity is closely associated with one's continuum of mental consciousness—and indeed since it is the mind-stream that is thought to continue from one life to the next—a close scrutiny of the mind is an essential component of this training. This raises the fundamental issue of whether or not the phenomena of the mind, including mental

[1] Tsongkhapa most comprehensively presents the means of cultivating contemplative insight in his *Great Exposition of the Stages of the Path to Enlightenment,* and a more concise account is given in his *Small Exposition of the Stages of the Path to Enlightenment* [*Byang chub lam gyi rim pa chung ba* (Collected Works, Vol. Pha)]. An English translation of the latter appears in *Life and Teachings of Tsong Khapa,* ed. Thurman, pp. 108–185.

65

processes,* mental imagery,* and consciousness itself, can be reliably examined by means of introspection.*[2]

An early Western account of introspection, though not by that name, is found in Augustine's *De Trinitate*. Augustine here maintains that the nature of the mind can be discovered not by withdrawing from it, but by withdrawing from the mind the sensory images and so on that have been added to it.[3] This introspective process, he claims, yields indubitable knowledge,[4] a view that became orthodox roughly from the end of the Middle Ages; for once the mind dispenses with adventitious ideas about itself—such as identifying the mind with the brain—and simply encounters its own inward presence, "then whatever still remains to it of itself, that alone is itself."[5] Augustine raises a number of questions concerning the manner in which the mind observes itself: Since the mind is never without itself, why does it not always observe itself? Does one part of the mind observe another part? In the process of introspection does the mind serve as both its subject and its object? To all such questions he responds that all such notions are artificial, conceptual constructions, "and that the mind is not such is absolutely certain to the few minds that can be consulted for the truth about this matter."[6]

The term "introspection" first appeared in the second half of the seventeenth century; and within the modern secular context this approach to understanding the mind remained dominant until the second decade of the twentieth century, when it was discarded on the grounds that it produced unreliable reports about mental phenomena. Introspection is no longer a topic treated in psychology textbooks, and in both psychology and the brain sciences, theorizing about the nature of introspection is at a

[2] This topic is discussed at length in the chapter "Theoretical Problems of Introspection in Indo-Tibetan Buddhism."

[3] Saint Augustine, *The Trinity*, trans. Stephen McKenna (Washington, D.C.: Catholic University of America Press, 1962), Bk. 10, c. 8, p. 305.

[4] Ibid., Bk. 9, c. 11, p. 286.

[5] Ibid., Bk. 10, c. 10, pp. 307, 310.

[6] Ibid., Bk. 14, c. 6, p. 421.

rudimentary stage in comparison with other types of cognition.[7] A central reason for this may be, as philosopher Daniel Dennett points out, that it, together with consciousness itself, are features of the mind that are most resistant to absorption into the mechanistic picture of science.[8]

For Tsongkhapa there is no way to study the phenomena of the mind without implicitly or explicitly studying consciousness. But how are we to go about this? We cannot observe other peoples' consciousness as such; we can observe only them and the relations between them, their behavior, and their environment.[9] Moreover, it is also impossible for consciousness to observe itself, just as the blade of a sword cannot cut itself.[10] To the suggestion that consciousness may indeed be aware of itself, just as a flame illuminates itself, Tsongkhapa counters that a flame does not illuminate itself any more than darkness obscures itself; for this would imply a distinction between the agent doing the illuminating and that which is illuminated.

The point of Tsongkhapa's rejection of the possibility of the mind observing itself is to demonstrate the invalidity of the substantive notion of purely subjective consciousness unrelated to any object. For Tsongkhapa, all states of subjective consciousness are intentional, that is, they all are conscious of some object. Thus, while it is possible to remember *being conscious of an*

[7] For a detailed analysis of introspection see William Lyons, *The Disappearance of Introspection* (Cambridge, Mass.: MIT Press, 1986). A critical history of introspectionism during the period 1880–1914, is presented in Kurt Danziger, "The History of Introspection Reconsidered," *Journal of the History of the Behavioral Sciences* 16 (1980), pp. 241–262.

[8] Daniel Dennett, *Content and Consciousness*, (New York: Routledge 1969), p. 40. See also his more recent work *Consciousness Explained* (Boston: Little, Brown, 1991).

[9] Buddhist contemplatives assert that the ability to perceive the minds of others can be developed on the basis of the achievement of quiescence.

[10] Tsongkhapa discusses the impossibility of the mind observing the mind in his commentary to the "Wisdom Chapter" of Śāntideva's *Bodhisattvacaryāvatāra* presented in *Notes on the Wisdom Chapter*, written down by his disciple rGyal tshab chos rje, IX:17-25 [*rGyal tshab chos rje'i drung du gsan pa'i shes rab le'u'i zin bris* (Collected Works, Vol. Pha)]. Cf. H.H. the Dalai Lama, Tenzin Gyatso,

object, this occurs due to the connection between the subject and the object; but this recollection is not a retrieval of a prior consciousness of pure subjectivity as an independent entity.[11]

Upon recognizing that consciousness cannot observe itself, one might go a step further in declaring that introspection of any sort is impossible, for conscious states, unlike the objects of vision and the other senses, are not independently existing objects, separate and independent from the consciousness of them. This view, which is based on the reification of sensory objects, ignores the fact that the universe we experience contains an irreducibly subjective component. Just as it is difficult to describe our conscious experience of objects apart from the objects that are experienced, so is it difficult to describe perceived objects independently of our perception of them. While Tsongkhapa acknowledges that our sensory experience of the physical world is produced in part by objects external to the perception,* there are many subjective influences that also structure experience. In normal visual perception we do not simply perceive undifferentiated shapes, but within the context of our conceptual frameworks we identify objects and features of objects. Thus, the objective world we experience is thoroughly structured, categorized, and made familiar

Transcendent Wisdom: A Commentary on the Ninth Chapter of Shantideva's Guide to the Bodhisattva Way of Life, trans. and ed. by B. Alan Wallace (Ithaca: Snow Lion, 1994), pp. 26–31. The analogy of the impossibility of a blade cutting itself is taken from the *Ratnacūḍasūtra.* This issue is also discussed at length in Nāgārjuna's *Mūlamadhyamakakārikā,* and in Candrakīrti's *Madhyamakāvatāra,* VI:73–78. Cf. C.W. Huntington, *The Emptiness of Emptiness: An Introduction to Early Indian Mādhyamika,* with Geshé Namgyal Wangchen (Honolulu: University of Hawaii Press, 1989), p. 166.

[11] In taking this stand, Tsongkhapa, like Śāntideva, is explicitly refuting the Yogācāra assertion of an incorrigible, self-cognizing awareness *(rang rig, svasaṃvedana)* that is substantially identical with the conscious states that it perceives. For a brief, lucid discussion of the nature of self-cognizing awareness, see Geshe Rabten, *The Mind and Its Functions,* pp. 12–14.

A fundamental difference between the Yogācāra view and Tsongkhapa's Prāsaṅgika view is that the former accepts the true, inherent existence of consciousness, while the latter does not. Although Tsongkhapa certainly acknowledges the possibility of introspection, as well as its epistemic and soteriological importance, he rejects the Yogācāra interpretation of the manner in which introspection takes place.

by our conceptual frameworks. And this element of subjectivity is in no way abandoned when we try to conceive of the nature of objects external to the mind. Although Tsongkhapa acknowledges the presence of objective stimuli that are external to the mind, he insists that the external objects we identify as the objective bases of sensory experience do not exist independently of our conceptual frameworks. As long as our minds function within the network of human concepts, the worlds we experience are irredeemably anthropocentric; and the ideal of pure objectivity is as unattainable as the ideal of pure subjectivity. Thus, neither the "primary attributes" of physical reality conceived by scientists nor the *nirvāṇa* conceived by Buddhists exist independently of conceptual designation.

According to Tsongkhapa, individuals have privileged access to their own subjective mental states in the sense that each of us is able to observe our mental processes in a way that is normally inaccessible to others. This assertion does not discount the fact that latent, or unconscious, predispositions exert powerful influences on our minds and behavior. Nor does Tsongkhapa deny that physical processes within the body condition our mental states. Indeed, this is a major theme of the esoteric theories and practices of Buddhist Tantra, or Vajrayāna, about which Tsongkhapa writes at great length. Nevertheless, Tsongkhapa leaves no room for doubt about his conviction that mental phenomena can be specified, studied, and understood without knowing how the brain works.

For Tsongkhapa, the fact that certain types of natural phenomena, such as the phenomena of the mind, are not equally accessible to all observers in no way implies that such phenomena are any less real than others. They are simply different. Moreover, the assertion that introspection is the primary means for exploring the mind does not imply that introspective observation is incorrigible. On the contrary, as we shall see in Tsongkhapa's presentation of the cultivation of quiescence, the faculty of introspection is fallible and needs to be developed and refined into a reliable tool. Moreover, it may atrophy as a result of disuse, even to the point that one may deny its existence altogether.

It is this faculty of introspection that enables us to shift the attention from the initial objects of consciousness to the manner in which those objects appear and are apprehended. But, like all other conventional modes of perception, introspection operates in close conjunction with our conceptual frameworks. The fact that extraspective scientific observations are made within the context of conceptual frameworks is not incompatible with the fact that genuine discoveries can be made and are made within those frameworks. Similarly, introspective contemplative discoveries can be made even when they are not conceptually unmediated.

Since Tsongkhapa denies the intrinsic existence of even the tiniest particle and the most basic unit of consciousness, there would seem to be no hope of testing theories against any reality existing independently of conceptual designations. The fact that the same phenomena may be perceived or inferred using different modes of observation and different theoretical constructs does not necessarily imply that those phenomena exist independently of *all* types of perception and conceptualization. A single phenomenon may be understood in diverse ways within the context of different conceptual frameworks, and multiple phenomena may be given the same label within different, incompatible theories.

If the validity of a conceptual system cannot be tested against a reality that is independent of all frameworks, on what grounds is one theory to be preferred over another? To address this issue, we must first note that the Buddhist path is essentially aimed at eliminating innate delusions of assuming the existence of things that do not exist, rather than at acquiring beliefs about positive phenomena*[12] that do exist. For example, Tsongkhapa asserts that sentient beings are innately afflicted with the delusion of grasping onto their own intrinsic personal identities. This innate ignorance may be compounded with contrived ignorance, such as grasping onto one's ego as an immutable, unified, independent substance. But it is innate delusion, not the contrived delusion acquired through philosophical speculation, that operates as the source of all other mental afflictions and suffering.

[12] This is an entity that is not apprehended through an explicit process of negation.

Tsongkhapa recognizes the value of multiple Buddhist philosophical systems, namely the Vaibhāṣika, Sautrāntika, Yogācāra, and Madhyamaka views;[13] for each of these can be used in the cultivation of valuable contemplative insights. The insight practices associated with the Vaibhāṣika and Sautrāntika systems, entailing a careful scrutiny of one's body and mind, result in the realization that there is no permanent, unified, independent self. And even closer examination reveals the absence of the self as an autonomous, substantial entity that is in control of the body and mind. While the notion of a permanent, unified, independent self is widely regarded by Buddhists as an acquired, contrived delusion, many believe that the sense of oneself as a controlling, autonomous, substantial entity is an innate delusion. It is noteworthy in this regard that modern cognitive science is still frequently infected with the "homunculus fallacy," which treats the brain as if there were some agent inside it that is in charge of its operations.[14] While yielding valuable insights that dispel certain misconceptions concerning personal identity, the Vaibhāṣika and Sautrāntika systems leave unchallenged our assumptions concerning the true, inherent existence of physical and mental events. Thus, they both advocate views of substance dualism.

The contemplative practices associated with the Yogācāra system penetrate deeply into the nature of consciousness, and they lead to the conclusion that only the mind and its appearances are real; no objects external to the mind exist. Although Tsongkhapa acknowledges the value of recognizing the lack of inherent existence of the physical world, he faults this system for denying the role of external stimuli upon perception and for failing to challenge the assumption of the inherent existence of the mind. This task is left to the advocates of the Madhyamaka view, which, according to Tsongkhapa's Prāsaṅgika interpretation, uproots our most fundamental assumptions concerning the inherent existence of all phenomena, subjective and objective.

[13] For a concise account of the tenets of these four systems see Geshe Lhundup Sopa and Jeffrey Hopkins, *Practice and Theory of Tibetan Buddhism* (New York: Grove Press, 1976), Part Two.

[14] Such a notion, however, is explicitly refuted in Daniel Dennett's *Consciousness Explained* (Boston: Little, Brown, 1991).

On the grounds that it denies nothing that does exist and affirms nothing that does not exist, Tsongkhapa regards the Madhyamaka as the middle way; and yet he acknowledges that everyone who adheres to any of the Buddhist philosophical systems regards his own view as the middle way. So how is one to judge which, if any, of these claims are valid? And on what grounds are the insights claimed by contemplatives to be regarded as superior to the views of non-contemplatives? Tsongkhapa draws a fundamental distinction between contemplatives who realize all phenomena as being empty of inherent existence and ordinary beings who assert the reality of phenomena (as well as those who give no thought to this matter).[15] The contemplatives' realization, he says, invalidates the realist assertions of others, and even among contemplatives with unified quiescence and insight, there are higher realizations that surpass the less penetrating insights.

In making this claim, Tsongkhapa is, of course, speaking from his own perspective, based upon his own theoretical understanding and contemplative insight. He does not ask others to accept his viewpoint simply on his own authority; rather, he counsels that the relative validity of the various Buddhist philosophical views must be tested with reasoning. If, upon careful investigation, one finds that some view other than the Madhyamaka theory best withstands critical analysis, one should adopt that view. However, the crucial point is to use that theoretical understanding in the pursuit of contemplative insight, for it is only such insight that dispels mental afflictions and obscurations.

Thus, rational evaluation of different views can and should be made before applying them to contemplative practice; but experiential evaluation can be made only by entering into the training of contemplation. Here one finds that different kinds of experiential realization attenuate and may eventually eliminate different

[15] Tsongkhapa discusses these issues in rGyal tshab chos rje's *Notes on the Wisdom Chapter of* Śāntideva's *Bodhisattvacaryāvatāra,* verses 3–5. Cf. H.H. the Dalai Lama, Tenzin Gyatso, *Transcendent Wisdom: A Commentary on the Ninth Chapter of Shantideva's* Guide to the Bodhisattva Way of Life, vs. 3–5, pp. 18–19.

degrees of obscurations. The degree of effectiveness of the practical application of a philosophy of the mind for dispelling the mental obscurations is the final criterion for evaluating such a theory. Thus, the initial evaluation of a conceptual framework is rational, but the final judgment is empirical.[16]

The fundamental difference between the view of Madhyamaka contemplatives and that of realists,[17] in the Buddhist philosophical sense of the term, is that the former deny the inherent existence of all phenomena, while the latter accept it. Tsongkhapa declares that the Madhyamaka contemplatives' insight into the emptiness of phenomena invalidates the realists' perception of reality; and this, he says, may be demonstrated by way of analogies that are common to everyone's experience. One such analogy is the dream state. Apart from those who are able to recognize a dream for what it is *while they are dreaming*, people tend to apprehend dream phenomena as if they were truly existent. That is, they grasp onto the objects and events in a dream as if they were inherently existent, and they respond to them accordingly. Dream phenomena, like the events of waking experience, do indeed appear as if they had their own intrinsic identities, independent of all conceptual constructs, and this is just how they are grasped while dreaming.

For example, one might dream of being a cognitive scientist exploring the nature of perception; and within the dream one might construct a theory of the ways in which external objects contribute to the production of perception. While dreaming, the evidence for such a theory may seem compelling, and the theory may seem perfectly coherent. Only when people awaken do they recognize that they had fundamentally misapprehended the nature of objects and events during the dream.

[16] Due to this initial emphasis on reasoning, the traditional monastic education in the Gelugpa order begins with extensive training in logic and debate. For a first hand account of this training see B. Alan Wallace, trans. and ed. *The Life and Teaching of Geshé Rabten* (London: Allen and Unwin, 1980), pp. 35–42. An extensive discussion of this topic is also found in Daniel Perdue's *Debate in Tibetan Buddhism* (Ithaca: Snow Lion, 1992).

[17] Buddhist realist schools include the Vaibhāṣika, Sautrāntika, and Yogācāra views.

According to Tsongkhapa, the contemplative cultivation of insight commences with discursive meditation,* entailing precise introspection and rational analysis. At the moment when the sheer absence of inherent existence of phenomena is realized, the contemplative enters into non-discursive, stabilizing meditation,* in which the attention is focused single-pointedly in that realization. Between formal meditation sessions, while actively engaged in the world, the Madhyamaka contemplative attends to the dream-like quality of phenomena: like events in a dream, everyday events appear as if they were inherently existent, but the contemplative knows that they exist in dependence upon conceptual designation.

A complementary practice may also be followed while sleeping, and that is dream *yoga*. In this training the initial task is to acquire the ability to recognize the dream state while dreaming, or in modern parlance to *dream lucidly*.[18] The ability to dream lucidly, long thought by Western psychologists to be impossible, has been amply demonstrated in recent years, and it is one more practical application of the human faculty of introspection. Once this ability has been developed, the second phase of the training consists in exercising one's ability to transform the contents of the dream. For example, one trains in transforming a single object into many objects, many objects into a single object, transforming the small into the large, the large into the small, inanimate objects into animate objects, and vice versa. None of the objects or events in the dream have their own intrinsic existence independent of one's thoughts, so in principle they can be changed in every imaginable way. Exercising this ability to transform them is helpful

[18] Tsongkhapa explains this training at length in his treatise *The Threefold Conviction: Stages of Guidance on the Profound Path of the Six Dharmas of Nāropa* [*Zab lam na ro'i chos drug gyi khrid rim yid ches gsum ldan* (Collected Works, Vol. Ta)]. An early translation of this text is found in *Esoteric Teachings of Tibetan Tantra*, trans. Chang Chen Chi, ed. C.A. Musès (York Beach: Samuel Weiser, Inc., 1982) pp. 123-264; see especially Ch. 6 on "The Practice of Dream Yoga." See also the chapter on dream yoga in Gyatrul Rinpoche's *Ancient Wisdom: Nyingma Teachings on Dream Yoga, Meditation and Transformation*, trans. B. Alan Wallace and Sangye Khandro (Ithaca: Snow Lion, 1993); and Namkhai Norbu, *Dream Yoga: The Practice of the Natural Light* (Ithaca: Snow Lion, 1992).

for recognizing their lack of inherent existence. Thirdly, with the knowledge that neither "external" events in the dream nor oneself have any inherent existence, when dangerous situations occur in the dream, instead of transforming them, one simply enters into them with the utter assurance that they pose no real threat to one's well-being.

Upon returning to the waking state, the contemplative accomplished in dream *yoga* further explores the extent of similarity between waking phenomena and dream phenomena. When one fails to recognize the actual dream state, one may helplessly suffer from events that are taken to be real and beyond one's control; and the same is true of those who grasp onto the true existence of phenomena during the waking state. There are many reports of highly accomplished Indian and Tibetan Madhyamaka contemplatives who, by their very realization of the dream-like nature of phenomena, have been able to control phenomena during the waking state in the same manner that they can be manipulated while dreaming. Within this Buddhist context, the Christian accounts of Jesus performing such feats as walking on water and multiplying loaves and fish sound perfectly plausible.

In terms of modern scientific naturalism, however, such accounts of paranormal abilities are dismissed out of hand; and the Madhyamaka denial of the true existence of the phenomenal world is in fundamental contradiction with the ontological principles of scientific realism.[19] And yet, as Tsongkhapa points out, the analogy of the dream state is presented to bridge this gap: is it not true that we ordinarily grasp onto the true existence of dream events, and emotionally respond to them as if they were real? A thoroughly pragmatic approach to testing the Madhyamaka view would be to begin with training in dream *yoga*, for realists and Madhyamaka advocates both agree that dream phenomena do not exist in the manner in which they

[19] It is important to distinguish here between genuine scientific theories and the ontological principles of scientific realism. I am using the term "scientific realism" in reference to a metaphysical position that accepts true scientific theories as accurate, objective accounts of the universe as it exists independently of our modes of observation and conceptualization.

appear. The ultimate test following such an approach might be to determine if it is possible mentally to manipulate phenomena in the waking state just as one accomplished in dream *yoga* can alter them while dreaming.

Tsongkhapa maintains that unless insight into the emptiness of inherent existence is integrated with a high degree of attentional stability, one's awareness of ultimate reality will invariably be filtered through preconceived ideas of that reality. Thus, unmediated, non-dual realization would remain beyond reach. However, this does not imply that such insight into ultimate reality is simply an *artifact* of one's conceptual framework. Indeed, Tsongkhapa cites many kinds of valuable insights that may be experienced through introspective inquiry, including the role of mental afflictions in causing suffering, the nature of consciousness, and so on. Conceptual theories are useful in opening up avenues of experience that were previously ignored, and fresh ideas may lead to valuable insights that were inhibited by other earlier preconceptions. But the mere fact that contemplative inquiry operates within the context of conceptual frameworks does not mean those frameworks predetermine all one's experiences. The same is true of extraspective inquiry operating within the context of scientific conceptual frameworks: scientists' perceptions of phenomena are structured by their preconceptions, but genuine discoveries are still made. Similarly, conclusions drawn from introspection may be erroneous or valid, and genuine discoveries are possible.

To understand Tsongkhapa's view of reality, it is imperative to make the subtle, but crucial, distinction between mere figments of the imagination and conventionally existent phenomena. Let us begin with the subject of personal identity. On the basis of our awareness of our own bodies, behavior, memories, feelings, thoughts, fantasies, consciousness, possessions, friends, environment and so on, we develop a sense of personal identity. This self-concept is not static, but varies in accordance with the personal events that capture our attention from moment to moment and from day to day. Thus, a very high degree of editing goes into the

selection of personal phenomena upon which we establish our identities. The self so designated is not identical with any of the phenomena upon which it is imputed; rather, it is conceived as the person who possesses those aggregates of the personality and so on as its own attributes or affiliations. Thus, while this self does not exist independently of this conceptual designation, it is conventionally valid to speak of it as performing actions, experiencing the consequences of those deeds, and interacting with other people, the environment, and so forth. In this way the self is said by Tsongkhapa to be conventionally existent.

There is a powerful, innate tendency, however, to hypostatize, or reify, this conceptually constructed self, grasping onto it as being inherently existent, independent of any conceptual designation. Such an intrinsic personal identity, Tsongkhapa claims, is totally a figment of the imagination, with no basis in reality whatsoever. A central task of contemplative inquiry is to establish experientially that such a self has no existence either among the constituents of one's personality or apart from them. Moreover, if the self is designated on the basis of non-existent attributes, or by means of a denial of existent attributes, even the conventionally designated self is a groundless fabrication, devoid of even conventional existence.

Even if one has a limited degree of insight into the conceptually designated status of one's identity, there remains a strong tendency to view one's body and other macro-objects of the physical environment as bearing their own intrinsic identities. Indeed, as we visually perceive the physical world, including our own bodies, it appears to exist purely objectively, from its own side. This mode of appearance, Tsongkhapa declares, is utterly deceptive. All that seems to appear purely from the side of perceived objects is in fact thoroughly structured by our conceptual frameworks.

Perceptual objects reified by the mind do not exist in nature, but are solely fabrications without even conventional existence. In addition, due to objective sources of illusion or psychological and physiological influences, we may apprehend objects that do not exist, misidentify objects that do exist, or fail to perceive objects that do exist and are otherwise accessible to our perceptions. All

of these faulty perceptions constitute errors of apprehension apart
from the tendency of reification.[20]

Recognizing that perceptual appearances are deceptive, we
may seek an understanding of the physical reality that lies beyond
those appearances and acts as their objective source. To take one
specific instance of this kind of pursuit, we may look to the work
of the physicist Michael Faraday. On the basis of the patterns in
which iron filings align themselves on and around a magnet,
Faraday developed the concept of "lines of force" as a powerful
tool of the imagination. The contemporary physicist and historian
Arthur Zajonc points out what happened next: "Originally, he had
considered the lines of force (his term for "fields") as nothing
more than useful fictions, but the more he thought about them,
the greater their reality appeared, until they became for him more
real than the atoms of matter that were thought to be their
sources . . . "[21] From Tsongkhapa's interpretation of the
Madhyamaka view, we can infer that he would accept the conven-
tional existence of lines of force, or fields, as "useful fictions"
based upon valid experience. As in the case of the self, they are
conceptually designated on the basis of perceived phenomena, but
they are not identical to those phenomena. Force fields exist as
conceptual constructs, and it is conventionally valid to regard
them as causal agents in nature. The same may be said of many
of the unconscious agents in the human psyche that are conceived
by modern psychology to influence human behavior. On the other
hand, it is certainly possible to conceive of physical and mental
theoretical entities that prove to be incompatible with observed
phenomena. The various nineteenth-century concepts of the ether
proved to fall into this category, so the ether so conceived has

[20] For a discussion of Tibetan Buddhist views on mistaken perception see Lati
Rinbochay, *Mind in Tibetan Buddhism*, trans. and ed. by Elizabeth Napper (Valois:
Gabriel/Snow Lion, 1981), Ch. 2. Cf. Gyaltsab *Chöje's Notes on Tsongkhapa's
Lectures on the "Perception Chapter"* [of Dharmakīrti's *Pramāṇavārtika*] [rGyal
tshab chos rjes rje'i drung du gsan pa'i mngon sum le'u'i brjed byang (Collected
Works, Vol. Ba)] and *An Account of Tsongkhapa's Teachings on the Commentary of
the "Perception Chapter"* [of Dharmakīrti's *Pramāṇavārtika*] [mNgon sum le'u'i
tikka rje'i gsung bzhin mdzad pa (Collected Works, Vol. Ma)].

[21] Arthur Zajonc, *Catching the Light: The Entwined History of Light and Mind* (New
York: Bantam, 1993), pp. 137–38.

rightly been discarded as a pure fabrication without even conventional existence. Within the Buddhist context, Tsongkhapa similarly rejects even the conventional existence of self-cognizing awareness* and the foundation consciousness* as these are conceived by advocates of the Yogācāra system.[22]

Where Tsongkhapa's Madhyamaka view fundamentally differs from scientific realism is in his rejection of the assertion that valid theoretical entities exist independently of their conceptual designation. From this perspective, the independent existence of the real world hypostatized by scientific realists is nothing more than a figment of their imaginations. Madhyamaka contemplatives seek to see experientially through all such deceptive appearances—both perceptual and conceptual—to realize the intrinsic identitylessness of all phenomena. Many Buddhist contemplatives claim to have succeeded in disengaging their consciousness entirely from all conceptual frameworks; and the reported effect is that while in that state, all appearances of the phenomenal world vanish completely.

Thus, the experienced phenomenal world exists in dependence upon the power of conceptual designation, and all our concepts about the world as it might exist independently of experience are simply further constructs. Not even the most minute building blocks of the physical world, Tsongkhapa maintains, are inherently existent. And yet our conceptual frameworks open the way for a myriad of genuine discoveries of conventionally existent phenomena that participate in the causal fabric of the natural world.

Tsongkhapa insists that the possibility of genuine discovery within the context of conceptual frameworks applies to ultimate reality as well as relative phenomena. The *nirvāṇa* that is non-

[22] Tsongkhapa discusses these topics in his *Ocean of Eloquence: An Extensive Commentary on the Difficult Points Concerning Cognition and the Foundation* [*Yid dang kun gzhi'i dka' gnas rgya cher 'grel pa legs bshad rgya mtsho* (Collected Works, Vol. Tsha)]. A Prāsaṅgika refutation of self-cognizing awareness and the foundation consciousness is presented in *A Dose of Emptiness (sTong thun chen mo)*, by Tsongkhapa's disciple Khedrup Gelek Palzang (mKhas grub dge legs dpal bzang), trans. José Cabezón, pp. 311–323, 345–356.

conceptually realized by an Arhat is a primordial reality that is not dependent upon human conceptualization. It is the sole ultimate truth, though there are a variety of ways to realize it, and it is called by different names. Moreover, there are different degrees of realization of this ultimate truth. The initial insight into empti- ness is bound to be filtered through one's preconceived ideas con- cerning emptiness, like gazing at the sun through a layer of clouds. But as one's realization deepens, the conceptual filter decreases; and the culmination of this contemplative process is a non-dual, conceptually unmediated realization of emptiness.

In short, the Madhyamaka tenet that no phenomenon bears its own intrinsic existence independent of conceptual designation does not mean phenomena are all simply artifacts of one's con- ceptual framework or that they are mere figments of one's imagi- nation. The validity of theories must be tested, not against a phantom-reality that purportedly exists independently of all con- ceptual frameworks, but within the context of experience. From the Madhyamaka perspective, this is equally true for extraspective scientific research. Insight into the transcendent, ultimate nature of existence may indeed be possible, but for this, consciousness must itself transcend the realm of human concepts.

As many aspiring contemplatives have discovered for them- selves, it is no easy feat to accomplish all the above three phases of dream *yoga*, let alone the even more advanced stages in that training. Moreover, even if one gains a conceptual understanding of the lack of inherent existence of phenomena, it is very difficult to stabilize one's attention in that insight. And as long as the mind compulsively persists in conceptualization even when one seeks non-conceptual attentional stability, there seems to be no way that consciousness can transcend the network of conceptual frame- works in which it normally operates.

A fundamental problem for the contemplative cultivation of insight is that the undisciplined mind is a very unreliable instru- ment for empirically exploring reality. Natural scientists try to cir- cumvent the unreliability of human perceptions with the development and use of external devices that augment and fre- quently supplant the human senses. But these instruments, as

effective as they are for detecting external physical phenomena, are unable to probe directly into the processes of the mind. These are immediately accessible to the mind alone. But the mind which is given this formidable task is prone to states of excitation,* in which the attention is carried away by distractions, and laxity,* in which clarity is lost. And in the meantime, the mind is frequently subject to the disrupting influences of such afflictions as sensual desire, malice, drowsiness and lethargy, excitation and remorse, and doubt. A mind that is dominated by such hindrances is hardly fit for the cultivation of contemplative insight. For this reason, Tsongkhapa, in accord with Indo-Tibetan Buddhism as a whole, encourages aspiring contemplatives first to train their minds in the cultivation of sustained voluntary attention.

The Cultivation of Quiescence

Tsongkhapa maintains that in order for the contemplative culti-vation of insight to eliminate forever the mental afflictions that lie at the root of suffering, such insight must be conjoined with a high degree of sustained voluntary attention. The most general term used for such attention is *samādhi*. Within the context of Buddhist soteriology, this term is used for a wide variety of con-templative states having the common characteristics of single-pointed attention and mental balance. In terms of the fifty-one mental processes* described in Indo-Tibetan Buddhist psychology, *samādhi*, or concentration, is included among the five object-ascertaining mental processes.[23] Here it is defined as a mental fac-tor having the unique function of focusing on its object continually, single-pointedly, and in the same mode.[24] As such, it serves as the basis for increasing intelligence,*[25] and it enables

[23] For a lucid account of all these 51 mental processes see Geshe Rabten, *The Mind and Its Functions*, trans. Stephen Batchelor (Mont Pèlerin: Tharpa Choeling, 1979), pp. 51–90.

[24] Cf. Blo bzang rgya mtsho, *Rigs lam che ba blo rigs kyi rnam bzhag nye mkho kun btus* (Dharamsala, 1974), p. 134.

[25] Intelligence is also included among the five object-ascertaining mental

one to gain mastery over all mundane and supramundane phe-
nomena. In this sense, everyone already possesses varying degrees
of concentration, but by and large this mental factor is undevel-
oped, and its potentials for enhancing intelligence and so on
remain undiscovered. William James comments that geniuses
commonly have extraordinary capacities for sustained voluntary
attention, but he adds, *"it is their genius making them attentive, not
their attention making geniuses of them."*[26] Buddhist psychology, in
contrast, suggests that concentration may indeed be a factor in
the emergence of extraordinary intelligence. This hypothesis is
one that can be tested empirically.

A second term that Tsongkhapa frequently uses with reference
to sustained voluntary attention is *meditative equipoise*. This term
is often used interchangeably with *samādhi*. However, the con-
templative access to the *plane of meditative equipoise** is equiva-
lent to achieving the state of *quiescence;** and this latter term
refers to a wide range of highly developed states of concentration.
With the achievement of quiescence, the attention is drawn
inwards and is maintained continuously, single-pointedly upon its
object. Tsongkhapa emphasizes that genuine quiescence is neces-
sarily preceded by an experience of an extraordinary degree of
mental and physical pliancy,* which entails an unprecedented
sense of mental and physical fitness and buoyancy.

In the state of meditative equipoise, only the aspects of aware-
ness, clarity, and joy of the mind appear, and all one's other sense
faculties remain dormant. Thus, while one's consciousness seems
as if it has become indivisible with space, one lacks any sensation
of having a body; and when rising from that state, it seems as if
one's body is suddenly coming into being. When genuine quies-
cence is achieved, one's attention can effortlessly be maintained

processes, where it is defined as a mental process having the unique function of
differentiating specific attributes or faults and merits of objects that are main-
tained with mindfulness. (Rabten, *Mind and Its Functions*, p. 63; Blo bzang rgya
mtsho, *Rigs lam che ba blo rigs kyi rnam bzhag nye mkho kun btus*, p. 135.) Defined
in this way, *prajñā*, normally translated as *wisdom*, is more accurately rendered in
English as *intelligence*.

[26] William James, *The Principles of Psychology* (New York: Dover, 1950) I:423.

for hours, even days, on end, with no interference by either laxity*
or excitation.*

Modern scientific research indicates that when people are arti-
ficially brought into a state of sensory deprivation, at first their
concentration seems to improve due to the restful atmosphere
and the lack of distractions. But after a day or two, concentration
and coherent thought become difficult to maintain, resulting in
random day-dreaming, repetitive thinking, or panic. The impli-
cation drawn from this research is that for our mental health we
always need to maintain a certain level of sensory life.[27] A
Buddhist interpretation of these findings might be that the imbal-
ances characterizing the mind that has not been trained in medi-
tative equipoise are normally shielded by the attentional
scattering and excitation that accompany a normal sensory life;
but once the mind is deprived of such sensory stimuli, its innate
dysfunctions* manifest. By means of training in quiescence, the
disequilibrium of the mind is said to be gradually dispelled, and
the attention is gradually withdrawn from the senses. The
reported end result of this discipline is that the mind may be with-
drawn from sensory stimulation for sustained periods—even days
on end—without the problems associated with the artificial
inducement of sensory deprivation.

While Tsongkhapa maintains that the Madhyamaka cultiva-
tion of insight is unique to Buddhism, methods for achieving qui-
escence were discovered in India long before the appearance of
Buddha Śākyamuni. Indeed, this was the first kind of contempla-
tive training that Prince Siddhārtha sought in his quest for
enlightenment. Since then, the practice of *samādhi* has been uti-
lized in theistic and non-theistic, monist and dualist forms of
Hinduism, in Buddhist schools advocating a diversity of views
including realism, idealism, and relativism, and in Taoism.
Historically, then, the cultivation of sustained voluntary attention
does not require allegiance to any one religious creed or philo-
sophical system; and the utilization of concentration in investi-

[27] Jack Vernon, *Inside the Black Room: Studies of Sensory Deprivation* (Pelican,
1966), pp. 85–86.

gating the nature of reality does not, in itself, necessarily result in adherence to any one ideology.

The importance of sustained voluntary attention has not been overlooked in the Christian contemplative tradition. In the writings of Augustine, the culminating state of contemplation is necessarily preceded by a training in "recollection" and "introversion." The object of recollection is to shut off all external things from the mind and to empty it of all distracting thoughts. This is the prelude to the mind entering into itself by means of introversion, which is a concentration of the mind on its own highest, or deepest, part. The process of introversion is described as the final step before the soul finds God.[28] Pope Gregory concurs that "Only a tranquil mind is able to hold itself aloft in the light of contemplation."[29] However, he maintains that such quiet of the mind can be sustained for only about half an hour. Similarly Aquinas asserts that "in contemplation man is capable of remaining longer without fatigue or distraction than in any other activity";[30] but he also maintains that man is not capable of an act continuing without interruption.[31] The Jesuit psychologist and scholar of mysticism Joseph Maréchal comments in this regard, "There can be no contemplation without sustained attention, at least for a few moments; now attention acts on the psychological elements after the fashion of the poles of a magnet, which gather up iron filings into magnetic shapes."[32]

Among Western psychologists, William James especially emphasizes the value of sustained voluntary attention. Under favorable conditions it is possible, he says, to maintain such attention upon a *developing* topic by repeatedly drawing the attention

[28] Dom Cuthbert Butler, *Western Mysticism: The Teaching of Augustine, Gregory and Bernard on Contemplation and the Contemplative Life*, p. 29.

[29] *Mor.* v. 55. Cited in *Western Mysticism*, p. 182.

[30] *Commentary on Aristotle's Nicomachean Ethics* 10, 10; no. 2088 ff. Cited in Josef Pieper, *Happiness and Contemplation*, trans. Richard and Clara Winston (Chicago: Henry Regnery, 1966), p. 101.

[31] *Summa Theologica* I, II, 3, 2 ad 4. Cited in *Happiness and Contemplation*, p. 101.

[32] Joseph Maréchal, S. J., *Studies in the Psychology of the Mystics*, trans. Algar Thorold (London: Burns Oates and Washbourne, 1927), p. 168.

back when one notes that it has been diverted to something else. He emphasizes, however, that such a topic is actually a succession of mutually related objects that form one identical object to which the attention is directed. To make this point perfectly clear he adds, *"There is no such thing as voluntary attention sustained for more than a few seconds at a time.* What is called sustained voluntary attention is a repetition of successive efforts which bring back the topic to the mind."[33] This remains the view of modern experimental psychology. Moreover, apart from pathological states, James rejects the possibility of attending continuously to an object that does not change.[34] Tsongkhapa acknowledges the possibility of dementia as a result of maintaining the attention on an unchanging object. This may occur, he says, by stabilizing the attention upon a fixed object, without distraction, then allowing the potency of attentional clarity to wane. The result of this malpractice is that one enters a kind of trance in which one's intelligence not only remains dormant but actually degenerates. In this way a state of mental stupor may be mistaken for meditation. The way to avert this danger is by taking on the difficult challenge of enhancing one's attentional clarity without sacrificing attentional stability.

The disparity of the claims concerning the possibility and value of sustained voluntary attention by Asian contemplatives, Western Christian contemplatives, and Western psychologists raises a number of fascinating questions for empirical research. Have Asian contemplatives developed more effective techniques for sustaining the attention than are found in Western Christian contemplative traditions, or have the former exaggerated their own attentional prowess? Are contemplatives who practice sustaining their attention upon an unchanging object enhancing their mental health, or are they actually courting idiocy? Finally, does the psychological evidence that attention cannot be sustained for more than a few seconds reflect a fundamental limitation of the human mind, or is this reflective of a high degree of

[33] James, *Principles of Psychology*, p. 420.
[34] Ibid., p. 423.

mental agitation that may be especially characteristic of modern Western society?

William James asserts that a steady faculty of attention is unquestionably a great boon. Indeed, he argues that "the faculty of voluntarily bring back a wandering attention, over and over again, is the very root of judgment, character, and will . . . An education which should improve this faculty would be the education *par excellence*. But it is easier to define this ideal than to give practical directions for bringing it about."[35] While he lauds the ideal of an education that would enhance the faculty of attention, he assumes that no one who is without it naturally can by any amount of drill or discipline attain it in a very high degree. Its amount, he speculates, is probably a fixed characteristic of the individual.[36]

Tsongkhapa acknowledges that sustained voluntary attention comes more easily to some types of individuals than to others, but he rejects the hypothesis that this faculty is immutably fixed in anyone. While James classifies people into those who are naturally scatter-brained and others who are easily able to follow a train of connected thoughts, Tsongkhapa identifies five psychological types for whom specific techniques for developing the attention are prescribed. Those are individuals with dominant tendencies towards (1) attachment, (2) hatred, (3) delusion, (4) pride, and (5) ideation.* Although it is easier for some of these types to achieve quiescence than it is for others, methods are presented to counteract these specific imbalances and promote attentional stability.

The type of sustained voluntary attention taught by Tsongkhapa may be applied both to discursive meditation, entailing attention upon a developing object, and to stabilizing meditation upon an unchanging object. In his presentations of the stages of the path to enlightenment, Tsongkhapa places an especially strong emphasis on the importance of discursive meditation, and this is fully effective only when one's attention is stable and clear—the two qualities cultivated in the training in quiescence.

[35] Ibid., p. 424.

[36] William James, *Talks to Teachers: On Psychology; and to Students on Some of Life's Ideals*, Intro. by Paul Woodring (New York: Norton, 1899/1958), p. 84.

Among the many Buddhist techniques for cultivating sustained attention upon a stable object, Tsongkhapa expounds on the practice of imagining a visual object, specifically a mental image of the Buddha. At the outset of this training it is difficult even to bring such an image to mind, and even when one succeeds, there is virtually no continuity of the attention. The undisciplined mind alternates between the states of being overwhelmed by habitual agitation and dispersive thoughts and the state of lethargy* when one is overcome by exhaustion. But by returning to this discipline for short session many times a day, compulsive ideation gradually subsides; and a few seconds of attentional continuity upon one's chosen object is accomplished.

The mental factor that allows for such continuity is mindfulness,* which is included together with concentration and intelligence in the class of object-ascertaining mental processes. Mindfulness has the function of again and again bringing to mind, without forgetfulness, an object with which one is already familiar. As it prevents the attention from straying from one's chosen object, it acts as the basis for *samādhi*.[37] When the power of mindfulness has fully emerged, the attention no longer strays from its object. It is especially at this time that there is a danger of falling into a complacent, pseudo-meditative trance, which may result in dementia. One may remain in this state for many hours without distraction, but because too little effort is applied to enhancing the potency of attentional clarity, the mind slips into laxity. The mental factor that has the function of recognizing both attentional excitation and laxity is introspection.* While the mental factor of mindfulness focuses on the meditation object, introspection attends to the quality of the attention itself. Thus, the latter is often likened to a sentry who stands guard against the hindrances of excitation and laxity.

Even the presence of mindfulness and introspection are no guarantee against complacency in meditation, for one may recognize the presence of laxity or excitation and still fail to take steps

[37] Geshe Rabten, *The Mind and Its Functions*, p. 62. Cf. Blo bzang rgya mtsho, *Rigs lam che ba blo rigs kyi rnam bzhag nye mkho kun btus* (Dharamsala, 1974), p. 133–34.

to counteract them. This failure to intervene inhibits further progress in the development of sustained voluntary attention. The remedy, Tsongkhapa declares, is the cultivation of the will,* which is here closely associated with intervention* and striving. The will is the mental factor that engages the mind with various types of objects and activities. In this case, when either laxity or excitation occurs, the mind is stimulated by the will to intervene in order to eliminate them. Tsongkhapa likens the relationship between the mind and the will to iron that moves under the influence of a magnet. The will to eliminate laxity and excitation is aroused by recognizing the disadvantages in succumbing to those hindrances and the advantages in overcoming them.

As a result of continuously, diligently counteracting even the most subtle laxity and excitation as soon as they occur, effortless, natural *samādhi* arises due to the power of habituation.* When this phase of the training is reached, only an initial impulse of will and effort is needed at the beginning of each meditation session; thereafter, uninterrupted *samādhi* occurs effortlessly. Moreover, the engagement of the will, of striving, and intervention at this point is actually a hindrance. It is time to let the natural balance of the mind maintain itself without interference. Now due to the extraordinarily high degree of stability and clarity of the attention, the imagined visual object acquires before the mind's eye almost the brilliancy of a visually perceived object, as William James predicts.[38]

The final transition prior to the actual achievement of quiescence entails a radical shift in one's nervous system, which Tsongkhapa describes in terms of a Buddhist theory of vital energies.* According to the Buddhist view, to the extent that people's minds are subject to laxity and excitation, they are of unsound body and mind. Even when they want to strive to eliminate mental afflictions, the unfitness of their bodies and minds makes them proceed arduously and despondently, as if this were an unpleasant act. Indian and Tibetan Buddhist contemplatives make the remarkable claim that the training in quiescence brings forth both

[38] James, *Principles of Psychology*, p. 425.

mental pliancy, that allows one to direct one's attention without resistance, and physical pliancy, which lends buoyancy and lightness to one's physical actions. Such mental and physical fitness, Tsongkhapa claims, arise gradually during this training, and just prior to the achievement of quiescence there is a breakthrough in which they suddenly arise to an unprecedented degree.

The key factor of both mental and physical pliancy is that they allow one to engage in virtuous pursuits with a sense of lightness, buoyancy, good cheer, and potency. Without this, genuine quiescence has not been achieved. And since quiescence is an indispensable support for the cultivation of contemplative insight, it appears that an exceptional degree of mental and physical fitness are regarded as necessary prerequisites to the unmediated realization of *nirvāṇa*. The achievement of quiescence also entails the subsiding of the five hindrances of (1) sensual desire,* (2) malice,* (3) drowsiness* and lethargy,* (4) excitation* and remorse,* and (5) doubt.*[39] These, too, are considered to be debilitating afflictions, and insofar as the mind is dominated by them, it is unfit for the cultivation of insight.

While Western psychology generally regards "normal people" as mentally healthy and fit, Indo-Tibetan Buddhism views everyone who is afflicted by the above hindrances as mentally unsound.

[39] Jñānagarbha explains the hindrance of sensual desire is for the five qualities of the desire realm; malice entails hatred toward sentient beings; lethargy is an unfitness of the body and mind, and drowsiness is edging towards sleep; excitation as non-pacification of the sense-faculties; and remorse entails fixation on non-virtuous deeds of omission and of commission; and doubt concerns the Buddha, Dharma, and Saṅgha, the four noble truths, and the relations between actions and their results. (*Ārya-saṃdhinirmocana-sūtre-āryamaitreyakevala-parivarta-bhāṣya*, trans. John Powers, p. 111). For a discussion of the five qualities of the desire realm, see Leah Zahler, *Meditative States in Tibetan Buddhism* (London: Wisdom, 1983), pp. 93–96.

For a detailed Theravāda account of these obstructions and the ways of overcoming them see Gunaratana, Henepola. *The Path of Serenity and Insight: An Explanation of the Buddhist Jhānas*. Columbia, Missouri: South Asia Books, 1985, pp. 28–48. The Sanskrit term *kautṛtya*, (Tib.: *'gyod pa;* Pāli: *kukkucca*), rendered here as "remorse," has the multiple connotations of remorse, worry, mental disturbance, and difficulties of conscience. Thus, English translations from the Pāli literature often list this hindrance as "worry" or "anxiety," while the Tibetan term clearly emphasizes the aspect of remorse.

It is because of this poor mental health that normal people experience so much suffering in their day-to-day lives. With such a degree of mental dysfunction,* it is impossible to achieve the insight that can cut through the root of all afflictions; so for this reason quiescence is cultivated before insight. In short, any introspective study of the mind and its functions that is not based on the prior refinement of attention is doomed to failure—not because of its utilization of introspection, but because the mind that is doing the introspecting is incompetent for this kind of inquiry.

As mentioned earlier, the Indo-Tibetan Buddhist tradition asserts that, technically speaking, the wisdom that uniquely arises from meditation* is possible only when the mind is established in a state of meditative equipoise. Tsongkhapa emphasizes this point by quoting the *Dharmasaṃgītisūtra* and the Indian Buddhist contemplative Kamalaśīla to the effect that ultimate reality can be known only when the mind is established in equipoise. This is the chief purpose of cultivating quiescence. In order to fulfill one's own and others needs, Tsongkhapa also encourages the development of extrasensory perception* and paranormal abilities,* which, he says, can be achieved on the basis of quiescence. It is with regard to the above two points that *samādhi* is said to enable one to gain mastery over all mundane and supramundane phenomena.

In this regard, the role of meditative equipoise in the discipline of contemplation may be likened to the role of mathematics in the physical sciences. Without knowledge of mathematics and the ability to apply this knowledge in the study of the laws of nature, modern physical science would have been impossible. Mathematics is indispensable not only for scientific understanding of the physical world, but also for developing the necessary technology to further our knowledge and control of nature. Similarly, meditative equipoise is said to be indispensable for gaining contemplative insight into the nature of mundane phenomena and ultimate reality; and it also allows for the development of paranormal abilities that can be used in controlling nature.

The achievement of quiescence also marks the contemplative's

initial access to a higher realm, or dimension, of existence, included in the plane of meditative equipoise. By attaining this state, the contemplative's mind is elevated beyond the desire realm,* which is so called because this realm of experience is dominated by sensual desire; and the mind is brought to the form realm,* which is a more rarefied dimension of existence beyond the human physical senses.[40] Upon gaining access to the form realm, one's consciousness continues to be structured by very subtle concepts; but Buddhist contemplatives assert that these are not uniquely human concepts. Rather, just as ordinary humans share much common experience with animals who also live in the desire realm, so do advanced contemplatives share a domain of experience common to higher beings known as *devas* who inhabit the form realm. However, as useful as such rarefied experience is said to be, the entire Buddhist tradition insists that it is still within the realm of *saṃsāra;* and though gross mental afflictions do not manifest in that state, they are not eliminated for good.

The contemplative access to the form realm and the even more abstract formless realm* may also be likened to the mathematical access to dimensions of reality that lie beyond the physical senses. Moreover, Theravāda Buddhist contemplatives discuss a variety of "counterpart signs"[41] that are perceived once one gains access to the form realm. These signs appear to include rarefied, archetypal representations of phenomena experienced in the desire realm, including the elements of solidity, fluidity, heat, motility, the four colors of blue, yellow, red, and white, and light and space. In addition, they claim that physical reality may be altered by the contemplative manipulation of these signs.[42] These assertions suggest an even closer parallel between the roles of meditative equipoise and mathematics.

[40] Tsongkhapa discusses these, and even more abstract, states of *samādhi* in his *Treatise on Meditative Stabilization and the Formless* [bSam gtan gzugs med kyi bstan bcos (Collected Works, Vol. Tsha)]. Cf. Zahler, *Meditative States in Tibetan Buddhism.*

[41] Skt. pratibhāga-nimitta, Pāli: paṭibhāga-nimitta

[42] Buddhaghosa's *The Path of Purification,* [trans. by Bhikkhu Ñāṇamoli, (Kandy: Buddhist Publication Society, 1979), Part II.

The initial achievement of quiescence is simultaneous with reaching the first proximate[43] meditative stabilization,* and in this state the five hindrances mentioned earlier are temporarily inhibited. If one wishes to proceed to more subtle states of quiescence, specific techniques may be followed that result in the achievement of the basic[44] first stabilization. Tsongkhapa, following the lead of the Indian Buddhist *paṇḍit* Mātṛceṭa,[45] maintains that by cultivating insight on the basis of the first proximate stabilization, without reaching even the first basic stabilization, it is possible to achieve *nirvāṇa*. In accordance with the *Śrāvakabhūmi*, a classic treatise by the Mahāyāna Buddhist patriarch Asaṅga, Tsongkhapa says that as soon as quiescence is achieved, the entire continuum and flow of one's attention should be single-pointedly focused inwards in the quiescence of the mind. One should then sequentially divest one's consciousness of signs and ideation, and allow it to remain in a state of tranquillity.[46] No longer does one mentally engage with the previously visualized object; rather when that object is dissolved and removed, the mind is placed in the absence of appearances. At this point, with the entirety of one's awareness withdrawn from one's physical senses, and with consciousness disengaged from all discursive thought and imagery, there arises a non-dual awareness of consciousness itself. In that way, the reality of the mind is directly perceived, and yet it is ungraspable and undemonstrable.

While many Tibetan contemplatives have apparently mistaken this awareness for realization of *nirvāṇa* or the Dharmakāya, Tsongkhapa regards it as a mundane experience of the phenomenal nature of the mind. In this state the innate tendency of reification may have been suspended, for there is no conceptual grasping onto any appearances. However, the mere temporary suspension of discursive thought and reification is by no means

[43] nyer bsdogs, sāmantaka; Pāli: upacāra-samādhi

[44] dngos gzhi, maula; Pāli: appaṇā-samādhi

[45] More commonly known as Aśvaghoṣa.

[46] This approach, which is common to the Tibetan Buddhist tradition, explains, I suspect, the lack of emphasis on counterpart signs in Tibetan contemplative literature.

equivalent to insight into the emptiness of inherent existence of the mind or any other phenomenon. Thus, the subsiding of mental afflictions while in the state of quiescence alone provides only a temporary respite, but it brings no radical, irreversible transformation in the mind. For this, the cultivation of insight is indispensable. Thus, while the achievement of meditative equipoise is necessary for the attainment of *nirvāṇa*, it is not sufficient.[47]

While the cultivation of quiescence is designed to enhance one's mental fitness, if this training is followed with insufficient preparation, it may instead aggravate one's mental afflictions and lead to further mental imbalances. For this reason, the aspiring Buddhist contemplative must first attend closely to the prerequisites for quiescence.

The Basis of Quiescence

In Tibetan Buddhist practice, a person seeking to achieve quiescence normally focuses on this training, largely to the exclusion of other activities, until it is brought to its culmination. For this type of single-minded endeavor, Tsongkhapa lists six immediate prerequisites, namely, living in a supportive environment, with few desires and contentment, leading an unbusy lifestyle, maintaining pure ethical discipline, and avoiding obsessive ideation. For the duration of one's single-minded quiescence practice, it is important to live in a place that is relatively safe, quiet, and in which one's basic necessities can easily be met. Obviously, in a dangerous environment, failure to shift one's attentional engagement may be detrimental to one's health. On the other hand, constant shifting or fragmentation of one's attentional engagement, triggered by sensory or conceptual stimuli, makes sustained, purposeful activity impossible and results only in behavioral chaos.[48] The training in quiescence is designed to overcome

[47] Tsongkhapa discusses this point in detail in his *Explanation of the Difficult Points of Both Quiescence and Insight According to the Intention of the Jina* [Zhi lhag gnyis kyi dka' gnad rgyal ba'i dgongs pa bzhin bshad pa (Collected Works, Vol. Pha)].

[48] Cf. Michael I. Posner, *Foundations of Cognitive Science* (Cambridge, Mass.: MIT Press, 1989), pp. 652–53.

directly this latter extreme; and when it is complete, one should have sufficient control over one's attention to shift it as needed in any kind of environment.

While the external, environmental prerequisite is relatively straightforward to arrange, the internal prerequisites may be far more challenging. The endeavor of spending many hours each day, for weeks or months on end, focusing on a single object provides fertile ground for a myriad of desires, intense boredom, restlessness, and a profusion of obsessive ideation. Thus, if one is to avoid these perils to one's mental health, it is first necessary to devote oneself for a prolonged period to other practices. The preparations that Tsongkhapa suggests include such devotional practices as worship, prayer, and confession, as well as discursive meditations designed to alter one's world view and values. This phase of Indo-Tibetan Buddhist contemplative training appears to be roughly analogous to the initial phase of the Augustinian contemplative training called "purgation."[49]

The first set of discursive meditations taught by Tsongkhapa is aimed at bringing about a thorough disenchantment with priorities and activities that are of benefit for this present life alone. By attending closely and for a prolonged period to the ever-changing nature of one's body, one's companions, living situation, and environment, and by focusing on the brevity of human life in general and the utter uncertainty of the time of one's own death, one counteracts the innate tendency to ignore one's own mortality and to mistake the conditions of one's life as being stable. In the course of pursuing fleeting sensory and intellectual pleasures, seeking to acquire material possessions and the praise and acknowledgment of others, one is bound to meet with obstacles, adversity, and frustration. Thus, the initial attachment that impelled one into those pursuits gives way to hostility and hatred towards anything that interferes with the fulfillment of these mundane desires. Even when such desires are gratified, the satisfaction that one derives from them is fleeting, and one relentlessly pursues other objects in the hope that they will prove more satisfactory. Looking back on one's prior joys and sorrows, victories and defeats, they linger on

[49] Cf. Butler, *Western Mysticism*, pp. 68–69.

as mere memories, with no lasting benefit or significance. Meditations along these lines are aimed at shifting one's priorities away from the mundane concerns of this life alone, to one's long-term welfare beyond this life.

The second phase of this training in discursive meditation is designed to cast light on the unsatisfactory nature of any state of existence within *saṃsāra*. Regardless of the nature of one's existence, as long as it is conditioned by one's mental afflictions, one remains vulnerable to all manner of pain and grief. By focusing on the pervasiveness of suffering throughout the whole of *saṃsāra*, one's disillusionment becomes complete, leaving only one priority: to attain *nirvāṇa*, in which there is total, irreversible freedom from all suffering.

This shift of priorities occurs directly as a result of one's sustained meditations on the unsatisfactory, even terrifying, nature of *saṃsāra* and the benefits of attaining *nirvāṇa*. In this regard, Tsongkhapa would surely endorse William James's claim that "each of us literally chooses, by his ways of attending to things, what sort of a universe he shall appear to himself to inhabit."[50] With their emphasis on the vanity of mundane things, a sense of sin,* and a fear of *saṃsāra*, the above meditations seem to be aimed at inducing the state of the "sick soul" eloquently discussed in James's *The Varieties of Religious Experience*.[51] Far from condemning the sick soul, James claims that this mind-state ranges over a wider scale of experience than that of those who avert their attention from evil and live simply in the light of good. The "healthy-minded" attitude of the latter, he says, is splendid as long as it will work; but it breaks down impotently as soon as melancholy arises. Moreover, the evil facts that the "healthy-minded" individual refuses to acknowledge are a genuine part of reality, which, he suggests, "may after all be the best key to life's significance, and possibly the only openers of our eyes to the deepest levels of truth."[52]

[50] *Principles of Psychology*, p. 424.

[51] James, *Varieties of Religious Experience*, Lectures VI and VII.

[52] Ibid., p. 163.

In these discursive meditations it is imperative that one's growing disenchantment with mundane existence is complemented with growing confidence in the real possibility of true freedom and lasting joy that transcends the vicissitudes of conditioned existence. Without this faith and the yearning for such liberation, the above meditations may easily result in profound depression, in which everything seems hollow, unreal, and futile.[53] Thus, instead of polarizing one's desires towards the single-pointed pursuit of *nirvāṇa*, one is reduced to a debilitating kind of spiritual sloth, or *acedia*. In short, the principle of the superiority of the changeless to all that is changeable, which Augustine regarded as the natural basis of religion and the determining factor in the quest for happiness,[54] is also a central theme of Buddhist soteriology.

With the attitude of emergence,* entailing a thorough disillusionment with the whole of *saṃsāra* and a consuming yearning for *nirvāṇa*, one's cultivation of quiescence may lead to the attainment of *nirvāṇa*. But because it is still tainted with self-centeredness, Tsongkhapa insists, this motivation will not lead to the attainment of perfect enlightenment. For this, one must extend one's awareness of suffering with regard to all sentient beings in a spirit of deep kinship, recognizing that each one seeks happiness and wishes to be free of suffering essentially like oneself.

An analogy often used in Indo-Tibetan Buddhism is to view all sentient beings, including oneself, as being like limbs of a single body.[55] The sense of the profound interconnectedness of all beings is the basis of the Buddhist cultivation of love* and compassion.* This seems analogous to the Christian idea of Philia, which theologian John Burnaby describes as a bond that links two or more centers of consciousness into a higher unity, which constitutes in itself the highest of intrinsic values.[56] One significant distinction between the Christian and Buddhist concepts of love appears to

[53] Cf. *Principles of Psychology*, Vol. II, pp. 285, 298.

[54] John Burnaby, *Amor Dei: A Study of the Religion of St. Augustine*, p. 42.

[55] Cf. *Śāntideva's Bodhicharyāvatāra*, trans. Parmananda Sharma (New Delhi: Aditya Prakashan, 1990), VIII: 91, 111–15.

[56] Burnaby, *Amor Dei*, pp. 18–20.

be that the former has only humans as its object, whereas the latter extends to all sentient beings.

The first task in the Buddhist cultivation of compassion is to develop a sense of equality between oneself and others in terms of the nature of suffering and the common desire to be free of it. The extension of the field of one's concern beyond oneself, to include all other beings, in fact brings a greater burden of suffering upon one's own shoulders. But the Buddhist response is that since this slight suffering (in comparison with the suffering of the whole world) may serve to remove the suffering of many others, it is to be accepted.[57] With this basis of equality, the next task is to "exchange oneself for others," meaning to cherish the well-being of others even more so than one's own. The meditative practice of "sending and taking," embraced by Tsongkhapa and the whole of the Tibetan Buddhist tradition, is designed to facilitate this shift of priorities. In this practice, one imagines taking upon oneself the mental afflictions, sins, and suffering of others, then sending out to others one's own joys and virtues.[58]

On the basis of cultivating great love and compassion for all sentient beings, one resolves to free each one from all suffering and bring each one to the joy of enlightenment. But as long as one is still subject to afflictive and cognitive obscurations, one's ability

[57] Cf. Śāntideva's *A Guide to the Bodhisattva Way of Life*, trans. Vesna A. Wallace and B. Alan Wallace (Ithaca: Snow Lion, 1997), VIII:104–106. In this classic treatise, on which Tsongkhapa and the whole of Tibetan Buddhism rely heavily, the author makes reference to the account of the Bodhisattva Supuśpa Candra (narrated in the *Samādhirājasūtra*) who emerged from the wilderness to give spiritual teachings in the realm of King Śūradatta, who was antagonistic to religion. The Bodhisattva did so, knowing that by teaching he would be placing himself in grave peril. At the king's order, the Bodhisattva's hands and feet were cut off and his eyes were gouged out. As the Bodhisattva departed, great miracles happened one after the other, seeing which, the king concluded that Supuśpa Candra must be a Bodhisattva, and he deeply repented his sins.

[58] Ibid., VIII: 131, 135–36. This practice was widely promulgated in Tibet due, in part, to the popularity of the Seven-Point Mind Training *(bLo sbyong don bdun ma)*, which was brought to Tibet by the Indian *paṇḍit* Atīśa. Cf. B. Alan Wallace, *A Passage from Solitude*, ed. Zara Houshmand (Ithaca: Snow Lion, 1992), pp. 47–58. See also Natalie Maxwell's dissertation *Compassion: The True Cause of Bodhisattvas* (University of Wisconsin, 1975)

[59] For Tsongkhapa the essential points of the path to enlightenment are the atti-

to fulfill this resolve is extremely limited. With this recognition, and with the faith of adoration for the Buddha, and the faith of yearning to achieve the enlightenment of the Buddha oneself, one aspires for perfect enlightenment for the sake of all beings. This aspiration is known as the spirit of awakening,* and it is the essence of being a Bodhisattva.[59] The Buddhist spirit of enlightenment invites comparison with the Christian love of God (Amor Dei), for, as John Burnaby points out, there is an intimate connection between this love, which is the desire for union with God, and the love of men, which is the sense of unity with all those who are capable of sharing the love of God.[60]

Upon bringing forth the spirit of enlightenment, a Bodhisattva is bound to carry through with this lofty resolve by embarking on the training to become a Buddha. The structure of this training is embodied in the six perfections,* namely generosity, ethical discipline, patience, enthusiasm, meditative stabilization, and wisdom. Thus, the first four of these trainings serve as preparations for the cultivation of quiescence, just as quiescence provides the basis for the training in wisdom. Similarly, the broadest structure of the paths to *nirvāṇa* and enlightenment, common to Indo-Tibetan Buddhism as a whole, is the threefold training in ethical discipline, *samādhi*, and wisdom. Here again, the training in quiescence is based upon ethical discipline and serves as the necessary prerequisite for the contemplative cultivation of wisdom.

While many strive on this contemplative path to enlightenment, few actually achieve it in this lifetime. Indeed, from the time that one first becomes a Bodhisattva, it is said to take three "countless great eons"*[61] of cultivating the six perfections before

tude of emergence, the spirit of awakening, and the authentic view of reality. These are the central themes of his two expositions of the stages of the path. His most concise treatment of these themes in found in his *Primary Exposition of Three Principles of the Path* [*Lam gyi gtso bo rnam gsum gyi rtsa ba* (Collected Works, Vol. Kha, in *Miscellaneous Works (bKa' 'bum thor bu ba)* pp. 193b–194b] which is translated with a commentary in *The Principle Teachings of Buddhism*, Tsongkhapa, trans. Geshe Lobsang Tharchin with Michael Roach, (Howell, NJ: Mahayana Sutra and Tantra Press, 1988)

[60] Burnaby, *Amor Dei*, p. 104.

[61] This is a finite, but unimaginably long period, extending over many, many cycles of cosmic evolution.

becoming a Buddha. However, according to the Mahāyāna tradition, one does not necessarily have to spend that time struggling from lifetime to lifetime in *saṃsāra*. According to the *Sukhāvatīvyūhasūtra, Amitābhavyūhasūtra,* and the *Puṇḍarīkasūtra,* due to the power of prayer of the Buddha Amitābha, the "Buddha of Boundless Light," one may be reborn in the heaven of Sukhāvatī, "the Blissful," if one single-pointedly prays to Amitābha to be reborn there. This heaven is said to have been produced by the spiritual power of Buddha Amitābha, and is not within the domain of *saṃsāra.* Once born in this heaven one experiences no suffering of birth, aging, sickness, or death, and due to one's continued spiritual practice under the direct guidance of the Buddha Amitābha and hosts of Bodhisattvas, all one's previous sins are purified, and the two types of obscurations are gradually eliminated. Moreover, it is said that the duration of one eon in our world is the equivalent of one day in Sukhāvatī.

In his prayer to be reborn in Sukhāvatī, Tsongkhapa describes this heaven as a transcendent realm of existence in which to perfect one's spirit of enlightenment, as well as to develop all states of *samādhi* and to cultivate liberating insight into the nature of reality.[62] Thus, the spiritual practice begun in this life is brought to culmination in the next, as the attainment of perfect enlightenment. Upon achieving the three embodiments of enlightenment, the Dharmakāya, Saṃbhogakāya, and Nirmāṇakāya, so that one's consciousness is identical with the omniscient mind of all the Buddhas, one effortlessly emanates throughout the universe to lead all beings away from all kinds of suffering to enlightenment.

Unlike the Christian concept of heaven, Sukhāvatī is not presented as a haven of ultimate rest, but as a blessed domain in which to perfect one's spiritual development. And while Christian

[62] This prayer is translated in *Life and Teachings of Tsong Khapa,* ed. Prof. R. Thurman (Dharamsala: Library of Tibetan Works and Archives, 1982), pp. 207–212. Cf. *Opening the Door to the Supreme Realm: A Prayer to Take Birth in the Heaven of Sukhāvatī* [bDe ba can gyi zhing du skye ba 'dzin pa'i smon lam zing mchog sgo 'byed (Collected Works, Vol. Kha, in *Miscellaneous Works (bKa' 'bum thor bu ba),* pp. 85a–100a, with Tsongkhapa's comments on taking birth in Sukhāvatī)].

doctrine states that even in heaven no created intelligence can *fully* see God's Essence or ever know Him as he knows Himself,[63] in Sukhāvatī one's own mind finally becomes the Dharmakāya, the mind of the Buddha. The love of Buddha Amitābha, who, Tsongkhapa writes, "considers every living being as his child,"[64] may be likened to God's gift of Agape, as this is understood in Christianity. For, as John Burnaby comments, "The divine gift of Agape, once accepted, makes men the channels of its outward and onward flow; but the substance of the stream . . . is 'mono-physite'—really not a human love at all. It cannot return upon itself: we cannot have Agape for the source of Agape. Its only object is the created world of men."[65] In the Buddhist view, the love of Buddha Amitābha has all beings as its object, and when one becomes a Buddha, one experiences the full depth of this love for others.

While rebirth in Sukhāvatī removes one from the sufferings of *saṃsāra*, it also temporarily removes one from active service to other sentient beings. Some Bodhisattvas, Tsongkhapa writes, feel such intense compassion for the world that they long for extraordinary means of attaining enlightenment in this very lifetime in order to be of swift, effective service to others. Such individuals are suitable, he says, to engage in the esoteric practices of Buddhist Tantra, or Vajrayāna.[66] Within this context of spiritual practice, one seeks to sublimate rather than directly counteract and eliminate one's mental afflictions. Thus, hatred is sublimated into mirror-like primordial wisdom, pride into the primordial wisdom of equality, attachment into the primordial wisdom of discernment, jealousy into the primordial wisdom of accomplish-

[63] Cf. Pope Gregory, *Morals* xvii. 92, 93, cited in *Western Mysticism: The Teaching of Augustine, Gregory and Bernard on Contemplation and the Contemplative Life*, p. 91.

[64] *Life and Teachings of Tsong Khapa*, p. 207.

[65] Cf. Burnaby, *Amor Dei*, p. 20.

[66] While Tsongkhapa is perhaps best known for his writings on the Madhyamaka view and the stages of the path according to the exoteric Sūtrayāna, most of his writings are concerned with the theories and practices of the Vajrayāna. His most comprehensive work on this vast subject is his classic treatise *The Great Exposition of Secret Mantra* [rGyal ba khyab bdag rdo rje 'chang chen po'i lam gyi rim pa gsang ba kun gyi gnad rnam par phye ba (Collected Works, Vol. Ga)], the first chapters of

ment, and delusion into the primordial wisdom of the absolute nature of reality.[67] The ethical discipline for followers of the Vajrayāna is based upon, and yet is far more demanding than, that of Bodhisattvas following the Sūtrayāna;[68] but it also allows for a wide range of activities in the service of others. These include activities of pacification (of illness, mental afflictions, and so forth), expansion (of knowledge, material prosperity, and so forth), domination, and ferocity.

The Vajrayāna includes its own unique methods for developing quiescence, which is just as necessary on this esoteric path as it is in the exoteric Sūtrayāna. Thus, one may achieve quiescence according to the purely Sūtrayāna techniques described by Tsongkhapa in the following translation, then proceed on to the practice of Vajrayāna; or one may initially achieve quiescence by means of the methods unique to the Vajrayāna. Either way, quiescence is said to be the indispensable foundation for the cultivation of contemplative insight, both in the Sūtrayāna and Vajrayāna.

which have been translated in *Tantra in Tibet: The Great Exposition of Secret Mantra—Volume I*, Tsong-ka-pa, trans. and ed. Jeffrey Hopkins (London: Unwin Hyman, 1987) and *The Yoga of Tibet: The Great Exposition of Secret Mantra—Volumes II and III*, trans. and ed. Jeffrey Hopkins (London: Unwin Hyman, 1981). See also Jeffrey Hopkins, *Deity Yoga* (Ithaca: Snow Lion, 1987), and Jeffrey Hopkins, *The Tantric Distinction* (London: Wisdom, 1984). A brief introduction to this complex topic is presented in my *Tibetan Buddhism From the Ground Up* (Boston: Wisdom, 1993), Ch. 16.

[67] Thus, the "five poisons" are transmuted into the five types of primordial wisdom, namely (1) *me long lta bu'i ye shes, ādarśajñāna*, (2) *mnyam pa nyid kyi ye she, samatājñāna*, (3) *so sor rtog pa'i ye shes, pratyaveksaṇājñāna*, (4) *bya ba sgrub pa'i ye shes, kr.tyānuṣṭhānajñāna*, and (5) *chos kyi dbyings kyi ye shes, dharmadhātujings*.

[68] In the history of Tibetan Buddhism, Tsongkhapa is especially noted for his strong emphasis on the importance of ethical discipline. His major work on Vajrayana ethics is *A Pod Of Siddhis: An Explanation of the Ethics of Secret Mantra* [gSang sngags kyi tshul khrims kyi rnam bshad dngos grub kyi sne ma (Collected Works, Vol. Ka)]; and his principle work on Bodhisattva ethics is *The Highway to Enlightenment: An Explanation of the Ethics of the Bodhisattvas* [Byang chub kyi sems pa'i tshul khrim kyi rnam bshad byang chub gzhung lam (Collected Works, Vol. Ka)]. Cf. Asaṅga's Chapter on Ethics with the Commentary of Tsong-Kha-Pa, *The Basic Path to Awakening, The Complete Bodhisattva*, trans. Mark Tatz (Lewiston: Edwin Mellen Press, 1986) Studies in Asian Thought and Religion, Vol. 4.

Chapter 2

The Cultivation of Quiescence

BY TSONGKHAPA

A *Specific Discussion of the Training in the Final Two Perfections*[1]

The means of cultivating quiescence* and insight* are included respectively in the perfections* of meditative stabilization* and of wisdom.* Here there are six sections: (I) the benefits of cultivating quiescence and insight; (II) the subsumption of all *samādhis* under those two; (III) the nature of quiescence and insight; (IV) the reasons why it is necessary to cultivate both; (V) the way to determine their order; and (VI) the way to train in each one.

[1] Exerpted from Tsongkhapa's *Small Exposition of the Stages of the Path to Enlightenment* [*Byang chub lam gyi rim pa chung ba* (Collected Works, Vol. Pha)].

I.
The Benefits of Cultivating Quiescence and Insight

In the *Saṃdhinirmocanasūtra*[1] it is said that all mundane and supramundane excellences of the Mahāyāna and Hīnayāna are results of quiescence and insight.

QUALM: Are quiescence and insight not excellences in a mind-stream that has achieved the meditative state?* How then could all those excellences be the result of those two?

RESPONSE: Actual quiescence and insight, are indeed excellences in a mind-stream that has achieved the meditative state, so all Mahāyāna and Hīnayāna excellences are not results of those two. Nevertheless, all *samādhis* ranging from single-pointed attention[2] upon a virtuous object are included in the domain of quiescence, and all virtuous forms of wisdom that investigate ontological and phenomenological issues are included in the domain of insight.[3] So, with this in mind, it is said that all the

[1] Cf. Étienne Lamotte, *Saṃdhinirmocanasūtra* (Paris: Louvain, 1935), VIII:32.

[2] This entire presentation of quiescence concerns training the attention, while scores of other Buddhist meditative disciplines train other aspects of the mind. Since the Tibetan term *sems* is the word used most frequently in reference to the aspect of the mind that is being trained, I have often translated it as "attention" instead of the more common and general translation of "mind."

[3] When referring to the agents of specific mental activities, Tsongkhapa usually cites specific mental processes, such as wisdom, mindfulness, and introspection, rather than using a personal pronoun or making explicit reference to a human agent. This style, characteristic of the Tibetan Buddhist tradition as a whole, may reflect the introspective observations of Buddhist contemplatives engaged in examining mental phenomena; and it may also be an implicit expression of the Buddhist view of personal identitylessness.

[4] The three vehicles refer to the Hīnayāna, Pāramitāyāna, and Vajrayāna, the latter two, according to Tsongkhapa, comprising the Mahāyāna.

106

excellences of the three vehicles[4] are results of quiescence and insight. Thus, there is no contradiction.

The *Saṃdhinirmocanasūtra* also states, "If an individual cultivates insight and quiescence, that person is freed from the bondage of dysfunctions* and signs."*[5] Here is the meaning: a *dysfunction*[6] is a latent propensity,* located in the mind-stream,* that has the ability to generate increasingly mistaken subjective states of awareness; and a *sign* is that which reinforces the latent propensities that give rise to ongoing obsession with mistaken objects.[7] The *Prajñāpāramitopadeśa* says that the former are eliminated by insight and the latter are eliminated by quiescence. Those are benefits of states given the appellations of *quiescence* and *insight*, but the meaning is similar even if those appellations are not given. Moreover, it should be understood that the benefits attributed to meditative stabilization and wisdom are also benefits of these two.

> COMMENTARY: The terms "sign" and "dysfunction" appear
> frequently in this text, and both are deeply embedded in
> Buddhist philosophy and psychology. The sign of an entity is
> that entity as it is conceptually grasped and thereby placed
> within a specific conceptual framework. Thus, "sign"

[5] Cf. Lamotte, *Saṃdhinirmocanasūtra* VIII:32. Derge, p. 69.2. Although this and numerous other quotations cited in this text were written in Sanskrit and Tibetan in metered verse to facilitate memorization, I have rendered them in prose to facilitate ease of reading in English. Usually when such verses are translated in verse-form into English, no meter is retained; so the original purpose of their versification is lost entirely.

[6] Jñānagarbha points out there are two kinds of dysfunctions due to: (1) afflictions of attachment and so on, and (2) afflictions of wrong views and so on. Quiescence counteracts the former, while insight eliminates the latter. *Ārya-saṃdhinirmocana-sūtre-āryamaitreyakevala-parivarta-bhāṣya* [John Powers, *Two Commentaries on the* Saṃdhinirmocana-sūtra *by Asaṅga and Jñānagarbha* (Lewiston: The Edwin Mellen Press, 1992) in *Studies in Asian Thought and Religion*, Vol. 13, p. 86].

[7] "Mistaken objects" refer to objects that are in reality impermanent, unsatisfactory, impure, and identityless mistakenly viewed as permanent, pleasurable, pure, and as bearing an intrinsic identity. A mistaken subjective awareness is one that falsely apprehends phenomena in any of the above four ways. *Ārya-saṃdhinirmocana-sūtre-āryamaitreyakevala-parivarta-bhāṣya*, trans. John Powers, pp. 95–96.

corresponds roughly to the modern philosophical notion of
"conceptual construct." Such conceptual identification often,
but not invariably, entails a reification of the entity, such that
it is apprehended as existing independently of the conceptual
designation of it.

The "bondage of signs" refers to mental afflictions,* such
as attachment,* that arise due to grasping onto the signs of
objects. The implication is that mental afflictions arise in
relation to an object only when one conceptually locks onto
its sign. It is the function of quiescence to counteract this
bondage of signs; for, upon the attainment of quiescence, as
the attention is withdrawn from all signs and is focused in
the nature of awareness* itself, the entire continuum of atten-
tion becomes free of ideation* and of signs.[8] Both the ten-
dency to grasp onto signs and the mental afflictions that arise
on that basis are only temporarily inhibited while the mind is
in the state of quiescence. Quiescence alone brings about no
irreversible, radical change in the functioning of the mind, so
it is incapable of eradicating either the tendency to reify
objects or the mental afflictions that arise on the basis of
such reification.

The "bondage of dysfunctions" here refers to falsely con-
ceiving the body and/or mind to be an inherently existent "I"
or "mine." Such conceptual grasping onto a personal identity
is said to be the root of other mental afflictions, and it is the
function of insight to eliminate this form of bondage.[9] The
term "dysfunction" has a somewhat different, yet related,
connotation within the context of quiescence, as will be seen
later on in this text.

[8] Cf. the citations from the *Śrāvakabhūmi* on pp. 205–206 of the present transla-
tion.

[9] *Ārya-saṃdhinirmocana-sūtre-āryamaitreyakevala-parivarta-bhāṣya*, trans. John
Powers, p. 110.

II.
The Subsumption of All *Samādhis* under Those Two

Furthermore, it is said in the *Saṃdhinirmocanasūtra* that all the limitless *samādhis* that are taught in the Mahāyāna and Hīnayāna are subsumed under quiescence and insight. Thus, since those who aspire for *samādhi* cannot investigate the limitless specific types, they should well explore the means of cultivating quiescence and insight, which are the general synthesis of all *samādhis*.

COMMENTARY: Although hundreds of different kinds of *samādhi* are taught in the Buddhist *sūtras* and *tantras,* Tsongkhapa points out here that they all fall within the twofold classification of quiescence and insight. So, an aspiring contemplative is advised to explore these two disciplines, for they provide the key to the vast array of contemplative practices taught in Buddhism.

Another inclusive twofold division of meditation often emphasized by Tsongkhapa is that of discursive meditation* and stabilizing meditation.* The former entails conceptual analysis or reflection in order to bring forth a specific insight or other virtue such as compassion. After convincing oneself of the validity of a certain aspect of the teaching by means of "thinking," discursive meditation is then used to bring the reality in question repeatedly to mind so that one may become well acquainted with it.

Stabilizing meditation involves the simple placement of the attention on a chosen object, often one that has been the topic of previous discursive meditation. In order for the mind to be radically transformed by insight into some aspect of reality, the attention must be repeatedly stabilized in that

insight for sustained periods. According to Tsongkhapa, insight meditation is a paradigmatic instance of discursive meditation, while quiescence is typical of stabilizing meditation. The two are complementary, for the insight (or other virtue) that arises due to discursive meditation can radically counteract the mental afflictions only when it is sustained by subsequent stabilizing meditation.

III.
The Nature of Quiescence and Insight

The nature of quiescence is stated in the *Saṃdhinirmocanasūtra*:

> Dwelling in solitude, perfectly directing the mind inwards, one attends just to the phenomena as they have been brought into consideration; and that attentive mind is mental engagement,* for it is continuously mentally engaged inwards. That state in which one is so directed and remains repeatedly, in which physical pliancy* and mental pliancy have arisen, is called *quiescence*.[1]

Here is the meaning: due to sustained mental engagement, without the attention being distracted elsewhere, the mind naturally remains on its object; and when the pleasure* and joy* of physical and mental pliancy arises, that *samādhi* becomes quiescence. This arises simply from sustaining the attention inwards without being distracted from one's object; it does not depend upon fathoming the nature of thatness.*

The nature of insight is stated in that same *sūtra*:

> When one has achieved physical pliancy and mental pliancy and dwells therein, one abandons the aspects of the mind[2] and inwardly examines and takes an interest in the phenomena under consideration as experienced images of *samādhi*.* With respect to such experienced images of *samādhi*, the differentiation of objects of knowledge, their thorough differentiation, investigation, analysis, forbearance,[3]

[1] Cf. Lamotte, *Saṃdhinirmocanasūtra*, VIII:3.

[2] Jñānagarbha comments that to abandon the aspects of the mind is to realize the lack of inherent existence of the mind, which, he states, is "just mind's absence of being mind." In this connection he cites the *Perfection of Wisdom Sūtra*: "That mind is non-mind; the nature of the mind is clear light." (*Ārya-saṃdhinirmocana-sūtre-āryamaitreyakevala-parivarta-bhāṣya*, trans. John Powers, pp. 72–73.)

[3] Jñānagarbha glosses "forearance" as "just mental freedom with respect to ascertaining phenomena that are countless non-dual objects." (Ibid., p. 73).

acknowledgment, classification, the view of those objects, and the ideation* concerning them are called insight. Thus is a Bodhisattva skilled in insight.[4]

Here, *differentiation* refers to probing into the diversity of phenomena, and *thorough differentiation* refers to probing into the real nature of phenomena; *investigation* refers to a gross investigation, and *analysis* refers to subtle analysis. The *Ratnameghasūtra* states, "Quiescence is single-pointed attention. Insight is discernment."* And the holy Maitreya says, "The path of quiescence is to be known as the fixation of mental representations* of phenomena,[5] while the path of insight is to be known as the investigation of their referents."*[6] And: "In dependence upon genuine stability,* due to directing the mind upon itself, and due to differentiating phenomena, there are quiescence and insight."[7]

In dependence upon genuine *samādhi* the placement of attention is said to be quiescence, and the wisdom that examines phenomena is said to be insight. The *Bodhisattvabhūmi* concurs with this,[8] and the *Intermediate Bhāvanākrama* also states:

> Upon calming distraction* towards outer objects, abiding in the mind-itself*[9] endowed with pleasure and pliancy in continuously and naturally attending to an inner meditative object is called *quiescence.* While abiding in that quiescence, the analysis of thatness is insight.[10]

The *Prajñāpāramitopadeśa* gives a similar explanation, so according to the *Bodhisattvabhūmi* and the *Prajñāpāramitopadeśa*

[4] Ibid. VIII:4.

[5] The Sanskrit reads "fixed representations of its phenomena."

[6] *Mahāyāna Sūtrālaṃkāra*, by Asaṅga, ed. by S. Bagghi (Darbhanga: Mithila Institute, 1970) XIV:8

[7] Ibid., XVIII:66

[8] *Bodhisattvabhūmi*, Asaṅga, ed. Unrai Wogihara. Vol. I. Tokyo, 1936, p. 109. Cf. Alex Wayman, *Calming the Mind and Discerning the Real: Buddhist Meditation and the Middle View* (New York: Columbia University Press, 1978), p. 86.

[9] This term refers to the state of being the mind, or "mindness," which is the very nature of awareness itself.

[10] Derge: dBu ma Ki 46.2.7-47.1.2

both quiescence and insight may have the real nature of phenomena and the diversity of phenomena as their meditative objects. Therefore, quiescence and insight are not to be distinguished in terms of their meditative objects; there is quiescence that realizes emptiness as well as insight that does not realize emptiness.

When the dispersion of the attention to external objects is calmed, and the mind remains inwardly upon its meditative object, that is called *quiescence;* and when there is superior—that is, special—vision, that is called *insight.* Those are mistaken who maintain that attention that remains without conceptualization* and without the potency of clarity[11] of awareness is quiescence, and [attention] with the potency of clarity is insight; for this contradicts all that was said previously, and that distinction is merely the difference between *samādhi* with and without laxity.* For all *samādhis* of quiescence it is certainly necessary to clear out laxity, and in all *samādhis* that are free of laxity the clarity of attention definitely ensues.

Therefore, the issue of whether or not a *samādhi* or wisdom is focused upon emptiness* must be decided in terms of whether or not that cognition* realizes either of the two types of identitylessness,[12] for there are incalculable joyful, clear, non-conceptual *samādhis* that are not focused on thatness.

[11]I have translated both the Tibetan terms *gsal ba* (Skt. *sphuṭa*) and *gsal cha* as *clarity,* even though the latter literally means the *factor of clarity.* Similarly, I have rendered both *gnas pa* (Skt. *sthiti*) and *gnas cha* as *stability.* Since clarity and stability are themselves the factors of being clear and stability, I feel nothing is gained by rendering *gsal cha* and *gnas cha* as the *factor of clarity* and the *factor of stability.*

[12]I have chosen to render the Tibetan *bdag med pa* (Skt. *nairātmya*) as "identitylessness" rather than the more common "selflessness" or "no-self" for the following reason: Within the Madhyamaka context in which Tsongkhapa writes, the term "identity" (Tib. *bdag*; Skt. *ātman*) refers to an intrinsic nature of a person or any other phenomenon, an essence that inherently possesses its own being and attributes. The erroneous tendency to grasp conceptually onto such an identity is instinctual, or inborn, not something acquired due to philosophical training. In English it is quite plausible to speak of instinctually grasping onto the inherent identity of an impersonal phenomenon such as a chair; whereas it sounds utterly contrived to speak of grasping onto the self of a chair. Thus, the term "selflessness" is fitting only with respect to personal identitylessness, but it gives a misleading impression in terms of phenomenal identitylessness.

It is perceptually established that even without discovering the view that realizes the way things are, attention may be sustained without conceptualizing anything. So there is not even the slightest inconsistency in non-conceptual *samādhi* arising despite the fact that one has not understood emptiness. In that regard, if the attention is sustained for a long period, due to the power of sustained attention, functional vital energies arise; and if they have arisen, pleasure and joy naturally arise in the body and mind. So there is no inconsistency in the fact that joy arises; and if that has occurred, due to the power of vivid feelings of pleasure and joy, clarity comes to the mind.

Therefore, it is impossible to maintain that all joyful, clear, non-conceptual *samādhis* comprehend thatness. Thus, in *samādhis* that realize emptiness joy, clarity, and non-conceptuality occur; and there are many instances of joy, clarity, and non-conceptuality occurring in *samādhis* in which the mind is not focused on emptiness. So one must distinguish between the two.

COMMENTARY: In the above section Tsongkhapa uses three terms interchangeably—thatness, identitylessness, and emptiness—all of them referring to ultimate truth,* but each bringing out a different facet of this truth. Tsongkhapa emphasizes the investigation of this view by way of an analysis of phenomena as dependently related events.* All composite phenomena* are regarded as dependently related events in terms of their dependence upon (1) their preceding causes, (2) their own components and attributes, and (3) the conceptual designation of them. All non-composite phenomena* are dependent in the latter two ways only, for they are not produced by causes.

In acknowledging the causal interdependence among phenomena that are external to the mind that cognizes them, Tsongkhapa shuns idealism. At the same time, he counters the nihilistic view of emptiness that undermines causality, including the causality operating in the infallible relationships between actions and their results.

The assertion that phenomena are *dependent* upon their components and attributes implies that they are not *identical*

with those components and attributes, which immediately raises the question: in what manner does an entity exist in relation to its attributes? Following the standard Madhyamaka reasoning, Tsongkhapa argues that it is not identical to any one of its attributes, nor to any partial or total sum of them, nor does it exist independently of them. Rather, it is conceptually designated upon its attributes, and nothing whatsoever exists apart from such conceptual designation. To realize the absence of any inherent nature* of a phenomenon—that is, a nature, or identity that exists independently of conceptual designation—is to realize the emptiness, or the identitylessness, of that phenomenon.

For instance, a person exists as an entity conceptually designated upon one's body and/or mind, and the absence of an inherent identity of a person is called personal *identitylessness*.* The absence of an inherent identity of any other phenomenon is called *phenomenal identitylessness*.* The distinction between the two types of identitylessness is made solely in reference to the bases of emptiness—persons and other phenomena—and does not suggest any difference in the nature of emptiness itself.

In asserting the existence of objects external to the mind, Tsongkhapa acknowledges that the visual perception of light, for instance, is caused in part by light stimulating the visual organ. But the light that we conceive to be causing this visual perception does not exist independently of our conceptual designation of it, nor does causality as we conceive it exist independently of our conceptual framework. Indeed, the very dichotomy of subject and object does not exist intrinsically, but emerges as a dependently related event that is contingent on the conceptual designation of it.

This implies that no world as it is conceived and articulated within any conceptual framework exists independently of that framework. And yet Tsongkhapa argues a non-conceptual, non-dualistic experience of reality is possible, and that such a realization is unmediated by concepts, ineffable and beyond the scope of conceptualization. Thus, the reality that

is so perceived is simply called *thatness*. Speaking in terms of the Madhyamaka conceptual framework, it can be said that thatness is the unconditioned, existent object of such a perceptual realization; but from the ultimate perspective of a contemplative immersed in this experience, in which all conceptual frameworks are purportedly transcended, there is no conceptual designation of thatness, of something unconditioned, of existence, or of an object.

This view of emptiness underlies Tsongkhapa's entire presentation of mental and physical processes and their interactions. Throughout this discussion of quiescence he makes repeated reference to vital energies, which are said to be perceived in the body by contemplatives well trained in quiescence and other more advanced meditative disciplines. The assertion that such energies exist implies simply that they are objects of valid cognition,* and not that they exist in any absolutely objective sense, independent of conceptual designation. Vital energies are said to exist in relation to the conceptual framework in which they are designated; and since there are multiple conceptual frameworks within the Buddhist *sūtras* and *tantras*, there are also multiple classifications and descriptions of the vital energies and their functions. Neither vital energies nor any other phenomena can be asserted to exist independently of all conceptual frameworks. The very notion of existence itself is not discovered, as if it were imbedded in some absolute reality; rather it is subject to varying definitions within diverse conceptual frameworks.

In the above section Tsongkhapa refutes various misconceptions concerning the distinction between quiescence and insight. One misconception is to assert that quiescence and insight are distinguished by the fact that quiescence is focused solely on the conventional, or phenomenal, truth;* while insight is focused on the ultimate nature of reality. Tsongkhapa counters that there are many types of insight, some concerned with the diversity of phenomena and others concerned with the ultimate nature of phenomena. Thus, insight may be either mundane or supramundane. When

quiescence is focused on the relative nature of a phenomenon, it is mundane; and when it is conjoined with supramundane insight focused on the real nature of phenomena, or emptiness, it is supramundane.*

A second misconception is to identify quiescence with non-conceptual attentional stability, and to identify insight with the potency of attentional clarity. Both attentional stability and clarity are indispensable elements of genuine quiescence: if the former is lacking there is no true *samādhi*, and if the latter is absent, the mind has succumbed to laxity. Thus, radiant clarity and luminosity of the mind are integral features of quiescence and are by no means confined to insight alone.

A third misconception is to maintain that any *samādhi* characterized by joy, clarity, and non-conceptualization necessarily realizes thatness. Tsongkhapa emphasizes there are many types of *samādhi* bearing those attributes, but not all of them involve a realization of ultimate truth. Joy and clarity are key elements of both mundane and supramundane quiescence, and the fact that the mind enters a state free of conceptualization does not necessarily mean that it fathoms ultimate truth transcending all conceptual frameworks. It is not enough that the tendency of grasping onto signs and of reifying objects is temporarily suspended during *samādhi*; rather, by means of critical investigation and analysis one must realize the absence of an intrinsic nature of phenomena, and conjoin that insight with the non-conceptual stability and clarity of quiescence. Thus, as mentioned previously, quiescence temporarily inhibits the manifestation of a certain range of mental afflictions; but only insight conjoined with quiescence can irreversibly eliminate delusion* and its derivative afflictions.

IV.
The Reasons Why It Is
Necessary to Cultivate Both

Why is it necessary to cultivate both quiescence and insight rather than just one or the other? To draw an analogy, in order to examine a hanging tapestry at night, if you light an oil-lamp that is both radiant and unflickering, you can vividly observe the depicted images. But if the lamp is either dim, or—even if it is bright—flickers due to wind, you would not clearly see the forms. Likewise, with respect to witnessing profound realities, if you possess both the wisdom that properly ascertains the meaning of thatness as well as unwavering, sustained, voluntary attention upon your meditative object, you clearly observe thatness. However, even with non-conceptual *samādhi* that is sustained without the attention becoming scattered, if you lack the wisdom that realizes the way things are, no matter how much you cultivate *samādhi* it is impossible to realize the way things are. And even with the view that fathoms identitylessness, if you lack stable *samādhi* in which attention is sustained single-pointedly, it is impossible to observe clearly the reality of the way things are. The need for both quiescence and insight is stated in the *Intermediate Bhāvanākrama*:

> With insight alone, divorced from quiescence, the contemplative's attention will become distracted to objects, and—like an oil-lamp that is located in a draft—it will not become stable. Therefore, the light of knowledge* will not become vivid, so apply yourself equally to both.[1]

And:

> Like an oil-lamp placed away from a draft, due to the power of quiescence the attention will not waver due to the winds of ideation. Due to insight eliminating all the snares of distorted views, you are not

[1] Derge: dBu ma Ki 45.1.4–5.

swayed by anything else. This accords with the statement in the *Candrapradīpasūtra:*[2] "Due to quiescence the [mind] becomes unwavering. Due to insight it becomes like a mountain."

Thus, if you investigate with wisdom conjoined with the meditative equipoise* of quiescence in which the mind is unperturbed by laxity and excitation,* you will come to know thatness. With this in mind the *Dharmasaṃgītisūtra* states, "If the mind is established in equipoise, you will come to know reality* as it is." The *First Bhāvanākrama* states:

> Because the mind moves like a river, it does not remain stationary without the foundation of quiescence. The mind that is not established in equipoise is incapable of knowing reality. The Lord, too, declared, "The mind that is established in equipoise discovers reality."[3]

If quiescence is accomplished, this remedies the problem of instability in the wisdom that properly investigates identitylessness. In addition, the problem of distraction away from the meditative object is remedied for all the applications of discursive meditation using discerning wisdom in the training concerning non-conceptuality, the law of actions and their results, the faults of the *saṃsāra*, love,* compassion,* and the spirit of awakening; and you focus on your object without being distracted to anything else. Thus, all virtuous activities are empowered. Until you attain quiescence there is a strong tendency to be distracted to other objects, so all your virtuous endeavors are weak, as it says in the *Bodhicaryāvatāra*, "A person whose mind is distracted dwells between the fangs of mental afflictions."[4] And:

> Even if you perform recitations, austerities and so on for a long time, the Sage has declared that if the mind is distracted elsewhere, those actions are pointless.[5]

[2] This is an alternate name for the *Samādhirājasūtra*. VII:10a-b (ed. P.L. Vaidya. Darbhanga, 1961).

[3] *First Bhāvanākrama*, G. Tucci, ed., in his *Minor Buddhist Texts, Part II* (Rome, 1958), p. 205.

[4] VIII:1.

[5] V:16.

COMMENTARY: Tsongkhapa here emphasizes the indispensable role of quiescence in relation to the two central avenues of Mahāyāna practice: the cultivation of wisdom and the spirit of awakening. The attainment of any Ārya path—be it that of Śrāvaka, Pratyekabuddha, or Bodhisattva—is contingent upon the unification of quiescence and insight.[6] Quiescence alone can only temporarily inhibit the activation of mental afflictions, and insight alone lacks the necessary degree of attentional stability and clarity needed to eliminate the afflictions altogether.

The cultivation of the spirit of awakening is based upon the prior cultivation of an emergent attitude, which is aroused by discursive meditation on such issues as the law of actions and their results and the faults of the *saṃsāra*. An emergent attitude, however, entails not only a thorough disenchantment with the allures of *saṃsāra*, but a powerful faith in, and yearning for, *nirvāṇa*. The attainment of quiescence has a strong bearing on both of these facets of renunciation, for it both counteracts attachment and yields unprecedented physical and mental well-being that stems from a balanced mind rather than from external pleasurable stimuli.

More specifically, the attainment of the first meditative stabilization entails the suspension of five hindrances[7] and the manifestation of five factors of the first stabilization.* The five hindrances are (1) sensual desire,* (2) malice,* (3) drowsiness *and lethargy,* (4) excitation *and

[6] Cf. Nāgārjuna's statement, "There can be no wisdom without meditative stabilization." (*Suhṛllekha*, vs. 107). The renowned Sakya (Sa skya) Lama Rendawa Zhönnu Lodrö (gZhon nu blo gros) comments on this verse: "there is no true wisdom which is true and exact knowledge without *dhyāna*, for it has been stated that true and exact knowledge comes when the mind is perfectly composed." [*Nāgārjuna's Letter:* Nāgārjuna's "Letter to a Friend" with a commentary by the Venerable Rendawa Zhön-nu Lo-drö, trans. by Geshe Lobsang Tharchin and Artemus B. Engle (Dharamasala: Library of Tibetan Works and Archives, 1979), p. 128].

[7] Cf. Louis de La Vallée Poussin, *Abhidharmakośabhāsyam* (Berkeley: Asian Humanities Press, 1991) English trans. Leo M. Pruden, Vol. III, pp. 851–52.

remorse,*[8] and (5) doubt;[9] and the five factors of stabilization are: (1) investigation,* (2) analysis,* (3) pleasure,* (4) joy,* and (5) single-pointed attention.* The factor of investigation counters the combined hindrance of lethargy and drowsiness; the factor of analysis counters the hindrance of doubt;[10] the factor of pleasure counters the hindrance of malice; the factor of joy counters the combined hindrance of excitation and remorse; and the factor of single-pointed attention counters sensual desire.[11] Due to these transformative effects, the

[8] For a detailed account of the five hindrances and the ways of overcoming them see Henepola, Gunaratana *The Path of Serenity and Insight: An Explanation of the Buddhist Jhānas* (Columbia, Missouri: South Asia Books, 1985), pp. 28–48. The Sanskrit term kautṛtya, (Tibetan: *'gyod pa;* Pāli: *kukkucca*), rendered here as "remorse," has the multiple connotations of remorse, worry, mental disturbance, and difficulties of conscience. Thus, English translations from the Pāli literature often list this hindrance as "worry" or "anxiety," while the Tibetan term clearly emphasizes the aspect of remorse.

[9] Jñānagarbha explains the hindrance of sensual desire is for the five qualities of the desire realm; malice entails hatred toward sentient beings; lethargy is an unfitness of the body and mind; and drowsiness is edging towards sleep; excitation is non-pacification of the sense-faculties, and remorse entails fixation on non-virtuous deeds of omission and of commission; and doubt concerns the Buddha, Dharma, and Saṅgha, the four noble truths, and the relations between actions and their results. *Ārya-saṃdhinirmocana-sūtra-āryamaitreyakevala-parivarta-bhāṣya*, trans. John Powers, p. 111. For a discussion of the five qualities of the desire realm, see Leah Zahler, *Meditative States in Tibetan Buddhism* (London: Wisdom, 1983), pp. 93–96.

[10] According to the Theravāda interpretation, the first of the factors of stabilization, *vitakka*, refers to the application of the attention to the meditative object; hence it is usually translated as "applied thought." The second factor, *vicāra*, refers to sustained mental application upon the same object with a view to investigation. According to the Indo-Tibetan tradition, which relies heavily on the *Abhidharmakośa*, *vitarka* and *vicāra* both entail a scrutiny of the meditative object, and they differ chiefly in the sense that the former operates on a grosser level and the latter on a subtler. Hence, they are usually translated as "investigation" and "analysis" respectively. Cf. Louis de La Vallée Poussin, *Abhidharmakośabhāṣyam* (Berkeley: Asian Humanities Press, 1991) English trans. Leo M. Pruden, Vol. I, pp. 202–204. Here Vasubandhu comments that at any given moment the first stabilization is endowed with either investigation or analysis in addition to the other three factors of stabilization.

[11] Paravahera Vajirañāṇa Mahāthera, *Buddhist Meditation in Theory and Practice.* (Jalan Berhala, Kuala Lumpur, Malaysia, 1975), pp. 36–37.

quiescence of the first meditative stabilization is at times
identified with an emergent attitude itself.[12]

Since an uncontrived emergent attitude is the decisive fac-
tor in ascending to the contemplative path that culminates in
the attainment of *nirvāṇa*, it appears doubtful that this path[13]
could be reached without the attainment of quiescence.
Moreover, since an uncontrived emergent attitude is the basis
for the arising of an uncontrived spirit of awakening, which
is the decisive factor in embarking on the path to Buddha-
hood, quiescence may also be necessary to progress on this
path.[14] This would imply that quiescence is also a prerequi-
site for becoming a Bodhisattva.

In short, the mind that is dysfunctional due to its domina-
tion by the five hindrances is an inadequate tool for the culti-
vation either of wisdom or the great compassion associated
with the spirit of awakening. In the Buddha's words: "So long
as these five hindrances are not abandoned one considers
himself as indebted, sick, in bonds, enslaved and lost in a
desert track."[15] Thus, an extraordinary degree of mental
health, or fitness, is needed to serve as a sufficient basis for
contemplative insight and for the cultivation of great love and
compassion.

[12]Cf. The sub-commentary to the *Mahāpadāna Sutta* of the *Dīgha Nikāya* [Dīgha
Sub-commentary (Sinh. ed.) 337] identifies the first meditative stabilization as
renunciation. Also note: "'Renunciation' means the first stabilization." (*Itivuttaka*
II, 41).

[13]I refer here specifically to the path of accumulation of either a Śrāvaka or a
Pratyekabuddha, which is first attained with the arising of an uncontrived emer-
gent attitude.

[14]I refer here to the Mahāyāna path of accumulation, which marks the beginning
of the Bodhisattva career.

[15]*Sāmaññaphala Sutta* (D. I, 73).

V.
The Way to Determine
Their Order

The *Bodhicaryāvatāra* states, "Recognizing that one who is well endowed with insight together with quiescence eradicates mental afflictions, one should first seek quiescence."[1] Thus, quiescence is accomplished first, then on that basis insight is cultivated.

QUALM: The *First Bhāvanākrama* says, "Its object is not definite,"[2] meaning that there is no strict rule concerning the meditative object of quiescence. And, as mentioned previously, both phenomena and reality-itself*[3] may be objects of quiescence; so by first understanding the meaning of emptiness and focusing on it, one could simultaneously develop both quiescence, in which the attention does not wander, and insight focused on emptiness. So why should one first seek quiescence and then cultivate insight?

RESPONSE: Here is the way in which quiescence precedes insight: It is not necessary for quiescence to precede the understanding of the view that realizes identitylessness, for we see that the view may arise even without quiescence. Moreover, in order for the experience of mental transformation to occur in relation to the view, quiescence does not need to come first. For even without quiescence, by means of repeated analysis and familiarization employing discerning wisdom, the mind is transformed. There is nothing inconsistent in this. If there were, this would absurdly

[1] VIII:4. The above translation is from the Sanskrit. The Tibetan version may be translated as follows: "Recognizing that the mental afflictions are eradicated by insight imbued with quiescence, one should first seek quiescence."

[2] *First Bhāvanākrama*, p. 207.

[3] This term refers to the ultimate nature of phenomena, also called "emptiness," "identitylessness," and "thatness."

imply, for similar reasons, that the experience of mental transfor-
mation in the training pertaining to impermanence, the faults of
saṃsāra, and the spirit of awakening would also depend upon
quiescence.

What, then, is the way in which quiescence precedes insight?
Here the development of insight refers to an ordinary being's ini-
tial, unprecedented development of realization arising from med-
itation. This does not include the methods of meditating on
identitylessness by means of a special subjective awareness* that
realizes emptiness, which is a special case that will be discussed
later on.[4] Apart from that, within the context of the Pāramitāyāna
and the three lower classes of *tantras,*[5] realization arising from the
meditative cultivation of insight does not occur without engaging
in discursive meditation in which the meaning of identitylessness
is investigated with discerning wisdom. Thus, discursive medita-
tion is necessary.

Before accomplishing quiescence, if you seek an understand-
ing of identitylessness and repeatedly explore its meaning, since
quiescence has not already been achieved, it would be impossible
to accomplish it in that way. If stabilizing meditation is per-
formed, without analysis, quiescence can be achieved on that
basis, but not with methods for cultivating insight, which are sep-
arate from the methods for cultivating quiescence. Thus, it is
necessary to seek insight afterwards. For this reason, the order of
first seeking quiescence and on that basis cultivating insight is not
violated. Therefore, according to this tradition, if the method of

[4] Tsongkhapa refers here to methods taught in the context of the two stages of
Anuttarayogatantra, namely the stage of generation *(bskyed rim, utpattikrama)* and
the stage of completion *(rdzogs rim, utpannakrama).*

[5] Tsongkhapa refers here to the fourfold classification of Buddhist *tantras* of
Kriyātantra, Caryātantra, Yogatantra, and Anuttarayogatantra, listed in order of
increasing profundity. In the above statement, Tsongkhapa implies that it is only
in the practice of the supreme class of *tantra,* namely the Anuttarayogatantra, that
insight into identitylessness can be cultivated without the use of discursive medi-
tation. Cf. H.H. the Dalai Lama, Tsongkhapa, and Jeffrey Hopkins, *Tantra in Tibet*
(Ithaca: Snow Lion, 1977), pp. 151–164.

developing insight did not entail the generation of pliancy by means of discerning, discursive meditation, there would be no compelling reason for cultivating insight on the basis of the prior quest for quiescence.[6]

Moreover, it is a great mistake not to practice meditation in that order, for the *Samdhinirmocanasūtra* declares that insight is cultivated in dependence upon the achievement of quiescence, as mentioned earlier. And, among the six perfections, for which it is said that the latter arise in dependence upon the former, the stages of meditative stabilization and of wisdom, as well as the stages of the higher training in wisdom arising in dependence upon the higher training in *samādhi*, are stages in which quiescence is first cultivated, followed by the cultivation of insight. Furthermore, the *Bodhisattvabhūmi* and the *Śrāvakabhūmi* also declare that insight is cultivated on the basis of quiescence; and the *Madhyamakahṛdaya*, the *Bodhicaryāvatāra*, the *Threefold Bhāvanākrama*, Jñānakīrti and Śāntipa state that one first seeks quiescence and then cultivates insight. Therefore, the assertion of some Indian masters that insight is initially developed by analysis with discerning wisdom, without any separate endeavor in quiescence, is incompatible with the treaties of the great authorities.*[7] So that assertion is not regarded as a reliable source by sensible people. Now this sequence for quiescence and insight refers to their initial, fresh development, but thereafter you may first cultivate insight and then cultivate quiescence. So there is no definite order.

QUALM: How then is it that the *Abhidharmasamuccaya* states, "Someone may achieve insight without achieving quiescence and strive for quiescence on the basis of insight."?[8]

[6] Tsongkhapa implies here that, upon the basis of quiescence, the accomplishment of insight by means of discursive meditation brings forth a degree of pliancy that surpasses even that generated by the achievement of quiescence alone. But if the pliancy of quiescence has not already been developed, the pliancy of insight could not arise.

[7] Literally, "the great chariots."

[8] Asaṅga's *Abhidharmasamuccaya*, Pralhad Pradhan, ed. (Santiniketan, 1950), p. 75.21.

RESPONSE: This does not refer to the non-achievement of the quiescence comprised by the first proximate[9] meditative stabilization, but to the non-achievement of the quiescence of the basic[10] first stabilization and higher. Moreover, after perceptually realizing the Four Noble Truths one may, upon that basis, accomplish the states of quiescence of the first stabilization and higher, for it says in *Bhūmivastu:*

> Furthermore, one may perfectly comprehend [the Four Noble Truths] from [the truth of] suffering to the [truth of the] path without having accomplished the first stabilization and so on. As soon as this happens, the attention is focused, without mental analysis. On the basis of that higher wisdom one applies oneself to a higher mental state.[11]

In general, in simpler terms, the nine states of attention[12] may be called *quiescence,* and the four modes of analysis,[13] etc. may be called *insight;* but genuine quiescence and insight, as stated, must be established from the occurrence of pliancy.

COMMENTARY: Tsongkhapa begins the above section by drawing a clear distinction between gaining a theoretical understanding of the view of emptiness and achieving contemplative insight into emptiness. Both can bring about virtuous mental transformation, but only the latter has the potency to eliminate mental afflictions; and while theoretical understanding does not require the previous achievement of quiescence, insight does. Similarly, without having accom-

[9] *nyer bsdogs, sānantaka;* Pāli: *upacāra-samādhi*

[10] *dngos gzhi, maula;* Pāli: *appaṇā-samādhi*

[11] According to Wayman, the title *Bhūmivastu* stands for the seventeen *bhūmis* of Asaṅga's *Yogācārabhūmi.* Cf. Wayman, *Analysis,* pp. 42–43.

[12] Tsongkhapa discusses these in detail in the section entitled "The Actual Progression in Which the Stages of Sustained Attention Arise."

[13] These include: (1) the analysis of reality-itself *(chos nyid kyi rigs pa);* (2) analysis of functions *(bya ba grub pa'i rigs pa);* (3) analysis of dependence *(ltos pa'i rigs pa);* and (4) analysis of establishing logical proofs *('thad pa sgrub pa'i rigs pa).* Cf. John Powers, *Two Commentaries on the* Saṃdhinirmocana-sūtra *by Asaṅga and* Jñānagarbha, p. 68.

plished quiescence, it is possible, by means of discursive meditation, to experience mental transformation in terms of cultivating an emergent attitude and the spirit of awakening. But it is questionable whether these states can be developed to the point that they are effortless and uncontrived without the support of quiescence.

Tsongkhapa points out, however, that the prior achievement of quiescence is necessary only for the initial, unprecedented development of realization arising from meditation. It is possible that an individual may develop such realization on the basis of quiescence in one life, and at a later time (for example in a future lifetime) that realization may become dormant. In that case, this realization may be made conscious once again without re-accomplishing quiescence. Apart from special instances of this sort, it is not possible to develop quiescence by means of discursive meditation, for this would undermine attentional stability, which is the initial emphasis of quiescence training; and it is not possible to develop insight by means of stabilizing meditation alone, for the cultivation of insight requires active investigation with discerning wisdom.

Vasubandhu emphasizes that the practice of the four applications of mindfulness, a fundamental Buddhist meditative discipline focused on the cultivation of insight, is to be cultivated after one has achieved quiescence.*[14] Thus, quiescence is presented as an indispensable prerequisite for this discipline of cultivating insight, which is common to the Hīnayāna and Mahāyāna paths.

Within the Mahāyāna context of the six perfections, the final perfection of wisdom is immediately preceded by the perfection of meditative stabilization, clearly indicating that quiescence is to be cultivated prior to the development of wisdom. This point is also implied in the ethical discipline prescribed for Bodhisattvas: one of the Bodhisattva root

[14] Louis de La Vallée Poussin, *Abhidharmakośabhāṣyam* (Berkeley: Asian Humanities Press, 1991) English trans. Leo M. Pruden, Vol. III: 14a-b, p. 925.

downfalls* is to reveal the view of emptiness to a person who is not well prepared to hear such teachings, for such a person—even one who has begun to cultivate the spirit of awakening—may well respond with fear and as a result abandon the quest for perfect enlightenment.* Since the cultivation of the first five perfections is for the sake of developing the wisdom that realizes emptiness,[15] it follows that the achievement of meditative stabilization is a necessary prerequisite for cultivating such insight.[16]

Finally, in a technical discussion concerning the possibility of developing insight before quiescence, Tsongkhapa draws the distinction between the first proximate meditative stabilization and the basic first stabilization. Simply put, in the former, preliminary stage, the five factors of stabilization are not fully developed; and, thus, even though the five hindrances are temporarily inhibited, they can reappear relatively easily if one's *samādhi* declines. One may indeed develop not only proximate stabilization, but the basic first stabilization prior to cultivating insight into emptiness; however, Tsongkhapa insists that the first proximate stabilization provides sufficient attentional stability and freedom from the hindrances to proceed on to the successful cultivation of insight. Thus, there are two ways of stabilizing the purification achieved in the first proximate stabilization: by means of more advanced quiescence practice, or by means of insight.

[15] *Bodhicaryāvatāra*, IX:1. H. H. the Dalai Lama, Tenzin Gyatso, *Transcendent Wisdom: A Commentary on the Ninth Chapter of Shantideva's* Guide to the Bodhisattva Way of Life, trans. and ed. B. Alan Wallace (Ithaca: Snow Lion, 1994), pp. 15–16.

[16] Asaṅga's Chapter on Ethics with the Commentary of Tsong-Kha-Pa, *The Basic Path to Awakening*, The Complete Bodhisattva, trans. Mark Tatz (Lewiston: Edwin Mellen Press, 1986) Studies in Asian Thought and Religion, Vol. 4, pp. 176–77.

VI.
The Way to Train in Each One

Here there are three sections: (A) the way to train in quiescence, (B) the way to train in insight, and (C) the way to integrate those two.

A. THE WAY TO TRAIN IN QUIESCENCE

Here there are three sections: (1) meeting the prerequisites for quiescence, (2) the way to cultivate quiescence upon that basis, and (3) the standard of accomplishing quiescence through meditation.

☐ 1. MEETING THE PREREQUISITES FOR QUIESCENCE

a. Living in a supportive environment refers to an environment having five virtues: (i) food, clothing, and so on are easily obtained, with no problem; (ii) you are not disturbed by people, carnivorous animals, and so on; (iii) the location is pleasant, that is, it is not inhabited by enemies, and so on; (iv) the land is good, that is, it does not make you ill; (v) you have good companions, i.e., their ethical discipline and views are compatible with your own; and (vi) there are the fine attributes of having few people around during the daytime and little noise at night. The *Mahāyānasūtrālaṃkāra* states:

> An excellent environment in which a sensible person practices is one in which [the necessities] are easily obtained, a pleasant location, good land, good companions, and a favorable combination[1] [of circumstances for practice].[2]

[1] Vasubandhu says this refers to a place that has little traffic by people during the daytime and is quiet at night. *Sūtrālaṃkārabhāṣya*, ed. S. Bagchi, p. 84.

[2] XIII:7

b. Few desires: being free of craving for either a high quality or a large quantity of robes and so on.

c. Contentment: a constant sense of satisfaction with acquiring merely adequate robes and so on.

d. Dispensing with many activities: dispensing with unworthy actions such as engaging in commercial transactions, overly fraternizing with lay people and renunciates,* giving medical treatment, performing astrological calculations, and so forth.

e. Pure ethical discipline: not violating the basis of practice by committing either natural* or proscribed* misdeeds with respect to both the precepts of individual liberation* and of Bodhisattvas. If they are transgressed due to negligence,* with swift remorse you restore them in the proper way.

f. Dispensing with ideation involving desire and so on: dispensing with all desirous ideation by meditating on the disadvantages associated with desires, such as being killed or put in prison in this lifetime and going to a miserable destination,* etc. in the hereafter. Or you may reflect, "If all attractive and unattractive phenomena of *saṃsāra* are subject to deterioration and are impermanent, and before long I shall certainly be separated from all of them, why should I be so obsessed with such things?"[3] The *Bodhipathapradīpa* also comments:

> If the components of quiescence have deteriorated, even though one diligently practices meditation, *samādhi* will not be accomplished even in thousands of years.[4]

Therefore, it is very important for those who earnestly wish to accomplish the *samādhi* of quiescence and insight to apply themselves to the thirteen prerequisites for quiescence that are taught in the *Śrāvakabhūmi*.

[3] Even ethically neutral thoughts that give rise to fear or anxiety are especially to be avoided, for such emotions greatly obstruct the cultivation of quiescence. [Cf. Geshe Gedün Lodrö, *Walking Through Walls: A Presentation of Tibetan Meditation*, trans. and ed. Jeffrey Hopkins (Ithaca: Snow Lion, 1992), p. 26.]

[4] vs. 38.

COMMENTARY: Most of the above prerequisites for quiescence are self-explanatory, but there are a few points worthy of elaboration. It is significant that Tsongkhapa—and Maitreya before him—encourage the aspirant to quiescence to practice not in complete solitude, but with companions sharing similar ethical discipline and views. Such companionship would seem to be even more important than practicing under the close supervision of a contemplative who is a master of *samādhi*, for the latter is not even mentioned as a prerequisite.

Although some novice meditators glamorize dwelling alone in the wilderness, the Buddha cautioned that it is hard for someone who has not already attained *samādhi* to find joy in such solitude; rather, it is more likely that this isolation will be found to be stifling. To illustrate this point, the Buddha takes the analogy of a great elephant who enters a shallow pond in order to enjoy the pleasures of drinking and bathing.[5] Due to its great size, the elephant finds a footing in the deep water and enjoys itself thoroughly. Then a cat comes along and, seeking to emulate the elephant, jumps into the pond. Unlike the elephant, the cat, finding no footing, will either sink or float to the top. Similarly, contemplatives who have achieved the first meditative stabilization[6] can find joy in sustained solitude due to being grounded in freedom from the hindrances and to experiencing the inner joy of mental balance. Those who lack such *samādhi* are bound either to sink into laxity and depression* or to float up into excitation.

The basis of Buddhist practice in general and of the training in quiescence in particular is ethical discipline. First of all, this includes abstaining from "natural misdeeds," namely those that are detrimental regardless of whether or not one has taken any Buddhist precepts. This includes abstaining from the four non-virtues of speech: lying, abuse, slander,

[5] A. V, 201ff.

[6] The commentary to this *sutta* explains that the necessary *samādhi* is either the first proximate or basic stabilization. (Sing. ed., p. 840).

and idle gossip, implying that one should speak only what is true, conducive to harmony, gentle, and significant. Secondly, it includes abstaining from the three non-virtues of physical action: killing, stealing, and sexual misconduct, implying that one should act in ways that are harmless, honest, and pure. Finally, one should follow a livelihood that does not entail harm and suffering for others.[7]

Only those who have taken Buddhist precepts—such as the lay or monastic precepts of individual liberation or the Bodhisattva precepts—run the risk of committing a proscribed misdeed, for this entails an action that violates a precept but is not prohibited for those who have not taken the precept. For example, if a Buddhist monk eats after midday he commits a proscribed misdeed, for he has a precept prohibiting him from doing so; but a lay person may eat after midday without committing any misdeed.

If one commits either kind of misdeed, the latent propensities of that act may be purified by a process of confession,* or disclosure, that includes remorse.[8] Remorse may be virtuous, as in the case of experiencing remorse for a misdeed; it may be non-virtuous if one regrets a virtuous deed; or it may be ethically neutral.* Remorse is a useful, purificatory response to a non-virtuous act insofar as it impels one to avoid such behavior in the future. However, it may become a hindrance if one becomes obsessed with past non-virtue, while ignoring the possibility of freedom from non-virtue in the present. Moreover, obsessive remorse may lead to a kind of depression known as self-deprecating spiritual sloth.* This mental process*[9] contemptuously focuses on oneself with the

[7] The above constitutes the essential features of right speech, right action, and right livelihood—the three aspects of the Eightfold Noble Path that comprise ethical discipline. Cf. Kheminda Thera, *The Way of Buddhist Meditation*, pp. 7–8.

[8] For a detailed account of the proper way to purify misdeeds see Śāntideva, *Śikṣā-samuccaya*, trans. Cecil Bendall and W.H.D. Rouse (Delhi: Motilal Banarsidass, 1981), pp. 165–174.

[9] The mind *(citta)* and its attendant mental processes always operate in conjunction with one another, and the character of the mind is determined by the mental

sense that one is incapable of engaging in virtue, and it is a derivative of delusion* in that it conceives of oneself as being intrinsically unworthy or incapable of virtue.[10] Thus, the *Upāli-paripṛcchā* states that after committing a misdeed, Bodhisattvas should sustain their virtue by not relinquishing the spirit of enlightenment; and they are counseled not to repent excessively for their misdeeds.[11]

The thirteen prerequisites for quiescence include one chief prerequisite and twelve subordinate ones. The chief prerequisite is (1) the discourse of others on the Dharma and thorough mental awakening with it. The twelve subordinate prerequisites are as follows: (2) personal endowment; (3) endowment of others; (4) virtuous yearning for Dharma; (5) becoming a renunciate; (6) restraint of ethical discipline; (7) restraint of the sense faculties; (8) moderation in food; (9) the practice of wakefulness; (10) behaving with introspection;* (11) solitude; (12) the elimination of the hindrances; and (13) the support of *samādhi*.[12]

□ 2. THE WAY TO CULTIVATE QUIESCENCE UPON THAT BASIS

Here there are two sections: (a) the preparation and (b) the actual practice.

□□ a. THE PREPARATION

For an extended period cultivate the six preparatory practices* and the spirit of awakening, as explained earlier, and ancillary to

processes with which it is imbued. While the mind apprehends the fundamental presence of an object, its concomitant mental processes apprehend the specific attributes of that object. Cf. Geshe Rabten, *The Mind and Its Functions*, trans. Stephen Batchelor (Mont Pèlerin: Tharpa Choeling, 1979), pp. 52–54.

[10] *bLo bzang rgya mtsho, Rigs lam che ba blo rigs kyi rnam bzhag nye mkho kun btus* (Dharamsala, 1974), p. 158.

[11] Cited in Śāntideva, *Śikṣā-samuccaya*, trans. Cecil Bendall and W.H.D. Rouse, pp. 173–74.

[12] For a detailed explanation of these thirteen prerequisites see Wayman, *Calming the Mind and Discerning the Real*, pp. 31–38.

that also train in the meditation topics that are common to the practices for people of small* and medium capacity.*

> COMMENTARY: According to Indo-Tibetan Buddhism, the successful practice of meditation requires a great store of spiritual power,* which is acquired by devotional practices focused on the Buddha, Dharma, and Saṅgha, by the cultivation of such virtues as love and compassion, and by virtuous deeds motivated by altruism. Without a sufficient store of spiritual power, meditation, such as training in quiescence and insight, may arise as little more than barren, mental gymnastics that transform neither the heart nor the mind.
>
> Thus, Tsongkhapa encourages the aspirant to quiescence to perform the six preliminary practices, which are common to Tibetan Buddhist contemplation as a whole:[13]
>
> 1. Cleaning the place where one will meditate and setting up an altar on which there are typically representations of the Buddha, Dharma, and Saṅgha.
> 2. Setting out offerings on the altar, such as seven bowls of water and other offerings that are pleasing to the senses.
> 3. Sitting on a comfortable cushion, with the body in the appropriate physical posture (discussed in the next section), and engaging in the three practices of (a) taking refuge in the Buddha, Dharma, and Saṅgha; (b) cultivating the spirit of awakening; and (c) cultivating the four immeasurables,* namely, love, compassion, empathetic joy,* and equanimity.*
> 4. Visualizing in front of oneself the objects of one's devotions.
> 5. For the sake of purifying one's mind-stream of detrimental latent predispositions and for accumulating spiritual power, performing the seven limbs of devotion* and offering the *maṇḍala*. The seven limbs

[13] Cf. Paṇchen blo bzang yes shes, *Byang chub lam gyi rim pa'i dmar khrid thams cad mkhyen par bgrod pa'i myur lam* (Tibetan MS), p. 6A.

of devotion include (a) homage to the objects of devotion, (b) offering, (c) confession of misdeeds, (d) rejoicing in virtue, (e) requesting that the Dharma continue to be revealed, (f) requesting the Buddhas to remain for the sake of sentient beings, and (g) dedicating the spiritual power of one's practice to the alleviation of suffering of all sentient beings.[14] The offering of the *maṇḍala* is a symbolic way of imagining the entire world as pure and offering it to the objects of one's devotions.

6. Making prayers of supplication to the objects of one's devotions to bestow their blessings for the swift fruition of one's Dharma practice.

Tsongkhapa particularly encourages an extensive cultivation of the spirit of awakening prior to developing quiescence. There are several reasons for this. Firstly, such practice is believed to be extraordinarily effective in acquiring spiritual power and in purifying the mind of harmful latent propensities.[15] Secondly, the cultivation of love, compassion, and altruism, which are integral to the development of the spirit of enlightenment, are powerful antidotes to hatred, resentment, and malice, all of which are especially detrimental for the training in quiescence. Finally, Tsongkhapa strongly promotes the general Indo-Tibetan Buddhist view that the motivation for any action bears a powerful influence on the long-range effects of that action, particularly in terms of one's own psychical experience. The spirit of awakening, entailing the aspiration to achieve perfect enlightenment for the benefit of all sentient beings, is regarded as the supreme motivation for any virtuous act; and only those deeds that are so motivated will lead to the fulfillment of that aspiration.

[14] For a brief explanation of these seven limbs of devotion see B. Alan Wallace, *Tibetan Buddhism From the Ground Up* (Boston: Wisdom, 1993), pp. 154–57.

[15] For an extensive discussion of the benefits of the spirit of awakening, see the first chapter of Śāntideva's *Bodhicaryāvatāra*.

Chapter 2

Thus, the cultivation of quiescence will lead to perfect
enlightenment only if it is motivated by the spirit of
awakening.

In the gradual meditative discipline introduced into Tibet
by the Indian Buddhist *paṇḍit* Atīśa[16] the cultivation of the
spirit of awakening and the six perfections, which comprises
the training of a person of great capacity,* is preceded by
training in the meditation topics for people of small and
medium capacity. Above all, these meditations are designed
to transform one's motivation. The meditations of a person of
small capacity entail first of all shifting one's emphasis away
from purely mundane concerns that are of significance for
this life alone, and turning to the Dharma as the source of
well-being and fulfillment. The desired result of this transfor-
mation is to act with full responsibility and understanding
concerning the long-range effects of one's behavior. The medi-
tations of a person of medium capacity are designed to bring
about a thorough disenchantment with all the allures of
saṃsāra, and to focus the motivation upon total, irreversible
freedom from suffering and its source. The meditations of a
person of great capacity extend the implications of the pre-
ceding training equally to all other sentient beings, leading to
the aspiration to achieve perfect enlightenment in order to be
most effective in liberating all beings from suffering.

These three phases of meditative training are designed for
a single individual, who passes from one capacity to the next.
An assumption implicit in this entire discipline is that one's
motivation for behavior is inextricably tied to one's value-sys-
tem; and that, in turn, is derived from—and also influences—
one's world view. By engaging in discursive meditation, the
attention is repeatedly brought to bear on specific aspects of
reality (according to Indo-Tibetan Buddhism) over an
extended period; and in this way the phenomena to which

[16] The fundamental treatise by Atīśa in which this discipline is set forth is his
Bodhipathapradīpa. For an English translation of this text see Alaka
Chattopadhyaya, *Atīśa and Tibet* (Calcutta: Indian Studies: Past and Present,
1967), Section 6.

one attends begin to dominate one's experience of reality as a whole. Thus, discursive meditation is instrumental in cultivating a specific world view that is conducive to the cultivation of an emergent attitude, a spirit of awakening, and a non-dual realization of thatness.

☐☐ b. THE ACTUAL PRACTICE

Here there are two sections: (i) meditating with the appropriate physical posture and (ii) an explanation of the stages of meditation.

☐☐☐ i. MEDITATING WITH THE APPROPRIATE PHYSICAL POSTURE

According to the *Bhāvanākrama,* on a very soft and comfortable cushion your posture should have eight qualities: (1) the legs should be either in the full or half cross-legged position; (2) the eyes should be directed over the tip of the nose, without being either wide open or closed; (3) the body should sit straight and erect, without being either bent or crooked, with the mindfulness* drawn inwards; (4) the shoulders should be even; (5) the head should be positioned without tilting up, down, or to one side, and the nose should be directly above the navel; (6) the teeth and lips should rest naturally; (7) the tongue should touch the palate; and (8) the respiration should not be audible, violent or agitated; rather it should by all means proceed slowly, effortlessly and without sensing the exhalation and inhalation. Thus, practice at the outset with the eight aspects of the posture and especially with the breath flowing quietly as explained.

> COMMENTARY: The Indo-Tibetan Buddhist tradition places considerable emphasis on the importance of the posture for meditation due to the intimate relationship between the body and mind. The vital energies in the body, of which there are various classifications, are regarded as playing a crucial role in this regard; and there is a general aim—implicit in the Sūtrayāna, but explicit in Vajrayāna—to direct these energies into the "central channel,"* which runs vertically up the

center of the torso to the crown of the head. The above posture—with special emphasis on keeping the torso straight—is specifically designed to facilitate that withdrawal of vital energies into the central channel, which results in effortless freedom from ideation, clarity of attention, and physical well-being.[17]

The vital energies are also closely associated with the breath as well as the mind. If one of these three is agitated, the other two are bound to be effected similarly; and if one is calmed, this will tend to have a soothing effect on the other two. Thus, Tsongkhapa here encourages the meditator to calm the respiration as a means of soothing the body and mind.

☐☐☐ *ii.* AN EXPLANATION OF THE STAGES OF
 MEDITATION

In most of the expositions of the stages of the path it is said that quiescence is accomplished by way of the eight interventions* that eliminate the five faults* as taught in the *Madhyāntavibhāga*. In the practical instructions of the lineage stemming from Geshe Laksor[18] it is said that in addition to that you should practice the six powers,* the four mental engagements, and the nine attentional states* explained in the *Śrāvakabhūmi*. In the *Mahāyānasūtrālaṃkāra* and the *Madhyāntavibhāga* the venerable Maitreya also discusses the nine methods for sustaining attention and the eight eliminative interventions. And following him, such Indian sages as the master Haribhadra, Kamalaśīla, and Śāntipa set forth many stages in achieving *samādhi*, and those should also be known in the Mantra[yāna].[19] In particular, such problems as the five faults in *samādhi* and the

[17] For a detailed account of the influence of each of the above points of the posture see the section "The Physical Posture" in Karma Chagmé's *Spacious Path to Freedom: Practical Instructions on the Union of Mahāmudrā and Atiyoga.* Gyatrul Rinpoche, comm., B. Alan Wallace, trans. and ed. (Ithaca: Snow lion, 1997).

[18] dGe bshes lag sor

[19] This is a synonym of Vajrayāna.

means of dispelling them are elaborately presented in the *sūtra* literature.

Here there are two sections: (I) the way to develop flawless *samādhi*, (II) the stages of sustained attention that arise on that basis.

☐☐☐ I). THE WAY TO DEVELOP FLAWLESS SAMĀDHI

Here there are three sections: (A) what to do before focusing the attention on the object, (B) what to do while focusing on the object, and (C) what to do after focusing on the object.

☐☐☐☐ A). WHAT TO DO BEFORE FOCUSING THE ATTENTION ON THE OBJECT

If you were unable to put a stop to spiritual sloth, in which you take no delight in cultivating *samādhi* and are attracted to its opposite, right from the beginning this would prevent you from entering into *samādhi;* and even if you were once to succeed, you could not sustain it, so it would swiftly degenerate. For this reason it is essential to counter it at the outset. Now if pliancy is achieved, which is enhanced by physical and mental pleasure and joy, throughout the day and night there is no depression or fatigue in applying yourself to virtue; so this counteracts spiritual sloth. To develop that, you must be able constantly to maintain enthusiasm* for *samādhi*, which is the cause of generating pliancy. To develop that, there must be the strong, constant yearning* of aspiring for *samādhi*. Since the cause of that is seeing the virtues of *samādhi*, firm, enthralling faith* is necessary; so repeatedly cultivate faith, reflecting on the virtues of *samādhi*.

The *Madhyāntavibhāga* states, "The basis and that which is based thereon, the cause and its effect."[20] Here the *basis* is yearning, which is the basis of striving;* *that which is based thereon* is the striving or enthusiasm. The cause of yearning is faith that believes in the excellent qualities. The effect of striving is pliancy.

These are the excellent qualities of the *samādhi* that is to be

[20] Ch. IV: vs. 5a–b.

cultivated: if quiescence is accomplished, pleasure fills the mind and joy saturates the body, so here and now you dwell in joy. Due to discovering physical and mental pliancy, the attention is ready to be voluntarily applied to any virtuous object; and since distraction towards mistaken objects is automatically calmed, not much misconduct occurs, and all virtuous deeds become powerful. Moreover, on the basis of quiescence you can accomplish such virtues as extrasensory perception* and paranormal abilities;* and in particular, on that basis there arises realization of insight that comprehends emptiness, so you can swiftly sever the root of *saṃsāra.*

Thus, understand and meditate on such virtues that increase the power of your inspiration for cultivating *samādhi.* If this arises, it stimulates you from within to cultivate *samādhi.* Thus, *samādhi* is easily achieved; and even after it is achieved, you repeatedly engage in it, so it is difficult for it to degenerate.

COMMENTARY: In terms of the immediate preparations for cultivating quiescence, Tsongkhapa first addresses the obstacle of spiritual sloth.[21] This is a mental process that is uniquely drawn to fleeting, pleasurable stimuli, and is disinclined to virtue. It is regarded in Buddhism as a basis for mental afflictions and as incompatible with all virtues. Indo-Tibetan Buddhist psychology[22] lists four kinds of spiritual sloth: (1) spiritual sloth of false mental engagement;* which sees no need to practice Dharma; (2) self-deprecating spiritual sloth,* a kind of depression that sees the possibility of

[21] The following account of spiritual sloth is drawn from Blo bzang rgya mtsho, *Rigs lam che ba blo rigs kyi rnam bzhag nye mkho kun btus,* p. 158.

[22] For simplicity's sake I have used this general term in this context to denote the system of Buddhist psychology adopted by Tsongkhapa and the Gelugpa order. In the monastic training of this order, the study of the mind and the mental processes is chiefly based on Asaṅga's *Abhidharmasamuccaya,* although Vasubandhu's *Abhidharmakośa* is also studied. The study of perception, inference, and other epistemological topics largely follows the works of Dignāga and Dharmakīrti. The Indo-Tibetan Buddhist psychology presented in this work is based on the writings of Asaṅga and Dharmakīrti, except where their views differ from the Prāsaṅgika tenets held by Tsongkhapa.

practicing Dharma but regards oneself as incapable of engaging in virtue; (3) procrastinating spiritual sloth* that sees oneself as capable of practicing Dharma but puts it off; and (4) spiritual sloth that sees the need of practicing Dharma now, but is overcome by attachment to non-virtuous behavior.* Thus, as this notion of spiritual sloth is so directly related to the practice of Dharma, it is misleading to render this term simply as "laziness," for even a person who is very energetic and ambitious in a worldly sense may well be dominated by any of the four kinds of spiritual sloth.

The approach that Tsongkhapa encourages for counteracting spiritual sloth follows the progression from faith to yearning, to striving (or enthusiasm), and finally to pliancy, which directly counteracts spiritual sloth. Faith is a mental process that uniquely takes delight in freedom from the contaminations of mental afflictions; and since it acts as the basis of yearning for virtue, it is regarded as the entrance to all virtues.[23] Yearning is a mental process that has the unique characteristic of aspiring for an object that is brought to mind.[24] Although enthusiasm is closely associated with striving, the former has the added connotation of taking delight in virtuous conduct, while mere effort, or striving, is not necessarily associated with virtue or delight. On the other hand, delight in non-virtuous behavior is classified as the fourth kind of spiritual sloth listed above.[25]

The above progression culminating in pliancy is said to bring forth a quality of mental and physical pleasure and joy that the Buddha says is to be cultivated, developed, and practiced, and is not to be feared.[26] Pleasures derived from sensual gratification and other objective stimuli, on the other hand, are to be shunned and feared by the aspiring contemplative. The reasons for this may be twofold. Firstly, such

[23] Cf. Śāntideva, *Śikṣā-samuccaya*, trans. Bendall and Rouse, pp. 3–5.

[24] Blo bzang rgya mtsho, *Rigs lam che ba blo rigs kyi rnam bzhag nye mkho kun btus*, p. 133.

[25] Ibid., p. 139–140.

[26] M. II, 454. S. IV, 225–28.

pleasures can never yield the fulfillment and enduring satis-
faction consciously sought by the aspiring contemplative; so
they arise as distractions that divert one's attention away
from the quest for the mental balance and purification that
alone can fulfill that yearning. Secondly, as a result of assidu-
ously seeking after transient, objectively stimulated pleasures,
one's own mental afflictions are bound to be aroused, leading
to non-virtuous behavior and its resultant harmful results.
Thus, instead of dispelling the inner hindrances that cause
one's own mind to be dysfunctional and subject to misery, in
the misguided pursuit of happiness one hastens after objects
that cannot fulfill one's desire, while, at the same time, aggra-
vate the inner causes of one's dissatisfaction and distress.

The Indo-Tibetan Buddhist tradition also claims that on
the basis of such mental and physical fitness one may
develop various kinds of extrasensory perception and para-
normal abilities. Tsongkhapa mentions such abilities almost
casually, without trying to substantiate this claim with scrip-
tural authority, reasoning, or empirical evidence. The slight
emphasis he places on them is due to the common Buddhist
view that mundane extrasensory perception and paranormal
abilities, although of some benefit in serving the temporal
needs of others, are inadequate as means for identifying the
source of suffering and eradicating it. Nevertheless, one of
the secondary Bodhisattva vows is to apply oneself to the cul-
tivation of *samādhi*,[27] and another is to not to refuse to dis-
play one's paranormal abilities if this would be of benefit to
others.[28] The assertion that such abilities are natural byprod-
ucts of developing *samādhi* was considered in Tsongkhapa's
time and place to be such common knowledge—for which
both scriptural authority and empirical evidence were triv-
ially obvious—that Tsongkhapa simply mentions this point
without attempting to justify it.

[27] Asaṅga's Chapter on Ethics with the Commentary of Tsong-Kha-Pa, *The Basic
Path to Awakening*, The Complete Bodhisattva, trans. Mark Tatz (Lewiston: Edwin
Mellen Press, 1986) Studies in Asian Thought and Religion, Vol. 4, pp. 225–27.

[28] Ibid. p. 238.

☐☐☐☐☐ B). WHAT TO DO WHILE FOCUSING ON THE
OBJECT

Here there are two sections: (1) determining the object that is
the basis on which the attention is focused; and (2) the method of
directing the attention to that.

☐☐☐☐☐☐ 1). DETERMINING THE OBJECT THAT IS
THE BASIS ON WHICH THE ATTENTION
IS FOCUSED

Here there are two sections: (a) a general presentation of med-
itative objects; and (b) determining the object for this context.

☐☐☐☐☐☐☐ A). A GENERAL PRESENTATION OF
MEDITATIVE OBJECTS

Here there are two sections: (i) a presentation of actual medi-
tative objects; and (ii) a presentation of the appropriate objects
for specific individuals.

☐☐☐☐☐☐☐☐ i). A PRESENTATION OF ACTUAL
MEDITATIVE OBJECTS

Among the contemplative objects taught by the Lord, there are
four pervasive objects: (1) [an object] attended to without analysis;
(2) an object of analysis; (3) the limits of ontological and phenom-
enological realities; and (4) achieving basic transformation[*29]
through meditation in which you attend to ontological and phe-
nomenological realities by way of the preceding two methods of
meditation, thereby accomplishing what is needed.[30]

With respect to meditative objects for purifying conduct, there
are the five meditative objects of unpleasantness,[31] love,[32] depen-

[29] This term, originally used within the Yogācāra context, refers to the fundamen-
tal transformation from delusion to purity.

[30] Cf. John Powers, *Two Commentaries on the Saṃdhinirmocanas-sūtra* by *Asaṅga
and Jñānagarbha*, p. 69.

[31] Cf. Louis de La Vallée Poussin, *Abhidharmakośabhāṣyam* (Berkeley: Asian
Humanities Press, 1991) English trans. Leo M. Pruden, Vol. III, pp. 916–920.

[32] Ibid., Vol. IV, pp. 1269–270.

dently related events, distinctions among the constituents, and the respiration,[33] which respectively counteract strong tendencies in former lives for attachment,* hatred,* delusion, pride,* and ideation.

There are also five meditative objects of expertise: the aggregates, the elements, the sense bases, the twelve links of dependent origination, and possibility and impossibility.[34]

There are two meditative objects that purify mental afflictions: the tranquil and gross aspects of higher and lower planes,[35] and the sixteen aspects, such as impermanence, of the Four Truths.[36]

The meditative objects for purifying conduct make it easy to overcome the attachment, etc. of those who especially behave with attachment, etc.; and on that basis it is easy to achieve *samādhi*, so these are special meditative objects. The meditative objects of expertise negate a personal identity that is not included among those phenomena. Thus, since they facilitate the birth of insight that realizes identitylessness, they are excellent objects for quiescence. The meditative objects that purify mental afflictions are very significant, for they serve as general antidotes for mental afflictions. The pervasive meditative objects do not exist separately from the preceding objects. Therefore, *samādhi* should be accomplished in dependence upon objects of quiescence that have a special purpose; so those who practice *samādhi* using such things as a pebble or stick as the basis of meditation are obviously unaware of the system of the objects of *samādhi*.

[33] Ibid., Vol. III, pp. 925–29.

[34] This refers to the possibility of pleasant results arising from virtuous action and the impossibility, in the long-term, of pleasant results arising from non-virtuous action.

[35] These refer to the relative grossness and subtlety of the of the desire realm relative to the form realm, the form realm relative to the formless realm, and to more basic levels of meditative stabilization relative to more advanced ones within the form and formless realms.

[36] For a brief account of the sixteen aspects of the Four Noble Truths see Louis de La Vallée Poussin, *Abhidharmakośabhāṣyam* (Berkeley: Asian Humanities Press, 1991) English trans. Leo M. Pruden, Vol. IV, pp. 1110–1116.

COMMENTARY: In the corresponding presentation in Tsongkhapa's *Great Exposition of the Stages of the Path*[37] he explains that the first of the four kinds of pervasive object (1) is a mental image on which, for the purpose of developing quiescence, the attention is focused without analysis; the second kind (2) is a mental image on which, for the purpose of developing insight, the attention is focused and accompanied with conceptual analysis. Thus, this twofold classification is made in terms of the type of attention that is focused on the meditative object.

The classification of the third type of pervasive object (3) is made in terms of the meditative object itself. The phenomenological limit of reality signifies the demarcation that distinguishes between what does and does not exist. Specifically, all composites are said be included among the five aggregates; all phenomena are included among the eighteen constituents and the twelve sense-bases; and all knowable entities are included within the Four Noble Truths. Nothing else exists. The ontological limit of reality signifies that phenomena may exist in a certain manner and in no other. This limit, which represents the real nature of phenomena, is to be established through reasoning.

The classification of the fourth type of pervasive object (4), namely, accomplishing what is needed, is made in terms of the result. Specifically, by repeatedly meditating on the mental images of the above objects, using the methods of quiescence and insight, one is freed from one's dysfunctions and experiences basic transformation.

Since Tsongkhapa mentions the above classifications of meditative objects only in passing, they will not be further explicated here.[38] The point of these erudite references on Tsongkhapa's part is to demonstrate the breadth of the

[37] *Lam rim chen mo*

[38] An extensive discussion of these classifications of meditative objects is presented in Geshe Gedün Lodrö, *Walking Through Walls*, Chs. 5 and 6.

Buddhist disciplines for cultivating quiescence. He dismisses
the usage of such objects as a pebble or a stick, not on the
grounds that quiescence cannot be achieved with such medi-
tative objects, but because they have none of the significance,
or special benefits, that are attributed to the range of objects
he cites.

As Tsongkhapa points out later on, quiescence cannot be
accomplished simply by focusing the attention on a visual
object; rather, the actual object of *samādhi* must be a direct
object of mental, not sensory, consciousness. The reason that
samādhi is not accomplished in sensory consciousness, but in
mental consciousness, is that the potency of attentional sta-
bility and clarity is maximized only when the attention is
drawn inwards, away from physical sense-objects.
Nevertheless, the cultivation of quiescence may *begin* with
focusing the attention on a physical object, then develop fur-
ther by attending to a mental image of that object.

□□□□□□□□ i). A PRESENTATION OF THE APPROPRIATE OBJECTS FOR SPECIFIC INDIVIDUALS

According to "The Questions of Revata,"[39] [in the
Śrāvakabhūmi] individuals with a dominant tendency for [one of
the five afflictions from] attachment to ideation should use as
their basis of meditation [the five objects ranging] respectively
from unpleasantness to the respiration. Those with balanced
behavior and those with slight mental afflictions may hold their
attention upon any of the previously mentioned objects that they
like. They do not need to focus on any one in particular.

Concerning a predominance of any of the five [afflictions] such
as attachment, due to habituation to attachment, etc. in previous
lifetimes, the five [afflictions] such as attachment arise for a
long time towards even a slight object of those five. Concerning
people with balanced behavior, even if they are not habituated to
attachment, etc. in previous lifetimes, they do not regard those
[afflictions] as disadvantageous. Thus, even though attachment,

[39] *Nam grus zhus pa*

etc. do not arise for a long time with respect to their objects, they are not absent altogether. People with slight mental afflictions have not habituated themselves to attachment, etc. in other lifetimes, and they have regarded them as disadvantageous and so on. Thus, even towards objects of attachment, etc. that are strong and plentiful, attachment and so forth are slow to arise; and towards medium and slight objects, they do not arise at all.

Moreover, people who are dominant in any of the five [afflictions] such as attachment take a long time to accomplish sustained attention; those with balanced conduct do so without taking a very long time; and those with slight mental afflictions succeed quickly.

> COMMENTARY: Tsongkhapa here returns to a classification of meditative objects based on psychological dispositions. He lists five psychological types: individuals with dominant tendencies towards (1) attachment, (2) hatred, (3) delusion, (4) pride, and (5) ideation; and the specific meditative objects for each type is, respectively, (1) unpleasantness, (2) love, (3) dependently related events, (4) distinctions among the constituents, and (5) the respiration.
>
> 1. Attachment is a mental affliction that by its very nature superimposes a quality of attractiveness upon its object and yearns for it.[40] It distorts the cognition of that object, for attachment exaggerates its admirable qualities and screens out its disagreeable qualities. The meditative object prescribed to counteract attachment (especially for one's own or others' bodies) is unpleasantness, referring specifically to the individual components of the human body and to the stages of deterioration of a human corpse.
> 2. Hatred[41] is a mental affliction that by its very nature

[40] Blo bzang rgya mtsho, *Rigs lam che ba blo rigs kyi rnam bzhag nye mkho kun btus*, p. 145.

[41] I am treating the Tibetan term *zhe sdang* (Skt. *dveṣa*) here as being synonymous with *khong khro* (Skt. *pratigha*), which I translate as "anger."

aggressively attends either to an object that inflicts harm, or to the manner in which one is harmed, or to the source of harm, thereby disturbing one's mind-stream.[42] The prescribed remedy is the cultivation of love, in which one wishes for the well-being of all sentient beings, including friends, foes, and neutral individuals.[43]

3. Delusion is a mental affliction that either actively misconceives the nature of reality or else obscures reality due to its own lack of clarity. For example, delusion may indistinctly apprehend the individual, dependently related events in one's body and mind, and then falsely impute upon them an intrinsically existent self. The prescribed remedy is to attend to phenomena that dependently arise in the past, present, and future, with the recognition that there is no agent of actions or experiencer of results apart from just those phenomena.

4. Pride is a mental affliction, based upon delusion, that uniquely clings to oneself or that which belongs to oneself in a conceited or haughty manner.[44] It is deluded, for it is based on the conception of one's mental and physical aggregates as being intrinsically "I" or "mine." The prescribed remedy is to attend to the distinctions of the six constituents of earth (solidity), water (fluidity), fire (heat), air (motility), space, and consciousness, recognizing that none of them are intrinsically "I" or "mine."

5. Ideation* is a specific type of conceptualization, which has the general characteristic of apprehending its main object by way of an idea* of it.[45] While conceptualization is indispensable for such mental functions as

[42] Ibid., p. 145–46.

[43] For a thorough treatment of this practice see Buddhaghosa, *The Path of Purification*, trans. Bhikkhu Ñāṇamoli, Ch. IX:1–176, pp. 321–340.

[44] Blo bzang rgya mtsho, *Rigs lam che ba blo rigs kyi rnam bzhag nye mkho kun btus*, p. 146.

[45] Lati Rinbochay, *Mind in Tibetan Buddhism*, trans. and ed. Elizabeth Napper (Valois: Gabriel/Snow Lion, 1981), p. 33.

memory and inference, in Buddhist literature the term *ideation* normally carries a negative connotation, suggesting a compulsive, at times chaotic, outflow of discursive thought. The prescribed remedy for compulsive ideation is to attend to the respiration, for example by counting each inhalation and exhalation.[46]

□□□□□□ b). DETERMINING THE OBJECT FOR THIS CONTEXT

On the basis of which object is quiescence practiced in this context? In general, the meditative objects for individual people are as explained previously. In particular, it is essential that those who are dominated by ideation meditate on the respiration. On the other hand, following the lead of the *Pratyutpanna-buddha-sammukhāvasthita-samādhi-sūtra* and the *Samādhirājasūtra,* the *Intermediate* and *Final Bhāvanākramas* promote the practice of *samādhi* focusing on the body of the Tathāgata; and Bodhibhadra's instructions on practicing *samādhi* by focusing on the Buddha's body are cited in the *Bodhipathapradīpa.*

Holding the attention on the body of the Buddha entails recalling the Buddha, resulting in limitless spiritual power; and if the image* of that body is vivid and stable, using it as a meditative object has the great distinction of serving as a devotional object for accruing spiritual power by means of prostrations, offerings, prayers, and so on, and as a devotional object for purifying obstructions by means of confession, restraint, and so forth. Moreover, at the time of death there are advantages such as the non-deterioration of the recollection of the Buddha; and if the path of Mantra[yāna] is cultivated, there are special advantages for deity *yoga,* etc., so there appear to be many advantages to this. Use this as the basis of meditation, as the *Samādhirājasūtra,* states, "The Lord of the World is adorned with a body like the color of gold, and the mind focused on that object is called the *meditative equipoise of a Bodhisattva.*"[47] Between the two alterna-

[46] For a thorough presentation of this practice see Buddhaghosa, *Path of Purification,* trans. Bhikkhu Ñāṇamoli, pp. 285–316.

[47] Ch. IV:13.

tives of imagining this as something freshly created by the mind
or as something naturally present, the latter has a distinct advan-
tage for the arising of faith, and since it accords with the shared
context of the [various] vehicles, adopt the latter.

 In terms of seeking the basis of meditation, which is the basis
on which the attention is first maintained, look for a fine image of
the Buddha, such as a painting or statue; gaze at it repeatedly, and
holding its characteristics in mind, accustom yourself to its
appearance as a mental object. Alternatively, seek the basis of
meditation by hearing a description from a spiritual mentor,*
reflect on what you have heard, and make this appear to your
mind's eye. Furthermore, do not relate to the basis of meditation
in its aspect as a painting, a statue, and so on; rather, practice see-
ing it in the aspect of the actual Buddha.

 The master Yeshe Dey[48] is perfectly correct in refuting the
meditation practice of some people who practice with the eyes
open, staring at a statue placed in front of them; for *samādhi* is
not accomplished in sensory consciousness, but in mental con-
sciousness, so the actual object of *samādhi* is a direct object of
mental consciousness upon which the attention must be main-
tained. And, as explained previously, it is said that you must focus
on the appearance of the idea or image of the meditative object. It
is said elsewhere that in terms of the gross and subtle features of
the body, first focus on the gross, and when [the attention is] sta-
bilized there, then focus on the subtle. Moreover, experientially it
is very easy to visualize the gross features, so the basis of medita-
tion should progress from gross to subtle. In particular, if you are
practicing until genuine quiescence is accomplished, it is inadvis-
able to shift around to many dissimilar objects; for if you cultivate
samādhi while roving to many different objects, this will become
a great obstacle to accomplishing quiescence. Āryasūra states:

> Stabilize the mind's thoughts by stabilizing on a single meditative
> object. By roving to a multitude of objects the mind is disturbed by
> afflictions.[49]

[48] Ye shes sde. Yeshe Dey was a great translator and student of Padmasambhava,
Śrī Siṃha and Śāntarakṣita, and both a student and teacher of Vimalamitra. It has

And the *Bodhipathapradīpa* states, "Settle the mind on virtue with respect to a single meditative object."[50] Here the emphasis is on the phrase *to a single.*

Thus, this is the criterion for initially having found the basis of meditation on which the attention is maintained: sequentially visualize a couple of times the head, the two arms, the color of the rest of the body, and the two legs. Finally, when the entirety of the body is brought to mind, if you are able to see just some fraction of the gross components, even without radiant clarity, be satisfied with just that, and maintain your attention there. Now if you are not content with that alone and do not maintain the attention, but rather visualize it again and again out of a desire for greater clarity, the object will become clearer; but not only will you fail to attain stable *samādhi*, this will act as an obstacle to that goal. Even though the object may be partially unclear, if the attention is maintained on just some portion, *samādhi* will swiftly be attained; and then with the derived benefit of vividness, clarity will easily be accomplished. This stems from the practical instructions of the master Yeshe Dey, and it is crucial.

Now hold onto the entirety of the body as well as you can, and if some portions of the body appear clearly, hold onto them. If they become unclear, hold onto the entirety again. At that time it may happen that you want to visualize yellow, but a color such as

been said that he used the name Yeshe Dey for his *sūtra* translations, and used the name Vairocana for his *tantra* translations [Cf. Jeffrey Hopkins, *Meditation on Emptiness*, (London, Wisdom, 1983), pp. 533–34]. However, while citing individual instructions of Padmasambhava, Karma Chagmé (Kar ma chags med) clearly shows that there were two disciples of Padmashambhava by the names of Yeshe Dey and Vairocana. [Cf. Kar ma chags med, *Thugs rje chen po'i dmar khrid phyag rdzogs zung 'jug thos ba don ldan* (Bylakuppe: Nyingmapa Monastery, 1984), pp. 654–657.] Yeshe Dey was instrumental in disseminating in Tibet the "Mental Class" *(sems sde)* and "Expanse Class" *(klong sde)* of the Atiyoga teachings. Cf. Yeshe Tsogyal, *The Lotus-Born: the Life Story of Padmasambhava*, trans. Erik Pema Kunsang (Boston: Shambhala, 1993), pp. 113–15, 292, 297; Gos lo tsva ba gzon nu dpal, *The Blue Annals*, trans. George Roerich (Delhi: Motilal Banarsidass, 1988), pp. 107, 168.

[49] This statement appears in Ārysūtra's *Pāramitāsamāsa*, ed. A . Ferrari, in *Annali Lateranensi*, vol. X (1946), Ch. V:12.

[50] vs. 40.

red appears; or you want to visualize a seated form, but there appears a standing form, etc.; or you want to visualize a single form, and two or more forms appear; or you want to visualize something large, and something small appears. When such things as size, number, and so on get mixed up, it is inadvisable to go along with this; so use as the basis of meditation only your primary object, whatever it may be.

Within the context of practicing secret Mantra[yāna] deity *yoga,* you must bring forth a clear image of the deity, so until that appears, many methods must be employed to generate that. But here, if it is difficult to see the aspects of the deity, *samādhi* may also be accomplished by maintaining the attention on any of the meditative objects presented earlier, or by settling it in the view that ascertains thatness; for the achievement of quiescence is the chief aim.

> COMMENTARY: Although Tsongkhapa centers the rest of his discussion of quiescence on the practice of focusing on an image of the Buddha, or the Tathāgata, he begins this section with yet another reference to attention to the breath as a means of calming ideation; for the mind that is inundated with compulsive ideation will find it very difficult to visualize anything, and the effort to sustain attention upon a visualized image may lead to debilitating tension and nervous exhaustion. Thus, in the Tibetan tradition meditators are often encouraged to spend at least a short time attending to the breath before commencing other types of meditation.
>
> Mahāyāna Buddhism as a whole, including both the Pāramitāyāna and the Mantrayāna, asserts that Buddha Śākyamuni was an embodiment of the Dharmakāya, an omnipresent, divine consciousness endowed with infinite knowledge, compassion, and power. According to this theory, when the Buddha passed into *nirvāṇa,* his physical body returned to the elements, but the Buddha's enlightened consciousness remains immanently present throughout the universe, spontaneously appearing in innumerable forms according to the needs and receptivity of sentient beings.

This assertion forms the theoretical basis of the Indo-Tibetan Buddhist devotional practices of making prostrations, offerings, prayers, confession, and so on to the Buddha. An image of the Buddha is placed upon one's altar and used as an object of devotion in order to bring to mind the qualities of the Buddha, especially his benevolent immanence. Likewise, if one visualizes the Buddha, this visualization is simply an image created by one's own mind on the basis of memory; and yet since the Buddha is believed to be omnipresent, he would be present in this visualized image as well. Thus, Tsongkhapa suggests that one focus on this actual, divine presence, rather than simply on the visualized representation of the Buddha.

The above belief is common to both the Pāramitāyāna and the Mantrayāna, but the latter goes a step further in asserting that it is only due to mental obscurations that people fail to recognize that their own minds are in reality none other than the Dharmakāya, and their own bodies are in reality embodiments of the Dharmakāya. To cut through ordinary, deceptive appearances stemming from ignorance, one practices deity *yoga*, in which one assumes the "divine pride"* of being a Buddha and regards all appearances as pure expressions of the Dharmakāya. This includes imagining one's own body in an idealized, enlightened form, such as that of Mañjuśrī, the embodiment of enlightened wisdom, or Avalokiteśvara, the embodiment of enlightened compassion. Before employing such extensive meditative imagination, it is essential that one recognize the conceptually contrived nature of one's ordinary experience of reality—including one's own identity, one's body, mind, and the environment. For without an understanding of the emptiness of inherent nature of all phenomena—*including those imagined in the practice of Mantrayāna*—the practice of deity *yoga* is reduced to an absurd fantasy.[51]

[51] For a fuller account of deity *yoga* see H.H. the Dalai Lama, Tsong-ka-pa, and Jeffrey Hopkins, *Tantra in Tibet* (Ithaca: Snow Lion, 1977), pp. 117–128.

In the practice of deity *yoga* it is essential that one's visualizations from the outset be as vivid as possible, and for this purpose there are various techniques taught within the Mantrayāna, particularly by manipulating specific vital energies in the body. But in the Pāramitāyāna approach that Tsongkhapa is teaching here, the initial emphasis must be on attentional stability and not on radiant clarity. The reason for this, as he points out, is that the repeated efforts to enhance clarity will in fact disrupt the mental calm initially needed to bring about attentional stability. Thus, premature insistence on radiant clarity yields only fleeting success in clarity, while undermining stability. On the other hand, once attentional stability is well maintained, clarity arises with very little effort.

Due to a predominance of compulsive ideation or to such afflictions as attachment, hatred, delusion, or pride, it may be very difficult for the image of the Buddha to appear to the mind's eye. Indeed, if one forcefully concentrates the mind that is dominated by such obstacles, this may lead to an aggravation of those very problems: increased tension may result in rampant, agitated ideation; or the mind may become obsessed with sensual fantasies, resentments, mental fabrications, or illusions of self-importance. In short, attentional training designed to balance the mind may, if followed without discernment, result in greater mental imbalance.

In light of Tsongkhapa's earlier emphasis on the necessity of cultivating quiescence before insight, it is remarkable that he closes the above section with the suggestion that, instead of focusing on a Buddha-image, some people might find it more effective to accomplish quiescence by settling their attention in the view that ascertains thatness. With this comment he leaves open the possibility that in some cases quiescence may be cultivated simultaneously with insight into thatness. The late, eminent Tibetan Buddhist scholar Geshe Gedün Lodrö, of the Gelugpa order founded by Tsongkhapa, acknowledges that it is possible to develop quiescence with emptiness as one's meditative object. However,

he emphasizes that this is generally extremely difficult, which is the reason why the *Bhāvanākrama* suggests using conventional phenomena as one's meditative object in this practice. On the other hand, the statement that this approach is extremely difficult does not mean that it must be difficult for everyone; indeed, for some people, he adds, this may be the easiest approach. This one must check out for oneself on an individual basis, optimally with the counsel of an experienced contemplative mentor.[52]

☐☐☐☐☐☐ *2*). THE METHOD OF DIRECTING THE ATTENTION TO THAT OBJECT

Here there are three sections: (a) a presentation of a flawless technique, (b) a refutation of a flawed technique, and (c) instructions on the duration of sessions.

☐☐☐☐☐☐☐ A). A PRESENTATION OF A FLAWLESS TECHNIQUE

The *samādhi* to be accomplished has two qualities: it has a potency of clarity in which the attention is extremely vivid, and it has a non-conceptual stability that is sustained single-pointedly upon the object. In this regard, some people make it three [qualities] by adding joy, and others make it four by adding limpidity. However, there are two kinds of limpidity. It may seem as if the limpidity of subjective awareness is even more limpid than that of a stainless crystal vessel filled with uncontaminated water into which the light of the sun, free of clouds, is shining. And when the image of an object, such as a pillar, appears, there may be such a limpidity that you feel as if you could count even the number of its atoms. Both of those arise due to developing and sustaining the potency of clarity in which even subtle laxity is eliminated, so there is no need to speak of them separately from the outset. Pleasure and joy in the sense of a feeling of well-being do occur as a result of the *samādhi* to be practiced within this context, but

[52] Lodrö, *Walking Through Walls*, pp. 141–42.

since they do not arise in conjunction with the *samādhi* comprised by the first proximate stabilization, they are not counted here.[53]

Laxity hinders the emergence of such potency of clarity, and excitation obstructs single-pointed non-conceptualization. Thus, those are the reasons why laxity and excitation are the chief obstacles to accomplishing pure *samādhi*. Therefore, if you do not properly recognize gross and subtle laxity and excitation, and if you do not know an effective way of sustaining *samādhi* that counteracts those two, then insight is out of the question. It would be impossible for even quiescence to arise, so sensible people aspiring for *samādhi* should become well-versed in that method.

Laxity and excitation are incompatible with accomplishing quiescence, and the recognition of those adverse factors as well as the actual means for counteracting them will be discussed later on. So here I shall discuss the way to develop *samādhi* in a manner conducive to the accomplishment of quiescence. *Samādhi* is the attribute of the attention being sustained single-pointedly upon its object, and this requires constantly remaining on the object.

In this regard a method is needed to prevent the attention from wandering away from its primary object, and you must correctly recognize whether or not the attention is distracted. The first entails mindfulness, and the second, introspection. The *Commentary on the Mahāyānasūtrālamkāra* states:

> Mindfulness and introspection are taught, for one prevents the attention from straying from the meditative object, while the second recognizes that the attention is straying.[54]

[53] Although mental and physical joy are experienced in conjunction with the pliancy that immediately precedes the accomplishment of the quiescence of the first proximate stabilization, these feelings subside with the onset of the first proximate stabilization itself. If one continues on to the accomplishment of the first basic stabilization, pleasure and joy are experienced again in conjunction with that *samādhi*.

[54] *Mahāyānasūtrālamkāra*, by Asaṅga, Sylvain Lévi, ed., (Paris, 1907) under XVIII:53. This commentary is Vasubandhu's *Mahāyānasūtrālamkāravyākhyā*.

If, upon the decline of mindfulness, the meditative object is forgotten, as soon as there is distraction the meditative object is dispersed; so mindfulness that does not forget the meditative object is primary.

Here is the manner in which mindfulness directs the attention upon the object: as explained previously, upon visualizing the basis of meditation, if it appears at least once, generate a powerful mode of apprehending it in which it is maintained with consciousness;* and with the attention at a high pitch, settle there without freshly analyzing anything. In the *Abhidharmasamuccaya* mindfulness is said to have three attributes: "What is mindfulness? The non-forgetfulness of the mind with respect to a familiar object, having the function of non-distraction."[55] Concerning (1) the attribute of the object, since mindfulness does not arise towards an object with which it is not already familiar, it says *a familiar object.*[56] In this context there appears the image of a basis of meditation that has already been ascertained. Concerning (2) the mode of apprehension, *the non-forgetfulness of the mind* refers to the aspect of the attention not forgetting the object; and in this context it is not forgetting the basis of meditation. The manner of non-forgetfulness does not refer simply to the ability to remember what was taught by your spiritual mentor, so that if asked by someone else and you put your mind to it, you can describe the basis of meditation. Rather, it is being constantly mindful of the object on which the attention has been fixed, without the slightest distraction. Insofar as the attention strays, mindfulness is dispersed. Therefore, after placing the attention upon the basis of meditation, bring forth the thought, "It is fixed upon the object like this"; and then without further conceptualization sustain the continuity without severing the strength of that very cognition.

[55] *Abhidharmasamuccaya*, Pradhan, ed., p. 6.6.

[56] This attribute of mindfulness implies that the Sanskrit term *smṛti* simultaneously bears the connotations of *mindfulness* as a crucial factor in the practice of meditation, and of *remembrance*, as a mental function common to meditators and non-meditators alike. The multiple uses of this term in Buddhist literature are discussed at length in the volume *In the Mirror or Memory: Reflections on Mindfulness and Remembrance in Indian and Tibetan Buddhism*, ed. Janet Gyatso.

This is an invaluable essential point of the method for applying mindfulness. (3) The attribute of its function is that it prevents the attention from straying away from the meditative object.

Thus, subduing the attention by fixing it upon a meditative object is taught using the analogy of subduing an elephant. For example, an untamed elephant is tied with many thick cords to a very solid tree trunk or pillar, and if it behaves according to the instructions of the elephant-tamer, well and good. If it does not, it is subdued by punishing it with repeated jabs with a sharp hook. Similarly, the attention which is like an untamed elephant is bound with the cord of mindfulness to the firm pillar of the meditative object that was discussed earlier; and if you cannot make it stay there, you incrementally gain control over it by pricking it with the hook of introspection. The *Madhyamakahṛdaya* states, "The elephant of the mind that goes astray is bound with the cord of mindfulness to the firm pillar of the meditative object, and it is gradually controlled with the hook of intelligence."[57] And the *Intermediate Bhāvanākrama* also states that *samādhi* is accomplished on the basis of mindfulness: "With the cord of mindfulness and introspection fasten the elephant of the mind to the trunk of the meditative object."[58]

Since it is said that mindfulness is used like a cord to fasten the attention continually to the meditative object, the principal way to accomplish *samādhi* is the cultivation of mindfulness. Furthermore, mindfulness entails a mode of apprehension qualified by ascertainment. So when *samādhi* is cultivated by focusing without

[57] Derge: dBu ma Dza 4.1.6. The text here reads "intelligence" (*shes rab, prajñā*) rather than "introspection," which is more commonly coupled with "mindfulness." Nevertheless, since introspection is regarded as a derivative of intelligence, it is not really incorrect to use this term in this context. The intelligence of which introspection is asserted to be a derivative is listed among the five object-ascertaining mental processes; and in this context, "intelligence" seems a more apt translation than the more common "wisdom." As a mental process, intelligence is a discriminating mental process that has the unique function of evaluating an object held with mindfulness. Its task is to arrive at certainty, and it is regarded as the root of all excellent qualities. Blo bzang rgya mtsho, *Rigs lam che ba blo rigs kyi rnam bzhag nye mkho kun btus*, p. 135. Geshe Rabten, *The Mind and Its Functions*, trans. Stephen Batchelor, pp. 63–64.

[58] Derge: dBu ma Ki 48.1.2-3.

a firm mode of apprehension of ascertaining consciousness,* limpid clarity of attention does ensue; but clarity does not emerge in which the potency of ascertaining consciousness unfolds. As a result, powerful mindfulness does not arise, and subtle laxity is also not stopped, so the *samādhi* becomes flawed.

Moreover, in the cultivation of mere non-conceptual attention, without focusing on any other basis of meditation such as the form of a deity, resolve, "I shall settle the mind without thinking about any object." Then without letting the attention become scattered, avoid distraction. Non-distraction, too, is identical with mindfulness that does not forget the meditative object, so it consists of nothing more than the cultivation of mindfulness. Therefore, in such meditation, too, mindfulness is cultivated in which the potency of ascertaining consciousness emerges.

COMMENTARY: As Tsongkhapa now begins explaining specific methods for cultivating quiescence, he emphasizes the indispensable role of sustained attention. The approach that he endorses to accomplish such *samādhi* centers on the vigorous implementation of mindfulness and introspection. The emphasis here is on maintaining strict control over the attention by sustaining it rigorously with mindfulness and monitoring the attention with introspection. In short, in the early stages of this training lapses in the continuity of attention are curbed with the swift intervention of introspection, in accordance with the analogy of punitively jabbing a wild elephant with a sharp hook.

To bring forth powerful mindfulness and the potency of clarity, Tsongkhapa insists that the mind must firmly apprehend, or ascertain, its meditative object. Otherwise, there is the danger that as the attention is stabilized, the mind will become peacefully nebulous and stupefied due to the onset of laxity. However, in his closing comments in the above section, Tsongkhapa does allow for the possibility of developing quiescence through "the cultivation of mere non-conceptual attention, without focusing on any other basis of meditation." This technique, prominent in the meditative traditions of

Mahāmudrā[59] and Atiyoga,[60] is described concisely by
Paṇchen Lozang Chökyi Gyaltsen[61] (1570–1662):

> By generating the force of mindfulness and introspection, relent-
> lessly cut off all thoughts completely as soon as they arise, with-
> out letting them proliferate. After cutting off the scattering of
> ideation, while remaining without dispersion, immediately relax
> your inner tension without sacrificing mindfulness or introspec-
> tion. You must release within the nature of meditative equipoise,
> as Machik[62] says, "Intensely concentrate and gently release. Be
> present where the attention has been placed."[63]

In Tsongkhapa's above allusion to this technique, it seems
that the meditative object in this practice is a negation*[64]—
the absence of conceptualization and of distraction—and he
implies that this absence must be ascertained while develop-
ing *samādhi* in this way. Thus, a strict distinction must be
made, both in theory and in practice, between ascertaining a
negation and not ascertaining anything at all.

[59] For an excellent, detailed discussion of this meditative tradition see Takpo Tashi
Namgyal, *Mahāmudrā: The Quintessence of Mind and Meditation*, trans. Lobsang P.
Lhalungpa (Boston: Shambhala, 1986).

[60] The theory and practice of this tradition, more commonly known as "Dzogchen"
(rdzogs chen) are set forth in Tulku Thondup Rinpoche, *Buddha Mind: An Anthology
of Longchen Rabjam's Writings on Dzogpa Chenpo* (Ithaca: Snow Lion, 1989).

[61] Paṇ chen blo bzang chos kyi rgyal mtshan. One of the most eminent scholars
and contemplatives of the Gelugpa order, and the first of the Paṇchen incarnations
to be the head of Tashilhunpo Monastery.

[62] Ma gcig labs kyi sgron ma. Machik Labkyi Drönma (1062–1150) was one of the
most renowned and accomplished women contemplatives in the history of Tibetan
Buddhism.

[63] This citation is from the "Sems gnas pa'i thabs" section of Paṇchen Lozang
Chökyi Gyaltsen's *dGe ldan bKa´ brgyud rin po che'i bka' srol phyag rgya chen po'i
rtsa ba rgyas par bshad pa yang gsal sgron me.*

[64] Simply stated, a negation is a phenomenon that is apprehended by means of an
explicit process of eliminating an object of negation. In the above case, there
appear to be two objects of negation: conceptualization and distraction. For an
illuminating explanation of the nature, divisions, and role of negations in Indo-
Tibetan Buddhist philosophy see Jeffrey Hopkins, *Meditation on Emptiness*, pp.
721–27.

In order to focus on a negation there must be a conceptual process of identifying and eliminating that which is to be negated. In the above case the object to be negated is conceptualization. How then is one to escape the logical and practical conundrum of conceptually seeking to free the mind of conceptualization? In experience this technique leads first to a conceptual *simplification* of awareness: instead of the attention coming under the sway of a diversity of thoughts, it is controlled with one thought, namely to sever all other conceptualization. During the course of this training, as the mind is increasingly habituated to conceptual silence, the conceptual resolve to sustain such awareness becomes decreasingly prominent. The more the mind becomes accustomed to non-conceptuality, the less effort is needed to sustain this type of awareness; and when there is sustained, effortless, vivid awareness of non-conceptuality, the conceptual resolve to maintain this may fall away by itself.[65] At that point, the attention may be thoroughly non-conceptual.

□□□□□□ B). A REFUTATION OF A FLAWED
 TECHNIQUE

There is the following misconception concerning clarity: as explained previously, when consciousness is concentrated, bringing it to a high pitch,* and settled non-conceptually, you may see that although there is no laxity there is a high degree of excitation; so the capacity for continual stability does not manifest. And, seeing that as a result of a low pitch of awareness and very loose *samādhi*, stability swiftly arises, there are those who conclude

[65] Tsongkhapa explains the cultivation of insight into emptiness as a process of focusing on the mere absence of an inherent identity of a phenomenon. The initial insight into this emptiness, or mere absence, is conceptual; but he argues that by habituating oneself to this experience of emptiness—in conjunction with the prior achievement of quiescence—the *idea* of emptiness gradually fades out, and the realization of emptiness gradually becomes non-conceptual. The quiescence practice discussed here may parallel this experiential shift from conceptual to non-conceptual awareness, but Tsongkhapa strongly refutes the notion that the mere absence of conceptualization implies a realization of emptiness [*Byang chub lam rim che ba* (mTsho sngon mi rigs dpe skrun khang), p. 495].

that this is a fine technique; and they say, "The best relaxation is in the best meditation." However, this position fails to distinguish between the occurrence of laxity and the occurrence of meditation. Thus, since flawless *samādhi,* as explained before, must have two attributes,[66] the stability of non-conceptual attention alone is insufficient.

QUALM: In such a case, when there is a darkness in which the attention has become muddled, this is laxity; but without that, the *samādhi* is flawless due to the limpid clarity of attention.

RESPONSE: It seems you have failed to distinguish between lethargy and laxity, so I shall discuss these at a later point.

Therefore, when awareness is empowered with excessive concentration, there is clarity, but due to a predominance of excitation it is difficult to generate stability. And if you practice with excessive relaxation, there is stability, but due to a predominance of laxity there is no clarity in which its potency emerges. Moreover, since it is difficult to determine the suitable degree of tension, it is difficult for *samādhi* free of laxity and excitation to arise. With this in mind Candragomin declares:

> If I apply enthusiasm, excitation occurs, and if I dispense with it, depression arises. When it is so difficult to discover the appropriate level of engagement, what shall I do with my turbulent mind? [67]

And:

> If I engage with effort, excitation occurs, and if I relax, depression arises. When it is so difficult to practice the middle way, what shall I do with my turbulent mind? [68]

This points out that when enthusiasm is applied while firmly concentrating the attention, excitation occurs; and upon observ-

[66] Namely, non-conceptual attentional stability and attentional clarity.

[67] *Deśanāstava.* Derge: bsTod tshogs Ka 205.2.5

[68] Ibid. Derge: bsTod tshogs Ka 205.2.6–7.

ing this, if the strenuously engaged attention is relaxed and effort released, laxity arises in which the attention becomes inwardly depressed. Therefore, it is difficult to find the middle way free of the extremes of laxity and excitation, in which balanced attention is evenly sustained. Thus, it is said that if relaxation is given the highest priority, there is nothing in which to take pleasure, and from this laxity arises. For these reasons, it is incorrect to assert that *samādhi* is accomplished in that way.

Concerning the appropriate level of tension, when you examine this for yourself, consider, "If the pitch of awareness is elevated to this point, excitation definitely arises," and ease off from that level; and consider, "If it is settled right here, it is easy for laxity to arise," and apply yourself to a higher pitch. Ārya Asaṅga also points out within the context of the first two attentional states, "To focus and properly place the attention on that, there is concentrated mental engagement."[69] And the *First Bhāvanākrama* also says, "Having dispelled laxity, one should hold more firmly onto that meditative object."[70] If you practice without knowing the foregoing technique for applying mindfulness, no matter how much you meditate, many problems will occur, such as excessive forgetfulness and retardation of the wisdom that discriminates among phenomena.

QUALM: Well then, while the attention is fixed upon the meditative object with mindfulness, is it appropriate to monitor conceptually whether or not the object is being well apprehended?

RESPONSE: The *Intermediate Bhāvanākrama* says this should be done. However, this does not entail abandoning *samādhi* and then making such an inspection. Rather, while sustaining *samādhi*, observe whether the attention is remaining as it was originally placed upon the object; and if it is not, simply observe whether it has veered towards laxity or excitation. After settling in *samādhi*,

[69] This statement is found in the *Śrāvakabhūmi* in the discussion of the four mental engagements.

[70] *First Bhāvanākrama*, Tucci, ed., p. 206.

monitor it occasionally, avoiding excessively frequent or slow intervals. If this is done without exhausting the preceding strength of cognition, its potency grows; then it is necessary to sustain that potency for a long time and to recognize quickly laxity and excitation. Similarly, practicing while intermittently simply bearing in mind the prior meditative object serves as a necessary cause for engaging in powerful and continual mindfulness.

This way to cultivate mindfulness is taught in the *Śrāvaka-bhūmi* and the *Madhyāntavibhāgaṭīkā* says, "The statement 'Mindfulness is not forgetting the meditative object' refers to expressing mentally the instructions on sustaining attention."[71] The application of mindfulness is for the purpose of preventing distraction away from the meditative object, then forgetfulness of the meditative object. Thus, not forgetting the object entails mental expression of the meditative object, which is to say, repeated mental engagement with the object. As an analogy, out of fear of forgetting some things you have learned, if you repeatedly bring them to mind, they will be difficult to forget.

COMMENTARY: The central theme of this section is the indispensability of seeking the optimal pitch of attention by avoiding excessive relaxation and excessive tension. The pitch of attention corresponds to the frequency of moments of ascertaining cognition the higher the pitch, the greater the frequency. Or, in relation to the intervening moments of non-ascertaining cognition, or inattentive awareness, the pitch of attention corresponds to the density of moments of ascertaining versus non-ascertaining cognition.

The position of placing sole emphasis on relaxation is most often taken within the context of cultivating quiescence by settling the mind in mere non-conceptualization, without taking any positive phenomenon*[72] as one's meditative object

[71] Sthiramati, *Madhyāntavibhāgaṭīkā*, ed. Susumu Yamaguchi, p. 175, 7–8; and ed. R.C. Pandeya, *Madhyānta-Vibhāga-Śāstra*, pp. 131–32.

[72] This is an entity that is not apprehended through an explicit process of negation.

Tsongkhapa warns that abandoning the challenge of finding the optimal, median pitch of attention and settling for relaxation alone may lead to absent-mindedness and intellectual retardation. Although this flawed approach may result in the short-term increase of attentional stability—implying a greater homogeneity of moments of attentive cognition—there would be no heightening of the pitch of attention. Thus, lax attentional stability would be won at the expense of attentional clarity.

On the other hand, if one perseveres in maintaining the attention at an excessively high pitch, this may lead to a short-term increase in attentional clarity and elation; but in the process, the potency of cognition is exhausted, resulting in hypertension and, in extreme cases, functional psychosis. Depression and hypertension, the common symptoms of persevering in the above two extremes, are common traits of a dysfunctional mind; but the misguided cultivation of meditative stabilization exacerbates them, while the proper cultivation of quiescence dispels them.

There is no pre-determined formula for setting the optimal pitch of attention. Each individual must experientially determine this for himself, and this can be done only by recognizing the signs of excessive tension and slackness: the former results in excitation and the latter, in depression and laxity. Thus, the optimal, median pitch of attention is discovered simply by avoiding debilitating extremes. By discovering that median level of tension and maintaining the awareness at that pitch without exhausting the strength of one's initial cognition, the power of attention increases. It is only in this way that the cultivation of quiescence is brought to its culmination.

☐☐☐☐☐☐ C). INSTRUCTIONS ON THE DURATION OF SESSIONS

QUESTION: Is there or is there not a prescribed duration of sessions during which the attention is fixed upon the meditative object with mindfulness?

RESPONSE: In the great treatises, such as the *Śrāvakabhūmi*, there does not appear to be a clearly prescribed duration of sessions. However, the *Final Bhāvanākrama* says, "At this stage, one should remain for one *ghaṭikā*,*[73] one half *prahara*,*[74] one full *prahara*, or as long as one can." This is stated in the context of the duration of sessions for cultivating insight after already accomplishing quiescence, but evidently it is similar in the case of beginning the practice of quiescence.

If you intermittently bear the meditative object in mind and intermittently perform monitoring according to the previously explained way of cultivating mindfulness and introspection, there is no problem in having the sessions be short or long. However, for most beginners if the sessions are long, forgetfulness arises and one slips into distractions; and meanwhile the occurrences of laxity and excitation are not swiftly recognized, but are noticed only after a long time. Even if mindfulness is not relinquished, it is easy to fall under the influence of laxity and excitation; and laxity and excitation are not quickly recognized.

The former of those two cases impedes the arising of powerful mindfulness, and the latter obstructs the arising of powerful introspection, and this makes it difficult to cut off laxity and excitation. Specifically, forgetting the meditative object, becoming distracted, and failing to notice the occurrence of laxity and excitation are far worse than failing to notice quickly the occurrence of laxity and excitation, without forgetting the meditative object. Thus, as the antidote to counteract distraction and impaired mindfulness, the previously described way of cultivating mindfulness is important.

In the event of excessive absent-mindedness and impaired introspection that does not swiftly notice laxity and excitation, the sessions should be short; and if it seems that forgetfulness hardly arises and that you are able quickly to recognize laxity and excitation, there is no problem in letting the sessions go a bit longer.

[73] This equals twenty-four minutes.

[74] One full *prahara*, or watch, equals three hours. In the passage the Sanskrit makes no reference to one-half *prahara*, while the Tibetan does.

With this in mind, it is said that the duration, of one *ghaṭikā* and so on, is variable.

In short, since this should accord with your own mental capacity, it is said, "as long as you can." Furthermore, if temporary injury to the body and mind does not occur, remain in meditative equipoise; but if it does, do not obstinately continue meditating. Rather, clear out the constitutional obstacles, then meditate. This is the counsel of the wise. Know that practicing like that is ancillary to the length of the sessions.

> COMMENTARY: The duration of each meditation session is to be determined on the basis of one's own individual experience. First one must determine for oneself the optimal pitch of attention, then see how long this pitch can be maintained. If the session goes on too long, and the mind slips into laxity or unmonitored distraction, the potency of awareness will actually decline as a result of the meditation; but if the optimal pitch of attention is maintained, the potency of awareness increases. Primary emphasis in the early stages of this training is on developing the power of mindfulness, which is the indispensable basis for introspection. Tibetan oral tradition generally suggests that the beginning meditator should keep each session relatively short; and if one is devoting oneself fully to accomplishing quiescence, one should have many sessions each day.[75] As the power of mindfulness increases, the duration of each session is gradually increased and the number of sessions each day is gradually decreased.

☐☐☐☐☐ C). WHAT TO DO AFTER FOCUSING ON
THE OBJECT

Here there are two sections (1) what to do when laxity and excitation occur, and (2) what to do when laxity and excitation are absent.

[75] Cf. Gen Lamrimpa, *Śamatha Meditation,* trans. B. Alan Wallace (Ithaca: Snow Lion, 1992), pp. 76–77.

□□□□□ *1)*. WHAT TO DO WHEN LAXITY AND
EXCITATION OCCUR

Here there are two sections: (a) applying the antidote for fail-
ing to notice laxity and excitation, and (b) applying the antidote
for not endeavoring to eliminate them even though they are
noticed.

□□□□□□ A). APPLYING THE ANTIDOTE FOR
FAILING TO NOTICE LAXITY AND
EXCITATION

Here there are two sections: (i) the definitions of laxity and
excitation, and (ii) the way to develop introspection that recog-
nizes them while meditating.

□□□□□□□ i). THE DEFINITIONS OF LAXITY
AND EXCITATION

Excitation is described in the *Abhidharmasamuccaya:* "What is
excitation? It is an unpeaceful mental state, included in the cate-
gory of attachment, which follows after pleasant signs and which
acts as an obstacle to quiescence."[76] Here there are three aspects:
(1) Its object is an attractive and pleasant one; (2) its aspect is the
attention being unpeaceful and scattered outwards; and since it is
a derivative of attachment, it apprehends its object in the manner
of craving; (3) its function is to obstruct the attention from being
sustained on its object.

When the attention is inwardly fixed upon its object, excitation
with attachment to form, sound, and so on pulls the attention
helplessly to those objects and makes it stray. As it says in the
Deśanāstava:

> Just as you are focused on meditative quiescence, directing your
> attention to it repeatedly, just then does the noose of the mental afflic-
> tions pull [the attention] helplessly with the rope of attachment to
> objects.[77]

[76] *Abhidharmasamuccaya*, p. 9.9–10.

[77] Derge: bsTod tshogs Ka 205.2.4–5.

In many translations *laxity* is also rendered as *depression,* and some people consider laxity to be a lethargic mental state lacking in clarity and limpidity, that is sustained without being scattered to other objects. This is incorrect, for the *Intermediate Bhāvanākrama* and the *Saṃdhinirmocanasūtra*[78] state that laxity arises from lethargy. And the *Abhidharmasamuccaya*[79] discusses laxity within the context of the secondary mental affliction* of distraction. However, in the distraction discussed there, virtue may also be present, so it is not necessarily afflictive.* Therefore, in the *Abhidharmasamuccaya* and the *Commentary on the Abhidharmakośa*[80] lethargy is said to be a derivative of delusion that makes the body and mind feel heavy and malfunctional. Laxity occurs when the attention's apprehension of the meditative object is slack, and it does not apprehend the object with clarity or forcefulness; so even though limpidity may be present, if the apprehension of the object is not clear, laxity has set in. It is said in the *Intermediate Bhāvanākrama*:

> Like a person born blind, or a person entering a dark place, or like having one's eyes shut, the attention does not see the object clearly. At that time, know that the attention has become lax.[81]

I have not seen a clear presentation of the definition of laxity in any other of the great treatises.

With respect to laxity, there are both virtuous and ethically neutral [mental states], whereas lethargy is either a non-virtue or an ethically neutral obstruction,*[82] and it is invariably a derivative of delusion. Moreover, the great treatises state that in order to

[78] Cf. Lamotte, *Saṃdhinirmocana,* chap. VIII, in sect. 34, para. 3.

[79] *Abhidharmasamuccaya,* Pradhan, ed., p. 9.8.

[80] This is Vasubandhu's autocommentary on II, 26, and its quotation is drawn from the Vaibhāṣika book *Jñānaprasthāna.* Cf. Louis de La Vallée Poussin, *Abhidharmakośabhāṣyam,* English trans. Leo M. Pruden, Vol. I, p. 193.

[81] Derge: dBu ma Ki 47.2.7–48a.1.1.

[82] Such mental states do not accrue negative latent propensities that propel one to unfavorable states of rebirth, but they do obscure the mind and thereby obstruct one's development towards *nirvāṇa* and enlightenment.

dispel laxity, you should bring to mind pleasant objects such as the body of the Buddha, and meditate on light, thereby stimulating the mind. Therefore, upon dispensing with an unclear object, which is like darkness descending upon the mind, and with the cognitive apprehension that has deteriorated, you need both a clear meditative object and a forceful way of apprehending the object.

Excitation is easy to recognize, but since laxity is not clearly explicated in the great, authoritative treatises, it is difficult to understand, and it is crucial; for it is a major source of error concerning flawless *samādhi*. Therefore, as it says in the *Bhāvanākrama*, with precise cognition investigate this well and recognize it on the basis of your own experience.

> COMMENTARY: Tibetan Buddhist psychology, based largely on the *Abhidharmasamuccaya*, lists fifty-one mental processes, among which six are primary mental afflictions* and twenty are secondary mental afflictions. Mental afflictions in general are conceptual mental processes that disrupt the balance, or equilibrium, of the mind, and make it rough and dysfunctional. Since their effects are unpleasant, they also act as a basis for remorse.[83] The root afflictions act as the basis for all intellectual distortion and emotional imbalance, while the secondary afflictions are derivative of, and occur in dependence upon, the primary afflictions.[84]
>
> To take one pertinent example from among the secondary afflictions, distraction* is defined as a mental process,

[83] Blo bzang rgya mtsho, *mTha' gnyis dang dral ba'i dbu ma thal 'gyur ba'i blo'i rnam gzhag ches cher gsal bar byed pa blo rigs gong ma* (Dharamsala: Institute of Buddhist Dialectics, 1993) p. 127.

[84] A list of these primary and secondary afflictions, with both their Tibetan and Sanskrit names, is presented in Lati Rinbochay, *Mind in Tibetan Buddhism*, pp. 37–38; and a description of each of these afflictions is given in Geshe Rabten, *The Mind and Its Functions*, pp. 74–90. An account in Tibetan of all these afflictions is found in Blo bzang rgya mtsho, *Rigs lam che ba blo rigs kyi rnam bzhag nye mkho kun btus* (Dharamsala, 1974), pp. 145–161. Another account of these same afflictions as they are understood in the Prāsaṅgika view is presented in Blo bzang rgya mtsho, *mTha' gnyis dang dral ba'i dbu ma thal 'gyur ba'i blo'i rnam gzhag ches cher gsal bar byed pa blo rigs gong ma*, pp. 117–127.

stemming from any of the three mental poisons,[85] that is unable to direct the attention to virtue and disperses it to a variety of other objects. It causes the power of *samādhi* to deteriorate and acts as the basis for losing the meditative object during both discursive and stabilizing meditation. Six kinds of distraction are listed, some of which may be virtuous or ethically neutral; so, while distraction is generally regarded as a mental affliction, not all cases of distraction are afflictive.

Tsongkhapa occasionally refers to coarse and subtle laxity and excitation. While excitation is a problem from the beginning of the training in quiescence, laxity arises only when the attention is stable. When coarse laxity is present, the clarity of the mind is poor; but when just subtle laxity remains, it is only the potency, or full intensity, of clarity, that is absent. When the mind comes under the sway of coarse excitation during meditation, the meditative object is forgotten altogether while the attention is distracted elsewhere; but in the case of subtle excitation, although the attention is chiefly fixed on the meditative object, there is still peripheral distraction, indicating that the mind is not completely focused on its chosen object.

☐☐☐☐☐☐☐☐ ii). THE WAY TO DEVELOP INTROSPECTION THAT RECOGNIZES THEM WHILE MEDITATING

It is not enough merely to have an understanding of laxity and excitation; when meditating you must be able to generate introspection that correctly recognizes whether or not laxity and excitation have arisen. Moreover, by gradually developing powerful introspection, not only must you be able to induce introspection that recognizes laxity and excitation as soon as they have arisen; you must generate introspection that is aware of them when they are on the verge of occurring, before they have actually arisen. For the last two *Bhāvanākramas* assert, "If one sees that the attention

[85] Attachment, hatred, and delusion.

is lax or that it is suspected of being lax . . . "[86] And: "One sees that the attention is excited or that it is suspected of being excited . . ."[87] Until such introspection has arisen, you cannot be certain that during a certain period there has been flawless meditation, free of laxity and excitation; for, since powerful introspection has not arisen, you may not be able to ascertain laxity and excitation even if they do occur. The *Madhyāntavibhāgabhāṣya* accordingly speaks of the need for introspection to recognize laxity and excitation: "Recognition of laxity and excitation . . . "[88]

Therefore, if introspection has not arisen that makes it impossible not to recognize laxity and excitation when they occur, even if you were to meditate for a long time, time could pass in subtle laxity and excitation, without your sensing that laxity and excitation are occurring.

How do you develop that introspection? The way of sustaining mindfulness that was taught earlier is a most important factor. Thus, if you are able to generate continual mindfulness, you will be able to stop forgetting the meditative object and straying away. Thus, since this prevents you from failing for long to sense the laxity and excitation that have arisen, it is easy to recognize laxity and excitation. The difference in the amount of time it takes to recognize laxity and excitation when mindfulness is impaired and when it is not impaired becomes perfectly obvious if you examine this in terms of your own experience. With this in mind, the *Bodhicaryāvatāra* states:

> When mindfulness stands at the gate of the mind to guard it, then introspection arrives and, having arrived, it does not depart again.[89]

[86] Cf. *Bhāvanākrama III*, Tucci, ed., p. 9.

[87] Ibid.

[88] *Madhyāntavibhāga-bhāṣya*, by Vasubandhu, Gadjin M. Nagao, ed., p. 52 (IV:5b).

[89] V:33a-c. The above translation accords with the Sanskrit. The Tibetan reads somewhat differently: "When mindfulness stands at the gate of the mind to guard it, then introspection arrives, and even if it departs, it will return."

And the *Madhyāntavibhāgaṭikā*[90] also speaks of mindfulness as the cause of introspection.

One cause is to focus the attention on an apprehended aspect such as of the body of a deity, or to an apprehending aspect such as the sheer awareness and the sheer clarity of experience. Then by devoting yourself to mindfulness, as explained previously, sustain the attention by continuously monitoring whether or not there is scattering elsewhere. Recognize this as a critical factor for sustaining introspection. This epitomizes the cultivation of introspection, as stated in the *Bodhicaryāvatāra:*

> In brief, this alone is the characteristic of introspection: the repeated investigation of the state of the body and mind.[91]

Thus, by so doing you develop introspection that is aware of laxity and excitation from the time they are on the verge of arising; and the method of cultivating mindfulness stops forgetfulness, in which the attention is distracted and slips away. So you must properly distinguish between them.

COMMENTARY: In the above section, as in many others, Tsongkhapa explains the practice of quiescence chiefly in terms of focusing on a visualized object such as the body of the Buddha, but he continues to return to techniques that are without any visualized meditative object. Tsongkhapa previously alludes to "the cultivation of mere non-conceptual attention, without focusing on any other basis of meditation,"[92] and he now refers to attending "to an apprehending aspect such as the sheer awareness and sheer clarity of experience." These two references may pertain to a single

[90] cf. *Madhyāntavibhāgaṭikā*, by Sthiramati, Yamaguchi, ed., text. p. 175.9–11.

[91] V:108.

[92] This statement is found at the end of the section entitled "A Presentation of a Flawless Technique."

method for accomplishing quiescence,[93] or they may be treated separately.

Paṇchen Lozang Chökyi Gyaltsen describes the technique that combines the above two references:

> Be unrelenting towards ideation, and each time you observe the nature of any ideation that arises, those thoughts will vanish by themselves, following which a vacuity appears. Likewise, if you examine the mind also when it remains without fluctuation, you will see an unobscured, clear and vivid vacuity, without any difference between the former and latter states. Among meditators that is acclaimed and called "the fusion of stillness and dispersion."[94]

The object of attention in this practice is the sheer awareness and sheer clarity of experience, devoid of conceptualization and distraction to any of the five sense fields. This object is a negation, for it is ascertained through a process of explicit negation; and it is further classified as a partial negation,*[95] for the terms expressing this object indicate a positive phenomenon in place of that which is negated. Conceptualization and distraction are negated, while the sheer awareness and sheer clarity of experience are the positive phenomena to be ascertained. Both phenomena of awareness and clarity are modified by the term "sheer,"*[96] which, I surmise, excludes any qualities uniquely attributed to the contents of experience, such as the form of imagined and sensory objects.

[93] This is the clear implication in Tsongkhapa's critique of this method found in the section "A Presentation of Actual Meditative Objects" in his *Byang chub lam rim che ba* (mTsho sngon mi rigs dpe skrun khang) pp. 494–95.

[94] This citation is from the "Sems gnas pa'i thabs" section of his *dGe ldan bKa' brgyud rin po che'i bka' srol phyag rgya chen po'i rtsa ba rgyas par bshad pa yang gsal sgron me.* Cf. Geshe Rabten, *Echoes of Voidness,* Stephen Batchelor, trans. and ed. (London: Wisdom, 1986), pp. 113–128.

[95] The formal definition of a partial negation is found in Jeffrey Hopkins, *Meditation on Emptiness,* p. 725.

[96] This term has the connotations of "just," "mere," and "alone."

Tsongkhapa refers to this meditative object as the "apprehending aspect"* of subjective experience, in contrast to the "apprehended aspect"* of an object of experience; and yet he suggests that it is possible to focus the attention on this very apprehending aspect, which would, *prima facie*, turn it into an apprehended aspect, or an object of experience. The technique for achieving this is to withdraw the attention from external distraction to any of the five sense fields; dispense with ideation; and be aware of just the lingering awareness and clarity of experience. In this practice, mindfulness consists of maintaining the attention in that mode, and introspection consists of monitoring whether the attention has (1) been carried away by sensory distractions or ideation, or (2) sunk into the vagueness of laxity.

According to Buddhist psychology, consciousness*[97] is defined simply as clarity and awareness. According to the Prāsaṅgika Madhyamaka school, to which Tsongkhapa adheres, every consciousness is imbued with a clear appearance, or clarity, for it is free of conceptualization with respect either to its own appearing object* or to the referent of that appearance; and it knows, or is aware of, its object by the power of experience.[98] Buddhist psychology asserts consciousness, cognition, and awareness to be mutually inclusive, that is, each of those terms refers to the same range of phenomena. Cognition*[99] is so called, for it is aware of its own object; and awareness*[100] is so called, for it has the function of perceptually knowing, or realizing, either the appearing object or the referent of that appearance to consciousness.

When Tsongkhapa asserts that in this practice the meditator focuses on the sheer awareness and sheer clarity of

[97] This definition is asserted by all four philosophical schools of Indo-Tibetan Buddhism, namely Vaibhāṣika, Sautrāntika, Yogācāra, and Madhyamaka.

[98] Blo bzang rgya mtsho, *mTha' gnyis dang dral ba'i dbu ma thal 'gyur ba'i blo'i rnam gzhag ches cher gsal bar byed pa blo rigs gong ma*, p. 5.

[99] Ibid., p. 5.

[100] Ibid., p. 6.

experience, he is explicitly referring to the defining character-
istics of consciousness, implying that this is a method for
ascertaining the nature of consciousness itself. Conscious-
ness, defined as clarity and awareness, is a positive phenome-
non; but consciousness devoid of conceptualization and
distraction is, as stated previously, a partial negation.

Since consciousness is present both in the presence and
absence of conceptualization, why does Tsongkhapa empha-
size first eliminating conceptualization in order to ascertain
consciousness? I suspect this is because as long as conceptu-
alization is occurring, there is a powerful tendency to focus
on the specific qualities of ideas and their referents.
Similarly, as long as the attention is distracted to sensory
objects, the mind is likely to attend to those objects, and not
to the sheer awareness and sheer clarity of the experience of
those objects. However, when the attention is withdrawn
from both conceptual and sensory objects, the sheer aware-
ness and clarity that comprise consciousness linger on, and it
is just this that remains as the meditative object.

The above commentary assumes the combination of the
two methods of eliminating conceptualization and distraction
and of focusing on the sheer awareness and sheer clarity of
experience. However, it is also quite feasible to treat these as
separate techniques. The first of these would entail withdraw-
ing the attention from sensory distractions and settling it in
the sheer absence of conceptualization. As Tsongkhapa
insists,[101] this by no means implies that the mind has no
object. Rather, if the meditative object is the mere absence of
conceptualization, this may be classified as a simple nega-
tion,*[102] for the terms expressing this negation do not indi-
cate a positive phenomenon in place of that which is negated.
Similarly, if the practice consists of sustaining the attention
without letting it disperse out to any object whatsoever, the

[101] *Byang chub lam rim che ba* (mTsho sngon mi rigs dpe skrun khang), p. 495.

[102] For the technical definition of this kind of negation see Jeffrey Hopkins, *Meditation on Emptiness*, p. 725.

meditative object in this case would be the absence of any dispersive object, which is also a simple negation.

Finally, one may simply take the awareness and clarity of experience as the meditative object, in which case the object would be classified as a positive phenomenon. Paṇchen Lozang Chökyi Gyaltsen describes this technique as follows:

> Whatever sort of ideation arises, without suppressing it, recognize where it is dispersing and where it is dispersing to; and focus while observing the nature of that ideation. By so doing, eventually the dispersion ceases and there is stillness.
>
> This is like the example of the flight over the ocean of an uncaged bird that has long been kept onboard a ship at sea. Practice in accord with the description in [Saraha's] *Doha:* "Like a raven that flies from a ship, circles around in all directions, and alights there again."[103]

Thus, in this practice one does not necessarily treat discursive thoughts as problems to be eliminated. Rather, since consciousness—defined as clarity and awareness—may be equally present in the presence and absence of conceptualization, when thoughts arise, one attends simply to the clarity and awareness of them. And during the conceptually silent intervals between thoughts, one attends to the clarity and awareness of that experience.

To sum up, in the initial, combined technique the meditative object is classified as a partial negation; in the second technique it is a simple negation; and in the third technique it is a positive phenomenon. These mutually exclusive categories of phenomena are designated in terms of the cognitive processes by which those phenomena are apprehended, which implies that mutually exclusive cognitive processes

[103] *Dohākoṣagīti,* Derge: rGyud Wi 73.2.5. Cf. "Saraha's Treasury of Songs," trans. D. L. Snellgrove, pp. 224–239 in E. Conze (ed.) *Buddhist Texts through the Ages* (Oxford: Cassirer, 1954), vs. 70, p. 233; Herbert Guenther, *Ecstatic Spontaneity: Saraha's* Three Cycles of Dohā (Berkeley: Asian Humanities Press), p. 108. This citation is from the "Sems gnas pa'i thabs" section of his *dGe ldan bKa' brgyud rin po che'i bka' srol phyag rgya chen po'i rtsa ba rgyas par bshad pa yang gsal sgron me.*

result in the apprehension of mutually exclusive phenomena. But is this necessarily so? Might it not experientially turn out to be the case that by focusing the attention on the mere absence of conceptualization, the sheer awareness and sheer clarity of experience may be naturally apprehended? Moreover, many meditators report that the third technique, in which conceptualization is not actively inhibited, experientially results in the effortless, gradual subsiding of thoughts, until eventually they vanish altogether.[104] In this case, it seems at least plausible that this method, too, may result in the non-conceptual apprehension of consciousness. Thus, these three different techniques may turn out to result in the apprehension of consciousness, even though they entail cognitive process of partial negation, simple negation, and affirmation. This question is one that may be answered convincingly only through meditative experience.

□□□□□□ B). APPLYING THE ANTIDOTE FOR NOT
ENDEAVORING TO ELIMINATE THEM
EVEN THOUGH THEY ARE NOTICED

By properly following the ways of sustaining mindfulness and introspection as explained previously, powerful mindfulness arises, and even subtle laxity and excitation can be detected with introspection. So there is no problem of failing to notice the occurrence of laxity and excitation. However, the complacency, or non-intervention,* in which you do not exert effort to stop those two as soon as they occur is a great problem for *samādhi*. So as the remedy for that, the will* is cultivated that is called *intervention*, or *striving*. This has two sections: (i) identifying the will and the means of stopping laxity and excitation, and (ii) identifying the causes in dependence upon which laxity and excitation arise.

[104] This point was drawn to my attention by the contemporary Tibetan Atiyoga master Kusum Lingpa.

□□□□□□□ i). IDENTIFYING THE WILL AND THE
MEANS OF STOPPING LAXITY AND
EXCITATION

The *Abhidharmasamuccaya* states, "What is the will? It is the mental activity of engaging the mind, having the function of drawing the mind to virtue, non-virtue, and the ethically neutral."[105] Here is the meaning: Just as iron moves with no autonomy under the influence of a magnet, similarly, the mental process that moves and incites the mind towards virtue, non-virtue, and the ethically neutral is the will. In this case, when either laxity or excitation occurs, the mind is stimulated by the will to intervene in order to eliminate them.

Well then, what are the means for stopping laxity and excitation? Lax attention entails excessive internal withdrawal followed by a degeneration in the way the meditative object is apprehended. So for this, pleasurable things are brought to mind that cause the attention to diffuse outwards. This would be something like an image of the Buddha, but not something pleasurable that gives rise to mental afflictions. Alternatively, if a sign of light, such as sunlight, is brought to mind and laxity is dispelled, immediately maintain the attention firmly upon the meditative object, as explained in the *First Bhāvanākrama*.[106] For this, do not meditate on a depressing object, for depression causes the mind to withdraw inwards. Laxity is also averted if you are enthused by the analysis, with discerning wisdom, of the object of your choice, as asserted in the *Pāramitāsamāsa*: "When depressed, stimulate and inspire yourself with the power of striving for insight."[107] Thus, laxity, or depression, entails a slackening in the way the meditative object is apprehended, and due to the resultant laxity and excessive inner withdrawal, it is depression. So this is averted by stimulating the mode of apprehension and taking delight in enlarging the meditative object. The *Madhyamakahṛdaya* states,

[105] *Abhidharmasamuccaya*, Pradhan, ed., p. 5 (last line) to p. 6.2.

[106] *First Bhāvanākrama*, Tucci, ed., p. 206.

[107] Āryasūra, *Pāramitāsamāsa*, ed. A. Ferrari. (Annali Lateranesi, vol. X, 1946) V, 13a–b.

"Eliminate depression by meditating on a vast object."[108] And: "Further, in the case of depression, inspire yourself by seeing the benefits of enthusiasm."[109] Here is the most important remedy for overcoming laxity: if you reflect on such excellences as the Three Jewels, the benefits of the spirit of awakening, and the great significance of attaining leisure,[110] you should be able to arouse your awareness, like throwing cold water in the face of a sleeping person. And this depends on acquiring experience through discerning, discursive meditation on these beneficial topics.

If you apply the antidote of brightness to the underlying causes of laxity—namely, lethargy, drowsiness, and a combination of the two in which the mind takes on a gloomy aspect—there will either be no resultant laxity or it will be counteracted once it has arisen. For this, the *Śrāvakabhūmi* suggests such behavior as going for a walk; holding an image of brightness in mind and familiarizing yourself with it repeatedly; pursuing any of the six recollections[111] of the Buddha, the Dharma, the Saṅgha, ethical discipline, generosity, and gods; stimulating the mind by means of other inspiring meditative objects; orally reciting teachings that discuss the faults of lethargy and drowsiness; gazing in different directions and at the moon and stars; and washing your face with water.

Further, if laxity is very slight and occurs only infrequently, meditate by tightening up the attention; but if laxity is dense and occurs repeatedly, suspend the meditation, apply any of those remedies, then meditate once the laxity is cleared out.

If the object on which your attention is trained becomes vague, as if a sense of gloom had descended upon the mind, be it slight

[108] Derge: dBu ma Dza 4.1.7. The Derge version correctly reads *spang pa nyid du bya*, instead of the *yangs pa nyid du bya* in Tsongkhapa's version.

[109] Derge: dBu ma Dza 4.1.7.

[110] This refers to the attainment of a human life with the eighteen attributes of leisure and endowment, discussed earlier in this treatise.

[111] A detailed discussion of these six recollections is to be found in chapter vii of Buddhaghosa's *The Path of Purification*, trans. by Bhikkhu Ñāṇamoli, pp. 204–246. For a Mahāyāna description of these six recollections see Conze, Edward (trans.), *The Large Sutra on Perfect Wisdom,*. (Berkeley: University of California Press, 1975), pp. 551–53.

or dense, as the remedy for that, hold in mind and repeatedly familiarize yourself with images of light, such as an oil-lamp, a flame, or sunlight. If you do this, there will arise great mental clarity and limpidity.

Excitation entails the attention, by way of attachment, scurrying after objects such as forms and sounds; so for that, bring to mind disenchanting things that cause the attention to be drawn inwards. As soon as that calms excitation, once again settle your mind in meditative equipoise. The *Madhyamakahṛdaya* states, "Calm excitation by bringing to mind impermanence and so on."[112] And: "Withdraw distraction by noting the disadvantages in the signs of distraction."[113]

If excitation arises that is either very strong or persistent, it is essential to relax the meditation for awhile and cultivate a sense of disillusionment; but do not draw the attention back in and focus it every time the mind is distracted. For excitation that is not so dominant, withdraw the dispersion, and fix the attention on the meditative object. The *Pāramitāsamāsa* states, "When the mind becomes excited, counter this by means of quiescence."[114] In the case of excited attention, do not bring to mind inspiring and delightful objects, for they cause the mind to be distracted outwards.

> COMMENTARY: In the cultivation of quiescence that Tsongkhapa sets forth here, mindfulness is directed toward an imagined image of the Buddha's body, while introspection monitors whether the mind is coming under the influence of either laxity or excitation. It may be helpful at this point to step back from the text and ask how these mental processes are understood within the context of Prāsaṅgika Madhyamaka psychology.
>
> As Tsongkhapa points out earlier, while focusing the attention on the mental image of the Buddha's body, one is also to

[112] Derge: dBu ma Dza 4.1.6–7.

[113] Derge: dBu ma Dza 4.1.7.

[114] *Pāramitāsamāsa*, V:13c–d.

"practice seeing it in the aspect of the actual Buddha." The
process of thinking of the actual Buddha by way of the idea,
or mental image, of the Buddha's body is a conceptual cogni-
tion of the Buddha; but the awareness of the mental image
itself is a perceptual cognition of that mental image. This is a
Buddhist psychological theory unique to the Prāsaṅgika
school, which defines perceptual cognition as an experiential
awareness that is unmistaken with respect to its chief
object.[115] If Tsongkhapa's instructions are taken to mean that
one is to focus on the mental image of the Buddha's body as
itself being an actual embodiment of the Buddha, this cogni-
tion would still be classified as a perceptual awareness of that
image, and not as a conceptual cognition of the Buddha. I
believe this is, in fact, what Tsongkhapa has in mind.

When the mind becomes distracted by scattered thoughts,
one conceives of the objects of those thoughts by way of the
ideas associated with them. But the introspection to be culti-
vated here is not focused on the objective referents of com-
pulsive ideation, but rather on the occurrence of the ideas
themselves. Thus, such introspection consists of perceptions
of purely mental phenomena, such as the internal symptoms
of laxity and the ideas produced by excitation.

☐☐☐☐☐☐☐☐ Ii). IDENTIFYING THE CAUSES IN
 DEPENDENCE UPON WHICH LAXITY
 AND EXCITATION ARISE

The causes common to both laxity and excitation are: not
guarding the sense-doors, not maintaining a proper diet, not

[115] Blo bzang rgya mtsho, *mTha' gnyis dang dral ba'i dbu ma thal 'gyur ba'i blo'i
rnam gzhag ches cher gsal bar byed pa blo rigs gong ma*, p. 9. In the other philo-
sophical schools of Indo-Tibetan Buddhism, perception is defined as a non-decep-
tive awareness that is free of conceptualization. The Prāsaṅgika school views
non-conceptual consciousness as a type of cognition that does not compulsively
fuse its apprehended object (*'jug yul, pravṛtti-viṣaya†*) with an idea of that object.
On this basis it may also be argued that the awareness of the mental image of the
Buddha's body is a mental perception (even given the above non-Prāsaṅgika defi-
nition of perception), for it does not fuse its apprehended object—the image of the
Buddha's body—with another idea of that same object. The hypothesis that such a
fusion does occur implies an infinite regress of an idea of an idea of an idea . . .

doing without sleep during the early and late parts of the night in order to apply yourself to practice, and remaining without introspection.

The causes of laxity are: strong drowsiness, excessive relaxation in the attention's hold on the meditative object, excessive concern with quiescence without a balance between quiescence and insight, letting the mind remain as if in darkness, and taking no pleasure in focusing on the meditative object.

The causes of excitation are said to be: little sense of disillusionment, excessive force in fixing the attention on the meditative object, lack of familiarity with exerting effort, and distracted attention due to thoughts of relatives, and so on.

Thus, even subtle laxity and excitation should be recognized with introspection and should always be counteracted. So, thinking, "Subtle excitation, distraction, and so on persist even though I cut them off at the beginning," you may ignore them; and you may think, "If they are not strong and do not arise continuously, since they are weak and of brief duration, no karmic impressions are stored. So I do not need to cut them off." Those who think this do not know how to achieve perfect *samādhi*, and they forsake the method of achieving *samādhi* that has been set forth by the Venerable Maitreya and so on.

Therefore, patch up the attention from scattering and excitation, inwardly fix it upon the meditative object, and seek stability. Each time stability occurs, take precautions against laxity and bring forth the potency of clarity. Flawless *samādhi* is achieved by alternating between those two, but do not rely on mere limpidity without the clarity that comes with the potency of apprehension.

COMMENTARY: On the one hand, the cultivation of quiescence may be seen as a means of developing attentional stability and clarity, and on the other hand it may be viewed as a way to eliminate attentional excitation and laxity. Following the latter emphasis, it is most revealing to identify the major causes that produce excitation and laxity. The first cause cited above is the failure to "guard the sense-doors," a very common theme in Buddhist literature as a whole. Guarding

the sense-doors entails not conceptually grasping onto, or reifying, any of the attributes of the objects of visual, audial, gustatory, olfactory, tactile, or mental consciousness. In addition, one needs to be particularly on guard against any conceptual grasping tinged with attachment or anger, for these afflictions disrupt the equilibrium of the mind and thereby obstruct the cultivation of quiescence. Thus, when you see, you just see; when you hear, you just hear, and so on with respect to each of the other types of consciousness.[116]

The first cause of excitation that Tsongkhapa mentions is having little sense of disillusionment with regards to the allurements of the senses. If during the cultivation of quiescence the mind remains drawn to sensual pleasures, this de-stabilizes the attention; and in order to compensate for such agitation, if one applies excessive force in fixing the attention, this in fact de-stabilizes it even more. Thus, the aspiring contemplative is encouraged to cultivate faith in the achievement of quiescence in order to avert depression, and to become disenchanted with sensual pleasures in order to avert excitation.

In short, the cultivation of quiescence involves an experiential balancing of the attention, alternately emphasizing stability free of laxity, and clarity free of excitation. A key to this, as Tsongkhapa points out, is to bring forth a "potency of apprehension," by apprehending the object vividly and with keen attention.

☐☐☐☐☐☐ 2). WHAT TO DO WHEN LAXITY AND EXCITATION ARE ABSENT

By practicing cutting off even subtle laxity and excitation as explained previously, the mind will enter a state of equipoise that is free of the imbalances of either laxity or excitation. When that happens, if you intervene or exert effort, this is a problem for *samādhi*, so cultivate equanimity as the remedy for that.

[116] *Sāmaññaphala Sutta: Sutta 2* in *Thus Have I Heard: The Long Discourses of the Buddha (Dīgha Nikāya)* trans. Maurice Walshe (London: Wisdom, 1987) para. 64, p. 100.

This is the way that intervention or exertion becomes a problem: By practicing stimulating the mind when it is withdrawn and lax, you may gain the faith that in each session laxity and excitation will not occur. When that happens, if you continue practicing with the same great caution against laxity and against excitation as you did at the outset, your attention will become distracted; so at that time you should know to relax. However, this entails relaxing the effort, not sacrificing the potency of the mode of apprehension. Therefore, this cultivation of equanimity is not to be done whenever laxity and excitation are absent, but only from the time that you have shattered the tip of laxity and excitation; for when the tip of laxity and excitation has not been shattered, there is no equanimity.

Well then, what is this equanimity? Among the three types of equanimity—(1) the feeling of equanimity,[117] (2) immeasurable equanimity,[118] and (3) equanimity with respect to intervention[119]—this is the last one. Its nature, as explained in the *Śrāvakabhūmi*,[120] is the achievement, in relation to a meditative object of quiescence and insight, of mental balance, tranquillity,[121] naturally engaging with one's object, and functionality. When such equanimity is achieved, *samādhi* is being cultivated, and laxity and excitation are absent, bring forth that equanimity and do not exert strong effort.

Those explanations are in accord with the *Madhyāntavibhāga*:

> The fitness of the basis is for the sake of achieving all goals. This occurs due to the cause of eliminating the five faults and enacting the eight interventions.

[117] This type of feeling is classified together with the feelings of pleasure and pain.

[118] Immeasurable loving kindness, compassion, empathetic joy, and equanimity. For a detailed discussion of these four practices see Paravahera Vajirañāna's *Buddhist Meditation in Theory and Practice*, pp. 263–313.

[119] *'du byed kyi btang snyoms*. In the Tibetan dictionary published by the Mi rigs dpe skrun khang, this term is defined as: dispelling the attributes of mental afflictions and abiding without mental afflictions.

[120] *Yogasthāna III*.

[121] The Tibetan term has the connotation of the mind "settling in its natural state."

(1) Spiritual sloth and (2) forgetting the practical instructions, (3) lax-
ity and excitation, (4) non-intervention, and (5) intervention—these
are regarded as the five faults.

[The eight interventions are:] (1) the basis [yearning for *samādhi*] and
(2) that which is dependent upon it [striving], (3) the cause of that
[faith] and its (4) result [pliancy], (5) not forgetting the meditative
object, (6) recognizing laxity and excitation, (7) intervention to elimi-
nate them, (8) and when [laxity and excitation] are calmed, there is
tranquillity.[122]

In that passage *the basis* refers to abiding in the enthusiasm to
dispel hindrances, and *samādhi* in which the attention is func-
tional arises from that. Moreover, since that is the foundation, or
basis, of paranormal abilities which accomplish all goals of
extrasensory perception and so forth, it fulfills all goals. Such
samādhi arises from the causes of eliminating the five faults and
enacting the eight interventions.

These are the five faults: At the time of preparation, spiritual
sloth is a fault, for it fails to bring you to *samādhi*. When striving
for *samādhi*, forgetting the practical instructions is a fault, for if
the meditative object is forgotten, the attention is not settled in
equipoise upon the meditative object. When it is established in
meditative equipoise, laxity and excitation are faults, for those
two make the mind non-functional. When laxity and excitation
occur, apathy is a fault, for it fails to calm those two. When laxity
and excitation are absent, the will to intervene is a fault. The
Bhāvanākramas point out that if laxity and excitation are classi-
fied together as one, there are five faults, and if they are listed sep-
arately there are six.

Among the remedies for those, namely the eight interventions,
there are four remedies for spiritual sloth: faith, yearning, striv-
ing, and pliancy. Then the remedies for forgetfulness, laxity and
excitation, non-intervention, and intervention are respectively
mindfulness, introspection that recognizes laxity and excitation,
the will to intervene, and calmly established equanimity. Those
have already been explained.

[122] *Madhyāntavibhāgā*, Gadjin M. Nagoa, ed., IV:3–5.

That mindfulness and introspection remove laxity and excitation from the *samādhi* of single-pointed attention is a common theme of all instructions on this practice. So do not adhere to the idea that this is an exclusive teaching of the vehicle of dialectics,[123] but that it is unnecessary in the Mantra[yāna]; for it is also taught in many of the collections of Anuttarayogatantras.

COMMENTARY: As a result of the skillful, sustained cultivation of quiescence, one eventually achieves a degree of meditative equipoise in which the mind is temporarily, effortlessly free of the hindrances of laxity and excitation. As the power of mindfulness and introspection gradually increases through this training, one becomes increasingly accustomed to mental balance; and the degree of effort needed to sustain and further improve this quality of attention gradually decreases.

When "the tip of laxity and excitation has been shattered," that is, when the mind is no longer prone to these hindrances, it is essential to release the effort that had previously gone to counteracting them. At this point, if one continues to exert the same amount of effort as before, this impedes further progress, for it agitates the mind. But if one prematurely stops exerting effort, this, too, impedes progress, for laxity would be bound to set in. The key to knowing how much to ease off is this: decrease effort only to the extent that the intensity and clarity of attention is not sacrificed.

The equanimity that arises due to such habituation is characterized by mental balance that is free of excitation and laxity; tranquillity in which the mind rests in its own nature without compulsively grasping onto objects; natural, effortless engagement with one's meditative object; and functionality, or fitness of the attention such that it can be employed at will.

[123] *mtshan nyid theg pa.* This is synonymous with the Sūtrayāna.

☐☐☐☐ *II).* THE STAGES OF SUSTAINED ATTENTION
THAT ARISE ON THAT BASIS

In this section there are three parts: (A) The actual progression
in which the stages of sustained attention arise, (B) The way to
accomplish them with the six forces, (C) The way the four mental
engagements are present in those.

☐☐☐☐☐ *A).* THE ACTUAL PROGRESSION IN WHICH
THE STAGES OF SUSTAINED ATTENTION
ARISE

The nine stages:

1. Placing the attention on any object: thoroughly withdraw-
 ing the attention from all outside objects and fixing it
 inwards upon the meditative object. The *Mahāyāna-
 sūtrālaṃkāra* states, "Having fixed the mind upon the medi-
 tative object . . . "[124]
2. Continual placement: placing the initially directed attention
 continually upon the meditative object, without letting it be
 distracted elsewhere. As stated: "Do not allow its continuity
 to be distracted."[125]
3. Patched placement:[126] If you are drawn away by forgetful-
 ness and are distracted outwards, recognize this and attend
 again to the meditative object. As stated: "Swiftly recogniz-
 ing distraction, patch it up again."[127]
4. Close placement: The *Prajñāpāramitopadeśa* asserts that the
 attention, which is by nature expansive, is repeatedly drawn
 in and refined, thereby enhancing it. This is in accord with

[124] *Mahāyānasūtrālaṃkāra*, S. Lévi, ed., XIV:11b.

[125] Ibid., XIV, 11a.

[126] The Tibetan dictionary published by Mi rigs dpe skrun khang comments that
blan pa is an alternate spelling for *glan pa* (to patch), and later commentators have
commonly chosen the latter meaning. Moreover, in our edition, the next citation
from the *Mahāyānasūtrālaṃkāra* reads *glan*, whereas the Dharamsala edition
reads *blan* in both references to this word.

[127] Ibid., XIV:11c–d.

the saying: "Perceptive ones, withdraw your attention inwards, elevating it higher and higher."[128]

5. Taming: Reflecting upon the advantages of *samādhi*, you take pleasure in it. As stated: "Then, because you see the advantages, the mind is tamed in *samādhi*."[129]

6. Pacification: Regarding distraction as a fault, you pacify any dislike for *samādhi*. As stated: "Because you see the faults of distraction, dislike is pacified."[130]

7. Complete pacification: The occurrences of attachment, melancholy,* lethargy, drowsiness, etc. are pacified. As stated: "Attachment, melancholy, etc. are pacified as they arise."[131]

8. Single-pointed attention: Effort is exerted in order to proceed effortlessly. As stated: "Then with restraint and enthusiasm, engaging with the attention, spontaneity is achieved."[132]

9. Balanced placement: According to the *Bhāvanākrama*, this refers to the equanimity that occurs when the attention becomes balanced; and the *Prajñāpāramitopadeśa* says this refers to spontaneous, natural attention and the attainment of independence as a result of getting used to unifying the mind-stream. Thus it is said: "Due to getting used to that, there is non-intervention."[133]

The names of the nine mental states are in accord with the lines in the *First Bhāvanākrama:* "This path of quiescence is explained in the *Āryaprajñāpāramitā* and so on . . . "[134]

> COMMENTARY: The above nine attentional states plot
> how the attention is stabilized and clarified up to, but not

[128] Ibid., XIV, 12a–b.

[129] Ibid., XIV, 12c–d.

[130] Ibid., XIV, 13a–b.

[131] Ibid., XIV, 13c–d.

[132] Ibid., XIV, 14a–c (of the Tibetan version)

[133] *Mahāyānasūtrālaṃkāra*, XIV, 14d (of the Tibetan version)

[134] *First Bhāvanākrama*, Tucci, ed., p. 207.

including, the actual achievement of quiescence. The accomplishment of the first state corresponds to the initial fixing of the attention upon the meditative object, such as a visualized image of the Buddha. Tibetan contemplatives point out that in this early phase of the training it seems as if the mind is exceptionally cluttered with compulsive ideation. In fact, one is simply recognizing, perhaps for the first time, how congested the mind normally is with rambling thoughts; for when the attention is directed outwards, frequently shifting from one object to another, one simply does not notice how agitated the mind is.

Only with the achievement of the second attentional state does there arise an appreciable degree of occasional attentional continuity, but most of the time during the meditation session the mind is still caught up in distractions. Only with the accomplishment of the third state is the attention fixed most of the time upon the meditative object, needing only now and then to be "patched up" when it strays away. The fourth attentional state marks the point at which the power of mindfulness has come into its own, and throughout the meditation session the attention never entirely loses its meditative object. Thus, at this point one has overcome coarse excitation. Moreover, due to this sustained attentional stability and relative pacification of ideation, the sense of duality between the meditating awareness and the object of meditation begins to dissolve.

The challenge during the fifth attentional state is to recognize and counteract coarse laxity. This is a crucial phase requiring a delicate balancing of the attention, for if too much effort is applied, the mind once again succumbs to coarse excitation; but if insufficient effort is exerted, the mind slips into coarse laxity. The median between these two extremes must be discovered with one's own experience. In the sixth state, coarse laxity has successfully been overcome, but subtle excitation—involving peripheral "noise," or distraction—remains a problem. In the seventh state, one must be particularly on guard against subtle laxity and melancholy.

It is common for depression to arise during this phase of the training due to remorse for earlier misdeeds of commission and omission, and it is necessary to recognize such remorse as a hindrance to the achievement of quiescence.

With the achievement of the eighth attentional state, as long as one continues to strive in this practice, not even subtle laxity or excitation any longer arise during the meditation session. At the ninth state, due to the strength of habitual mindfulness and introspection, effort no longer needs to be applied to sustain the attention with stability and clarity upon its object; and laxity and excitation no longer arise, even though no effort is exerted to recognize or counteract them.[135]

□□□□□ A). THE WAY TO ACCOMPLISH THEM WITH THE SIX FORCES

There are six forces: the force of hearing, of thinking, of mindfulness, of introspection, of enthusiasm, and the force of complete habituation.* The method of accomplishing the various mental states with those forces is as follows:

1. With the force of hearing, the attentional state of placement is accomplished. The reason for this is that this is simply the initial fixing of the attention upon the meditative object in accordance with the practical instructions that have merely been heard from someone else about placing the attention upon the object; but this is not due to familiarity gained by your own repeated thinking.
2. With the force of thinking, the attentional state of continual placement is accomplished; for the ability is initially achieved to maintain a little continuity as a consequence of repeatedly thinking about the continuum beginning with the initial fixation of attention upon the meditative object.

[135] The above explanation is based on the account of the contemporary Tibetan contemplative Gen Lamrimpa in his *Samatha Meditation*, trans. B. Alan Wallace (Ithaca: Snow Lion, 1992), pp. 115–123.

3. With the force of mindfulness, the attentional states of both patched placement and of close placement are accomplished; for, [with patched placement] when the attention is distracted away from the meditative object, upon recalling the previous meditative object, the attention is drawn back in; and [with close placement] the power of mindfulness is generated from the beginning, and this prevents the attention from being distracted away from the meditative object.

4. With the force of introspection, the attentional states of taming and of pacification are accomplished; for, introspection recognizes the disadvantages of being scattered towards ideation and the signs of the secondary afflictions, and by regarding them as disadvantageous, scattering towards those two is prevented.

5. With the force of enthusiasm, the attentional states of complete pacification and of single-pointed attention are accomplished; for, by diligently eliminating even subtle ideation and secondary afflictions, you do not submit to them; and by so doing, *samādhi* is accomplished that arises in a continuum, without laxity, excitation, etc. being able to obstruct it.

6. With the force of habituation, the attentional state of balanced placement is accomplished; for, with the force of great familiarity with the above, effortless, natural *samādhi* arises. This accords with the intended meaning of the *Śrāvakabhūmi;* so do not rely on alternative explanations.

The achievement of the ninth attentional state can be understood in terms of an analogy: In the case of one who is extremely familiar with reciting scriptures and so on, if the initial motivation to recite arises and one begins, even though the attention is occasionally distracted elsewhere, the recitation continues effortlessly, without interruption. In a similar fashion, if at first the attention is once settled in meditative equipoise with mindfulness trained upon the meditative object, then even if mindfulness and introspection are not always continually cultivated, *samādhi* can

proceed steadily for a long time, without being interrupted by scattering. This case in which effort is not needed to maintain a continuous stream of mindfulness and introspection is said to be without intervention or effort.

For that to arise, in an earlier phase of practice when mindfulness and introspection are continually, diligently cultivated, *samādhi* must arise that can be sustained throughout long meditation sessions, without such hindrances as laxity and excitation being able to obstruct it. That is the eighth attentional state. That and the ninth state are similar in that they cannot be disturbed by factors such as laxity and excitation that are incompatible with *samādhi*. However, in this [eighth state], mindfulness and introspection must be cultivated uninterruptedly, so it is said to be accompanied with intervention, or effort.

For that to arise, even subtle laxity, excitation, etc. must be stopped as soon as they occur, without submitting to them; so the seventh attentional state is necessary.

For that to arise, distractions due to ideation and the secondary afflictions must be recognized as disadvantageous, and powerful introspection is needed to monitor the attention so that it is not dispersed to them. So the fifth and sixth attentional states are necessary, for those two are accomplished by empowering introspection.

Furthermore, for that to arise, there must be mindfulness that swiftly recalls the meditative object when the attention is distracted from it, and mindfulness that prevents distraction from the meditative object in the first place. So the third and fourth attentional states are necessary, for those two are accomplished with those two kinds of mindfulness.

For that to arise, the attention must first of all be fixed upon the meditative object, and there must be an undistracted continuity of that fixation. So the initial two attentional states arise first.

Therefore, in summary, first of all follow the instructions that you have heard, and correctly apply the method for placing the attention in a balanced fashion. Then repeatedly think about that way of attending, and as you are able to establish a little continu-

ity, maintain a continuous stream [of attention]. Then if mindful-
ness declines and is distracted, swiftly draw the attention back in
and quickly recall that the meditative object has been forgotten.
Then generate strong mindfulness and bring forth the power of
mindfulness that prevents distraction away from the meditative
object in the first place. By accomplishing powerful mindfulness
and by seeing the faults of laxity, excitation, etc., which distract
the attention away from the meditative object, develop intense
introspection to monitor [the attention]. Then when there is dis-
traction due to even subtle forgetfulness, recognize this immedi-
ately and cut it short; and upon eliminating it, generate the power
of striving to lengthen the continuity [of attention] uninterrupted
by hindrances. Once that has arisen, due to meditating diligently,
there occurs relaxed habituation, and the ninth attentional state is
accomplished, in which *samādhi* proceeds effortlessly.

Therefore, until the ninth attentional state has been attained,
the contemplative must exert effort to apply the mind to *samādhi;*
but upon attaining the ninth attentional state, even if no effort is
exerted to settle the attention in meditative equipoise, the mind
goes entirely into *samādhi.*

Even though this ninth attentional state is attained, if pliancy
is not achieved, then—as will be explained later—as the attain-
ment of quiescence is still not reached, how much less is the
achievement of insight!

> COMMENTARY: In the above section Tsongkhapa first
> describes, in forward order, how the six powers are used to
> accomplish the nine attentional states, then he reviews these
> states in reverse order to show the causal relations from one to
> the next. As a general observation it is said that the greatest
> effort in this training is needed during the initial stages; and as
> the mind is increasingly habituated to attentional stability and
> clarity, less and less effort is needed to maintain and enhance
> these qualities. At the ninth attentional state, no effort at all is
> required once the meditative process has begun.
>
> At the beginning of this training, the mind is habituated to
> excitation and lethargy, but its plasticity allows these traits to

be gradually removed, so that new habits of attentional sta-
bility and clarity are formed. The effortless attention at the
ninth state is likened to reciting scriptures effortlessly and
occasionally inattentively. However, whereas for verbal or
physical habitual acts habit often diminishes conscious atten-
tion, in this attentional training it is said that the level of
attention remains high even though the effort applied to
maintaining mindfulness and introspection occasionally
lapses. All that is needed in the ninth attentional state is an
initial effort to begin the meditative process, then it continues
effortlessly. In the immediately preceding attentional state, a
last vestige of effort is needed to recognize and immediately
counter even the slightest occurrence of either subtle laxity or
excitation.

Tsongkhapa emphasizes that the habit of properly bal-
anced attention is one to cultivate from the beginning of this
training, and this habit is to be cultivated as continuously as
possible until it becomes effortless.

☐☐☐☐☐ C). THE WAY THE FOUR MENTAL
ENGAGEMENTS ARE PRESENT
IN THOSE

To explain the presence of the four mental engagements
among the nine attentional states in accordance with the *Śrāvaka-
bhūmi*.[136] During the first two attentional states the attention
must be strenuously concentrated, so this is concentrated engage-
ment. Then during the phases of the next five attentional states,
there is interference by laxity and excitation and it is not possible
to maintain long meditation sessions; so this is interrupted
engagement. Then in the eighth attentional state since it is possi-
ble to sustain long meditation sessions without interference by
laxity and excitation, there is uninterrupted engagement. Then in
the ninth attentional state since there are no interruptions and no
need for continuous exertion, effortless mental engagement is
applied.

[136] *Yogasthāna III.*

In this case, during the first two attentional states there is interrupted engagement, and during the intermediate five attentional states, concentrated engagement is still needed; so why is it not said that interrupted mental engagement is present in the first two, and that concentrated mental engagement is present in the intermediate five attentional states?

In the first two attentional states, the periods when the attention is unconcentrated are much longer than those when the attention is concentrated; whereas in the five intermediate states the time spent in sustained *samādhi* is much longer. Therefore, the designation of *interruption to samādhi* is used for the latter and not for the former. Thus, although those two [sets of attentional states] are similar in terms of the presence of concentrated engagement, they are dissimilar in terms of the presence and absence of interrupted engagement; so the five intermediate attentional states are not included in concentrated mental engagement.

Thus, practice as it says in the *Pāramitāsamāsa:*

> With uninterrupted contemplation strive to accomplish meditative stabilization. If you repeatedly pause to rest, fire will not arise from friction. Similarly, in the contemplative process, do not give up until a lofty state has been reached.[137]

COMMENTARY: According to Indo-Tibetan Buddhist psychology, mental engagement is one of five mental processes— together with feeling,* recognition,* will,* and contact*—that are said to be always present* in the mind, though some of these may at times remain unconscious. Mental engagement has the unique function of directing the mind to an object and apprehending it. Whereas the will directs the mind to a general object, mental engagement focuses it on a specific object and holds it there, thereby serving as the basis for mindfulness and introspection.[138]

[137] *Pāramitāsamāsa*, V:10c–d and 11. The "lofty state" presumably refers to the ninth mental state, in which strenuous effort is no longer needed, as explained earlier.

[138] Blo bzang rgya mtsho, *Rigs lam che ba blo rigs kyi rnam bzhag nye mkho kun btus*, p. 132. cf. Geshe Rabten, *The Mind and Its Functions*, trans. Stephen Batchelor, p. 60.

The progression of the four types of mental engagement—concentrated, interrupted, uninterrupted, and effortless—corresponds directly to the degree of habituation to *samādhi*, and inversely to the degree of effort needed in this training. Thus, it is not the case that one applies the same amount of effort throughout all the first eight attentional states, then suddenly ceases striving altogether with the achievement of the ninth state.

Continuity of practice is particularly important for the cultivation of quiescence, for if the mind is allowed to indulge freely in distractions between sessions, or if there are long lapses between periods of concerted practice, whatever mental balance that may have been achieved will swiftly deteriorate. For this reason, one is encouraged to simplify one's lifestyle radically during this training, as Tsongkhapa outlined in his discussion of the prerequisites for quiescence. However, there have been cases of individuals achieving quiescence even while maintaining an active lifestyle,[139] presumably by maintaining a high degree of mindfulness and introspection between sessions.

□ *3.* THE STANDARD OF ACCOMPLISHING QUIESCENCE THROUGH MEDITATION

Here there are three sections: (a) The demarcation between accomplishing and not accomplishing quiescence, (b) a general presentation of the way to proceed along the path on the basis of quiescence, and (c) a specific presentation of the way to proceed along the mundane path.

□□ *a.* THE DEMARCATION BETWEEN ACCOMPLISHING AND NOT ACCOMPLISHING QUIESCENCE

This has two sections: (i) The actual meaning, and (ii) the signs of having mental engagement and the elimination of qualms.

[139] Lodrö, *Walking Through Walls*, p. 30.

□□□ *i.* THE ACTUAL MEANING

This has two sections: (I) The correspondence of the achievement of quiescence to the complete achievement of pliancy, and (II) the way quiescence is accomplished following the complete achievement of pliancy.

□□□□ *I).* THE CORRESPONDENCE OF THE
 ACHIEVEMENT OF QUIESCENCE TO THE
 COMPLETE ACHIEVEMENT OF PLIANCY

QUALM: Is quiescence achieved or not if, as explained previously, in the ninth attentional state, long meditation sessions can be maintained free of subtle laxity and excitation, and spontaneous *samādhi* is achieved without resorting to the effort of continually applying mindfulness and introspection?

RESPONSE: In achieving this *samādhi* pliancy may or may not have been achieved; so if pliancy were not attained, this would be a facsimile of quiescence, but not genuine quiescence. The *Saṃdhinirmocanasūtra* states:

> Lord, when a Bodhisattva directs his attention inwards, with the mind focused upon the mind, as long as physical pliancy and mental pliancy are not achieved, what is that mental activity called? Maitreya, this is not quiescence. It is said to be associated with an aspiration that is a facsimile of quiescence.[140]

The *Mahāyānasūtrālaṃkāra* also states:

> Due to familiarity, there is non-intervention. Then upon achieving great pliancy of your body and mind, you are said to have mental engagement.[141]

In this passage *mental engagement* refers to quiescence. The *Intermediate Bhāvanākrama* also clearly states:

[140] Cf. Lamotte, *Saṃdhinirmocana*, VIII:5.

[141] *Mahāyānasūtrālaṃkāra*, XIV, (14d of the Tibetan version), 15a–c.

For you who have cultivated quiescence in that way, when your body and mind become pliant and you have control over the mind in terms of voluntary attention, at that time know that quiescence has been accomplished.[142]

The *Prajñāpāramitopadeśa* also states:

> Here, the Bodhisattva, dwelling alone in a solitary place, brings to mind his intended object. Ridding himself of mental conversation, he repeatedly brings to mind the mind-itself as it appears in that way. So long as physical and mental pliancy do not arise, this is a mental engagement that is a facsimile of quiescence; but when they do arise, that is quiescence.

Well then, what plane incorporates the *samādhi* in which pliancy has not yet arisen? That *samādhi* is included in the plane of the desire realm.* Although such single-pointed attention is present there, it is a plane of non-equipoise; it is not established as a plane of meditative equipoise. The *Bhūmivastu* says that this is due to the fact that it is not accomplished by means of lack of remorse, by supreme pleasure and joy, and pliancy.[143]

Thus, without having achieved pliancy, even when mindfulness is not applied continually, the mind may naturally become non-conceptual; and this *samādhi*, which seems as if it can be integrated with all activities of moving, walking, lying down and sitting, is called *single-pointed attention of the desire realm*. But it is not genuine quiescence.

> COMMENTARY: In the above section Tsongkhapa emphasizes the crucial role played by pliancy in the achievement of quiescence. This achievement corresponds to one's first encounter with a higher plane of experience known as the form realm,* and this also signifies the initial plane of meditative equipoise. To reach this state, the prior psycho-physio-

[142] Derge: dBu ma Ki 48.1.3–4.

[143] Wayman suggests this is probably in Asaṅga's *Samāhitabhūmi* (*Calming the Mind and Discerning the Real*, p. 450. fn. 136).

logical transformation involved in the experience of pliancy is said to be indispensable.

Mental pliancy is included among the eleven virtuous mental processes listed in Indo-Tibetan Buddhist psychology. It has the function of enabling the attention to be directed to the virtuous object of one's choice, and it counteracts mental and physical dysfunction. Thus, it is crucial for both mental and physical fitness. Physical pliancy is a type of tactile sensation imbued with a physical sense of well-being, so it is not a mental process. Both types of pliancy serve as the basis for all types of meditation imbued with quiescence and insight.[144]

☐☐☐ *II).* THE WAY QUIESCENCE IS ACCOMPLISHED FOLLOWING THE COMPLETE ACHIEVEMENT OF PLIANCY

Well then, what is the way to achieve pliancy, and upon achieving it, how does it lead to quiescence? Pliancy is explained in the *Abhidharmasamuccaya:* "What is pliancy? Due to the cessation of the continuum of dysfunctions of the body and mind, this is a fitness of the body and mind, having the function of dispelling all obstructions."[145] The dysfunctions of the body and mind are the unfitness of the body and mind for voluntarily pursuing virtuous deeds. Their antidotes, physical and mental pliancy, entail great fitness in terms of applying the body and mind to virtuous deeds, due to the freedom from both physical and mental dysfunctions.

Moreover, physical dysfunction that is affiliated with mental afflictions interferes with one's delight in eliminating mental afflictions; and when effort is exerted to eliminate the afflictions, the body becomes unfit, having a sense of physical heaviness and so on. Once one is free of that, the body becomes buoyant and light, and this is a fit body.

[144] Blo bzang rgya mtsho, *Rigs lam che ba blo rigs kyi rnam bzhag nye mkho kun btus,* pp. 140–142. Also see Geshe Rabten, *The Mind and Its Functions,* pp. 70–71.

[145] *Abhidharmasamuccaya,* Pradhan, ed., p. 6.19 f.

Likewise, mental dysfunction, which is affiliated with mental afflictions, interferes with one's delight in eliminating afflictions; and when one tries to eliminate the afflictions, it prevents one from taking pleasure in focusing on a virtuous object. Once one is free of that, the mind focuses on the meditative object without resistance, and this is a fit mind. Thus, the master Sthiramati states:

> The fitness of the body is that from which buoyancy and lightness arise in one's physical actions. The fitness of the mind is the cause of the cheerfulness and lightness of the mind that participates in genuine mental engagement. If one is endowed with this transformative quality that arises from the mind, one engages with the meditative object without resistance. Therefore, this is called the *fitness of the mind*.

In short, even when one wants to strive to eliminate mental afflictions, the unfitness of the body and mind make one proceed arduously and despondently, as if it were an unpleasant act. When pliancy is achieved, this is counteracted, and the body and mind become very easy to use. Such complete physical and mental fitness arises to a slight degree from the time that *samādhi* is first achieved. Due to this, it gradually increases until finally it turns into pliancy and single-pointed quiescence. The *Śrāvakabhūmi* says that at first this is difficult to recognize due to its subtlety, but later on it becomes easy to recognize.[146]

The portent of the arising of easily discernible, perfected pliancy is this: the individual who is striving in the cultivation of *samādhi* experiences a sense of heaviness and numbness on the top of the head, but it is not an unpleasant heaviness.[147] As soon as that occurs, one is freed of the mental dysfunction that obstructs one's delight in eliminating mental afflictions, and there first arises mental pliancy, which is the remedy for that. The *Śrāvakabhūmi* states:

[146] *Yogasthāna III.*, Bihar MS., 13B.2–6a.

[147] This sensation is like the feeling of a warm hand placed upon a bald head. Cf. Gen Lamrimpa, *Śamatha Meditation*, p. 34.

The portent of the proximate occurrence of gross, easily discernible single-pointedness of mind and of mental and physical pliancy is a sensation of heaviness on the top of the head; but this is not a harmful symptom. As soon as this happens, mental dysfunction, which is included among the mental afflictions that obstruct delight in eliminating [the afflictions], is itself eliminated; and mental fitness and mental pliancy arise due to this antidote.[148]

Then in dependence upon the power of the pliancy of mental fitness, vital energies that cause physical pliancy course through the body. When those energies have pervasively coursed through all parts of the body, one is freed of physical dysfunction and physical pliancy arises, which is the remedy for physical dysfunction. Once these saturate the entire body, there is an experience as if one were filled with the power of this functional energy. The *Śrāvakabhūmi* states:

> Due to its occurrence, vital energies of the great elements[149] that are conducive to the arising of physical pliancy course through the body. Because of their movement, one is freed of physical dysfunction affiliated with mental afflictions that obstruct delight in meditation; and it seems as if the entire body were filled with physical pliancy as the antidote for that.[150]

Now, physical pliancy is a very pleasant sensation within the body, not a mental process. The master Sthiramati states:

> The *sūtras* say that if a distinctive physical sensation is imbued with pleasure, recognize this as physical pliancy. When there is mental pleasure, the body becomes pliant.

[148] *Yogasthāna III.*, Bihar MS., 13B.2–7b. Derge: Sems tsam Dzi.163.1.

[149] The great elements include earth (solidity), water (fluidity), fire (heat), air (lightness and motility), and space. The single Tibetan term *rlung* is the common translation for both the Sanskrit *vāyu* and *prāṇa*. Buddhist physiology also makes reference to the vital energy of each of the great elements.

[150] *Yogasthāna III.*, Bihar MS., 13B.2–8c. The first sentence of the Sanskrit version reads somewhat differently from the Tibetan, rendered as follows: "Due to its occurrence, the great elements that are aroused by the vital energies and that are conducive to the arising of physical pliancy course through the body."

Thus, when physical pliancy initially arises, due to the power of the vital energies a great sense of well-being arises in the body, and in dependence upon that a most exceptional experience of pleasure and joy also arises in the mind. Thereafter, the force of that initial pliancy gradually subsides, but it is not being exhausted. Rather, that gross pliancy excessively agitates the mind; so with its disappearance, there occurs a pliancy, tenuous like a shadow, that is compatible with unfluctuating *samādhi*. Once the rapturous pleasure of the mind has disappeared, the attention is sustained firmly upon the meditative object; and one achieves quiescence that is freed from the turbulence caused by great pleasure. The *Śrāvakabhūmi* states:

> When that first arises, having taken delight in the extraordinary mental joy in superb mental engagement, there is supreme mental pleasure in the accompanying meditative object. At that time that is called the mind. That which arises first immediately thereafter is the force of pliancy, which incrementally becomes more subtle.[151] Pliancy occurs in the body, following it like a shadow. The extraordinary mental joy is relinquished, the mind having a serene aspect becomes stabilized with quiescence with respect to the meditative object.[152]

The *Śrāvakabhūmi* says that once that happens, due to the attainment of mental engagement and quiescence that are included in the first proximate meditative stabilization, one achieves the small level of mental engagement on the plane of meditative equipoise.

COMMENTARY: Although Tsongkhapa asserts that the ultimate nature of reality can be realized without the support of quiescence, such insight is always mixed with an idea of ulti-

[151] The Tibetan term *phra ba* means "subtle," while the Sanskrit *praślathatara* means "more relaxed."

[152] *Yogasthāna III.*, Bihar MS., 13A.3-1b: The following two lines of the Sanskrit text have no counterpart in the Tibetan translation: *cittasya tasmin samaye khyāti/tasyordhva˙ yo 'sau tatprathamopanipātī praśrabdhivegaḥ.* The Sanskrit version of this citation is clearer and more complete than the Tibetan, so my translation follows the Sanskrit where it differs from the Tibetan.

mate truth. The conceptually unmediated, non-dual realization of thatness, he claims, can occur only on the basis of non-conceptual, effortless quiescence imbued with the strength of pliancy. Moreover, since *nirvāṇa* and perfect enlightenment can be achieved in this lifetime only by the power of such non-conceptual realization of identitylessness, Buddhist contemplation can be perfected in this life only if it is conjoined with genuine quiescence.

Further, contemplation of ultimate reality unsupported by quiescence would necessarily be a transient experience that could be sustained only with great effort, and the mind would soon fall back from this exalted realization and be inundated once again with compulsive ideation. This descent back into gross mental afflictions may well be accompanied with an experience of loss and depression.

In short, the Buddhist contemplative path commences with establishing a sound basis in ethical discipline; it then focuses on the cultivation of mental balance resulting in exceptional mental and physical fitness; and finally it reaches for a transcendent experience of ultimate reality, which irreversibly liberates the mind from all afflictions and opens the way to perfect enlightenment.

□□□ *ii.* THE SIGNS OF HAVING MENTAL
ENGAGEMENT AND THE ELIMINATION OF
QUALMS

Here there are two sections: (I) the actual signs of having mental engagement, and (II) the elimination of qualms.

□□□□ *I).* THE ACTUAL SIGNS OF HAVING MENTAL
ENGAGEMENT

These are the characteristics by which to recognize that oneself and others have achieved mental engagement, as taught in the *Śrāvakabhūmi:*[153]

[153] *Yogasthāna III.,* Bihar MS., 13A.3–3b, 13A.3–5b, and 13A.3–6a.

1. The achievement in small measure of these four: attention associated with the plane of form,[154] physical pliancy, mental pliancy, and single-pointedness.
2. Having the ability to purify mental afflictions either by means of the path bearing the aspects of calmness and grossness, or the path bearing the aspects of [the Four Noble] Truths.
3. When the attention is settled inwardly, meditative equipoise, and physical and mental pliancy arise ever so swiftly.
4. For the most part, the five hindrances, including sensual desire and drowsiness, do not occur.
5. When one rises from meditative equipoise, one still possesses some degree of physical and mental pliancy.

Upon achieving mental engagement bearing such signs, it is easy for the path of quiescence to be purified. Following meditative equipoise in the quiescence of single-pointed attention, physical and mental pliancy can be swiftly induced, resulting in increasing pliancy. The *Śrāvakabhūmi* says that insofar as pliancy increases, quiescence is increased, so that they mutually enhance each other.[155]

In summary, when the mind is fit, the vital energies become fit. At that time, extraordinary physical pliancy occurs, and when that happens, exceptional *samādhi* arises. That, in turn, brings forth exceptionally fit vital energies leading to physical and mental pliancy. Moreover, the *Śrāvakabhūmi* states:

> . . . due to the expansiveness[156] of all signs from the beginning, due to the prevention of distraction, and due to the absence of mindfulness and of mental engagement.[157]

[154] That is, the form realm *(gzugs khams, rūpadhātu).*

[155] *Yogasthāna III.,* Bihar MS., 12A.3–1a.

[156] The Tibetan reads "not being directed to" *(mi phyogs)* in contrast to the Sanskrit "expansiveness" *(vaipulya).*

[157] *Yogasthāna III.,* Bihar MS., 12B.1–1. Derge: Sems tsam Dzi 145.1.6. The complete sentence from which this citation is extracted reads: "There is insight due to the preceding nine attentional states, due to the inner withdrawal of the mind, due to the expansiveness of all signs from the beginning, due to the prevention of distraction, and due to the absence of mindfulness and of mental engagement."

This declares that when the attention is initially focused single-pointedly, it is placed without any other mindfulness or mental engagement. When one grows accustomed to that, the *Śrāvaka-bhūmi* continues:

> The entire continuum and flow of your attention, focused in single-pointedness and internally focused in the quiescence of the mind, should sequentially be signless, devoid of ideation, and calm. Direct your attention in that way.
>
> When the mind has achieved quiescence, if—due to forgetfulness,* loss of mindfulness, and the fault of a lack of habituation,* signs, ideation, and secondary mental afflictions appear, show their face, and act as objects—as soon as they occur and the mind has succumbed to the previously seen problem, be without mindfulness and without mental engagement.
>
> That is to say, due to the absence of mindfulness and of mental engagement, when that object is dissolved and removed, the mind is placed in the absence of appearances. Good sir, that meditative object* is subtle and difficult to realize,* so proceed with yearning and strenuous effort in order to realize it.[158]

This states the manner in which *samādhi* arises. The passage up to the phrase "Direct your attention in that way" shows the way in which the three [features] of signlessness, and so on, gradually arise as a result of the preceding practice.

Then the passage up to the phrase "without mental engagement" explains: even though quiescence is achieved, due to a lack of strong habituation and so on, if signs, etc. appear to the mind, you should be mindful of the disadvantages of the mind coming under the influence of those, and focus the attention without following after them and without thinking of anything.

Then the passage up to the phrase "absence of appearances" explains: by habituating yourself like that, due to the strength of habituating yourself to not thinking anything, the three [features] of signs, etc., naturally subside, without resorting to intentional focusing of the attention. Then remaining in the non-appearance of those three, you are not carried away by them. The remainder

[158] *Yogasthāna III.*, Bihar MS., 12A.6–5.

of the passage shows that this quiescence is subtle and that its explanation is difficult to comprehend.

Here, signs refer to the ten signs of the five objects including visual form,[159] of the three poisons, of male and of female. This is the way they vanish: at first a variety of signs of the objects such as visual form appear, and as soon as they appear they naturally subside and are purified. Finally, when you settle in meditative equipoise, only the aspects of the sheer awareness, clarity, and vivid joy of the mind appear, without the appearance of the signs of visual form, sound, and so on.[160]

Then this is the way ideation vanishes: by placing the attention in the absence of mindfulness and mental engagement as before, like bubbles emerging from water, any ideation that arises cannot be prolonged in great diffusion, but naturally subsides. Then by practicing as before, without intentionally inhibiting them, experiential awareness and the sense of ongoing joy do not bear observation; rather, like peeling bark, they naturally subside and are purified as soon as they arise. Joy and the experiential awareness then become subtle.

At that time, while in meditative equipoise no appearances of your own body and so on arise, and there is a sense as if the mind has become indivisible with space. When rising from that state, there is a sense as if the body is suddenly coming into being. Moreover, in post-meditative experience the occurrence of the ideation of afflictions such as hatred is also utterly different than before, being feeble and incapable of being very prolonged.

That phase is called *the phase of complete pacification*. The sense of clarity is so great that you feel that you could count the

[159] That is, visual form, sound, smell, taste, and tactile object. In his discussion of signless *samādhi (mtshan ma med pa'i ting nge 'dzin, ānimittasamādhi)* Vasubandhu gives a comparable list of ten signs of which *nirvāṇa* is free: the five sensory objects, the male and female, and the three characteristics of conditioned things, namely, arising, duration, and cessation. Cf. Louis de La Vallée Poussin, *Abhidharmakośabhāṣyam*, English trans. Leo M. Pruden, Vol. IV, p. 1257.

[160] Vasubandhu concurs that in the first meditative stabilization the five sense consciousnesses are absent in a person who has entered into contemplation. Cf. Louis de La Vallée Poussin, *Abhidharmakośabhāṣyam*, English trans. Leo M. Pruden, Vol. IV, p. 1231.

atoms of the pillars and walls of your house; and due to deep attentional stability, sleep does not occur as it did prior to achieving *samādhi*. Rather, you feel as if your sleep were suffused with *samādhi*, and many pure dream appearances take place.

> COMMENTARY: The above section, in which Tsongkhapa draws chiefly from Asaṅga's *Śrāvakabhūmi*, describes the method for purifying quiescence once it has been achieved. While quiescence is initially accomplished by means of mindfulness and mental engagement—and, indeed, is even called "mental engagement"—the method for purifying quiescence entails placing the attention in "the absence of appearances." Thus, if one has achieved quiescence by focusing on a mental image of the Buddha's body, for example, one would now release that image, so that "only the aspects of just the awareness, clarity, and vivid joy of the mind appear . . . "
>
> This implies that, regardless of the type of meditative object used during the prior training, upon the achievement of quiescence, the mind is settled in the absence of appearances in which only the salient characteristics of consciousness itself remain. In other words, by following this technique, all paths to quiescence finally result in an experiential realization of the nature of consciousness.
>
> Tsongkhapa comments, however, that "experiential awareness and the sense of ongoing joy do not bear observation," indicating that awareness cannot be its own object in the way that a mental image can be observed. This position conforms to the Prāsaṅgika assertion that the mind cannot observe the mind, just as the blade of a sword cannot cut itself, and it is applied in the Prāsaṅgika refutation of the Yogācāra assertion of self-cognizing awareness* and of the inherent existence of consciousness.[161] It must be emphasized that the gist of this

[161] The principle points of this debate are presented in *Śāntideva's Bodhicaryāvatāra*, IX:17–25. Cf. H.H. the Dalai Lama, Tenzin Gyatso, *Transcendent Wisdom: A Commentary on the Ninth Chapter of Shantideva's* Guide to the Bodhisattva Way of Life, trans. and ed. B. Alan Wallace; *Śāntideva's Bodhicaryāvatāra*, trans. Parmananda Sharma (New Delhi: Aditya Prakashan, 1990).

Prāsaṅgikas refutation is to deny the existence of consciousness as an intrinsic, substantial entity, not to dismiss the possibility of gaining an experiential realization of consciousness.

The Prāsaṅgikas maintain that the introspective attempt to seek out the mind and focus the attention on the intrinsic nature of consciousness results in not finding such a truly existent mind; and this analytical process yields insight into the emptiness of consciousness, which is to say, its ultimate nature. In contrast, it is possible to realize the phenomenological nature of consciousness by means of the above cultivation and purification of quiescence. In this case, the qualities of experiential awareness, clarity and joy are not dualistically experienced as objects of attention; rather, they are non-dualistically experienced once the mindfulness of, and mental engagement with, objective appearances has been released.

□□□□ *II)*. THE ELIMINATION OF QUALMS

When *samādhi* such as that explained previously is achieved, where does that fit within the context of the five paths?[162] If the preceding is a *samādhi* that is cultivated on the basis of the view of identitylessness after correctly ascertaining that, it can be established as a path of liberation of the phase of ordinary beings.*[163] However, in the case of meditation that is not practiced like that, the *Śrāvakabhūmi* says that even the mundane paths[164]

[162] These are the paths of accumulation *(tshogs lam, saṃbhāramārga)*, preparation *(sbyor lam, prayogamārga)*, seeing *(mthong lam, darśanamārga)*, meditation *(sgom lam, bhāvanāmārga)*, and no more training *(mi slob lam, aśekṣamārga)*. Tsongkhapa bases his discussion of the five paths chiefly on Maitreya's *Abhisamayālaṃkāra*.

[163] This refers to all non-Ārya beings, that is, beings who have not achieved a non-conceptual, unmediated realization of ultimate truth. The implication here is that it is possible first to understand the meaning of identitylessness, then to conjoin that understanding with quiescence. Such *samādhi* would initially be imbued with a conceptual realization of identitylessness, still mixed with an idea of its referent. Thus, it would not be an Ārya's non-conceptual realization of identitylessness.

[164] Mundane paths consist of avenues of practice that do not, of themselves, lead beyond the *saṃsāra*.

which look to the aspects of calmness and coarseness for accomplishing the first basic stabilization are accomplished on the basis of this *samādhi*. Therefore, non-Buddhist sages, who, by means of mundane paths, free themselves from attachment to the plane of nothingness[165] and lower planes, must proceed to higher paths on the basis of this *[samādhi]*. So this is a *samādhi* common to both non-Buddhists and Buddhists.

Furthermore, if this *[samādhi]* is imbued with the view that correctly realizes identitylessness, and with the attitude of emergence that well comprehends the faults of the whole of *saṃsāra*, is disillusioned with *saṃsāra*, and aspires for *nirvāṇa*, it turns into the path to *nirvāṇa*. And if it is imbued with the spirit of awakening, it turns into the Mahāyāna path. By analogy, if the generosity of giving a single morsel of food to an animal and maintaining even one type of ethical discipline are imbued with those attitudes, they turn into spiritual power on the paths to liberation and omniscience respectively.[166] However, in this case one does not analyze whether it becomes a path to *nirvāṇa* and awakening in terms of its being imbued with other paths; rather one analyzes which path it becomes by the very nature of the *samādhi* itself.[167]

Therefore, meditation that is without mindfulness and mental engagement, and the state of joy, clarity, and non-conceptuality that is said to be intellectually uncontrived and without grasping may or may not be emptiness meditation that is settled in

[165] This is the third meditative absorption *(snyoms 'jug, samāpatti)* in the formless realm in which the mind is focused on nothingness. The first two are absorption in limitless space and in limitless consciousness, and the final absorption in the formless realm is known as the peak of mundane existence. For a more detailed account of these formless absorptions see Leah Zahler, *Meditative States in Tibetan Buddhism: The Concentrations and Formless Absorptions* (London: Wisdom, 1983), pp. 129–133.

[166] That is, if either of those actions is imbued with an aspiration for liberation or the spirit of awakening, it turns into the path of liberation or omniscience respectively.

[167] That is, the factors that determine whether a *samādhi* is an avenue to *nirvāṇa* or perfect enlightenment are not external to that *samādhi*, but rather are to be found in the nature of the *samādhi* itself.

equipoise in the reality of thatness. So proper discrimination is very important, for there is a great possibility of mistaking that which is not a realization of the meaning of thatness for such a realization. If you fail to make this distinction as explained previously, you may grasp onto *samādhi* that is common to this [Buddhist] Dharma and that of others as a chief point of the stage of completion of Anuttarayogatantra. So investigate carefully!

COMMENTARY: The main point of the above section is to counteract the temptation to confuse the achievement of quiescence with much more advanced realizations on the Buddhist path. Tsongkhapa begins by pointing out that the quiescence of the first proximate meditative stabilization is common to Buddhists and non-Buddhists; and if it is not conjoined with insight into identitylessness, it does not belong anywhere on the uniquely Buddhist paths to *nirvāṇa* and perfect enlightenment.

Such quiescence is the contemplative basis for the cultivation of mundane insight, common to Buddhists and non-Buddhists, and for the uniquely Buddhist cultivation of insight into identitylessness. Quiescence conjoined with insight into identitylessness has the power to eliminate mental afflictions irreversibly, but quiescence alone can only temporarily inhibit the arousal of afflictions associated with the desire realm. Moreover, after achieving quiescence, if this *samādhi* is not carefully maintained, it can degenerate and be lost altogether, without bringing about any lasting, beneficial, mental transformation whatsoever.

The actual state of quiescence described previously on the basis of the *Śrāvakabhūmi* is characterized by an absence of mindfulness and mental engagement. This absence of mindfulness does not imply that the clarity or stability of attention has been sacrificed, but only that the attention has been disengaged from its accustomed meditative object. It should be recalled that mindfulness as it has been defined in this con-

text, on the basis of the *Abhidharmasamuccaya*, arises only with respect to a familiar object that has already been ascertained. Similarly, the absence of mental engagement does not imply here a vague, inattentive awareness, but only that the attention is no longer willfully directed to a specific object and held there.

In this sense the state of quiescence may be regarded as mentally uncontrived and free of conceptual grasping. It is also immediately preceded by an experience of extraordinary joy, and it is sustained in a state of exceptional mental clarity and non-conceptuality. All of these characteristics appear frequently in descriptions of profound realizations of thatness which arise in the practice of Mahāmudrā and Atiyoga. Because of the superficial resemblance of quiescence and these much more advanced *samādhis*, Tsongkhapa cautions aspiring contemplatives to examine carefully the differences between them. The authentic insights of Mahāmudrā and Atiyoga are based upon the prior attainment of quiescence, and they differ from quiescence in terms of the practices leading to them, the nature of the realizations themselves, and their resultant benefits.[168]

[168] Two aphorisms of the Kagyü (bKa' brgyud) order of Tibetan Buddhism, in which the insight practice of Mahāmudrā is most emphasized state: "Where there is no quiescence, there is no insight," and "If one seeks insight too early, one will not achieve quiescence." (Takpo Tashi Namgyal, *Mahāmudrā: The Quintessence of Mind and Meditation*, trans. Lobsang P. Lhalungpa, p. 173. I have slightly modified the translation to conform to my translation of *śamatha* as "quiescence.")

Karma Chagmé (Kar ma chags med), a seventeenth-century Nyingma (rNying ma) Lama who was a principle holder of the lineages of both Mahāmudrā and Atiyoga, similarly emphasizes that primordial wisdom *(ye shes, jñāna)* does not arise in the absence of meditative equipoise, and that the cultivation of quiescence must precede insight. Moreover, in the conclusion of his chapter on insight, he declares that if one does not first reach definite insight by means of discursive investigation into the nature of consciousness, the later, more advanced instructions on the principle techniques of Mahāmudrā and Atiyoga will have little impact. (*Spacious Path to Freedom*, Chs. 3, 4). For a brief account of the life of Karma Chagmé and his role in the Kagyü and Nyingma orders see Tsering Lama Jampal Zangpo, *A Garland of Immortal Wish-fulfilling Trees*, trans. Sangye Khandro (Ithaca: Snow Lion, 1988), Ch. 3.

Tsongkhapa points out that similar confusion may arise by mistaking the experience of quiescence with a chief point of the stage of completion of Anuttarayogatantra. That chief point is the manifestation of the ultimate clear light, in which emptiness is non-conceptually realized with the subtlest of minds. Such realization is necessarily preceded by a series of earlier, preparatory contemplative achievements (including quiescence), and it bears only the most superficial resemblance to quiescence alone.

☐☐ *b*. A GENERAL PRESENTATION OF THE WAY TO PROCEED ALONG THE PATH ON THE BASIS OF QUIESCENCE

Should one who has achieved the mental engagement of non-conceptual *samādhi* in accordance with the foregoing discussion practice just that non-conceptuality characterized by clarity, non-conceptuality, and so forth? The generation of such *samādhi* in one's mind-stream is for the purpose of developing insight that overcomes mental afflictions; so if insight does not arise on that basis, however much one is habituated with that *samādhi*, it cannot eliminate even the afflictions of the desire realm, let alone eliminate all mental afflictions.[169] Thus, it is necessary to cultivate insight.

Furthermore, there are two kinds of insight: the insight proceeding by the mundane path, which eliminates manifest mental afflictions, and the insight proceeding by the supramundane path, which radically eliminates the "seeds" of mental afflictions. The former, bearing the aspects of calmness and coarseness, regards the lower planes as coarse, and the higher as calm; and the latter observes the sixteen aspects of the Four [Noble] Truths, including impermanence, and so on.[170] The more important of these two

[169] There are different sets of mental afflictions specifically associated with the desire realm, form realm, and formless realm. Although the various meditative stabilizations and absorptions of the form and formless realms can inhibit the manifestation of these mental afflictions, those *samādhis* by themselves cannot irreversibly eliminate any afflictions.

[170] For a description of these sixteen aspects see Jeffrey Hopkins, *Meditation on Emptiness*. (London: Wisdom, 1983), pp. 292–96.

meditations taught in the *Śrāvakabhūmi* is the view that realizes personal identitylessness.

Therefore, whether one is a non-Buddhist who eliminates manifest afflictions by cultivating the path bearing calm and coarse aspects, or a Buddhist who radically eliminates afflictions by meditating on the meaning of identitylessness, at the outset the quiescence discussed above is needed as the basis for eliminating the afflictions of both non-Buddhist and Buddhist contemplatives. Furthermore, all Mahāyāna and Hīnayāna contemplatives must accomplish that *samādhi;* and among Mahāyānists, all Mantrayāna and Pāramitāyāna contemplatives must also accomplish that quiescence. So this quiescence is important as the basis for proceeding along all contemplative paths.

For Buddhists the former of the two kinds of insight is not indispensable, but the latter—the insight that realizes identitylessness—is crucial. Moreover, if the previously explained quiescence is accomplished, which is included in the plane of the first proximate meditative stabilization, even without achieving either the stabilizations above[171] that or formless quiescence,[172] by cultivating insight on that basis it is possible to achieve liberation that frees one from all the fetters of *saṃsāra*. On the other hand, if one does not realize or meditate on the meaning of identitylessness, by means of the previously explained quiescence and the mundane insight that is based on it, one may achieve the mind of the peak of mundane existence, which eliminates all the manifest afflictions up to [the plane of] nothingness. But one is not liberated from *saṃsāra*. Thus, the "Praise of Non-reply" section of the *Varṇāhavarṇa* declares:

> People opposed to your Dharma are blinded by delusion. Even after venturing to the peak of mundane existence, suffering occurs again, and mundane existence is maintained.

[171] Including the first basic meditative stabilization and all more advanced stabilizations.

[172] That is, meditative absorptions in the formless realm.

Those who follow your Dharma—even if they do not achieve basic stabilization—turn away from mundane existence, while under the steady gaze of the eyes of Māra.[173]

Therefore, Anuttarayogatantra contemplatives, too, must develop quiescence even if they do not develop phenomenological insight bearing the aspects of calmness and coarseness, or the quiescence generated by that [insight]. Moreover, the point at which quiescence first arises is the occasion of the stage of generation.

COMMENTARY: In the above section three types of contemplative practice are discussed: (1) the quiescence of the first proximate meditative stabilization; (2) the mundane meditative stabilizations and absorptions of the form and formless realms that are achieved by appreciating the relative coarseness of the lower stabilizations and the calmness of the higher; and (3) the supramundane insight derived from meditation on identitylessness. The third of these is said to be unique to Buddhists and is indispensable for gaining liberation from *saṃsāra;* the second is common to Buddhists and non-Buddhists, but is not indispensable for achieving liberation; while the first, Tsongkhapa insists, is necessary for both Buddhist and non-Buddhist contemplative paths. This clearly implies that the cultivation and achievement of quiescence is not inextricably tied to any one philosophical or religious doctrine or ethical discipline.

Tsongkhapa maintains that the first proximate meditative stabilization provides a sufficient contemplative basis for the further cultivation of insight into ultimate truth. The first basic stabilization provides a more stable and enduring freedom from the five hindrances, and a stronger presence of the

[173] The personal embodiment of evil, often appearing, at times with his hosts, as a tempter in Buddhist narrations. Traditionally, four types of Māra are cited: (1) the Māra of the psycho-physical aggregates; (2) the Māra of mental afflictions; (3) the Māra of the Lord of Death; and (4) the Māra of Devaputra, the personification of lust.

five factors of stabilization. Tsongkhapa seems to imply, how-
ever, that these and greater benefits can be achieved by culti-
vating supramundane insight on the basis of the first
proximate stabilization.

Here is one possible reason for the Tibetan Buddhist lack
of emphasis on achieving higher states of stabilization.
Virtually all Tibetan Buddhist contemplatives have their
sights set on achieving enlightenment by means of Tantric
practice, especially following Anuttarayogatantra. A central
theme of such practice is to sublimate the mental afflictions,
especially sensual desire, so that they actually empower one
towards enlightenment.[174] In order to achieve this soteriologi-
cal transmutation of desire, this passion must manifest in
one's consciousness. However, upon accomplishing the first
basic stabilization, sensual desire is very effectively inhibited,
which precludes the possibility of its sublimation. The
achievement of the first proximate stabilization, in contrast,
yields a tenuous mastery over the five hindrances, including
sensual desire; but the passions may still be aroused—and
then sublimated—at will.

While this explanation of the cultivation of quiescence is
presented within the context of the Sūtrayāna, Tsongkhapa
acknowledges that it may first be developed as a Vajrayāna
practice. Specifically, with respect to the two stages of
Anuttarayogatantra—the stages of generation and of comple-
tion—quiescence must be achieved in the former stage.[175]
Thus, it is a necessary prerequisite for all practices belonging
to the stage of completion, such as the Six Dharmas of
Naropa.[176] One may of course engage in these more advanced

[174] For an illuminating account of the role of passion in Buddhist Tantra see
Miranda Shaw, *Passionate Enlightenment: Women in Tantric Buddhism* (Prince-
ton: Princeton University Press, 1994).

[175] This view is by no means unique to Tsongkhapa and his school. For instance,
Longchen Rabjam (kLong chen rab 'byams), one of the foremost representatives
of the Nyingma (rNying ma) order of Tibetan Buddhism, makes this same point.
Cf. Tulku Thondup Rinpoche, *Buddha Mind*, p. 13.

[176] *Na ro chos drug*

practices without having first achieved quiescence, but—as in the case of cultivating supramundane insight into emptiness, and the practices of Mahāmudrā and Atiyoga—without quiescence, it is not possible to bring these practices to their intended culmination.

□□ c. A SPECIFIC PRESENTATION OF THE WAY TO PROCEED ALONG THE MUNDANE PATH

The *Śrāvakabhūmi* says that from the ninth attentional state up to, but not including, the achievement of mental engagement, one is a novice at mental engagement; and upon achieving mental engagement, one who, out of a desire to purify mental afflictions, cultivates the mental engagement that discerns characteristics[177] is a novice at purifying mental afflictions. If one has not well understood this explanation in the *Śrāvakabhūmi*, the mistaken idea might arise: "The lowest stage on the path of the stabilizations and the formless absorptions is the first proximate stabilization. And the first of the mental engagements explained in that regard is discernment of characteristics. Therefore, the initial occurrence of the attention belonging to the proximate state is discernment of characteristics."

It is incorrect to believe that, for these reasons: (1) without achieving quiescence there is no way that the first proximate stabilization can arise; (2) if that proximate state is not achieved, quiescence will not be achieved; and (3) since discernment of characteristics consists of discursive meditation, by cultivating that it is not possible to freshly accomplish quiescence that has not been achieved earlier.

Therefore, the first of the six mental engagements[178] of the first proximate state is the entrance to cultivating the insight included

[177] *mtshan nyid so sor rig pa'i yid byed, lakṣaṇapratisaṃvedīmanaskāra*. This type of mental engagement is discussed in Geshe Gedün Lodrö, *Walking Through Walls*, Ch. 15.

[178] These six mental engagements are: (1) mental engagement of discerning characteristics *(mtshan nyid so sor rig pa'i yid byed, lakṣaṇapratisaṃvedīmanaskāra)*; (2) mental engagement arising from appreciation *(mos pa las byung ba'i yid byed, adhimokṣikamanaskāra)*; (3) mental engagement of thorough isolation *(rab tu dben*

in the proximate state; but it is not the beginning of just the first proximate state, for it must be preceded by the quiescence that is included in the proximate state. All *samādhis* prior to the achievement of the *samādhi* included in the proximate state are single-pointed attention of the desire realm. So judging by the great treatises, there seem to be very few who achieve even quiescence. I have not written about the manner in which the six proximate mental engagements free one from attachment to the desire realm, for I fear this would become too wordy.

COMMENTARY: Tsongkhapa here makes a brief reference to the relationship between quiescence and the six types of mental engagement that precede the achievement of the first basic stabilization. However, out of fear of verbosity, he chooses not to elaborate on this complex topic, and for the same reason it will not be discussed further in this commentary.[179]

Tsongkhapa commented in the early fifteenth century that there seemed to be very few people who achieved quiescence as it has been taught in the great treatises. In 1980, I began field research to try to discover whether this statement holds true nowadays. During the spring and summer of 1980, I lived in a loose-knit community of Tibetan Buddhist contemplatives in the mountains above Dharamsala, India. Over the course of this period, I enjoyed numerous conversations with a number of seasoned recluses and with His Holiness the Dalai Lama concerning contemporary Tibetan Buddhist con-

pa'i yid byed, prāvivekyamanaskāra); (4) mental engagement of pleasure-withdrawal *(dga' ba sdud pa'i yid byed, ratisaṃgrāhakamanaskāra)*; (5) mental engagement of analysis *(spyod pa yid byed, mīmāṣsāmanaskāra)*; and (6) mental engagement of final training *(sbyor mtha'i yid byed, prayoganiṣṭhamanaskāra)*. A detailed account of the role of these six mental engagement in progressing from the first proximate to the first basic meditative stabilization is given in Geshe Gedün Lodrö, *Walking Through Walls*, Ch. 14. To compare this Indo-Tibetan account with the Theravāda explanation of this process, see Paravahera Vajirañāṇa Mahāthera, *Buddhist Meditation in Theory and Practice*, pp. 327–331.

[179] In addition to the sources already cited, this topic is also explained at length in Leah Zahler, *Meditative States in Tibetan Buddhism*.

templative practice in general, and the cultivation of quiescence in particular. The consensus among them was that the achievement of genuine quiescence today among Tibetan Buddhism contemplatives living in exile is not unknown, but it is exceptionally rare. In Tibet during the decades prior to the Chinese Communist occupation, there seem to have been considerably more cases of individuals who had achieved quiescence.

During the summer of 1992, I conducted a cursory survey of experienced Tibetan Buddhist contemplatives living at that time in the Tibet Autonomous Region and in the areas of western China largely inhabited by Tibetans. Although I learned of hundreds of Tibetan men and women devoting their lives to full-time contemplative practice—as is the case among the Tibetans living in exile—those who have accomplished quiescence would seem to be very rare at best. It is noteworthy that Tibetans living under Chinese Communist domination have enjoyed what relative freedom they now have to practice Buddhism only since 1980, following a twenty-year period of absolute suppression.

During the autumn and winter of 1980–81, I conducted field research in several monasteries and hermitages in Sri Lanka for the purpose of learning about the practice of quiescence in contemporary Theravāda Buddhism. My principle Sri Lankan teacher, the Ven. Ānandamaitreya Mahānāyakathera, informed me that despite the fact there are hundreds of Buddhist meditators in numerous hermitages throughout the country, only a small handful had achieved genuine quiescence. Most Theravāda meditators nowadays focus almost entirely on the cultivation of insight, often to the exclusion of quiescence altogether.

Since 1970, I have spent many years in Tibetan and Theravāda Buddhist centers in Europe and North America. Although training in quiescence is encouraged in a minority of these centers, for the most part it receives little or no emphasis; and I have yet to hear of a single Western Buddhist who has accomplished quiescence as it has been presented here.

Modern Theravāda Buddhist contemplatives tend to over-
look the training in quiescence in favor of insight practice
alone, and many justify this on the grounds that quiescence
can be accomplished simultaneously with the cultivation of
insight. Modern Tibetan Buddhists tend to overlook the train-
ing in quiescence in favor of preliminary discursive medita-
tions followed by the practice of Anuttarayogatantra,
Mahāmudrā, or Atiyoga. Although uniquely tantric techniques
for achieving quiescence are presented in the generation stage
of Anuttarayogatantra, it is common for contem- platives
nowadays to de-emphasize these, and to move on swiftly to the
completion stage. This is sometimes justified on the grounds
that quiescence can be accomplished as a by product of the
completion stage of Anuttarayogatantra, of Mahāmudrā, or
Atiyoga. However, those who make this claim often equate qui-
escence with the simple achievement of stable, non-conceptual
mindfulness—an assertion utterly rejected by Tsongkhapa and
the Theravāda patriarch Buddhaghosa alike.

The Indo-Tibetan Buddhist tradition does acknowledge
that in exceptional cases quiescence may be accomplished
simultaneously with Sūtrayāna training in insight, in the
completion stage of Anuttarayogatantra, or in the practice of
Mahāmudrā or Atiyoga. These are possibilities for rare indi-
viduals of extraordinary contemplative acuity. But for the vast
majority of aspiring contemplatives, launching into advanced
practices with an insufficient basis in quiescence may be
both unproductive and misleading.[180]

One factor contributing to the rarity of the achievement of
quiescence seems to be that such practice is very demanding
and the desired results often do not arise as swiftly or as pre-
dictably as one might hope. Boredom, frustration, and hyper-
tension may then easily set in, and the temptation to proceed
on to more advanced, interesting, and hopefully fruitful
contemplative methods may turn out to be overwhelming.
Even among Tibetan contemplatives who have now been
influenced by the fast-paced modern mentality, a sense of

[180] Cf. Tulku Thondup Rinpoche, *Buddha Mind*, p. 4.

hurriedness may influence their choice of practices; and this is all the more the case with people raised in the West. And when the Buddhist tradition informs its followers that the most transformative meditations are those that are more advanced than mere quiescence, those seeking liberation and enlightenment may easily follow the urge to pass over this training with the assumption that the higher practices will bring the same benefits and more. Moreover, the scarcity of contemplatives who have accomplished quiescence means there are few who can teach this training from personal experience from start to finish. Therefore, those who aspire to achieve this goal may be unable to acquire the tacit knowledge that can be acquired only from an accomplished teacher. Thus, regardless of their personal qualifications, such aspirants face the disadvantage of a lack of experiential guidance; and they may well question their own ability to achieve a contemplative state that their own teachers have not reached. This is all the more the case for Western aspirants, who have been brought up in a culture that denies the value, and even the possibility, of achieving such sustained voluntary attention.

While the benefits attributed to the achievement of quiescence are modest within the overall framework of the Buddhist paths to liberation and enlightenment, they seem to be extraordinary—and at times simply incredible—from the perspective of modern psychology and natural science as a whole. From a religious perspective, the relevance of quiescence is not confined to Buddhism alone; rather, it is a common heritage of Buddhist and non-Buddhist contemplative traditions alike, and its significance may extend even to non-Asian religions. But the scientific and religious significance of such training hinges on the questions: Has anyone in the past ever accomplished quiescence and its alleged benefits? Is it possible for these to be achieved and demonstrated today? While the former question may be settled in the affirmative with religious faith, or in the negative with scientific skepticism, the second question lingers as a challenge that can be met only with experience.

Chapter 3

An Analysis of Quiescence

The Role of Mindfulness in the Cultivation of Quiescence

Quiescence According to Tsongkhapa

In the cultivation of quiescence, introspection has the function of monitoring the meditating awareness, while the task of mindfulness is to attend without distraction to the object of meditation.[1] In his two expositions of the stages of the path, Tsongkhapa gives brief accounts of a wide range of objects suitable for the cultivation of quiescence; but he gives detailed explanations of the method of focusing on a mental image of the Buddha's body.[2] Here a clear distinction must be made between the support* for the meditative object and the meditative object* itself. A statue or painting of the Buddha may be used in the preliminary stages of this practice to gain familiarity with the features of the Buddha's body; but during the actual meditation, one focuses purely on a mental image of that form. This image is not to be viewed merely as a product of the imagination, but as being naturally present. This advice is to be understood in terms of the Mahāyāna Buddhist assertion that the mind of the Buddha, or Dharmakāya, is everywhere present. Thus, when bringing an image of the Buddha to mind, the meditator recalls the compassion and other qualities of the Buddha as being immanently present.[3]

[1] Anne Klein discusses the contemporary context for mindfulness in Ch. III of *Meeting the Great Bliss Queen: Buddhists, Feminists, and the Art of the Self* (Boston: Beacon Press, 1995).

[2] For this technique he invokes the authority of the *Pratyutpanna-buddha-sammukhāvasthita-samādhi-sūtra*, the *Samādhirājasūtra*, the *Bhāvanākramas II* and *III*, and the *Bodhipathapradīpa*.

[3] Paul Harrison correctly points out that the *sūtra* basis for this technique is derivative of the early practice of "recollection of the Buddha" *(buddhānusmṛti)*; Paul Harrison, "Commemoration and Identification in *Buddhānusmṛti*" in *In the Mirror of Memory*, Janet Gyatso, ed., pp. 220–238.

If this practice entailed remembering the body of the Buddha of which one has heard descriptions, or if it entailed remembering a previously perceived visual object, such as a statue or painting of the Buddha, that memory would be a conceptualization*[4] that recalls the Buddha's body by way of a generic image.*[5] In this case, the generic image *appears* to the mind, but it is not *ascertained*. That is not what Tsongkhapa has in mind for this practice. Here the main object of the attention is the mental image itself, which is viewed as an actual embodiment of the Buddha. One may use a statue or painting of the Buddha as the *basis* for one's visualization, but the mental image is viewed as a three-dimensional, transparent, luminous image of the actual Buddha.[6] The mindfulness that directly apprehends this image as its main object must therefore be an instance of mental perception, and not a conceptualization. Thus, mindfulness may operate either as a conceptualization or as a mental perception, depending on whether it apprehends *its main object by way of a generic image* or it apprehends *a mental image as its main object*. Furthermore, to accomplish genuine quiescence it is necessary that mindfulness be directed upon a mental object, for *samādhi* is accomplished with mental, not sensory consciousness.[7]

Tsongkhapa bases his discussion of the role of mindfulness in the cultivation of quiescence on Asaṅga's definition in the *Abhidharmasamuccaya:* "What is mindfulness? The non-forgetfulness of the mind with respect to a familiar object, having the

[4] For a detailed explanation of conceptualization see Lati Rinbochay, *Mind in Tibetan Buddhism,* trans. and ed. by Elizabeth Napper, pp. 21, 50–51, and 130–32. For a specifically Prāsaṅgika account of the distinction between conceptual and non-conceptual cognition see Blo bzang rgya mtsho, *mTha' gnyis dang bral ba'i dbu ma thal 'gyur ba'i blo'i rnam gshag ches cher gsal bar byed pa blo rigs gong ma,* pp. 39–43.

[5] For an account of the Gelugpa debates concerning the nature of generic images see Jeffrey Hopkins, *Meditation on Emptiness,* pp. 347–349.

[6] Tsongkhapa, *Byang chub lam gyi rim pa chung ba,* p. 142A. For a Buddhist who believes that the Buddha is omnipresent, this perception of the mental image as being an actual Buddha could be regarded as valid; but for one who does not accept that theory, this cultivation of quiescence would entail the development of a sustained mistaken awareness.

[7] Ibid.

function of non-distraction."[8] This definition indicates that mindfulness can arise only with respect to an object with which one is already familiar, and it entails not forgetting the object by being constantly mindful of it, without the slightest distraction. Mindfulness is the most important factor for developing introspection, and it is the principal means of accomplishing *samādhi*.

The purpose of mindfulness is first to prevent distraction away from the meditative object and then forgetfulness of that object. When subtle excitation arises, it may seem that one is continuously attending to the meditative object while the mind is peripherally distracted by other objects; whereas in the case of coarse excitation the meditative object is forgotten entirely. However, according to the *sūtra*-based Buddhist theory of moments of cognition, a single consciousness cannot attend simultaneously to two or more dissimilar objects. Thus, I surmise that the occurrence of subtle excitation must entail successive moments of cognition of the meditative object briefly interrupted by cognitions of other objects. As these moments of cognition are experientially blurred together, the meditator might have the mistaken impression that, despite these distractions, there is an unbroken continuity of awareness of the meditative object. In the case of coarse excitation, the continuity of attention focused on the meditative object is interrupted so long that the meditator notes that the meditative object has been forgotten altogether.

Tsongkhapa emphasizes that in the cultivation of quiescence it is not enough that one's attention is clear and limpid; rather, one must *ascertain* the meditative object by apprehending it firmly with mindfulness. Otherwise, the full potency of attentional clarity cannot arise, subtle laxity is not dispelled, and one's *samādhi* remains impaired.[9] Among the nine attentional states leading up

[8] *Abhidharmasamuccaya*, Pradhan, ed., p. 6.6. In her essay "Mindfulness and Memory: The Scope of *Smṛti* from Early Buddhism to the Sarvāstivādin Abhidharma," Collett Cox cogently argues that the term *smṛti* represents an interrelated semantic complex, rather than two distinct mental processes of memory and mindfulness (*In the Mirror of Memory: Reflections on Mindfulness and Remembrance in Indian and Tibetan Buddhism*, Janet Gyatso, ed., pp. 67–107).

to the actual attainment of quiescence, the power of mindfulness is well developed in the fourth state. At that point, coarse excitation has been overcome, for the attention can no longer be distracted away from the meditative object during meditation sessions.[10] When quiescence is finally achieved, the entire continuum of one's attention is focused single-pointedly, non-conceptually, and internally in the very quiescence of the mind; and the attention is withdrawn fully from the physical senses. At that point, if occasional thoughts do arise, even about the meditative object, the meditator is counseled not to follow after them, but to be *without mindfulness and without mental engagement.*[11] Thus, one now disengages not only from extraneous thoughts and so forth, but even from the meditative object. For the first time in this training, one does not attempt to fix the attention upon a familiar object. One's consciousness is now left in an absence of appearances, an experience that Asaṅga says is subtle and difficult to realize.[12]

Kamalaśīla, on whom Tsongkhapa relies heavily for his presentation of quiescence, points out that when something is perceived by being presented to cognition, it may then be removed through mental non-engagement.* Genuine mental non-engagement, however, is not a mere absence of mental engagement; rather it is a non-objectification that occurs only due to the analytical examination which penetrates beyond the signs* of phenomena.[13] The mind engages with signs whenever a phenomenon is apprehended as indicating something else; thus mentally grasp-

[9] Tsongkhapa, *Byang chub lam gyi rim pa chung ba,* p. 145A. Cf. *Madhyāntavibhāgaṭīkā,* by Sthiramati, Yamaguchi, ed., text. p. 175.9–11.

[10] During the spring and summer of 1980, I conducted field research on the practice of quiescence while living among Tibetan Buddhist contemplatives in the mountains above Dharamsala, India. Gen Jhampa Wangdü, a monk who had been living in contemplative retreat in Tibet and India for more than twenty years at that time, informed me that in the fourth attentional state one can maintain continuous meditation sessions of a few hours without distraction.

[11] *Yogasthāna III.,* Bihar MS., 12A.6–5.

[12] *Yogasthāna III.,* Bihar MS., 12A.6–5.

[13] Cf. Bhāvanākrama I. (ed. Tucci) p. 212; Kamalaśīla, *Avikalpapraveśadhāraṇi-ṭīka* (P, f. 156b–157B); Cf. David Seyfort Ruegg, *Buddha-nature, Mind and the*

ing onto signs corresponds closely to the process of cognizing an object as something that makes sense within one's conceptual framework.[14] The mental non-engagement upon the achievement of quiescence is, therefore, not of the same degree that occurs due to the cultivation of insight. For in quiescence, the mind is simply withdrawn from sensory objects and its own meditative object, without gaining insight into their true nature. The absence of phenomenal signs* is comprehended only by means of the analytical investigation that is characteristic of the cultivation of insight; and this is not pursued in the training in quiescence.

Tsongkhapa, drawing on Asaṅga,[15] states that upon achieving quiescence, the mind disengages from the signs of sensory objects, and only the aspects of the sheer awareness, clarity, and vivid joy of the mind appear.[16] Thus, joy is said to arise from the very nature of consciousness once it is free of the afflictions of laxity and excitation and is disengaged from all sensory and mental appearances. In this state, he says, any ideation* that arises is

Problem of Gradualism in a Comparative Perspective: On the Transmission and Reception of Buddhism in India and Tibet (London: University of London, 1989) fn. 179. While the process of analytical investigation is associated with mindfulness and mental engagement, when brought to its culmination, it is the necessary condition for the absence of both mindfulness and mental engagement and the ceasing of all conceptual proliferation. Cf. *Bhāvanākrama III* (ed. Tucci), pp. 15–17; Ruegg, *Buddha-nature, Mind and the Problem of Gradualism in a Comparative Perspective*, p. 183. Asaṅga concurs that the culmination of contemplative insight does not entail a mere lack of mental engagement, as in the case of deep sleep or catatonia. Otherwise, one could effortlessly be liberated from all delusion. (*Mahāyānasaṃgraha VIII*, 2, p. 233–cy). Cited in Edward Conze, trans., *The Large Sutra on Perfect Wisdom: with the Divisions of the Abhisamayālaṅkāra* (Berkeley: University of California Press, 1975), fn. 175, p. 30.

[14] Cf. Edward Conze, trans., *The Large Sutra on Perfect Wisdom*, p. 11.

[15] *Yogasthāna III.*, Bihar MS., 12A.6–5.

[16] Vasubandhu concurs that in the first meditative stabilization the five sense consciousnesses are absent in a person who has entered into contemplation. [Louis de La Vallée Poussin, *Abhidharmakośabhāṣyam*, English trans. Leo M. Pruden, Vol. IV, p. 1231.] I strongly suspect that the apprehension of these characteristics of the mind is analogous to the acquisition of the "sign of the mind" (*cittassa nimitta*) as a result of mental single-pointedness, which is regarded in the Pāli suttas as a prerequisite for the cultivation of insight. Cf. *Saṃyutta-Nikāya V*, 150–52; Kheminda Thera, *The Way of Buddhist Meditation*, pp. 53–54.

neither sustained, nor does it proliferate; rather it vanishes of its own accord, like bubbles emerging from water. One has no sense of one's own body, and it seems as if one's mind has become indivisible with space. Tsongkhapa characterizes this as a state of joy, clarity, and non-conceptuality, without mindfulness or mental engagement. He emphasizes that such a meditative state, sometimes said to be "intellectually uncontrived" and "without grasping,"* does not necessarily imply a realization of ultimate truth.[17]

Quiescence According to Mahāmudrā and Atiyoga

While Tsongkhapa does not elaborate here on the nature of meditation that is intellectually uncontrived and without grasping, this is a major theme in the Mahāmudrā and Atiyoga traditions of Indo-Tibetan Buddhism. Karma Chagmé[18] (1612–1678), a major lineage holder in both those traditions, addresses this point with respect to the achievement of quiescence:

> By the power of stopping ideation and familiarizing oneself with that, one remains in a state of brilliant clarity without scattering. That must occur first, but that is not the point[19] of Mahāmudrā and Atiyoga, for this is common to the view of the Chinese Hvashang, the four meditative stabilizations of non-Buddhist traditions, and the cessation of Śrāvakas. Why is that not Mahāmudrā and Atiyoga? Because it is not an uncontrived state, but a contrived one; and because there is the grasping of thinking, "attention is being sustained."[20]

[17] Tsongkhapa, *Byang chub lam gyi rim pa chung ba*, p. 162B. For Kamalaśīla's discussion of this point see his *Bhāvanākrama III* in The Third Process of Meditative Actualization, trans. Robert F. Olson and Masao Ichishima (Taishō Daigaku Sōgō Bukkyō Kenkyūsho Nenpō 1, 1979), pp. 38–40. Tsongkhapa returns to this topic in his short treatise *Zhi lhag gnyis kyi dka' gnad rgyal ba'i dgongs pa bzhin bshad pa* (Collected Works, Vol. Pha).

[18] Kar ma chags med. A brief biography of this contemplative is found in Tsering Lama Jampal Zangpo, *A Garland of Immortal Wish-fulfilling Trees: The Palyul Tradition of Nyingmapa*, trans. Sangye Khandro (Ithaca: Snow Lion, 1988), pp. 35–44.

[19] *don*

This view, which I find to be representative of the Mahāmudrā and Atiyoga traditions as a whole, clearly indicates that the state of quiescence, with its qualities of joy, clarity, and non-conceptuality, is not considered to be intellectually uncontrived, or unstructured, nor is it free of conceptual grasping. Thus, Tsongkhapa seems to agree with these contemplative traditions that quiescence by itself is not free of conceptual structuring or contrivance, and it is not free of conceptual grasping, even though it is easily mistaken as such.[21]

On the other hand, it does seem clear from Tsongkhapa's discussion, based on Asaṅga's *Śrāvakabhūmi*, that he believes the cultivation of quiescence to culminate in an experiential realization of the nature of consciousness. This assertion need not be interpreted as contradicting the premise, accepted by Tsongkhapa, that the mind cannot apprehend itself. That premise denies that a single consciousness can have itself as its own object. During the development of quiescence, introspection has

[20] Karma Chagmé, *Spacious Path to Freedom*, "The Ultimate Quiescence of Maintaining the Attention upon Non-conceptuality." There is at least one significant difference between Karma Chagmé's account of quiescence and that of Asaṅga, Vasubandhu, and Tsongkhapa. According to the Mahāmudrā and Atiyoga traditions, Karma Chagmé asserts that in the state of quiescence, the five kinds of sensory consciousness do not cease, but remain clear.[*Great Commentary to* (Mi 'gyur rdo rje's) *Buddhahood in the Palm of Your Hand (Sangs rgyas lag 'chang gi 'grel chen)* Ch. 15, p. 683.] The Nyingma Lama Gyatrul Rinpoche explained this passage to me by asserting that whereas in flawed quiescence the senses are totally withdrawn, in flawless meditation sensory objects do *appear* to the senses, but they are not *apprehended*. I believe this interpretation is compatible with the assertion that the *signs* of sensory objects do not appear to the mind while in the state of quiescence; for those objects are not perceived *as anything*.

[21] Although the state of quiescence is said to be non-conceptual, the meaning here is that the mind is not consciously engaged in discursive thought. However, it seems that conceptualization is still operating on a subliminal level, and one's experience is still structured by one's previous conceptual conditioning. According to the Madhyamaka view of Tsongkhapa, the mind is totally free of conceptualization only while engaged in the non-dual, conceptually unmediated realization of emptiness; and according to the Atiyoga tradition, one thoroughly transcends conceptual modification and grasping only in the unmediated realization of the empty and clear nature of the mind.

the function of monitoring the meditator's consciousness, particularly regarding the occurrence of the mental processes of laxity and excitation. Such metacognition is a form of recollective awareness that cognizes previous moments of consciousness. Likewise, once quiescence is accomplished and one's meditative object dissolves, in this absence of appearances the continuum of one's attention may attend to previous moments of consciousness. Due to the homogeneity of this mental continuum, the experiential effect would be that of the mind apprehending itself.

When Asaṅga and Tsongkhapa assert that with the achievement of quiescence one experientially fathoms the phenomenal nature of the mind, they are positing a realization that cuts through one's culturally and personally derived conceptual conditioning. This is not believed to be a uniquely Buddhist comprehension of the mind, nor is it regarded as a comprehension of a uniquely Buddhist mind. Rather, this is presented as a transcultural and transpersonal realization of the nature of consciousness. In the state of quiescence, the mind is no longer consciously engaged with human thought, mental imagery, or language, and it is disengaged from the human senses. Moreover, Tsongkhapa claims that the mind is also free of the signs of gender,[22] clearly implying that the experienced mind is not seen as being either male or female. Thus, the training in quiescence is presented as a means for experientially ascertaining the phenomenal nature of consciousness itself, which is common to people of different cultures and times, to human and non-human sentient beings, and to males and females. For these reasons the achievement of quiescence is taught as a crucial step to reaching the conceptually unstructured and unmediated realization of ultimate truth by means of the cultivation of insight.[23]

If it is possible to attend to previous moments of consciousness upon achieving quiescence, and if it is possible for introspection to monitor the flow of consciousness throughout the training in quiescence, we may well ask: might it then be possible to develop

[22] Tsongkhapa, *Byang chub lam gyi rim pa chung ba,* p. 162A.

[23] Cf. Anne C. Klein, "Mental Concentration and the Unconditioned: A Buddhist Case for Unmediated Experience" in Robert E. Buswell, Jr. and Robert M.

quiescence with the mind as one's meditative object, instead of a mental image? Tsongkhapa does in fact acknowledge this possibility, and he briefly mentions ways in which this might be carried out. One method he cites is to cultivate quiescence by maintaining the attention free of ideation, by maintaining the resolve, "I shall settle the mind without thinking about any object."[24] That very absence of thought becomes the object of mindfulness, which has the function of preventing the attention from becoming scattered or distracted; and Tsongkhapa asserts that here, too, mindfulness must *ascertain* that object. Thus, Tsongkhapa takes non-conceptuality—one of the characteristics of the mind that is discerned upon accomplishing quiescence—as the primary object for the cultivation of quiescence. The implication is that if quiescence is achieved by focusing on this object, the other characteristics of consciousness—namely, clarity and joy—will be realized as a matter of course.

This technique is not without basis in the Mahāyāna sūtras. For example, the *Saṃdhinirmocanasūtra* states:

> "Lord, how many objects of quiescence are there?"
> He replied, "There is one: it has the form of no ideation . . . "
> "How is one to cultivate quiescence?"
> "When, with constant mental engagement, continually engaging with the mind itself, there is *samādhi* uninterrupted by laxity and excitation, that is flawless mental engagement with the mind itself."[25]

Although this is not a technique strongly emphasized by Tsongkhapa or the Gelugpa order as a whole, it does figure prominently in the Mahāmudrā and Atiyoga traditions. The Indian Mahāsiddha Maitrīpa calls this the "ultimate quiescence of main-

Gimello, ed., *Paths to Liberation: The Mārga and Its Transformations in Buddhist Thought* (Honolulu: University of Hawaii Press, 1992) (Studies in East Asian Buddhism 7), pp. 278, 294.

[24] Tsongkhapa, *Byang chub lam gyi rim pa chung ba*, p. 145A.

[25] Cited in Kar ma chags med, *Great Commentary to* (Mi 'gyur rdo rje's) *Buddhahood in the Palm of Your Hand (Sangs rgyas lag 'chang gi 'grel chen)*, pp. 672–73. This is a new edition printed presumably in India, but I have been unable to discover the place or date of publication. The Tibetan translation of the *Saṃdhinirmocanasūtra* reads: *bcom ldan 'das du zhig gis zhi gnas dmigs pa lags.*

taining the attention upon non-conceptuality," and he describes it
as follows:

> Vacantly direct your eyes into the intervening vacuity.[26] See that the
> three conceptualizations of the past, future, and present, as well as
> wholesome, unwholesome, and ethically neutral thoughts, together
> with all the causes, assembly, and dispersal of thoughts of the three
> times are completely cut off. Bring no thoughts to mind. Let the mind,
> like a cloudless sky, be clear, empty, and evenly devoid of grasping;
> and settle it in utter vacuity. By so doing there arises the quiescence
> of joy, clarity, and non-conceptuality.[27]

As noted previously, Tsongkhapa characterizes the achieve-
ment of quiescence as a state of non-conceptuality in which it
seems as if one's mind has become indivisible with space. The
above technique for developing quiescence takes those two *resul-
tant* qualities as the *method* for achieving that same result.
Tsongkhapa also states that upon achieving quiescence one real-
izes the aspects of the sheer awareness and clarity of experience,[28]
and any thoughts that arise vanish of their own accord, like bub-
bles emerging from water. Moreover, he acknowledges that these
aspects of awareness and clarity can also be taken as one's medi-
tative object for developing quiescence.[29] Thus, both these tech-
niques are analogous to the Vajrayāna theme of transforming the
result into the path.[30]

*bka' rtsal pa. gcig ste, rnam par mi rtog pa'i gzugs can no . . . ji tsam gyis na gcig zhi
gnas bsgom pa lags. gang gi tshe rgyun chags su yid la byed pas bar chad med pa'i
sems nyid yid la byed pas, bying rgod bar chad med pa'i ting nge 'dzin skyon med pa'i
sems nyid yid la byed pa'o.*

[26] *bar stong.* This intervening vacuity is the appearance of clear space that is per-
ceived as being between one's visual object and oneself as the perceiving subject.
As such, this space is a type of form that is apprehended by mental, and not sen-
sory, perception *(mngon par skabs yod pa, abhyavakāśika).* Thus, it is included
together with all types of mental imagery in the category of *dharmāyatanarūpa.* Cf.
Jeffrey Hopkins, *Meditation on Emptiness,* p. 233.

[27] In the treatise entitled *Grub chen mi tri'i dmar khrid,* cited in Karma Chagmé,
Spacious Path to Freedom, "The Ultimate Quiescence of Maintaining the Attention
upon Non-conceptuality."

[28] *myong ba rig tsam gsal tsam*

According to the Prāsaṅgika Madhyamaka view advocated by Tsongkhapa, all types of consciousness are non-conceptual with respect to their own appearances, so they are said to be imbued with *clarity* regarding those appearances.[31] In this sense, one of the defining characteristics of consciousness is said to be clarity.* Because consciousness is always experientially *aware* of those appearances, its second defining characteristic is said to be awareness, or knowing.* As mentioned previously, Tsongkhapa asserts that when recalling an object, one may also remember *perceiving* that object; and this should be equally true for short-term and long-term memory. While so doing, it is possible to shift the attention more towards the *object,* which de-accentuates the subjective experience; or one may focus more on the *experience,* which de-accentuates the object. When Tsongkhapa proposes focusing the attention on the *sheer* awareness and the *sheer* clarity of experience, he seems to be suggesting that one is to attend to the defining characteristics of consciousness alone, as opposed to the qualities of other objects of consciousness. Thus, in this technique the object of mindfulness is preceding moments of consciousness; and introspection monitors whether or not the attention is straying from those qualities of awareness and clarity of experience.

This technique also receives much stronger emphasis in the Mahāmudrā and Atiyoga traditions than in the Gelugpa order. The Mahāsiddha Maitrīpa calls this "quiescence in which the attention is focused on conceptualization," and he describes it as follows:

[29] Ibid., p. 149B. Both these suggestions are also found in the corresponding sections of Tsongkhapa's *Byang chub lam rim che ba* (Collected Works, Vol. Pa). The late, eminent Gelugpa Buddhist scholar and contemplative Geshe Rabten describes this technique in his *Echoes of Voidness,* Stephen Batchelor, trans. and ed. (London: Wisdom, 1986), pp. 113–128.

[30] *bras bu lam khyer.* The one cited quality of quiescence that is not presented here as a potential object for developing quiescence is joy, but this theme is well developed in Vajrayāna techniques of training in quiescence. Cf. Daniel Cozort, *Highest Yoga Tantra* (Ithaca: Snow Lion, 1986).

[31] Blo bzang rgya mtsho, *mTha' gnyis dang bral ba'i dbu ma thal 'gyur ba'i blo'i rnam gshag ches cher gsal bar byed pa blo rigs gong ma,* p. 5.

In relation to the excessive proliferation of conceptualization, includ-
ing such afflictions as the five poisons or the three poisons, thoughts
that revolve in subject/object duality, thoughts such as those of the ten
virtues, the six perfections or the ten perfections—whatever virtuous
and non-virtuous thoughts arise—steadily and non-conceptually
observe their nature. By so doing, they are calmed in non-grasping;
clear and empty awareness vividly arises, without recognition;[32] and
it arises in the nature of self-liberation, in which it recognizes itself.
Again, direct the mind to whatever thoughts arise; and without accep-
tance or rejection, let it recognize its own nature. Thus implement the
practical instructions on transforming ideation into the path.[33]

The renowned Tibetan Atiyoga master Tertön Lerab Lingpa
describes this same technique as "a crucial way of maintaining
the mind in its natural state."[34] In his presentation he stresses the
importance of meditation "without distraction and without grasp-
ing," a theme that appears prominently in the Atiyoga tradition.
At first glance, this emphasis on non-grasping may seem at odds
with Tsongkhapa's insistence that quiescence must be developed
while firmly apprehending one's meditative object. This first
impression, however, is misleading.[35] When Tsongkhapa states
that the meditative object must be apprehended, he means simply
that it must be ascertained.[36] In contrast, when Mahāmudrā and
Atiyoga masters speak of grasping, they refer to the mental
process of conceptually identifying, or labeling, the objects of the
mind. Thus, in this practice, one does not grasp onto the inten-

[32] Judging by the following statement that in this training, awareness recognizes
its own nature, this statement that it is without recognition must mean that it does
not ascertain any object other than the characteristics of consciousness.

[33] *Grub chen mi tri'i dmar khrid.* Cited in Karma Chagmé, *Spacious Path to
Freedom,* Ch. 3.

[34] gTer ston las rab gling pa, *rDzogs pa chen po man ngag sde'i bcud phur man ngag
thams cad kyi rgyal po klong lnga'i yi ge dum bu gsum pa lce btsun chen po'i vɪ ma
la'i zab tig gi bshad khrid chu 'babs su bkod pa snying po'i bcud dril ye shes thig le,*
ed. Ven Taklung Tsetrul Pema Wangyal (Darjeeling: Orgyan Kunsang Chokhor
Ling), pp. 20B–21B.

[35] The basis for misunderstanding here is that the same term, *'dzin pa,* (Skt. *graha*),
is used, which is translated here as *apprehend* and *grasp* for these two different
contexts.

tional objects of thoughts concerning the past, present or future, nor does one judge or evaluate the thoughts themselves. Without apprehending the objects of the mind as anything, one tries simply to perceive them in their own nature, without conceptual elaboration.[37] It is only in this way that one can follow the Mahāmudrā and Atiyoga injunction to observe thoughts non-conceptually. Thus, without conceptually grasping onto the contents of the mind, one perceptually ascertains their clear and cognitive nature, leading to insight into the nature of consciousness itself.

Lerab Lingpa states that due to such practice there arises "a non-conceptual sense that nothing can harm the mind, regardless of whether or not ideation has ceased. Whatever kinds of mental imagery occur—be they gentle or violent, subtle or gross, of long or short duration, strong or weak, good or bad—observe their nature, and avoid any obsessive evaluation of them as being one thing and not another."[38] Like Tsongkhapa, Lerab Lingpa makes no claim that this technique alone results in a realization of ultimate truth. He does claim, however, that when this method of maintaining the mind in its natural state is followed precisely, "the afflictions of one's own mind-stream will be inhibited, one will gain the autonomy of not succumbing to them, and one's mind will constantly be calm and dispassionate." And like Tsongkhapa, he asserts this as a sound basis for developing all the more advanced *samādhis* of the Vajrayāna stages of generation and completion.

[36] That is, *'dzin pa = nges pa.*

[37] I am indebted to the contemporary Atiyoga teacher Gyatrul Rinpoche for clarification on this point. Compare this to the Buddha's advice to Bāhiya Dārucīriya: "Thus must you train yourself: so that in the seen there will be just the seen, in the heard just the heard . . . you will have no 'thereby,' you will have no 'therein.' As you, Bāhiya, will have no 'therein,' it follows that you will have no 'here' or 'beyond' or 'midway between.' That is just the end of ill." (*Udāna* 8).

[38] This would be an instance of cultivating "unfastened mindfulness," which is discussed in Pāli Buddhist literature. Cf. Collett Cox, "Mindfulness and Memory: The Scope of *Smṛti* from Early Buddhism to the Sarvāstivādin Abhidharma" in *In the Mirror or Memory: Reflections on Mindfulness and Remembrance in Indian and Tibetan Buddhism,* ed. Janet Gyatso (Albany: State University of New York, 1992), pp. 71–2.

Paṇchen Lozang Chökyi Gyaltsen[39] (1570–1662), a major scholar and contemplative in the Gelugpa order describes the results of this practice as follows:

> Due to such practice, the nature of meditative equipoise is limpid and very clear, unobscured by anything. As it is not established as any entity having form, it is vacuous like space, as it were. Moreover, whatever good and bad objects of the five senses arise, it clearly, luminously takes on any appearance, like the reflections in a limpid mirror. You have the sense that it cannot be recognized as being this and not being that.
>
> However stable such *samādhi* may be, if it is not imbued with the joy of physical and mental pliancy, it is single-pointed attention of the desire realm, whereas *samādhi* that is so imbued is said to be quiescence; and that is the source of many qualities such as extrasensory perception and paranormal abilities. In particular, the Ārya paths of all three vehicles are also reached in dependence upon this.

Well then, how is this path identified in terms of its own nature?

> In that way, the reality of the mind is insightfully perceived, and yet it is ungraspable and undemonstrable. "Whatever appears, loosely attend to it without grasping—this is the quintessential advice that passes on the torch of the Buddha." Such is the uniform proclamation nowadays of most meditators in these snowy mountains. Nevertheless, Chökyi Gyaltsen contends that this approach is a wonderfully skillful method for novices to still the mind, and it is a way to identify the phenomenal nature of the mind.[40]

Thus, like Tsongkhapa, Chökyi Gyaltsen acknowledges the value of this practice as a means of developing attentional stability and of fathoming the phenomenal, or relative, nature of the mind; but he denies that it results in a realization of ultimate truth.

[39] Paṇ chen blo bzang chos kyi rgyal mtshan. For a brief biography of this teacher see Janice D. Willis, *Enlightened Beings: Life Stories from the Ganden Oral Tradition* (Boston: Wisdom, 1995), pp. 85–96.

[40] This passage is at the conclusion of the "Sems gnas pa'i thabs" section of his *dGe ldan bKa' brgyud rin po che'i bka' srol phyag rgya chen po'i rtsa ba rgyas par bshad pa yang gsal sgron me*. The concluding indented paragraph is from Chökyi Gyaltsen's

Tsongkhapa's writings on the whole do not explicitly deal with the Atiyoga tradition, but he did receive extensive teachings from the contemplative Lhodrak Khenchen Namkha Gyaltsen,[41] a master of the Nyingma order of Tibetan Buddhism, which is most closely linked to the Atiyoga tradition. With this realized visionary as his channel, Tsongkhapa received instructions on Atiyoga from Vajrapāṇi, the divine embodiment of the power of the Buddhas. These teachings, entitled *Garland of Supremely Healing Nectars*,[42] are included in Tsongkhapa's Collected Works, and he praises them as being free of excess, omission, and error.[43]

Tsongkhapa and numerous contemplatives from the Mahāmudrā and Atiyoga traditions are in agreement that the accomplishment of quiescence—whether by focusing on a mental image, on the absence of conceptualization, or on the salient qualities of consciousness—does not by itself yield insight into the ultimate nature of the mind or any other phenomenon. Particularly in the latter two techniques, one tries to meditate non-conceptually, but at least some subliminal ideation persists. In Tsongkhapa's account, the thought is: "I shall settle the mind without thinking about any object"; and as Karma Chagmé describes it, there remains a lingering thought: "attention is being

primary text on Mahāmudrā [*Phyag rgya chen po'i rtsa ba* (Asian Classics Input Project, Source CD, Release A, S5939F.ACT, 1993)]. This primary text has been translated under the title *The Great Seal of Voidness* in Alex Berzin, (trans.) *The Mahāmudrā Eliminating the Darkness of Ignorance* (Dharamsala: Library of Tibetan Works and Archives, 1978). A commentary, entitled *sNyan rgyud lam bzang gsal ba'i sgron me (The Lamp of the Clear and Excellent Path of the Oral Tradition Lineage)* on the Panchen Lozang Chökyi Gyaltsen's autocommentary, was composed by Yongdzin Yeshe Gyaltsen (Yongs 'dzin ye shes rgyal mtshan), included in *The Collected Works of Tshe-mchog gling Yongs-'dzin Ye-shes-rgyal-mtshan* (New Delhi: Tibet House Library, 1974). For a concise account of Mahāmudrā in the Gelugpa order see Janice D. Willis, *Enlightened Beings: Life Stories from the Ganden Oral Tradition* (Boston: Wisdom Publications, 1995), pp. 111–124.

[41] Lho brag nam mkha' rgyal mtshan

[42] *Zhu lan sman mchog bdud rtsi phreng ba* (Collected Works, Vol. Ka). An English translation of this work is found in *Life and Teachings of Tsong Khapa*, ed. Prof. R. Thurman (Dharamsala: Library of Tibetan Works and Archives, 1982), pp. 213–230.

[43] Ibid., p. 230.

sustained." Thus, the various techniques of quiescence alone are regarded as being insufficient for entering a contemplative state that is truly intellectually uncontrived and free of conceptual grasping.

According to the Madhyamaka, Mahāmudrā, and Atiyoga traditions alike, in order to realize ultimate truth in a manner that is intellectually unstructured and free of conceptual grasping, one must actively, discursively seek out the ultimate nature of phenomena by means of insight practices.[44] Once one has gained insight by means of such conceptual analysis, one sustains that insight in a manner that closely parallels the above technique of settling the mind in its natural state. But now, due to the power of insight, it is said that one may actually transcend all conceptual constructs, dispense with all grasping, and experientially realize ultimate truth.

For that to occur, however, all three of those traditions maintain that the attentional stability and clarity gained by the training in quiescence is indispensable. All three traditions also acknowledge the value of the whole range of quiescence practices discussed above. Among them, there is a distinctive flavor, however, in the practice which Tsongkhapa describes as focusing on the sheer awareness and the sheer clarity of experience, in Maitrīpa's technique of focusing the attention on conceptualization, and Lerab Lingpa's method for maintaining the mind in its natural state. In such practice, one does not suppress or counteract any mental process, any thoughts, desires, or emotions. Even

[44] This point can be verified by examining almost any authoritative treatise on quiescence and insight in all of these three Buddhist traditions. Śāntideva makes this point abundantly clear in his *Bodhisattvācaryāvatāra;* Tsongkhapa does so in his two major expositions of the stages of the path; Padmasambhava does so in his treatise *Natural Liberation: Padmasambhava's Teachings on the Six Bardos,* Gyatrul Rinpoche, comm., B. Alan Wallace, trans. and ed. (Boston: Wisdom, 1997); Takpo Tashi Namgyal makes this point in his classic *Mahāmudrā: The Quintessence of Mind and Meditation,* trans. Lobsang P. Lhalungpa (Boston: Shambhala, 1986); and the late Dudjom Rinpoche, Jigdrel Yeshe Dorje, Head of the Nyingma order of Tibetan Buddhism, concurs in his essay "The Illumination of Primordial Wisdom" in Gyatrul Rinpoche, *Ancient Wisdom: Nyingma Teachings on Dream Yoga, Meditation and Transformation,* trans. B. Alan Wallace and Sangye Khandro (Ithaca: Snow Lion, 1993), pp. 133–142.

if even laxity and excitation occur, they are not to be counteracted with antidotes, as in the technique explained by Tsongkhapa. Rather, one simply observes the clear and cognizant nature of these and all other mental events, letting them arise and vanish of their own accord, like bubbles emerging from water.

In effect, one tries to use the resultant state of quiescence as the means for achieving quiescence; and, particularly according to the Mahāmudrā and Atiyoga traditions, that state of non-conceptual, clear awareness, as free as possible of conceptual grasping, is the natural state of the mind. Thus, rather than trying to create that state by applying intellectually contrived techniques, such as focusing the attention on a mental image, one lets the mind settle in its own nature, so that those qualities emerge spontaneously.[45]

In terms of the effect of this technique on the mental processes themselves, this turns out to allow for a kind of "free association" of ideas, desires, and emotions. Because one is not intentionally suppressing, evaluating, judging, or directing any thoughts and so on that appear to the mind, and because the attention is maintained within the field of mental phenomena, without being distracted by physical objects, a wide variety of latent predispositions are brought into consciousness. These may included old memories, long-forgotten fears and resentments, repressed desires and fantasies, and so on. As in the dream state, latent propensities are catalyzed so that unconscious processes—including those that influence one's behavior, health, and so forth—are made conscious. If one can simply take note of these mental events, without grasping onto them as "mine," and without judging them, but simply observing their clear and cognizant nature, one can see that they dissolve of their own accord; and they cannot harm one's mind in the present. This is regarded as a most direct, uncontrived

[45] During an interview in April, 1994, the Tibetan Atiyoga master Kusum Lingpa expressed to me his conviction that quiescence achieved in this manner is more durable than that achieved by other more contrived methods; for this quiescence is less artificial than that achieved, for example, by focusing on a mental image.

means to realizing the nature of consciousness, and to bringing elements from the unconscious into the clear light of awareness.[46]

This practice of cultivating quiescence by attending to thoughts, however, is not without its own pitfalls. As one has no fixed object on which to focus the attention, one may easily succumb to mere day-dreaming, drifting from one thought to another, without attentional stability or clarity. Instead of leading to the actual achievement of quiescence, such pseudo-meditation results merely in mental lassitude. Moreover, the method of focusing on non-conceptuality as one's object of quiescence, if not followed properly, may result in blank-mindedness, in which the mind apprehends nothing and is devoid of clarity. Although there may be some degree of attentional stability in this trance-like state, Tsongkhapa cautions that, rather than leading to the achievement of quiescence, such sustained practice actually impairs one's intelligence.

Using a visualized mental image as one's meditative object, as Tsongkhapa suggests, provides the meditator with a clearly defined object on which to fix the attention. With such an object held with mindfulness, one can readily employ introspection to determine the degree of one's attentional stability and clarity. Thus, the danger of slipping into idle day-dreaming or trance-like mental vacuity is decreased. In short, although the methods of attending to non-conceptuality and to conceptualization may, at first glance, appear easier, they are actually more subtle and challenging than methods using visualization. In the Tibetan tradition, the choice of technique is usually made in close collaboration with an experienced meditation teacher, so that the most appropriate method may be tailored to each individual.

[46] The closest analog to such experience that I have found in Western writings is in William James's essays on radical empiricism. Cf. "Radical Empiricism" in *The Writings of William James: A Comprehensive Edition*, John J. McDermott, ed. (Chicago: University of Chicago Press, 1977), pp. 134–310.

Beyond Quiescence

The central aim of Mahāmudrā and Atiyoga practice is the conceptually unmediated realization of a state of Awareness[47] that transcends all conceptual constructs of subject and object, the personal and the impersonal, unity and multiplicity, *saṃsāra* and *nirvāṇa*, and existence and non-existence. This awareness is said to be the primordial ground* of the whole of *saṃsāra* and *nirvāṇa*, and it is identified as the Dharmakāya, the Buddha-nature,* the Essence of the Tathāgata,* and mind-itself.*[48] While it is utterly transcendent and never contaminated by mental afflictions or obscurations, it is constantly, immutably present in every moment of everyone's experience, unproduced and unconditioned by one's body or environment. It is this awareness that is the basis, the path, and the fruition of the practice of Mahāmudrā and Atiyoga.

What role do quiescence, meditative stabilization, and *samādhi* have in such training? Many passages in the literature of the Mahāmudrā and Atiyoga traditions seem to imply that meditative stabilization is simply antithetical to such practice. Herbert Guenther, who has probably written more on these two traditions than any other Western Buddhologist, depicts the cultivation of meditative stabilization as a process of exchanging "one fixation

[47] This Atiyoga term has been variously translated as "pristine awareness," "intrinsic awareness," "basic awareness," and so on, with all of these modifiers intended to distinguish this from ordinary, conditioned awareness. In most psychological and philosophical contexts, the Tibetan term *rig pa* may be rendered simply as "awareness," "knowing," or "cognition," but in this Atiyoga context, the word clearly has a more exalted and transcendent connotation, while at the same time it is said to refer to simple, conceptually unmodified awareness that is manifest in each moment of ordinary consciousness. Since the Tibetan Atiyoga writers use the common term *rig pa*, I have chosen to translate it simply as *Awareness*, with only the capitalization to suggest its exalted, or primordial, status.

[48] This is a term for the ultimate nature of the mind. While Tsongkhapa's approach to Madhyamaka entails an investigation of the nature of objects of the mind, moving from phenomenal reality *(chos, dharma)* to reality-itself *(chos nyid, dharmatā)*, the emphasis in Mahāmudrā and Atiyoga is to investigate the nature of the mind, moving from the mind *(sems, citta)* to the mind-itself. When the nature of the mind-itself is realized, it is seen to be non-dual with reality-itself.

(physical reality) for another (imaginal reality), culminating in a state of quasi-comatose absorption;"[49] and he contrasts this with the practice of Mahāmudrā, which aims to transcend the subject-object dichotomy in a realm of experience that is beyond the scope of the intellect.[50] Guenther asserts that advanced states of meditative stabilization are regarded in the Atiyoga tradition as forms of reifying, dichotomizing thought that must be replaced with the natural limpidity and clarity of Awareness.[51] In short, he suggests that Atiyoga "marks a radical break from the older mechanistic determinism . . . ";[52] and he claims that Saraha, who is regarded as one of the earliest and most important

[49] Herbert Guenther, *Ecstatic Spontaneity: Saraha's* Three Cycles of Dohā (Berkeley: Asian Humanities Press, 1993), p. 57.

[50] Guenther, well known for his idiosyncratic translations of Buddhist terms, renders *dhyāna* as "foundation of thinking" (Ibid., p. 66, fn. 20). This translation, however, is not only idiosyncratic, but simply incorrect. The Sanskrit *dhyāna* is derived from the root *dhyai*, itself related to several Vedic terms derived from the root *dhī*, which denotes a vision, while the corresponding verb means "to have a vision." In the Tibetan *bsam gtan, bsam* may be rendered as "thought ,"or "mentation," while *gtan* means "enduring," "sustained," and "stabilized"; so the two terms together etymologically suggest "stabilized mentation." Thus, the etymologies of neither the Sanskrit nor the Tibetan suggest a "foundation of thought." In terms of the actual meaning of *dhyāna* in the Buddhist context, this term technically denotes a series of meditative states that begin with the attainment of quiescence and proceed to more subtle states of *samādhi* belonging to the form realm. As such, they do not function as the foundation of thought either in advanced contemplatives or in ordinary people. Thus, Guenther's translation seems unfounded and incorrect, and his pejorative rendering of *samādhi* as "quasi-comatose absorption" appears equally misleading. His "foundation of thought" is most directly translated back into Tibetan as *bsam pa'i rten, or bsam rten,* which has the same pronunciation, but a totally different meaning than *bsam gtan.* I hope the basis of his translation is not simply a confusion of the two terms *gtan* and *rten,* which would be unworthy of a scholar of his great erudition.

[51] Herbert Guenther, *Ecstatic Spontaneity,* p. 66, fn. 20.

[52] Anne Klein makes a similar claim when she writes, "Mental quiescence is just one of the many splendid qualities spontaneously associated with this primordial wisdom; unlike in the dGe-lugs-pa described here, there is in rDzogs-chen no need to speak of or cultivate it separately." ["Mental Concentration and the Unconditioned: A Buddhist Case for Unmediated Experience," p. 296 in Robert E. Buswell, Jr. and Robert M. Gimello, ed. *Paths to Liberation: The Mārga and Its Transformations in Buddhist Thought* (Honolulu: University of Hawaii Press, 1992) (Studies in East Asian Buddhism 7). In contrast, to Guenther, Klein displays a

representatives of the Mahāmudrā tradition, rejects meditative stabilization outright.[53]

While the more advanced states of meditative stabilization may indeed be incompatible with the practice of Mahāmudrā, it is a mistake to draw the same conclusion regarding the achievement of quiescence. Far from rejecting this attainment outright, Saraha states in a manner representative of Indo-Tibetan Buddhism as a whole:

> Quiescence depends upon its cause—ethical discipline. Its nature is isolation from mental afflictions and ideation. Its cooperative condition is reliance upon special sustained attention. The benefit is that gross mental afflictions and suffering are inhibited.[54]

To understand the role of quiescence in the practice of Mahāmudrā and Atiyoga, it is important to recognize that different types of people are said to reach the same contemplative goals by different means. Karma Chagmé points out that in "simultaneous individuals"[55] the signs of realization appear swiftly and simultaneously as a result of their spiritual maturation from past lives. Such people may not need to engage in the sequential trainings in ethics, quiescence, and insight, but may realize the nature of Awareness as soon as it is pointed out to them. But such individuals, Karma Chagmé says, are rare. "Gradually guided individuals," (rim skyel ba) who are far more common, can reach the

sympathetic understanding of both the Gelugpa and Nyingma orders, and she avoids such pejorative, unilluminating phrases as "mechanistic determinism." Guenther's own aversion towards the Gelugpa order and his enthusiasm for the Nyingmapa order are flagrantly displayed in his caricatures of these two in his polemical essay "Buddhism in Tibet," in *Buddhism and Asian History*, Joseph M. Kitigawa and Mark D. Cummings, ed. (New York: Macmillan, 1989), pp. 175–187.

[53] Guenther addresses this theme at greater length in his *From Reduction to Creativity: rDzogs-chen and the new Sciences of the Mind* (Boston and Shaftsbury: Shambhala, 1989), Ch. 5.

[54] Cited in Karma Chagmé's *Great Commentary to* [Mi 'gyur rdo rje's] *Buddhahood in the Palm of Your Hand* (Sangs rgyas lag 'chang gi 'grel chen), pp. 680–81. *zhi gnas rgyu ni tshul khrims la brten te, ngo bo nyon mongs rnam rtog dben pa yi, rkyen ni sems gnas khyad par la brten te, phan yon nyon mongs sdug bsngal rags pas gnon.* Cf. Herbert Guenther, *Ecstatic Spontaneity*, p. 199, fn. 26.

[55] *gang zag cig char*

same degrees of contemplative realization only as a result of continual, sustained meditation.[56] While the former may follow a "sudden path" to enlightenment, the latter have no practical option other than applying themselves to a "gradual path." While the separate cultivation of quiescence may be unnecessary for the former, it is indispensable for the latter. For such people, Karma Chagmé claims, the more advanced practices of Mahāmudrā and Atiyoga will have little impact if they are not preceded by a thorough training in quiescence and insight.[57]

The assertion that Mahāmudrā and Atiyoga practice is incompatible with the achievement of meditative stabilization is largely based on the frequent statements in the literature of these traditions that meditative experience of joy, clarity, and non-conceptuality are actually *hindrances* to the recognition of Awareness. Moreover, these traditions, like Tsongkhapa, assert that these are the salient characteristics of the achievement of quiescence. It should be immediately obvious, however, that the *sheer presence* of joy, clarity, and non-conceptuality are not the problem. The cultivation of their opposites, namely, misery, dullness, and compulsive conceptualization, is obviously not the way to fathom the essential nature of the mind. Moreover, Awareness itself is often described as being of the nature of inborn bliss and clear light, and as transcending all concepts. Thus, on the face of it, joy, clarity, and non-conceptuality hardly seem incompatible with the nature of Awareness.

The issue here is not so much the simple presence of these three qualities as it is the manner in which they are experienced. Citing such Tibetan patriarchs of the Mahāmudrā tradition as Jigten Gönpo,[58] Phagmo Drupa,[59] Gyalwa Chö Dingwa,[60]

[56] Karma Chagmé, *Spacious Path to Freedom*, Ch. 7.

[57] Ibid., Ch. 4.

[58] 'Jig rten mgon po

[59] Phag mo gru pa rdo rje rgyal po, a principle disciple of Dvags po lha rje, who in turn was a disciple of Mi la ras pa.

[60] rGyal ba chos lding ba

Min-gyur Dorje,[61] and Gyalwang Chöjey,[62] Karma Chagmé begins by commenting that "joy, clarity, and non-conceptuality are pitfalls of meditation."[63] He then explains that if one responds to any of these experiences with craving and attachment, this simply perpetuates one's continued existence in *saṃsāra*, in the desire, form, and formless realms. In particular, he notes that the absence of even subtle conceptualization may be mistaken for an experience of the Dharmakāya; but if one becomes fixated on such experience, this leads one away from the path of liberation to rebirth in the formless realm.

Joy, clarity, and non-conceptuality are pitfalls to meditation, he says, as long as they are experienced within a context of conceptual structuring, involving such ideas as *existence* and *non-existence*. When all conceptual modification, or adulteration, has been left behind, "the threefold sense of joy, clarity, and non-conceptuality are merged into one taste,"[64] resulting in "non-meditation" which is to be sustained constantly throughout the day and night. Thus, the very distinctions among these qualities of awareness are transcended. This "breakthrough"[65] experience to the ascertainment of Awareness is traditionally preceded by analytical meditation leading to insight into the clear and empty nature of the mind; and in order for such meditation to proceed effectively, quiescence is deemed to be indispensable.

While Mahāmudrā and Atiyoga do indeed entail practices that differ from other types of insight practices, including the Madhyamaka approach taught by Tsongkhapa, there is sufficient common ground among them to suggest that their break from other Buddhist traditions is not as radical as some authors, such as Guenther, would have one believe. Referring to the practices of Madhyamaka, Mahāmudrā, and Atiyoga, Paṇchen Lozang Chökyi

[61] Mi 'gyur rdo rje

[62] rGyal dbang chos rje

[63] Karma Chagmé, *Spacious Path to Freedom*, Ch. 7.

[64] Ibid., p. 460.

[65] *khreg chod*

Gyaltsen comments that although they go under a variety of labels,

> . . . if these are examined by one who is well-versed in the scriptures and reasoning by which one distinguishes between provisional and definitive meanings, they are seen, not as mutually incompatible, like hot and cold, but as coming down to the same point.[66]

[66] This comment is made at the end of his introduction preceding the "Sems gnas pa'i thabs" section of his *dGe ldan bKa' brgyud rin po che'i bka' srol phyag rgya chen po'i rtsa ba rgyas par bshad pa yang gsal sgron me.*

The Role of Introspection in the Cultivation of Quiescence

In Indo-Tibetan Buddhist contemplative practice, mental perception plays a key role in the cultivation of insight, and it is refined chiefly by means of the training in meditative quiescence. Tsongkhapa bases his presentation of the cultivation of quiescence on the following definition found in the *Saṃdhinirmocanasūtra:*[1]

> Dwelling in solitude, perfectly directing the mind inwards, one attends just to the phenomena as they have been brought into consideration; and that attentive mind is mental engagement,*[2] for it is continuously mentally engaged inwards. That state in which one is so directed and remains repeatedly, in which physical pliancy* and mental pliancy have arisen, is called *quiescence.*

The fact that the mind is directed inwards in this discipline suggests that the overall training in quiescence is introspective in nature. However, in the technique, emphasized by Tsongkhapa, of focusing on a mental image *in the space in front of one* casts an interesting light on the notion of *inwards.* The distinction between

[1] Cf. Lamotte, *Saṃdhinirmocanasūtra*, VIII:3.

[2] Mental engagement is a mental process having the unique function of directing the mind and its concomitant mental processes upon an object and apprehending it. The province of mental engagement is to apprehend the object firmly without letting the attention stray elsewhere, so it is the basis of both mindfulness and introspection. Cf. Asaṅga, *Abhidharmasamuccaya,* ed. Pralhad Pradhan (Visva Bharati, Santiniketan, 1950), p. 6.; Herbert V. Guenther and Leslie S. Kawamura, *Mind in Buddhist Psychology* (Emeryville: Dharma Publishing, 1975), p. 28.; Blo bzang rgya mtsho, *Rigs lam che ba blo rigs kyi rnam bzhag nye mkho kun btus* (Dharamsala, 1974), p. 132; and Geshe Rabten, *The Mind and Its Functions,* trans. Stephen Batchelor (Mont. Pèlerin: Tharpa Choeling, 1979), p. 60; See Edward Conze's discussion of mental engagement in his *The Large Sutra on Perfect Wisdom: with the Divisions of the Abhisamayālaṅkāra* (Berkeley: University of California Press, 1975), p. 29.

inwards and outwards is evidently not one of physical location or
direction. Rather, turning the attention inwards means turning it
away from the five fields of sensory objects and directing it towards
the field of phenomena that are perceived by the mind alone.*

The training in quiescence hinges upon the development and
employment of two mental processes—mindfulness* and intro-
spection*—and both of these are directed towards mental phe-
nomena. The distinction between them is that mindfulness is
focused upon the meditative object, while introspection monitors
the awareness of that object. Let us now attend to a detailed
examination of the nature and function of introspection in
Tsongkhapa's presentation of quiescence.

Tsongkhapa cites Śāntideva's general summation of introspec-
tion as the repeated investigation of the state of one's body and
mind.[3] Although introspection is not included among the fifty-one
mental processes listed in Asaṅga's *Abhidharmasamuccaya*, it is
regarded as a derivative of intelligence,*[4] which is listed there.
Non-introspection, on the other hand, is explicitly included
among those mental processes as one of twenty secondary mental
afflictions. There it is defined as an intelligence that is afflicted
due either to failing to discriminate or doing so in a crude fash-
ion. As such, it induces a sense of carelessness, for it leaves one
unaware of one's own physical, verbal, and mental conduct. In
short, non-introspection acts to impair the power of one's intelli-
gence and serves as a basis of non-virtuous behavior of all kinds.[5]
Defined in this way, it is clear that non-introspection is more than

[3] *Bodhicaryāvatāra*, V:108.

[4] Although *prajñā* frequently is translated as *wisdom*, within the context of the
mental factors *intelligence* seems more accurate, for it is there defined as a dis-
criminating mental process that has the unique characteristic of evaluating an
object held with mindfulness. Its province is to arrive at certainty, and it is
regarded as the root of all excellent qualities. Cf. Asaṅga, *Abhidharmasamuccaya*,
ed. Pralhad Pradhan (Visva Bharati, Santiniketan, 1950), p. 6.; Herbert V.
Guenther and Leslie S. Kawamura, *Mind in Buddhist Psychology* (Emeryville:
Dharma Publishing, 1975), pp. 37–38; Blo bzang rgya mtsho, *Rigs lam che ba blo
rigs kyi rnam bzhag nye mkho kun btus*, p. 135; Geshe Rabten, *The Mind and Its
Functions*, trans. Stephen Batchelor, pp. 63–4.

simply the absence of introspection; it is an afflicted type of intelligence that fails to take careful note of one's own conduct, including the functioning of one's own mind.

While introspection plays an important soteriological role in Buddhist practice as a whole, it is particularly crucial for the training in quiescence, in which it has the function of recognizing whether the attention has succumbed to either laxity or excitation. In the early stages of this training, the mind is especially prone to excitation, which is an agitated mental process that follows after attractive objects.[6] As excitation draws the attention away from the meditative object towards sensory objects and other mental phenomena, it is a major obstacle to the cultivation of quiescence. By definition, excitation is defined as a derivative of attachment,*[7] though on other occasions the mind may also be distracted due to other mental processes such as anger and guilt.

Once the attention has been sufficiently trained so that it can remain unwaveringly on the meditative object for a sustained period of time, laxity becomes a formidable problem. This mental process occurs when the attention becomes slack and the meditative object is not apprehended with clarity and forcefulness.[8] Tsongkhapa identifies laxity as a derivative of delusion,* which is a mental affliction that either actively misconceives the nature of reality or else obscures reality due to its own lack of clarity.

[5] Cf. Blo bzang rgya mtsho, *Rigs lam che ba blo rigs kyi rnam bzhag nye mkho kun btus*, pp. 159–160; Geshe Rabten, *The Mind and Its Functions*, trans. Stephen Batchelor, pp. 87–88.

[6] *Abhidharmasamuccaya*, p. 9.9–10.

[7] Attachment is a mental affliction that by its very nature superimposes a quality of attractiveness upon its object and yearns for it. It distorts the cognition of that object, for attachment exaggerates its admirable qualities and screens out its disagreeable qualities. Cf. Asaṅga, *Abhidharmasamuccaya*, ed. Pralhad Pradhan (Visva Bharati, Santiniketan, 1950), p. 9.; Herbert V. Guenther and Leslie S. Kawamura, *Mind in Buddhist Psychology* (Emeryville: Dharma Publishing, 1975), p. 96; Blo bzang rgya mtsho, *Rigs lam che ba blo rigs kyi rnam bzhag nye mkho kun btus*, p. 145; Geshe Rabten, *The Mind and Its Functions*, trans. Stephen Batchelor, pp. 74–75.

[8] *Intermediate Bhāvanākrama*, Derge: dBu ma Ki 47.2.7–48a.1.1.

⌐In the cultivation of quiescence, mindfulness of the meditative object needs to be maintained constantly, whereas introspection is only intermittently needed to monitor the functioning of the meditating awareness. While a conceptual understanding of laxity and excitation is relatively easy to acquire, Tsongkhapa emphasizes, "It is not enough merely to have an understanding of laxity and excitation; when meditating you must be able to generate introspection that correctly recognizes whether or not laxity and excitation have arisen."[9] Until such introspection has arisen, he insists, one cannot be certain that one's meditation is free of laxity and excitation; and as long as the mind is still prone to these afflictions, quiescence has not been achieved.⌐

In the process of counteracting laxity and excitation, attentional stability and clarity are enhanced. To understand these two qualities in terms of Buddhist psychology, one must note that Buddhists commonly assert that the continuum of awareness is composed of successive moments of cognition having finite duration; though different schools pose varying hypotheses concerning the exact frequency of these moments.[10] Moreover, commonly in a continuum of perception, many moments of awareness consist of non-ascertaining cognition,* that is, objects appear to this inattentive awareness, but they are not ascertained.[11]

[9] Tsongkhapa, *Byang chub lam gyi rim pa chung ba* (Collected Works, Vol. Pha) p. 149A.

[10] Tibetan Buddhist psychology generally accepts the *Abhidharmakośa* assertion that a moment *(skad cig, kṣaṇa)* last for one-sixty-fifth of the duration of a finger-snap. (Louis de La Vallée Poussin, *Abhidharmakośabhāṣyam*, English trans. Leo M. Pruden, Vol. II, p. 474.) This is said to be the shortest duration in which a phenomenon can arise or change from one state to another—an assertion that can hardly stand up in light of modern science, which measures physical processes in terms of nanoseconds. Vasubandhu's interpretation of the duration of a moment is one among five opinions expressed in the *Vibhāṣā* (TD, 27, p. 701b2). I have not seen any evidence that this interpretation is derived from Buddhist contemplative experience, nor have I seen any practical application of this theory for contemplative training. According to the *Vibhāṣā*, the Buddha did not tell the true duration of a moment, for no one is capable of understanding it. (Louis de La Vallée Poussin, *Abhidharmakośabhāṣyam*, English trans. Leo M. Pruden, Vol. II, p. 540, fn. 484).

[11] For a detailed account of non-ascertaining cognition see Lati Rinbochay, *Mind*

In terms of this theory, I surmise that the degree of attentional stability increases in relation to the proportion of ascertaining moments of cognition of the intended object; that is, as stability increases, fewer and fewer moments of ascertaining consciousness are focused on any other object. This makes for a homogeneity of moments of ascertaining perception. The degree of attentional clarity corresponds to the ratio of moments of ascertaining to non-ascertaining cognition: the higher the frequency of ascertaining perception, the greater the clarity. Thus, the achievement of quiescence entails an exceptionally high density of homogenous moments of ascertaining consciousness.

In the training in quiescence the stated function of introspection is to monitor the awareness of the meditator and to detect in particular any occurrence of either laxity or excitation. Now laxity and excitation are themselves mental processes having their own intentional objects. In such practice, the object of laxity is the meditative object itself, apprehended without the full force of clarity. The object of excitation may be any attractive, or interesting, object other than the meditative object. In light of our previous analysis of the ways in which the mind can and cannot monitor itself, it is evident that, according to Tsongkhapa, introspection may perceive an immediately prior occurrence of laxity and excitation in relation to their own intentional objects. Such perception is a clear case of *participatory observation*. That is, the very perception of any mental process by introspection necessarily influences the observed mental process. This is particularly evident in the case of excitation. For a continuum of excitation to be sustained, the mind must continually attend, with attachment, to one or more attractive objects. However, if introspection free of attachment detects the presence of excitation, the continuum of excitation would necessarily be interrupted. Likewise, if introspection with a high degree of clarity detects the presence of laxity, this would interrupt the continuum of laxity.

in *Tibetan Buddhism,* trans. and ed. by Elizabeth Napper (Valois: Gabriel/Snow Lion, 1981), pp. 92–110.

Tsongkhapa hammers home the subtlety of the introspective perception of laxity and excitation when he writes, "Moreover, by gradually developing powerful introspection, not only must you be able to induce introspection that recognizes laxity and excitation as soon as they have arisen; you must generate introspection that is aware of them when they are on the verge of occurring, before they have actually arisen."[12] Thus, introspection must be so developed that it notes even a *proclivity* towards either of these hindrances. Finally, introspection may monitor the awareness even when neither laxity nor excitation is either present or on the verge of arising. On such occasions, one moment of introspection would note a prior moment of the meditating consciousness free of those mental processes.

As indicated by the preceding discussion, the fact that introspection entails a form of participatory observation does not exclude the possibility of its role in the scientific study of the mind. Buddhist contemplatives, such as Tsongkhapa, seem to be keenly aware of the fallibility of mental perception of mental phenomena; and it is for this reason that the training in quiescence is so strongly emphasized as a necessary prerequisite to the cultivation of contemplative insight into the nature of the mind and other phenomena. This training is not necessarily linked with any one psychological, philosophical, or theological theory of the mind, so there seems no reason in principle why it could not be incorporated into modern scientific research. For this to be done with full effectiveness, however, it would seem necessary for researchers themselves to enter into such training, and not simply leave it to "subjects" who would become objects of scientific scrutiny.

[12] Tsongkhapa, *Byang chub lam gyi rim pa chung ba*, p. 149A.

Quiescence in Theravāda Buddhism

The Cultivation of Quiescence

In the Indo-Tibetan Buddhist tradition many techniques for developing quiescence are taught, and there are many levels of sustained, voluntary attention as well as many types of insight. Tsongkhapa points out that the distinction between quiescence and insight is not made on the basis of their objects, for either may be focused on conventional or ultimate realities. Likewise, in Theravāda Buddhism the classification of mundane and supramundane pertains to both *samādhi* and wisdom.[1]

In both traditions one is usually encouraged to cultivate quiescence initially with respect to a conventional reality. Tsongkhapa emphasizes the discipline of focusing on a mental representation of the Buddha, while Buddhaghosa, the fifth-century authority on Theravāda Buddhism, gives an elaborate account of techniques for developing quiescence using emblems* of various elements of experience. The Indo-Tibetan tradition lists ten types of emblems corresponding to the four elements of earth, water, fire, and air; the four primary colors of blue, yellow, red, and white; and finally space and consciousness.[2] Some early Pāli sources give this same list,[3]

[1] Kheminda Thera, *The Way of Buddhist Meditation* (Photocopy: publication unknown), p. 10.

[2] Louis de La Vallée Poussin, *Abhidharmakośabhāṣyam* (Berkeley: Asian Humanities Press, 1991) English trans. Leo M. Pruden, Vol. IV., pp. 1277–280. See also the *Mahāyānasūtrālaṃkāra*, ed. and trans. Lévi (Bibliothèque de l'École des Hautes Études, 159 and 190, Paris, 1907, 1911) vii.9, xx–xxi.44; the *Gaṇḍavyūha*, ed. Suzuki and Idzumi (Kyoto, 1934), 523.11; and the *Divyāvadāna*, ed. Cowell and Neil (Cambridge, 1886), 180.17 f.

[3] E.g., *Mahāsakuludāyi Sutta* (M.II.14) M. 77, *Pañcattaya Sutta* (M. 102), and the *Aṅguttara Nikāya* (V. 60). In these accounts, the emblem of consciousness is the sublime consciousness that prevails in space (which remains after the removal of the meditative object belonging to the form realm). This is identical to the

255

while Buddhaghosa later replaces the final two emblems with light and limited space.[4]

To describe briefly one example of such practice according to the Theravāda tradition, in the case of focusing on the earth-emblem, one first attends closely to a disc prepared of clay as a physical representation of the entire element of earth, or solidity. One repeatedly gazes at this device until an acquired sign,[5] or mental image, of it appears in the mind as clearly when the eyes are shut as when they are open. This mental image is a sign of the earth element, and that becomes the chief meditative object of the preliminary concentration[6] leading up to the first proximate meditative stabilization. Once the quiescence of the first proximate stabilization has been achieved, there arises to the mind's eye a counterpart sign[7] of the earth element, which is far more "purified" than the previous mental image. This counterpart sign is an appearance that arises purely from perception, being without color or the appearance of solidity, and having none of the blemishes of the original earth-emblem that were evident in the earlier mental image. In short, the counterpart-sign is regarded as a mental representation of the primal quality of object, in this case the element of earth.[8]

In this Theravāda account, the development of quiescence is closely linked to three kinds of signs that are the objects of one's attention. The first of these is the sign for preliminary practice,[9]

limitless consciousness which is revealed by the removal of the element of space. The emblem of space is that which is revealed by removing the meditative object of the form realm, so it is identical to limitless space. ·

[4] Pāli: *paricchinna-ākāsa. The Path of Purification*, [trans. by Bhikkhu Ñāṇamoli, (Kandy: Buddhist Publication Society, 1979), V. 21–26, pp. 181–182. Buddhaghosa explains his reasons for this alteration in his *Atthasālini*, p. 186.

[5] Skt. *udgraha-nimita*, Pāli: *uggaha-nimitta*.

[6] Pāli: *parikamma-samādhi*

[7] Skt. *pratibhāga-nimitta*, Pāli: *paṭibhāga-nimitta*

[8] A definitive presentation of the use of emblems is found in Buddhaghosa's *The Path of Purification*, IV and V. Another illuminating explanation of these practices if presented by Paravahera Vajirañāna in his *Buddhist Meditation in Theory and Practice*, Ch. 13.

[9] Pāli: *parikamma-nimitta*

which in the case of the earth-emblem is the actual physical symbol of earth used for this practice. The second is the acquired sign, which in the case of the earth-emblem is the thought impression as a precise copy of the first sign, with all its specific limitations, such as its molded form, color, and shape. The third is the counterpart sign,[10] which is a subtle, emblematic representation of the whole quality of the element it symbolizes.[11] This threefold division of signs relating to stages in the development of quiescence does not appear to be prevalent in the Tibetan Buddhist tradition.

Within Tibetan Buddhism, the Mahāmudrā and Atiyoga traditions strongly emphasize the cultivation of quiescence while focused on the nature of consciousness, as in the previously discussed technique of "maintaining the attention upon non-conceptuality." This seems to be analogous to the Theravāda practice of attending to the emblem of consciousness, and the culmination of this training is the appearance of the sign of consciousness, presumably referring to the counterpart sign. Mahāmudrā and Atiyoga also encourage the practice of "quiescence in which the attention is focused on conceptualization," also called "maintaining the mind in its natural state." This method, which is also said to lead to a realization of the essential characteristics of consciousness, appears to have a counterpart in Pāli Buddhist literature, where it is called "unfastened mindfulness."[12] As noted previously, according to Asaṅga and Tsongkhapa, an immediate perception of the primal characteristics of consciousness also occurs upon achieving the first proximate meditative stabilization, after the attention has been disengaged from the previous mental image used as one's meditative object.

Indo-Tibetan Buddhist accounts of the cultivation of quiescence commonly emphasize the role of mindfulness and intro-

[10] Pāli: *paṭibhāga-nimitta*

[11] Paravahera Vajirañāna, *Buddhist Meditation in Theory and Practice* (Kuala Lumpur, Malaysia: Buddhist Missionary Society, 1975), p. 145.

[12] Cf. Collett Cox, "Mindfulness and Memory: The Scope of Smṛti from Early Buddhism to the Sarvāstivādin Abhidharma" in *In the Mirror or Memory: Reflections on Mindfulness and Remembrance in Indian and Tibetan Buddhism*, ed. Janet Gyatso (Albany: State University of New York, 1992), pp. 71–72.

spection, as these have been discussed here in earlier chapters. The Theravāda tradition, however, understands the corresponding Pāli terms in a somewhat different manner. According to Nyanaponika Thera, mindfulness[13] applies preeminently to the attitude and practice of bare attention in a purely receptive state of mind. The Pāli equivalent of the term translated here as "introspection," namely *sampajañña*, is commonly translated from the Pāli as "clear comprehension"; and it comes into operation when any kind of action is required, including active reflective thoughts on things observed. The purpose of clear comprehension is to make all our activities purposeful, efficient and accordant with reality. In both traditions this mental factor is regarded as a facet of intelligence.[14]

The Relation between Quiescence and Insight

Tsongkhapa maintains that the first proximate meditative stabilization provides a sufficient basis in *samādhi* for the further cultivation of insight into ultimate truth. While the Pāli *suttas* indicate that the first stabilization alone is indispensable for the cultivation of supramundane insight and the achievement of *nirvāṇa*, they do not make the distinction between proximate[15] and basic[16] stabilization. This distinction appears first in the commentaries to the *suttas*. Thus, when the *suttas* declare that the first meditative stabilization is a necessary prerequisite to the cultivation of insight, this may be interpreted as referring to either the first proximate or basic stabilization. The Theravāda tradition, however, maintains that the first basic stabilization is neces-

[13] Pāli: *sati*

[14] Pāli: *paññā*. The four kinds of clear comprehension discussed in the Pāli commentaries to the Buddha's discourses are explained in Nyanaponika Thera, *The Heart of Buddhist Meditation* (New York: Samuel Weiser, 1973), pp. 45–56.

[15] Pāli: *upacāra*

[16] Pāli: *appanā*

sary due to the strength its five factors of stabilization and its free-dom from the five hindrances.[17] Nevertheless, since supramun-dane insight in union with quiescence is capable of utterly eliminating the five hindrances, it seems at least plausible that the first proximate stabilization could provide an adequate basis in *samādhi* for the development of such insight.

In the Pāli canon the Buddha explicitly states that the four applications of mindfulness[18] can bring about the realizations for which they were designed only if the meditator has already aban-doned the impurities and practices with a concentrated, unified mind.[19] Specifically, it is said that one must have acquired the "sign of the mind,"[20] which the Indo-Tibetan tradition suggests is characteristic of the achievement of the first proximate meditative stabilization. Moreover, it is noteworthy that the terms "concen-trated"[21] and "unified mind"[22] correspond to the terms used to describe the final two of the nine attentional states leading to that state of quiescence. The commentary to this discourse explains that "the impurities" refers to the five hindrances;[23] and in the Buddha's words, "So long as these five hindrances are not aban-doned one considers himself as indebted, sick, in bonds, enslaved and lost in a desert track."[24]

[17] This point is made in the commentary and sub-commentary to the *Saṃyutta sutta* (cf. Kheminda Thera, *The Way of Buddhist Meditation*, p. 31). However, in his *Theravāda Meditation: The Buddhist Transformation of Yoga* (University Park: Pennsylvania State University Press, 1980), Winston L. King suggests that proxi-mate stabilization may indeed be a sufficient basis for the successful cultivation of insight in Theravāda Buddhist practice.

[18] Tib., *dran pa nye bar bzhag pa;* Skt., *smṛtyupasthāna;* Pāli, *satipaṭṭhāna.* These four are the application of mindfulness to the body, feelings, mental states, and mental objects. For a clear exposition of this training in the modern Burmese Buddhist tradition see Nyanaponika Thera, *The Heart of Buddhist Meditation* (New York: Samuel Weiser, 1973).

[19] S. V, 144–45, 150–52.

[20] Pāli: *cittassa nimitta*

[21] Pāli: *samāhita*

[22] Pāli: *ekaggacitta*

[23] Spk. III, 201.

[24] *Sāmaññaphala Sutta* (D. I, 73).

Thus, according to both the Indo-Tibetan and Pāli traditions the attainment of any Ārya path—be it that of a Śrāvaka, Pratyekabuddha, or Bodhisattva—is contingent upon the unification of quiescence and insight. As Buddhaghosa's classic treatise *The Path of Purification* declares, "there is no supramundane [insight] without meditative stabilization."[25]

Quiescence alone can only temporarily inhibit the activation of mental afflictions, and insight alone lacks the necessary degree of attentional stability and clarity needed to eliminate the afflictions altogether. The Indo-Tibetan and Theravāda Buddhist traditions agree that only by means of the union of quiescence and insight can one achieve *nirvāṇa*. However, there is a recent trend among Theravāda Buddhists to substitute momentary stabilization[26] for genuine meditative stabilization. Momentary stabilization is discussed in traditional Theravāda literature, and it is defined in the *Paramatthamañjūsā* as "concentration lasting only for a moment. For that too, when it occurs uninterruptedly on its object in a single mode and is not overcome by opposition, fixes the mind immovably as if in absorption."[27] But *The Path of Purification* explains this point as follows:

> When, having entered upon those *jhānas* and emerged from them, he comprehends with insight the consciousness associated with the *jhānas* as liable to destruction and fall, then at the actual time of insight momentary unification of the mind arises through the penetration of the characteristics [of impermanence, and so on.]"[28]

Thus, as Kheminda Thera, a modern Theravāda Buddhist scholar, points out,[29] momentary concentration is here shown definitely and clearly to emerge during the actual time of insight

[25] *Vis. Mag.* 461. The sub-commentary to the *Mahāpadāna Sutta* of the *Dīgha Nikāya* [*Dīgha* Sub-commentary (Sinh. ed.) 337] identifies the first meditative stabilization as renunciation; and the *Itivuttaka* (II, 41) states, "'Renunciation' means the first stabilization."

[26] Pāli: *khaṇika samādhi*

[27] *Paramatthamañjūsā* 278.

[28] *The Path of Purification*, XIII, 232, pp. 311–12.

[29] *The Way of Buddhist Meditation*, p. 44

specifically for a person who has *already achieved meditative stabilization.* Moreover, within the context of the seven purifications discussed at length in *The Path of Purification,* momentary concentration occurs only after the third purification, namely, purification of the view, which already presupposes completion of the second purification, purification of mind, which entails at least the attainment of the first meditative stabilization. Thus, according to Buddhaghosa, momentary concentration is the prerogative solely of one who has accomplished meditative stabilization, and it cannot serve as a substitute for genuine stabilization.

On the other hand, there are numerous accounts in the Pāli *suttas,* such as the well-known *Ādittapariyāyasutta,* of individuals suddenly achieving *nirvāṇa* upon hearing the Buddha or his disciples reveal the Dharma.[30] For people of this type, there may be no need to train in quiescence prior to achieving insight, for the two may arise swiftly and simultaneously. But such individuals appear to be rare, so for almost everyone following this gradual path, actual meditative stabilization, and not merely momentary stabilization, appears to be an indispensable prerequisite to the successful cultivation of insight.

Tsongkhapa also acknowledges that some individuals may practice most effectively by cultivating quiescence and insight simultaneously. Moreover, as we have noted previously, Karma Chagmé, representing the Mahāmudrā and Atiyoga traditions, declares that there are rare "simultaneous individuals" in whom the signs of realization appear swiftly and simultaneously as a result of their spiritual maturation from past lives. For such people, like those mentioned in the *Ādittapariyāyasutta,* liberating realization arises as soon as Dharma teachings are heard. But Karma Chagmé points out that such individuals are rare, and most people can cultivate insight only by following the traditional, sequential path of ethical discipline, *samādhi,* and wisdom.

[30] Cf. Rahula, Walpola Rahula, *What the Buddha Taught,* Rev. ed. (New York: Grove Weidenfeld, 1974), pp. 95–97.

The Achievement of Quiescence

According to Tsongkhapa's account of the attainment of quiescence by meditating on a mental image of the Buddha, in the final stage one mentally disengages from all signs—including the sign of that mental image—and attention is sustained in the absence of appearances. This is the achievement of the first proximate stabilization, and he soon moves on to the discussion of the cultivation of insight. The Theravāda tradition, on the other hand, is concerned with achieving at least the first basic stabilization as a minimum prerequisite for the cultivation of insight; and it therefore strongly emphasizes the nurturing of the counterpart sign as a means to achieve basic stabilization.

The fact that the counterpart sign does not figure prominently in the Indo-Tibetan tradition raises the question of whether or not the Indo-Tibetan and Theravāda accounts of the first proximate and basic stabilizations are even referring to the same meditative states. Moreover, there appear, at least at first glance, to be significant differences in their descriptions of the first stabilization with respect to the state of one's physical senses. According to Buddhaghosa, during the training in meditative stabilization that immediately follows the attainment of the first proximate stabilization, one may practice in any of the four traditional Buddhist postures, namely, walking, standing, sitting, or lying down.[31] The fact that the sign can be maintained while walking suggests that the physical senses are not dormant while one is striving to progress from proximate to basic stabilization; otherwise, it is hard to imagine how the meditator would be able to meditate while walking. Moreover, Buddhaghosa also remarks that in the first proximate stabilization one may experience bodily pain due to being bitten by gadflies, or due to the discomfort of an uneven seat; and in the first basic stabilization the whole body is saturated with bliss. This, too, indicates that one's bodily awareness has not become dormant even in the first basic stabilization.[32]

[31] *The Path of Purification*, IV, 41, p. 134.

[32] *The Path of Purification*, IV, 187, pp. 172–73.

This assertion appears to be incompatible with the view of Tsongkhapa and of Asaṅga and Vasubandhu,[33] on whom Tsongkhapa relies. Tsongkhapa acknowledges that even after quiescence is achieved, sensory images may appear to the mind due to lack of strong habituation with quiescence. If this occurs, one is advised to be mindful of the disadvantages of the mind coming under the influence of sensory objects, and not follow after them. By habituating oneself to such practice, he says, sensory objects no longer appear to the mind,[34] and one no longer senses the presence of one's physical body. The Theravāda view, on the other hand, appears to accord with certain discussions of quiescence in the Atiyoga tradition. Karma Chagmé, for example, writes of the attainment of quiescence:

> Now then, what is flawless meditation? Wherever the mind is directed, it remains still and clear. When you are meditating, the eight collections of consciousness, including the eyes, ears and so on, do not cease; rather each one is clear. The body and mind are saturated with joy, without irritation. This happens whenever you are meditating. When you are not meditating, effortlessly there is great freedom. This is quiescence alone, and it is the foundation of meditation.[35]

Although Karma Chagmé does not explicitly identify the attainment of quiescence with the first proximate stabilization, as Tsongkhapa does, his description of this state does have some resemblance with the Theravāda account of that initial state of stabilization. However, according to the contemporary Atiyoga teacher Gyatrul Rinpoche, the assertion that in the state of quiescence the sensory faculties are "clear" means that sensory objects do *appear* to the senses, but they are not necessarily *apprehended*. In contrast, in the flawed cultivation of quiescence the senses are

[33] *Yogasthāna III.*, Bihar MS., 12B.1-1. Derge: Sems tsam Dzi 145.1.6. Cf. Louis de La Vallée Poussin, *Abhidharmakośabhāṣyam*, English trans. Leo M. Pruden, Vol. IV, p. 1231.

[34] Cf. Tsongkhapa's discussion of "The Actual Marks of Having Mental Engagement" in Chapter 2 above.

[35] Karma Chagmé's *Great Commentary to* [Mi 'gyur rdo rje's] *Buddhadhood in the Palm of Your Hand (Sangs rgyas lag 'chang gi 'grel chen)*, Ch. 15, p. 683.

totally withdrawn, and objects do not even appear to them. In this case, this Atiyoga account of quiescence differs significantly from the views of both Tsongkhapa and Buddhaghosa. This would seem to imply that the achievement of quiescence, specifically the first proximate stabilization, is understood differently by Asaṅga, Vasubandhu, and Tsongkhapa on the one hand, and Buddhaghosa on the other; while the Atiyoga tradition may accord with Buddhaghosa's account, or it may present its own unique interpretation of quiescence.

This issue becomes yet more complex, however, when one takes into consideration the striking similarity between the Indo-Tibetan and Theravāda Buddhist accounts of the experience of consciousness once the first proximate stabilization has been attained. Asaṅga claims that upon achieving quiescence, the qualities of awareness, clarity and joy are experienced non-dually once the mindfulness of, and mental engagement with, objective appearances has been released. In this sense the state of quiescence may be regarded as mentally uncontrived and free of conceptual grasping. It is also immediately preceded by an experience of extraordinary joy, and it is sustained in a state of exceptional mental clarity and non-conceptuality. All of these characteristics are also cited frequently in descriptions of profound realizations of thatness which arise in the practice of Mahāmudrā and Atiyoga. Because of the superficial resemblance of quiescence and these much more advanced *samādhis*, Tsongkhapa cautions aspiring contemplatives to examine carefully the differences between them. The authentic insights of Mahāmudrā and Atiyoga are based upon the prior attainment of quiescence, and they differ from quiescence in terms of the practices leading to them, the nature of the realizations themselves, and their resultant benefits.

Similarly, the Theravāda tradition asserts that upon the achievement of the first proximate meditative stabilization there arises an experience of the "constituent of becoming."[36] This is characterized as the original, or primal, state of the mind from which thoughts originate; and it is said to be "process-free",[37] in

[35] Pāli: *bhavaṅga*

[36] Pāli: *vīthi-mutta*

contrast to the "active mind".[38] This natural state of the mind is further said to be free not only from all impurities *but also from all sense impressions* that cause impurities; hence it shines in its own radiance, which is obscured only due to external influence.[39] Thus, it seems that when one is experiencing this constituent of becoming without the presence of a counterpart sign, the mind is totally withdrawn from the physical senses. This accords quite closely with Asaṅga's account cited above. Moreover, the Theravāda tradition cautions that, due to its superficial similarity with the state of cessation[40] the constituent of becoming may be mistaken for the consciousness of one who is freed.[41] The parallel to Tsongkhapa's warning is obvious.

Although the aquisition of the sign of the mind is said to be a necessary prerequisite to the successful cultivation of the four applications of mindfulness—and thus, to the cultivation of insight—and though the experience of the constituent of becoming is closely linked to the first proximate stabilization, I have seen no evidence that the Theravāda tradition equates these two experiences. On the contrary, in the context of meditative stabilization, Buddhaghosa refers to the experience of the constituent of becoming merely as a failure to maintain the counterpart sign, and he does not appear to attach any particular value or significance to that experience of consciousness.[42] The Indo-Tibetan and Theravāda traditions, however, do both agree that once the first proximate stabilization is attained, one enters into a state of appearance-free consciousness, during which the physical senses remain dormant. Buddhaghosa indicates that when one proceeds in the training to sustain the counterpart-sign as a means to achieving the first basic stabilization, the physical senses are once again activated. Thus, it seems plausible that Asaṅga's and

[38] Pāli: *vīthi-mutta*

[39] Cf. Paravahera Vajirañāna's *Buddhist Meditation in Theory and Practice*, pp. 151, 327–28; David J. Kalupahana, *The Principles of Buddhist Psychology* (Albany: State University of New York Press, 1987), pp. 112–15.

[40] Pāli: *nirodha-samāpatti*

[41] Pāli: *nibbuta*

[42] *The Path of Purification*, IV, 33, p. 131.

Buddhaghosa's discussions of the first proximate stabilization are indeed referring to the same, or at least very similar, states of *samādhi*.

Is the Atiyoga account of quiescence actually at variance with both Asaṅga and Buddhaghosa? In the context of quiescence, Karma Chagmé characterizes "flawed meditation" as a state of consciousness comparable to deep sleep, in which the physical senses are dormant and mental awareness is unclear. If one persists in that semi-comatose state, he warns, one will be reborn as an animal.[43] This description closely parallels Tsongkhapa's account of the state of subtle laxity, in which the mind is excessively withdrawn and the full force of attentional clarity is absent. Tsongkhapa claims that by dwelling in such a state, which can easily be confused with meditative equipoise, in the near term one's intelligence is impaired, and in the long term one is reborn as an animal. Subtle laxity, he insists, must be completely eliminated before quiescence is accomplished. Thus, Karma Chagmé's previously cited description of quiescence may indeed refer to the first proximate stabilization, but not to the specific experience of appearance-free consciousness. He may, in fact be referring to this experience when he mentions a meditative state in which there is the mere discrimination of the mind's remaining single-pointedly, without the presence of any other thoughts or memories. In common with Theravāda writings, he comments that this bears some similarity with the Śrāvaka state of cessation. And he concludes with the comment that there is no harm in remaining in this state momentarily, but it is inappropriate to meditate continually in that way.[44] Taking all the above points into account, there seem to be sufficient similarities in the accounts of Asaṅga, Buddhaghosa, and Karma Chagmé to conclude that their discussions of quiescence are indeed referring to the same, or at least very similar, meditatve states. And all are agreed that quiescence is an indispensable prerequisite to the cultivation of insight, which alone has the power to liberate the mind from all afflictions.

[43] Karma Chagmé, *Sangs rgyas lag 'chang gi 'grel chen*, Ch. 15, p. 682.

[44] Ibid., pp. 682–83.

In addition to serving as the basis for insight, Tsongkhapa claims that the first proximate stabilization is a sufficient basis for developing a wide array of paranormal abilities. In the Tibetan tradition such abilities are said to have been cultivated chiefly by means of methods unique to the Vajrayāna. In the Theravāda tradition, on the other hand, the fourth meditative stabilization is often cited as the basis for developing paranormal abilities. Moreover, the Theravāda tradition closely associates the acquisition of counterpart signs with the form realm and the plane of meditative equipoise.[45] Buddhaghosa explains in detail how the mind is exercised in the use of counterpart signs in order to develop paranormal abilities.[46] To take one example, if one wishes to move unimpededly through solid objects, one enters into the fourth meditative stabilization focused on the counterpart sign of the space-emblem. Then, upon emerging from the state of meditative equipoise, one focuses the attention on a solid object, such as a wall, and resolves, "Let there be space"; and it becomes space, so that one can move through it freely.[47]

Although the counterpart sign does not figure prominently in Indo-Tibetan Buddhist accounts of quiescence, the contemporary Tibetan Buddhist contemplative Gen Lamrimpa claims that the signs of any of the ten emblems can be made to transform into the actual entities that they represent.[48] The hypothesis that one can gain mastery over the physical elements by meditatively acquiring and manipulating the quintessential ideas that represent them is one that conforms closely to the Prāsaṅgika Madhyamaka theory

[45] It should be noted that in Buddhaghosa's *The Path of Purification* only twenty-two of the forty subjects for the cultivation of *samādhi* transform into counterpart signs. Cf. Paravahera Vajirñāṇa Mahāthera, *Buddhist Meditation in Theory and Practice*, p. 106.

[46] *The Path of Purification*, trans. by Bhikkhu Ñāṇamoli, Ch. XII. The standard list of paranormal abilities that can be achieved through the cultivation of meditative stabilization is presented in *Discourses of Gotama Buddha: Middle Collection*, trans. David W. Evans (London: Janus, 1992) "Major Discourse with Vacchagotta," pp. 213–14.

[47] *The Path of Purification*, XII, 87–91.

[48] Gen Lamrimpa, *Śamatha Meditation*, trans. B. Alan Wallace, p. 122.

that all phenomena come into existence solely by the power of conceptual designation.

The late Tibetan Buddhist scholar Geshe Gedün Lodrö gives another explanation for the paranormal ability to move through solid objects. He claims that the cultivation of *samādhi* and the accomplishment of pliancy results in the formation of an unimpeded mental body,* pervading and equal in size to one's physical body, but not composed of matter. After achieving this mental body, he says, one can move both one's mental body and physical body unimpededly through solid objects while the mind is in the state of *samādhi*. He adds that a mental body, together with this ability to move through walls, can also be achieved through repeated, conceptual realization of emptiness, even without the achievement of quiescence.[49]

In short, the above accounts hypothesize that the paranormal ability to move unimpededly through solid objects may be achieved either through the manipulation of ideas using the power of meditative stabilization, without insight into emptiness, or through complete familiarization with emptiness, without the achievement of meditative stabilization. If so, it would naturally follow that unified meditative stabilization and realization of emptiness would also provide a more than adequate basis for the development of a variety of paranormal abilities.

There are certainly striking similarities between the Indo-Tibetan and Theravāda Buddhist accounts of quiescence, and yet differences remain between the claims of these two traditions and within the Indo-Tibetan tradition itself. It is difficult to draw definite conclusions at this time about the relationship between these meditative states as they are cultivated in these different disciplines. With further research, both textual and experiential, greater clarity may be forthcoming. Whatever future investigations may reveal, the cultivation of quiescence certainly plays a vital role in both these Buddhist traditions, and it warrants greater attention than it has been granted in the recent past.

[49] Geshe Gedün Lodrö, *Walking Through Walls: A Presentation of Tibetan Meditation*, trans. and ed. Jeffrey Hopkins, pp. 227–29, 232–33.

Theoretical Problems of Introspection in Indo-Tibetan Buddhism

Introspection in Modern Cognitive Science

Since the Scientific Revolution, major advances have been made in the exploration of a broad range of natural phenomena, from the origins of the universe to the intricate functioning of the human brain; but one natural phenomenon remains a mystery, and it is one that is central to our knowledge of everything else: human consciousness itself. Despite three hundred years of philosophical introspection, more than a century of empirical psychology, and recent advances in the neurosciences, there is still no scientific consensus concerning the origins, nature, or causal efficacy of consciousness.

Particularly since the collapse of the "introspectionist school" of psychology at the beginning of this century, Western cognitive scientists have tended to overlook consciousness and to focus rather on behavior and the brain. This trend can be explained in large part by the fact that the physical behavior of humans and the functioning of the brain can be observed objectively and quantitatively; and, thus, they can in principle be studied in accordance with time-tested scientific methods of observation, experiment, and mathematical analysis. Only during the past ten years or so has consciousness begun to come into fashion, and an increasing number of books by cognitive scientists and philosophers are now addressing this topic.

The limitation of the behavioral and neuroscientific methodologies is that they have no direct access to conscious states themselves, as we experience them first-hand. Thus, in terms of those objective procedures, subjective states of consciousness are relegated to a "black box"; and all empirical data are drawn from human behavior and brain functions that purportedly cause or

are caused by the subjective contents of that black box. Francis Crick, co-discoverer of DNA and a prominent neuroscientist, clearly points out a fundamental problem in this approach:

> The difficulty with the black-box approach is that unless the box is inherently very simple a stage is soon reached where several rival theories all explain the observed results equally well. Attempts to decide among them often prove unsuccessful because as more experiments are done more complexities are revealed. At that point there is no choice but to poke inside the box if the matter is to be settled one way or the other.[1]

The central limitation in the black-box approach to studying any phenomenon is known as the problem of *underdetermination:* given any amount of information about phenomena produced by the hidden contents within a black box, multiple incompatible theories can be devised to account for those hidden causes.[2]

For Crick, "poking inside the box" of mental phenomena—into the domain of joys, sorrows, memories, ambitions, and consciousness itself—means studying the brain; for he believes that all such mental events are nothing more than the behavior of a vast assembly of nerve-cells.[3] Another option, of course, is to poke into the mind introspectively by observing conscious states first-hand. While Crick does not reject this approach altogether, he insists that "the evidence of introspection should never be accepted at face value. It should be explained in terms other than just its own."[4] That is, subjective accounts of conscious states must be recast in the objective terminology of the brain sciences.

Whether first-hand experience of states of consciousness should be understood in their own terms or should be translated into neuroscientific terms is a matter of philosophical preference.

[1] F.H.C. Crick, "Thinking about the Brain," (*Scientific American,* September 1979), p. 183.

[2] I have discussed the problem of underdetermination in physics in my *Choosing Reality: A Buddhist View of Physics and the Mind* (Ithaca: Snow Lion), Ch. 8.

[3] This theme is treated in detail in F.H.C. Crick, *The Astonishing Hypothesis: The Scientific Search for the Soul* (London: Simon and Schuster, 1994).

[4] Crick, "Thinking about the Brain," p. 183.

The present fact of the matter is that scientists do not know what it is about the brain that enables it to produce conscious states; and they do not have compelling empirical evidence to identify individual conscious states with individual patterns of neuronal behavior. Thus, the reduction of subjective consciousness to objective brain states is an unrealized metaphysical ideal, not a present scientific fact.

While objective, empirical methods of studying the brain do reveal neurophysiological processes that are necessary for the production of specific states of consciousness, they never reveal thoughts, emotions, desires or any other mental events as they are experienced first-hand. That is, information about the behavior of nerve-cells alone never tells us what a person is thinking, feeling, desiring, remembering, imagining, or experiencing. If the ideal of reducing these subjective mental states to objective brain states is ever to be realized, it would seem that introspective modes of observation must be developed together with neuroscientific advances. For if the first-hand accounts of conscious states are vague, distorted, or simply mistaken, this undermines the possibility of identifying them with brain states—however precise and thorough our knowledge may eventually be of the brain.

On the other hand, perhaps the reason for our present inability to identify one-to-one relationships between mental states and brain states is that the former exist solely as first-person, subjective phenomena; and they cannot be reduced to anything else. This is the view developed by the distinguished philosopher John Searle. If this is the case, how are such phenomena to be studied scientifically? In a refreshing departure from the dominant trend in modern cognitive science, Searle suggests that we let the subject matter dictate our research methods, rather than the converse: "Because mental phenomena are essentially connected with consciousness, and because consciousness is essentially subjective, it follows that the ontology of the mental is essentially a first-person ontology . . . The consequence of this . . . is that the first-person point of view is primary."[5] Searle rightly cautions that

[5] John R. Searle, *The Rediscovery of the Mind* (Cambridge, Mass.: MIT Press, 1994), p. 20.

it is immensely difficult to study mental phenomena, and the only guide for methodology is the universal one, namely to use anything that works.

It is very difficult to follow through with this pragmatic dictum, however, when it comes to studying subjective consciousness scientifically. Science deals with "empirical facts" that are testable by "empirical methods," and this traditionally entails testability by third-person means. But this methodology, Searle insists, entails a false assumption, namely: "that all empirical facts, in the ontological sense of beings facts in the world, are equally accessible epistemically to all competent observers. We know independently that this is false. There are lots of empirical facts that are not equally accessible to all observers."[6] And that false assumption excludes all uniquely first-person accounts of mental phenomena, which, with one fell swoop, removes all subjective events from the realm of empirical facts.

The obvious implication of Searle's view of consciousness is that mental phenomena must be studied primarily from a first-person perspective; and this apparently opens the door to the possibility of scientific introspection of mental phenomena. However, Searle utterly rejects this possibility, stating:

> . . . if by "introspection" we mean a special capacity, just like vision only less colorful, that we have to *spect intro*, then it seems to me there is no such capacity. There could not be, because the model of specting intro requires a distinction between the object spected and the specting of it, and we cannot make this distinction for conscious states.[7]

The reason for this, he asserts, is that while the model of vision works on the presupposition that there is a distinction between the things seen and the seeing of them, for "introspection" there is simply no way to make this separation. "Any introspection I have of my own conscious state is itself that conscious state . . . the standard model of observation simply doesn't work for conscious subjectivity."[8] Moreover, just as the metaphor of introspec-

[6] Ibid., 72.

[7] Ibid., p. 144.

[8] Ibid., p. 97.

tion breaks down when the only thing observed is the observing itself, so does the metaphor of a private inner space break down due to the impossibility of making the necessary distinctions between the three elements of oneself, the act of oneself entering such an inner space, and the space into which one might enter.

Introspection and Reflexive Awareness

The role of introspection in exploring mental phenomena has been of concern not only in the modern West but in the ancient cultures of the East, in which contemplative practice, as opposed to objective, scientific research, has been the predominant mode of empirical inquiry into the mind. Nowhere is this more evident than in Buddhism. The analysis of introspection presented here is drawn from the Buddhist Centrist View (Madhyamaka),[9] which poses an alternative to the metaphysical options of materialistic reductionism, monistic idealism, and absolute dualism, which have dominated Western thinking at various times since the era of Hippocrates. The Centrist view rejects the notion that mental processes can be reduced to physical processes; it similarly denies that physical phenomena can be reduced to mental phenomena; and it also refutes the assumption that there is an inherent, absolute distinction between mental and physical phenomena. According to this view, neither mental nor physical phenomena as we conceive them exist independently from our conceptual constructs. Neither class of phenomena inherently exists either subjectively or objectively, so the distinction between subjects and objects is also of a conventional, not an absolute nature.

Centrist discussions of introspection commonly cite a discourse attributed to the Buddha, namely the *Ratnacūḍasūtra*,[10] which states that the mind cannot be observed introspectively, nor

[9] This discussion draws specifically from the Prāsaṅgika Madhyamaka view as propounded by the Indian Buddhist philosophers Candrakīrti and Śāntideva and the Tibetan Buddhist philosopher Tsongkhapa.

[10] Cited in Śāntideva *Śikṣā-samuccaya: A Compendium of Buddhist Doctrine.* trans. from the Sanskrit by Cecil Bendall and W.H.D. Rouse (Delhi: Motilal Banarsidass, 1971), pp. 220–21.

can it be seen in external sense objects, nor can it be detected in
the sense organs. Although the mind can apprehend a wide range
of objective phenomena, it cannot observe itself, just as the edge
of a sword cannot cut itself, and a fingertip cannot touch itself.
The Indian Centrist philosopher Candrakīrti (seventh century)
asserts, "The actor, the object of action, and the action are not
identical, so it is illogical to maintain that [a cognition] appre-
hends itself."[11] Just as a carpenter, the wood, and the activity of
cutting cannot be the same, so it is impossible, he argues, for the
cognizing agent, the cognized object, and the act of cognition to
be identical.[12]

Following what appears at first to be a similar line of reason-
ing, Searle claims that our modern model of reality and of the
relation between reality and observation simply cannot accom-
modate the phenomenon of subjectivity. This model is one of
objective observers observing an objectively existing reality, and
this precludes the possibility of an observation observing itself.[13]
Despite this ideological stance, on empirical grounds Searle
acknowledges the existence of "self-consciousness," which he
describes as "an extremely sophisticated form of sensibility . . .
[that] is probably possessed only by humans and perhaps a few
other species."[14] Such consciousness is "directed at states of con-
sciousness of the agent himself and not at his public persona,"[15]
and it entails awareness of one's mental and physical behavior.
Searle goes on to make the experiential claim that just as we can
shift our attention from the objects at the center of consciousness
to those at the periphery, we can also shift our attention from the
object of conscious experience to the *experience* itself. "In any con-
scious state," he asserts, "we can shift our attention to the state

[11] Candrakīrti. *Madhyamakāvatāra*, VI:76

[12] C.W. Huntington, (1989) *The Emptiness of Emptiness: An Introduction to Early
Indian Mādhyamika.* with Geshé Namgyal Wangchen. (Honolulu: University of
Hawaii Press, 1989), pp. 166, 245 n.105. Cf. Tsong kha pa. *dBu ma dgongs pa rab
gsal* (Collected Works, Vol. Ma) p. 165B.

[13] *The Rediscovery of the Mind*, p. 99.

[14] Ibid., p. 143.

[15] Ibid., p. 142.

itself. I can focus my attention, for example, not on the scene in front of me but on the experience of my seeing this very scene."[16]

Searle's rational rejection of introspection seems incompatible with his experiential affirmation of self-consciousness. How do Buddhist philosophers account for the fact that it does seem possible to attend not only to the object of conscious experience, but to the experience itself, and to recall that experience later on? And how do they account for the fact that we are aware of our mental behavior? Buddhist philosophers advocating views of idealism and absolute dualism[17] have proposed the existence of a reflexive awareness* that is an infallible, non-conceptual, non-dual perception of mental phenomena. Such awareness is said to be of the same nature as the mental events that it apprehends.

Reflexive awareness also plays a crucial role in their theory of memory. According to this view, the memory of an object is simply a memory of an object and not a memory of the subjective experience of that object. If the memory of an object were to include the memory of the subjective experience of that object, then a second cognition would be needed to apprehend that memory, a third cognition to apprehend the second cognition, and so on, resulting in an infinite regression. The Buddhist Idealist view claims that this conundrum is avoided by positing the existence of reflexive awareness.

This theory of reflexive awareness is thoroughly rejected by Candrakīrti, and by later philosophers following his interpretation of the Centrist view, including the Indian philosopher Śāntideva (eighth century) and the Tibetan philosopher Tsongkhapa (fourteenth century). Śāntideva counters the above interpretation of memory by suggesting that when we remember seeing a certain event, we recall both the perceived event and our-

[16] Ibid., p. 143.

[17] These philosophers belong to the Sautrāntika school, which advocates absolute dualism between subject and object and between mind and matter, to the Yogācāra school, which asserts a type of idealism, and to the Yogācāra Svāntantrika Madhyamaka school, which adopts an idealist interpretation of the basic tenets of the Madhyamaka view tracing back to Nāgārjuna (second century, C.E.).

selves perceiving that event. The two are recalled in an interrelated fashion, even without being conscious of our own presence as the perceiver during the original experience.[18]

Let us now return to Searle's claim that "In any conscious state we can shift our attention to the state itself." Although I have not discovered in Tsongkhapa's writings any explicit reference to such an apparent shift of the attention, I believe the following explanation accords with experience and with his Centrist interpretation of introspection. When my attention is focused on the color blue, I am not observing my perception of that color. However, when my interest shifts to my experience of blue, I am in fact *recalling* seeing that color just a moment ago. As Śāntideva suggests, when I remember seeing that color—whether this happened a year ago or a split-second ago—I recall myself observing that color. Thus, when I shift my attention back and forth between attending to the color and to remembering seeing the color, it seems as if such a shift is comparable to shifting my attention from the objects at the center of consciousness to those at the periphery, as Searle suggests. However, according to the above explanation, the attention is instead shifted from the perceived object to a remembered event. Unlike Searle's explanation, this account maintains the distinction between the observation and the observed object.

The contemporary philosopher William Lyons also rejects the existence of introspection as a meta-process that monitors first-level occurrences of perception, memory, imagination, thinking, and so on.[19] In support of this refutation, he cites the research of Woodworth and Schlosberg indicating that simultaneous performance of two attentive acts of cognition, rarely if, ever occurs.[20] This empirical conclusion, he asserts, casts doubt on the possibil-

[18] Śāntideva, *Bodhicaryāvatāra* IX:23. Cf. Dalai Lama, *Transcendent Wisdom: A Teaching on the Wisdom Section of Shantideva's* Guide to the Bodhisattva Way of Life. trans., ed., and annot. by B. Alan Wallace (Ithaca: Snow Lion, 1994), pp. 26–31.

[19] William Lyons, *The Disappearance of Introspection* (Cambridge, Mass.: MIT Press, 1986), p. 123.

[20] Robert Woodworth and Harold Schlosberg, *Experimental Psychology*, 3d ed. (New York: Methuen, 1955), p. 90.

ity of simultaneously attending to an object of consciousness and to the subjective consciousness of that object.

How is it that we detect the presence of our present perceptions of the physical world? Lyons suggests:

> When one is doing something like looking, hearing, or tasting in a conscious or attentive fashion, then ipso facto one has knowledge of so doing, for part of the analysis of such attention, consciousness, or awareness will be that one knows what one is doing and is able to describe it if one has sufficient linguistic competence. To know that one is perceiving, one does not have to engage in some second-order process of inspecting the perceiving.[21]

Tsongkhapa similarly rejects the possibility that a single cognition can simultaneously attend to two or more dissimilar objects. For example, although one might attend at the same time to an apple and its color, one could not attend simultaneously to an apple and the sound of music, or to an apple and one's perception of the apple. Thus, when we are seemingly attending simultaneously to a person's face and to our conversation with that person, in fact our attention is rapidly shifting back and forth, many times per second, between these visual and audial objects. Tsongkhapa's account of the manner in which we do know of our consciousness of a given object is also remarkably akin to that of Lyons:

> Simply by recalling an object, the subject is also recalled, so there is no need for a separate recollection of the subject. Likewise, simply by determining the presence of an object as in the case of apprehending blue, the cognition of blue is determined. There is no need for a method of determining the presence of the cognition of blue in addition to the method of determining the presence of blue.[22]

Thus, the presence of the cognition of a color is detected by sensory perception itself, for it is implicit in the cognition of the color detecting its own object. This is said to be equally true of all types of valid cognition.

[21] *The Disappearance of Introspection*, p. 108.

[22] Tsong kha pa, *dBu ma dgongs pa rab gsal*, (commentary on *Madhyamakāvatāra*, VI:75), p. 161A.

Mental Perception of Mental Phenomena

In response to the question of the awareness of our own mental
behavior, Tsongkhapa distinguishes between two types of percep-
tion:[23] (1) the sensory awareness of visual form, sounds, and so
on; and (2) mental perception.* While the various types of sensory
perception apprehend their objects directly, mental perception
apprehends form, sounds, and so on by the power of the sensory
consciousness of them. Mental perception does not apprehend
sensory objects directly; in fact it is said to *recollect* them.[24]
However, just as the sensory consciousnesses directly cognize
form, sound, and so on, mental perception directly cognizes the
inner experiences of such things as the feelings of joy, sorrow, and
so on.[25] Such inner experiences are detected solely with mental,
and not sensory, awareness.

[23] According to the Prāsaṅgika view advocated by Tsongkhapa, perception is
defined as an unmistaken, experiential awareness with respect to the main object
of cognition *(rang yul gyi gtso bo la myong stobs kyis mi slu ba'i rig pa).* To clarify
the crucial term "experiential," when I conceptually bring Honolulu to mind while
reading travel brochures, this city is not apprehended experientially, but by way of
a generic image. Likewise, if I recall my visit to Honolulu last year, the city is again
apprehended, not experientially, but by way of a generic image. However, when I
am actually in Honolulu, I experientially apprehend this city with both sensory
and mental perception. Moreover, if I dream of being in Honolulu, I experientially
apprehend the dream images of Honolulu with mental perception. Cf. Blo bzang
rgya mtsho, *mTha' gnyis dang bral ba'i dbu ma thal 'gyur ba'i blo'i rnam gshag ches
cher gsal bar byed pa blo rigs gong ma* (Dharamsala: Institute of Buddhist
Dialectics, 1993), p. 9.

[24] Tsong kha pa. *dBu ma dgongs pa rab gsal,* p. 163A. *Dang po dbang shes kyis gzugs
sogs kyi don de dngos su rig la, yid shes kyis dbang shes kyi stobs kyis rig gi dbang
shes bzhin du dngos su mi rig par gsungs shing dran par yang gsungs so.* The con-
temporary Tibetan Buddhist scholar Losang Gyatso asserts that according to
Tsongkhapa, the mental perception of a sensory object, such as visual form, is
induced by the immediately prior instant of visual perception. That mental per-
ception of the sense object is a kind of recollective cognition *(dran shes),* for it
apprehends something with which one is already familiar. [Blo bzang rgya mtsho,
*mTha' gnyis dang bral ba'i dbu ma thal 'gyur ba'i blo'i rnam gshag ches cher gsal bar
byed pa blo rigs gong ma,* p. 14.]

[25] Tsongkhapa also acknowledges the existence of contemplative perception *(rnal
'byor mngon sum, yogi-pratyakṣa),* which need not concern us here. For a

Tsongkhapa asserts that the term "feeling,"* refers at different times (1) to the agent who feels; (2) to the mental process of feeling; and (3) to feeling as an intentional object.[26] The phrase "I feel good" is an illustration of the first usage. Secondly, the actual mental process*[27] of feeling has its own referent, or intentional object. For example, I may perceive a sunrise with pleasure, and the intentional object of that pleasure is the sunrise. Tsongkhapa writes, "The third is a cognized object, namely, joy, suffering, and indifference. Moreover, this falls in the domain of mental consciousness . . . "[28] He justifies this on the grounds that the *sūtras* describe feeling as a special type of experience, and worldly convention also acknowledges that happiness and suffering are experienced.

We are now in a position to ask: what type of phenomena are these feelings and so on, which are intentional objects of mental perception? It is tempting to conclude that in Tsongkhapa's view the feelings and so forth that are apprehended by mental perception are not genuine mental processes in the sense of having their own intentional objects. If that were the case, such mental phenomena would have to be included in the category of *non-associated composites,** which are neither material entities nor intentional states of consciousness. But this hypothesis collapses upon noting that such mental phenomena are not included in any of the Buddhist lists of the varieties of non-associated composites.[29] Moreover, the entire range of mental processes are

discussion of this type of perception in Indo-Tibetan Buddhism see Charlene McDermott, "Yogic Direct Awareness as Means of Valid Cognition in Dharmakīrti and Rgyal-tshab" in *Mahāyāna Meditation: Theory and Practice*, ed. Minoru Kiyota (Honolulu: University of Hawaii Press, 1978), pp. 144–166.

[26] Tsong kha pa, *dBu ma dgongs pa rab gsal*, p. 163A.

[27] The general consensus in Buddhist psychology is that the consciousness *(rnam shes, vijñāna)* apprehends the sheer presence of its object, while the various mental processes apprehend the specific characteristics of that same object. Cf. Louis de La Vallée Poussin, *Abhidharmakośabhāṣyam* English trans. Leo M. Pruden (Berkeley: Asian Humanities Press, 1991), Vol. I, p. 340, fn. 178.

[28] Tsong kha pa, *dBu ma dgongs pa rab gsal*, p. 163A–B.

[29] Jeffrey Hopkins, *Meditation on Emptiness*, (London, Wisdom, 1983), pp. 268–271; S. Jaini, "Origin and Development of the Theory of *viprayukta-*

explicitly listed among the phenomenal elements,* which are cognized solely by mental consciousness.[30]

Thus, I surmise that, according to Tsongkhapa, the feelings and other mental processes perceived with mental awareness are indeed intentional. How then does mental perception apprehend these mental processes? One possibility is that mental perception observes mental processes that are simultaneous with the observation of them. However, this hypothesis is incompatible with the Buddhist theory, accepted by Tsongkhapa, that at any moment the mind and its concomitant mental processes have the same intentional object; and in any given moment only one mind can be produced in a single individual.[31] Thus, according to this theory, at any given moment it would be impossible for a feeling to have an intentional object such as a sunset, while the same person has another cognition with that feeling as its intentional object. For this reason, if mental processes are observable by mental perception, it must be the case that the mental perception recalls those processes from a prior moment of experience. William James seems to come to a similar conclusion when he writes, "No subjective state, whilst present, is its own object; its object is always something else. There are, it is true, cases in which we appear to

saṃskāras." Bulletin of the School of Oriental and African Studies, University of London 22/3 (1959) 531–547. In his unpublished dissertation *Pratītyasamutpāda— The Discussion in the* Abhidharmasamuccaya, *Together with the Commentary of the* Abhidharmasamuccayabhāṣya (Berkeley: University of California Press, 1995), Robert Kritzer has done an exhaustive study of Hīnayāna and Mahāyāna lists of *cittaviprayuktasaṃskāras,* and nothing suggestive of non-intentional mental processes is included in any of them.

[30] Buddhism asserts that all phenomena are included within a classification of eighteen elements *(dhātu):* the six types of consciousness—visual, audial, olfactory, gustatory, tactile, and mental consciousness—the six sense faculties which are the bases of those consciousnesses, and the six types of objects of those consciousnesses. According to this classification, the objects of mental consciousness are called phenomenal elements *(dharmadhātu),* and the above mental processes that are observable by mental perception—and by no other means of observation—are included in this category. Cf. Jeffrey Hopkins, *Meditation on Emptiness,* p. 273; Louis de La Vallée Poussin, *Abhidharmakośabhāṣyam,* Vol. I, pp. 106, 129.

[31] Louis de La Vallée Poussin, *Abhidharmakośabhāṣyam,* English trans. Leo M. Pruden, Vol. I, pp. 206, 272.

be naming our present feeling, and so to be experiencing and observing the same inner fact at a single stroke, as when we say 'I feel tired,' 'I am angry,' etc. But these are illusory, and a little attention unmasks the illusion."[32]

According to Śāntideva and Tsongkhapa, in recalling a previous experience of seeing blue, the blue object and the experience of that object are recalled simultaneously as a subject/object matrix. The same process should be applicable in terms of very short-term memory from one moment to the next. If this is possible, we may well ask: why could mental perception not observe an immediately prior moment of visual perception, say of the color blue, in a similar fashion? In Śāntideva's explanation of the recollection of an earlier perceptual experience, he does not explicitly deny the possibility of a mental perception of visual perception; he simply asserts that one may later recall the visual experience even though one is not attending to it while actually perceiving the color blue. Tsongkhapa adds that no other method is *needed* for determining the presence of the experience of blue, but this assertion does not necessarily preclude the *possibility* of a mental perception observing a previous moment of sensory perception.

The question remains: if it is possible, by means of short-term recollection, to observe the experience of a feeling, why should it not be possible to observe in a similar fashion the experience of seeing, hearing, and so on? This is a way of accounting for Searle's claim that it is possible to shift the attention from the visual *object* to the *experience* of that object, although it occurs in a different manner than shifting the attention from the center to the periphery of one's field of vision. Lyons flatly denies this possibility, stating, "to perceive a beaker in front of oneself, on the table, and then to attend to one's perceiving of it is not to engage in two processes or activities but to modify one's approach to the one and only activity: that of perceiving. One can perceive the beaker, and then one can do it attentively—that is, with care, banishing distractions, with alertness, concentration, and so on. The same will be

[32] James, *Principles of Psychology*, I:189–90.

[33] *Disappearance of Introspection*, p. 107.

true of imagining. One cannot imagine a beaker full of water and then focus on the imagining."[33]

Tsongkhapa certainly rejects the notion that it is impossible to focus on a prior moment of the mental process of imagining, and it is not clear that he denies the possibility of mentally observing prior sensory perceptions. Experientially, when I concentrate fully on a visual object, I am, according to Tsongkhapa, focusing my mental perception on that object; and while doing so, I am not apprehending the *experience* of that object. Then when I seem to shift my attention, or mental perception, to the visual experience itself, the visual object becomes indistinct, though it does not fade out altogether. Such experience, if valid, flatly contradicts Lyons's denial of any kind of retroactive meta-cognition of experience, either sensory or mental. This apparent shift of the attention from the object to the subject seems to entail a shift within a subject/object field, or matrix, of visual experience: as I focus more closely on the object, I become less conscious of the subject; and as I focus more closely on the subjective experience, I become less conscious of the object. Śāntideva's point in this regard seems to be that although I am not conscious of the subjective experience of a visual perception while it is occurring, I may later recall the entire subject/object matrix, thereby bringing the initial subjective experience into consciousness.

Vasubandhu comments on the difficulty of such questions:

> Subtle, unquestionably, are the specific characteristics of the mind and its mental processes. One discerns them only with difficulty even when one is content to consider each of the mental processes as developing in a homogenous series; how much more so when one envisions them in the (psychological) moment *(kṣana)* in which they all exist. If the differences of the taste of vegetables, tastes that we know through a material organ, are difficult to distinguish, how much more so is this true with non-material phenomena that are perceived through the mental consciousness.[34]

[34] de La Vallée Poussin, *Abhidharmakośabhāṣyam*, Vol. I, p. 190. I have altered the translation of Poussin/Pruden slightly so that the terminology conforms to the present work.

Mental perception may also observe mental images of visual forms, sounds, smells, tastes, and tactile sensations. None of these mental phenomena cognize their own objects, so they are not mental processes in the Buddhist sense of the term. Nor are they material in the Buddhist sense of being composed of particles of matter. Rather, they are regarded as forms for mental consciousness,*[35] of the same type of qualia as the forms, sounds, and so on that appear in the dream-state. While intentional mental processes may be perceived only retrospectively, non-intentional mental phenomena and the mental perception of those phenomena arise simultaneously. Thus, this type of perception is unlike both sensory and mental perception of sensory objects, in which an object precedes and conditions the perception of that object.

In Tsongkhapa's view, introspective mental perception apprehends a wide array of mental phenomena as being distinct from itself, and that perception is not infallible. In these critical ways such mental perception is posited as being fundamentally unlike the refuted reflexive awareness. How is it that we are able to detect the presence of introspective mental perception? This, Tsongkhapa asserts, is established simply by determining the presence of the perceived mental phenomena. This assertion follows the same reasoning as applied to sensory perception and recollection.

The Introspective Detection of Mistaken Cognition

The above account of determining the presence of a cognition by determining the presence of its cognized object holds up as long as the cognized object actually exists. But how does Tsongkhapa account for the fact that we can note the presence of a deluded cognition that apprehends a non-existent object? Citing Candrakīrti,[36] Tsongkhapa begins with the assertion that appear-

[35] Cf. Jeffrey Hopkins, *Meditation on Emptiness*, pp. 232–34.

[36] Tsongkhapa cites here Candrakīrti's *Prasannapadā*, de la Vallée Poussin, ed. (Saint Petersburg: Bibliotheca Buddhica 1913), IV, p. 75. sDe dge Tibetan trans.

ances associated with all objects, both specific and general, occur to the mind that apprehends those objects; and those appearances are evident to those cognitions.[37] For example, when I think of the specific pippin apples that are now stored in my refrigerator, an image of several green apples comes to mind. And when I think simply of an apple (as a general phenomenon), an image of a single, red mackintosh apple appears to my awareness. Likewise, when I think of the justice of a human rights activist receiving a well-earned Nobel Peace Prize, images come to mind of the ways in which that person has struggled for human rights and the manner in which those efforts were appreciated. When I think simply of justice, an image of a judge in a courtroom appears in my mind's eye. The point that Tsongkhapa is making is that for *all* our cognitions of any type of object, something that is associated with, or represents to us, that object appears directly to the mind. There is no one image that totally captures the phenomenon of justice, for example, but there are many images that people may associate with it; and these come to mind when we think of justice.

Honing in on the issue of mistaken cognition, Tsongkhapa asserts that all mental representations, or images,*[38] are evident to the cognitions to which they appear; and all cognitions are

folio 25B. The passage cited by Tsongkhapa is also cited in the same context by his disciple Khedrup Gelek Palzang (mKhas grub dge legs dpal bzang). This passage is translated in *A Dose of Emptiness,* trans. José Cabezón (Albany: SUNY Press, 1992), p. 373.

[37] This discussion is based on Tsongkhapa's *dBu ma dgongs pa rab gsal,* pp. 163B–164B. This theme is also explained by Tsongkhapa's disciple Khedrup Gelek Palzang in his discussion of the three types of direct perception *(pratyakṣa)* in *A Dose of Emptiness,* pp. 372–379.

[38] Vasubandhu defines this term as follows: "A mental representation *(ākāra)* is the mode in which the mind and mental processes apprehend objects." The *Abhidharmakośabhāṣya* on *Abhidharmakośabhāṣyarika* VII.13b1; *Abhidharmakośa,* Dwārikādās Śāstrī, ed., *Abhidharmakośa* and *Bhāṣya* of Acārya Vasubandhu (Varanasi: Bauddha Bharati, 1981), p. 1062. Asaṅga's *Abhidharmasamuccaya,* on which Tsongkhapa's references to the mind and mental processes is based, and Vasubandhu's *Abhidharmakośa* agree that every mental process *(caitta)* has an intentional object, namely the object of the mind *(citta)* with which it arises in conjunction. Paul Griffiths points out that Vasubandhu, Asvabhāva, and Sthiramati all agree that consciousness cannot arise without an object and a mental repre-

valid with respect to the mental representations that appear to them. Thus, for even a mistaken cognition there is an appearance of a non-existent object; and by determining the presence of that appearance, the presence of the cognition is also established, as in the case of the earlier examples of other types of cognition. According to Tsongkhapa, a mistaken cognition is mistaken only in terms of how it apprehends or conceives of its object; but all cognitions—including sensory and mental perception as well as all types of valid and invalid conceptual cognitions—are unmistaken with reference to the representations that directly appear to them. Likewise, all mental perceptions are valid with respect to the appearances of mental phenomena; but they, like any other perception, may be mistaken in the way they apprehend those phenomena.

For example, a person who is visually hallucinating due to taking a mind-altering drug may see a fire-breathing dragon flying through the air. The visual appearance of that dragon does exist, and visual perception of the dragon is valid *with respect to that appearance.* However, since there is no dragon up there in the sky, that perception is mistaken *with respect to its apprehended object, the dragon.* As another example, I may mistakenly recall having paid the heating bill last month, whereas in fact it slipped my mind. As I recall paying the bill, the image of my writing out the check does exist, and my memory is valid with respect to that image. But upon looking at my checkbook and seeing that no such check was written, I recognize that my memory was mistaken with respect to paying the bill.

If one attends with mental perception to a mental representation itself, there is room for error in the manner that one apprehends that object. It seems that a modern distinction may be drawn here between *perceiving* and *perceiving as.* Tsongkhapa's argument seems to imply that mental perception is always valid with respect to the *mere appearance* of mental representations; but

sentation; and the same is true of mental processes. Paul J. Griffiths, "Memory in Classical Yogācāra," in *In the Mirror of Memory: Reflections on Mindfulness and Remembrance in Indian and Tibetan Buddhism,* Janet Gyatso, ed. (Albany: SUNY Press, 1992), p. 126, fn. 16.

it may be mistaken in the manner in which it apprehends them. For example, a Tibetan contemplative may experience a mental vision[39] bearing the appearance of Avalokiteśvara, the Buddhist personification of enlightened compassion; and that vision may even appear to speak to the contemplative. Although the mental perception of that appearance is valid, error may creep in as soon as one apprehends the mental form and speech as being the actual body and words of this deity or anything else. To take another example, while dreaming, I may mentally perceive an image of a unicorn. That perception is valid. But if I apprehend it as a real unicorn, that cognition is mistaken; whereas if I am dreaming lucidly and apprehend it as a unicorn in a dream, that cognition is valid.

Qualms Concerning Tsongkhapa's Account of Mental Perception

When expounding on the Centrist view, Tsongkhapa gives the above account of the indirect manner in which we are able to detect the presence of a cognition implicitly by explicitly establishing the presence of its object. This line of reasoning seems designed to account for our knowledge of conscious states without resorting to the hypothesis of reflexive awareness. However, in this same account he acknowledges that it is possible for mental perception to observe such mental processes as feelings. Moreover, in his practical writings on the cultivation of meditative quiescence, he explains at length the ways in which one mental process, namely introspection, is used to detect other mental processes, namely laxity and excitation. Neither the mental perception of feelings, other mental processes, or sensory perceptions, nor the detection of one mental process by another necessarily requires the acceptance of reflexive awareness as it has been discussed in this essay. Moreover, the mental perception of mental processes and subject/object matrices of experience does not require the abandonment of the distinction between the

[39] *snang ba*

observing subject and the observed object. It does, however, suggest a participatory kind of observation in which the very observation itself immediately influences the continuum of one's awareness. Thus, although I find Tsongkhapa's account of the implicit detection of conscious states quite cogent, it does not seem necessary if in fact it is possible to detect modes of experience explicitly by means of recollective mental perception, as he apparently acknowledges.

The entire range of mental phenomena that can be observed by mental perception, including mental processes and imaginary forms, are nowadays called mental *qualia*. The very existence of mental qualia is totally rejected by William Lyons for various reasons. While Lyons accepts the existence of sensory qualia such as tactile and visual sensations, he denies that there are qualia in connection with any so-called introspective processes. Thus, "there are no ideas floating in our heads or felt surges of the will, though we may consciously imagine ideas floating in some mental fluid or imagine we feel the rising tide of volition swelling over the seawalls of the mind."[40] He implies, moreover, that the only perceptions we have are sensory perceptions of sensory phenomena; there are no mental perceptions of mental phenomena.

According to Lyons, "introspection" is purely an exercise of perceptual memory and imagination. Rather than observing any inner phenomena, it substitutes a working model or dynamic picture for what it cannot know firsthand. Thus, "introspection" neither allows us to observe our perceptions, sensations, thoughts, desires, or feelings and so on, nor does it entail any inner viewing of mental copies of earlier experiences. All that "introspection" actually does is to "fashion models of particular cognitive or appetitive episodes by abstracting them from perceived overt cognitive acts and 'replay' them by means of perceptual memory and imagination."[41] Neither memory nor imagination is involved in producing internal copies of reality; instead they produce "replays" of events that occurred in ordinary perception. "A

[40] *Disappearance of Introspection*, p. 154

[41] Ibid., p. 152.

replay," he contends, "is not a copy of the original experience; it is having the original experience again, at least in its essentials or else in a form edited to suit one's present purposes."[42] Lyons insists that so-called introspection does not give us knowledge of any aspect of the nature of our cognitive life that is unavailable to others or any aspect of the nature of the 'mind' that is unavailable to others, though it does give us knowledge of what is going on in my perceptual memory and imagination . . . "[43]

On two counts, Lyons's theory seems to fly in the face of experience. First, when I recall my experience of eating lunch this afternoon, if I am in fact *replaying* that original experience, as Lyons proposes, then I should be experiencing the colors, shapes, tastes, smells, and textures of my food, together with the sounds of my eating it *as if these events were happening right now.* This, after all, is what we mean by a *replay,* as opposed to a *copy.* Moreover, as replays, my memories of those events should be exact, incorrigible replicas of the original experiences. In short, I would have the sense of eating my lunch all over again. Obviously, our memories are experienced neither so vividly nor so accurately as Lyons's theory would imply.

Secondly, since Lyons's theory of "introspection" denies that it provides me with knowledge of any aspect of the nature of my cognitive life that is unavailable to others, apart from observing my public behavior, it should be impossible for me to ascertain whether my mind right now is agitated or calm, alert or dull; there should be no way for me to know whether I desire a drink of water or whether I intend to fulfill that desire in the near future; nor should I be able to observe whether I am feeling sad, cheerful, or indifferent. Lyons's theory lends itself to the joke commonly aimed at behaviorism: Upon concluding their love-making, one partner comments to the other, "It was good for you; how was it for me?"

I suspect a fundamental reason why an experientially and rationally coherent view of introspection eludes such modern, erudite thinkers as Searle and Lyons is that the very idea of men-

[42] Ibid., p. 116.

[43] Ibid., p. 131.

tal perception is alien to twentieth-century Western thought. Our common assumption is that perception is confined to the senses, while the mind thinks, feels, desires, intends, remembers, imagines, and so on. But we do not think of the mind *perceiving* any type of phenomena that are accessible to it alone. The term "mental perception" is not commonly used nowadays; and, as James, points out, when a word is lacking, "We are then prone to suppose that no entity can be there; and so we come to overlook phenomena whose existence would be patent to us all, had we only grown up to hear it familiarly recognized in speech. It is hard to focus our attention on the nameless, and so there results a certain vacuousness in the descriptive parts of most psychologies."[44]

To sum up, whether or not one believes that conscious states can be reduced to physical processes, the Centrist view argues that introspective perception of mental phenomena is an experiential fact of life that can be explained without sacrificing the distinction between the observed object and the observation of it. However, such mental perception of mental events is no more infallible than our sensory perceptions of physical events.

[44] *Principles of Psychology,* I:195.

The Epistemic Role of Introspection in Western Psychology

The suggestion that introspection might be used in the scientific exploration of the mind can swiftly be countered by pointing out that it has already been tried by the introspectionist school of psychology, which flourished around the turn of the century; and it proved to be a total failure. John Searle claims that inner observation of the mind never occurs, because the introspection of any conscious state would have to be that same conscious state; and that is an impossibility. Thus, introspective psychology was doomed from the start.[1] William Lyons comments that even if the concept of introspection did make sense and the process was feasible, in fact introspection proved to be an unreliable source of psychological data; and it was the failure of the introspectionist school that led to the rise of behaviorism.[2] Since then, despite the bankruptcy of behaviorism, introspection continues to be dismissed as a method in psychology, where it is retained "at most as a crude curtain raiser to serious scientific endeavor."[3]

In his illuminating essay entitled "The History of Introspection Reconsidered," focusing on academic psychology during the period 1880–1914, Kurt Danziger challenges the above, prevailing views concerning the demise of the introspectionist school. His conclusion, in short, is that the total rejection in principle of introspection was not a rational conclusion in the light of the problems that the method encountered. Rather, it was due to a shift of interests among psychologists, especially in America. "Such interests," he asserts, "redefine the goals of psychological research and hence produce a re-selection of the methods needed to achieve these

[1] *Rediscovery of the Mind*, p. 97.

[2] *Disappearance of Introspection*, p. 21.

[3] Ibid., p. 151.

goals. Introspection was less a victim of its intrinsic problems than a casualty of historical forces far bigger than itself."[4]

Introspection, however, certainly did present significant problems in terms of acquiring scientific knowledge of mental phenomena, and Danziger gives a fine account of the various objections that were raised against this method of inquiry.

1. The first, and perhaps most fundamental, objection is that scientific observation demands a kind of independence of subject and object which is impossible in introspection. As noted previously, this point is regarded by some contemporary philosophers of mind to be sufficient grounds for rejecting the possibility of introspection altogether. There is a wonderful historical irony in this position, for the academic psychologists who rejected introspectionism in favor of behaviorism were of the same generation as the pioneers of quantum mechanics. And in this revolutionary, and extraordinarily successful, branch of modern physics it is common knowledge that the physical phenomena under observation can not be studied independently of the mode of observation. In other words, when it comes to extremely minute physical phenomena, scientific observation cannot maintain the independence of subject and object, and it is a matter of ongoing debate as to whether quantum entities even exist independently of their measurement. This theme is specifically addressed in the well-known Heisenberg Uncertainty Principle.[5] Thus, the participatory nature of scientific observation in quantum mechanics has been accepted in this branch of physics and has given rise to a great deal of fascinating debate; while the participatory nature of introspective observation in psychology has been taken as grounds for rejecting the very possibility of such

[4] Kurt Danziger, "The History of Introspection Reconsidered," *Journal of the History of the Behavioral Sciences* 16 (1980), p. 259. For another incisive account of different historical perceptions of introspection, see Gerald E. Myers, *William James: His Life and Thought* (New Haven: Yale University Press, 1986), pp. 64–80.

[5] I address this topic in *Choosing Reality: A Buddhist View of Physics and the Mind*, Ch. 9.

scientific observation. As a result, introspection is no longer a topic even treated in psychology textbooks; and in both psychology and the brain sciences, theorizing about the nature of introspection remains at a rudimentary stage.[6]

2. A second, fundamental objection to introspection is based on the premise, traced back to Leibniz and Kant, that mental events in general, and all causally efficacious mental processes in particular, are unconscious and therefore inaccessible in principle to introspective observation. One modern, materialistic reinterpretation of this view asserts that mental events in general, and all causally efficacious mental processes in particular, are unconscious; for they are actually brain states that can be studied solely by objective, scientific means. The notion that all mental processes are unconscious simply flies in the face of experience, and that alone should be sufficient to discount this rationalistic premise. However, the hypothesis that all causally efficacious mental processes are unconscious is not so easily discounted. In identifying a mental or physical process as the cause of another, if it is deemed necessary to identify a *mechanism* by which the effect is produced, problems abound for all materialists and dualists alike. The collapse of Cartesian dualism is commonly attributed in part to its failure to identify a mechanism by which an immaterial mind influences the body. However, despite the rapid progress of modern neuroscience, it, too, has failed to account scientifically for the mechanism by which the brain produces subjectively experienced states of intentional consciousness.

 An alternative approach is to acknowledge that causality does not necessarily require a real medium or mechanism of influence—a conclusion drawn long ago in quantum mechanics. A "minimalist" interpretation of causality that may be applied to mental causation asserts simply: If A precedes B, and B would not have occurred in the absence of A, A causes B. This concept of causation can of course be applied in individual cases only retrospectively; but this is, arguably, how we

[6] *Disappearance of Introspection*, p. xi.

often conclude that one event caused another. Specifically, if one adopts this phenomenological view of causality, introspectively observable mental phenomena certainly do act as causes of subsequent mental and physical events. Moreover, it is the mind alone that is able to perceive both mental and physical events as well as the relations between them; so introspection should naturally play a vital role in determining such causal interactions.

3. A third criticism leveled at the scientific use of introspection points out that when the introspecting subject is compelled to reply to the questions of the experimenter, this not only biases the observations and responses, but also carries the implicit message to the subject that all the questions are answerable. If the fact that an observer must reply to pre-established questions necessarily biases the observations so that they are distorted or even invalidated, then virtually all scientific observations would fall under this same ax. As Werner Heisenberg comments, "What we observe is not nature in itself but nature exposed to our method of questioning."[7] Einstein comments in a similar vein, ". . . on principle, it is quite wrong to try founding a theory on observable magnitudes alone. In reality the very opposite happens. It is the theory which decides what we can observe."[8] Insofar as this is true of the physical sciences, the same allowance must be granted to the cognitive sciences: the type of questions we ask invariably influences the type of observations we make, and introspective observations are no exception.

Concerning the implicit message to introspecting subjects that all the questions put to them are answerable, the solution is quite simple: openly acknowledge that not all such questions are necessarily answerable.

[7] Werner Heisenberg, *Physics and Philosophy: The Revolution in Modern Science* (New York: Harper and Row, 1962), p. 58.

[8] Cited in Werner Heisenberg, *Physics and Beyond: Encounters and Conversations* (New York: Harper and Row, 1971), p. 63.

4. A fourth, and closely related, objection states that when the words in which the experimental subject describes his experiences do not induce in the experimenter corresponding experiences of his own, a specific interpretation, and hence a scientific evaluation, of such introspective reports is impossible.

 This problem, however, is not confined to introspective reports of mental phenomena. For example, I know the difference in taste between a plum and a cherry; but my ability to articulate this difference diminishes as I try to express it to a person who has tasted one and not the other, to a person who has tasted neither, and to a person who has never tasted anything sweet. Similarly, individuals who are adept at introspection may be able to communicate meaningfully among themselves about certain experiences, while others listening in could literally not make sense of their conversation. Such communication may not be different in principle from other instances of "privileged conversation" that commonly occurs among highly trained mathematicians, musicians, and so on.

 The implication for the scientific use of introspection is that the experimenter should be *more* experienced in introspection than the subject; but this goes against the grain of the standard relationship between the experimenter and the experimental subject. With this new model, the use of a less experienced subject seems superfluous; rather, the experimenter should be conducting the research either (1) on his own, or (2) under the guidance of an even more experienced researcher. The former option, however, would undermine the sacrosanct division between the scientist, as the objective observer, and the object of the scientist's research. The latter option suggests more the relation between a contemplative mentor and his disciple, which is even further distant from the orthodox paradigm of psychological research.

5. A final objection raised against the scientific use of introspection, particularly of the sort promoted by the German physiologist and psychologist Wilhelm Wundt, is that scientific introspection is so artificial and contrived that it bears no

relevance to everyday introspection. Wundt sought to present a model of the introspective observation of subjective, mental phenomena so that it appeared akin to the well-established, scientific modes of extraspective observation of objective physical phenomena. His response was to try to order and control the *external* conditions of introspection by having subjects sit still and confront simple perceptual stimuli, such as a green triangle, and to report according to well-defined rules. By "sanitizing" introspection so that it conformed as closely as possible to extraspective, scientific observation, it could no longer be used to inquire into any but the most primitive of human cognitions, while the higher functions of thought and feeling were ignored.

While Western academic psychology has largely overlooked the topic of introspection as a form of self-monitoring, modern clinical psychology does offer some interesting insights into the absence of self-monitoring. Psychiatrist David Galin acknowledges the important role of self-monitoring, claiming "it is more damaging to a person's integration to be out of touch with the dimensions of 'personal' reality through loss of self-monitoring than to be out of touch with the externals through sensory loss or paralysis."[9] Self-monitoring, he writes, is critical in acquiring and maintaining complex types of behavior and in adapting to changing conditions. While most contemporary philosophers of mind reject the notion of any type of metacognition, Galin counters:

> There must be a high order metacognitive subsystem whose function is to monitor the current state of the self. It must keep an updated 'map' of what subsystems are working, how well they are working, and how they are interacting. We can infer its existence since we often know a lot about our present "mode" of organization, including such things as the level and quality of our awareness, our cognition, and our status as an agent . . . Like any other map, it can be incomplete,

[9] David Galin, "Theoretical Reflections on Awareness, Monitoring, and Self in Relation to Anosognosia," *Consciousness and Cognition* I. (1992), p. 152.

or wrong. It remains to be learned what its inputs are, what aspects of organization it can monitor and what it cannot, what sort of errors it can make, how it can be turned on and off, and how its functioning varies from time to time or from person to person.[10]

Although such monitoring of one's mental processes is not often considered as a separate skill or general capacity apart from the specific performance being studied, it has begun to be studied in its own right, mostly under the heading of metacognition.[11]

William James defined introspection as "the looking into our own minds and reporting what we there discover," and he declared that in psychology this is what we have to rely on "first and foremost and always."[12] For the past eighty years, Western academic psychology has ignored this dictum, but with the recent surge of interest in the nature of consciousness, perhaps introspection, too, will be freshly evaluated both in theory and practice.

[10] Ibid., p. 157. See also Thomas Nagel, *The View from Nowhere* (Oxford: Oxford University Press, 1986).

[11] Cf. J.H. Flavell, and H.M. Wellman, "Metamemory." In R.V. Kail, Jr. and J.W. Hagen eds. *Perspectives on the Development of Memory and Cognition.* (Hillsdale, NJ: Erlbaum); E.M. Markman, Realizing What You Don't Understand: A Preliminary Investigation. *Child Development*, 48, (1977), 986–992.

[12] *Principles of Psychology*, I:185.

The Bridge of Quiescence

"When we consider what religion is for mankind, and what science is, it is no exaggeration to say that the future course of history depends upon the decision of this generation as to the relations between them."[1]

<div align="right">A.N. Whitehead</div>

The Scientific Revolution began in the sixteenth century with a mathematical treatment of the movements of heavenly bodies in relation to the earth. Initiated in the field of astronomy, focusing on the physical phenomena most distant from the human subject, it took modern science more than three hundred years to apply its methodologies to the empirical study of the human mind. Indeed, it was only in the closing decades of the nineteenth century, when many leading physicists regarded their knowledge of the physical universe as essentially complete, that experimental psychology made its first appearance. By then, the principles of scientific naturalism—including physicalism, the closure principle, and the principle of reductionism—had been widely adopted by natural scientists, principles that had ostensibly been derived from and verified by the scientific investigation of the nature.

The subject matter of natural science is, presumably, the whole of nature. But the fact that the first three hundred years of the development of natural science focused exclusively on the physical world resulted in a practical re-definition of the term *nature* as "the sum total of phenomena in time and space; the physical world as presented to the senses."[2] Scientifically speaking, this definition has come to replace more inclusive, traditional definitions, such as: "The material and spiritual universe, as distinguished from the Creator; the system of things of which man

[1] Alfred North Whitehead, *Science and the Modern World: Lowell Lectures,* 1925 (New York: Fontana Books, 1975), p. 215.

[2] *Dictionary of Philosophy and Psychology,* ed. James Mark Baldwin (New York: Macmillan, 1925), Vol. II, p. 139.

forms a part."[3] Due to this physical bias, the three-hundred-year-long omission of consciousness from the domain of natural science effectively excluded the mind from nature. The development of the empirical and analytical tools of science ingeniously created during this period were designed solely for the exploration of the physicalist world. By implication, if a subject matter was to be deemed worthy of scientific investigation, it had to be accessible to the research tools developed by scientists; in other words, it had to be physical.

As we approach the close of the twentieth century, there is some degree of scientific consensus concerning the origins of the physical universe many billion of years in the past, concerning the constitution of galaxies and other phenomena millions of light-years distant, and concerning the most likely scenarios for the ultimate destiny of the universe. But there is no such empirically based, scientific consensus concerning the precise nature of the origins of consciousness (either of life in the cosmos, or of a human fetus), the nature of mental events, or the final destiny of the human mind. The tools of mechanistic science were simply not designed to grapple with such issues. Thus, earlier movements in modern cognitive science have argued that mental phenomena simply do not exist because they are *identical* with brain states; and more recent cognitive scientists argue that mental phenomena do not exist because they are *not identical* with brain states. As John Searle points out, this pattern is very revealing, for it shows an inexorable urge to get rid of mental phenomena at any cost.[4]

An important factor in this exclusion of consciousness and other mental phenomena from the natural world may be called the *cult of objectivity,* which is a central feature of scientific naturalism. This trend earns the label of "cult" not because of its laudable emphasis on open-mindedness and lack of bias on the part of the subject, nor because of the emphasis placed on the existence

[3] *The Century Dictionary and Cyclopedia,* (New York: The Century Co., 1897), Vol. V, p. 3943.

[4] *Rediscovery of the Mind,* pp. 48–49.

of entities that can be detected by multiple observers (or "the public") or by diverse modes of observation. Rather, the type of objectivity lauded in scientific naturalism suppresses the ubiquitous fact that a subjective observer is part of the process of identifying any object. This cult would have us believe that the certainty of our knowledge of the objective existence of an entity is inversely proportional to the role played by subjective awareness in ascertaining its existence. Scientific naturalism, for example, regards the theoretical entities of physics (such as fields and subatomic particles) as more real than observational entities (such as rocks and trees). The reason for this bias may be traced to the fact that the latter are observable by lay people using their ordinary subjective perceptual faculties; while the former can be detected only with the ostensibly objective modes of detection devised by scientists.

The cult of objectivity is literally an instance of superstition: for it is an unreasonable belief tenaciously held as a carry-over from unfounded religious notions of objectivity. The antidote for this superstition is keen empirical and analytical inquiry, which is characteristic of the scientific spirit that has dispelled so many other superstitions.

Modern cognitive science, operating under the domination of the ideology of scientific naturalism, has let its research methods dictate its subject matter, rather than the converse. John Searle likens this situation to the drunk who loses his car keys in the dark bushes but looks for them under the streetlight, "because the light is better there." In a similar fashion, he argues, modern cognitive scientists try to find out how humans might resemble their computational models rather than trying to figure out how the conscious mind actually works. As a result of this misguided approach, he concludes, "In spite of our modern arrogance about how much we know, in spite of the assurance and universality of our science, where the mind is concerned we are characteristically confused and in disagreement."[5]

[5] Ibid., p. 247.

From an outside perspective that does not fit simply into our Western categories of religion, science, or philosophy, Tsongkhapa presents the hypothesis that highly developed, sustained voluntary attention, when applied introspectively, may play a crucial role in fathoming the nature, origins, and potentials of consciousness. Indeed, it may be as important to cognitive science as mathematics has been to the physical sciences. The discipline he explains for stabilizing and refining the attention is one that acknowledges—and even highlights—the fallibility of the human faculty of introspection. But instead of responding by trying to exclude subjectivity from the investigation of reality, he suggests methods for developing and refining the mind so that it becomes a more reliable instrument of observation and analysis.

The means of achieving advanced states of sustained voluntary attention and claims concerning the therapeutic and epistemic value of such cognitive training are not unique to Buddhism, nor are they bound to any one religious or philosophical ideology. As noted previously, such methods have been practiced for centuries in India, China, and Tibet, within the context of very diverse conceptual frameworks. Thus, the cultivation of quiescence stands as a bridge spanning multiple streams of Asian contemplative traditions.

The importance of turning the awareness inwards and stilling sensory and conceptual agitation has also been recognized in the Western Christian contemplative tradition. However, it is not apparent that Christianity has developed such attentional training to the extent that is found in Hinduism, Buddhism, or Taoism. Moreover, particularly since the Scientific Revolution and the Protestant Reformation, Christian contemplation appears to have fallen into decline. During the dynamic rise of modern science, contemplation, now called "mysticism" has come to be associated by many Christians with extravagance, fanaticism, and delusion. Dom Cuthbert Butler concludes that the old tradition of the Christian Church was that contemplation is the objective of a spiritual life earnestly lived and that it is open to everyone. The modern idea, in contrast, is that contemplation is a thing practically out of reach of all but a very restricted number of specially called

and favored souls, a thing to be wondered at from afar, but hardly to be aspired to without presumption.[6]

Buddhism adopted techniques for developing sustained voluntary attention from the Hindu tradition and adapted them to Buddhist ends, and the Taoists did likewise when they adopted such methods from Buddhism. If the cultivation of quiescence presented by Tsongkhapa experientially refines the attention as claimed, and if such results are also valued by Christian contemplatives, those methods might well be adapted to Christianity for the enrichment of its own contemplative tradition. In this way, quiescence might serve as a bridge between Eastern and Western religions.

Whether one is operating within a scientific or a contemplative conceptual framework, there are truths to be discovered concerning the nature, origins, and potentials of consciousness. These truths do not identify themselves as being either scientific or religious, but they must be of central interest to both scientific and religious concern with the nature of human existence. Is it possible for human attention to be trained in the way Tsongkhapa describes? If it has been possible within traditional cultures such as Tibet, is it still a viable type of training in the modern West? If so, does the achievement of quiescence actually result in experiential insight into the nature of consciousness? Is there any validity to Tsongkhapa's claims concerning the types of extrasensory perception and paranormal abilities that can be developed on the basis of quiescence? Is it possible to disengage the human mind from all conceptual frameworks; and if so, does this open up to consciousness dimensions of reality beyond the scope of human concepts? All of these questions can be readily answered on the basis of various ideologies; but the far greater challenge is to put them to the test of experience, for this, it may be said, is the origin of all genuine science and religion.

[6] Dom Cuthbert Butler, *Western Mysticism: The Teaching of Augustine, Gregory and Bernard on Contemplation and the Contemplative Life*. 3rd ed., with "Afterthoughts" by Prof. David Knowles. (London: Constable, 1967), pp. 212–13.

Glossary

Sanskrit terms marked with a † havae been reconstructed on the basis of the corresponding Tibetan terms.

English	Tibetan	Sanskrit
adventitious affliction	glo bur gyi nyon mongs	āgantukleśa
afflictiveny	on mongs can	kliṣṭa
afflictive obscuration	nyon mongs kyi sgrib pa	kleśa-āvaraṅa
aggregate	phung po	skandha
analysis	dpyod pa	vicāra
	yongs su dpyod pa	paricāra
anger	khong khro	pratigha
appearing object	snang yul	pratibhāsa-viṣaya†
applications of mindfulness	dran pa nyer bzhag	smṛtyupasthāna
apprehended object	'jug yul	pravṛtti-viṣaya†
apprehended aspect	gzung rnam	grāhyākara†
apprehending aspect	'dzin rnam	grāhakākara†
ascertaining awareness	nges shes	niścayaja†
attachment	'dod chags	rāga
attention	sems	citta
attentional state	sems	citta
attitude of emergence	nges 'byung	naiśkramya
Awareness	rig pa	vidyā
basic	dngos gzhi	maula
basic transformation	gnas sgyur	āśrayaparavṛtti
Buddha-nature	sang rgyas kyi rigs	buddhadhātu
central channel	rtsa dbu ma	avadhūti
clarity	gsal ba'i cha	sphuṭa
	gsal ba	
cogent inference	dngos stobs rjes dpag	vastu-bala-anumana†
cognition	blo	mati
cognitive obscuration	shes bya'i sgrib pa	jñeya-āvaraṇa
compassion	snying rje	karuṇā
composite phenomenon	'du byas	saṅskṛta
concealed phenomenon	lkog gyur	parokṣa

303

English	Tibetan	Sanskrit
conceptualization	rtog pa	kalpanā
confession	bshags pa	deśanā
consciousness	shes pa	jñāna
contact	reg pa	sparśa
contemplative	rnal 'byor ba	yogin
contemplative perception	rnal 'byor mngon sum	yoga-pratyakṣa
contrived ignorance	ma rig pa kun btags	parikalpita-avidyā
conventional truth	kun rdzob bden pa	saṃvṛti-satya
definitive meaning	nges don	nītārtha
deity yoga	lha'i rnal 'byor	devatāyoga
delusion	gti mug	moha
dependently related events	rten cing 'brel bar byung ba	pratītya-samutpanna
depression	zhum	paviṣāda
desire realm	'dod khams	kāmadhātu
discernment	so sor rtog pa	pratyavekṣaṇā
discriminatio	nrab tu rnam 'byed pa	pravicaya
discursive meditation	dpyad sgom	vicāra-bhāvanā†
distraction	rnam par g.yeng ba	vikṣepa
divine pride	lha'i nga rgyal	divya-māna
doubt	the tshom	vicikitsā
downfall	ltung ba	āpatti
drowsiness	gnyid	middha
dysfunction	gnas ngan len	dauṣṭulya
emblem	zad pa	kṛtsna
emptiness	stong pa nyid	śūnyatā
enlightenment	byang chub	bodhi
enthusiasm	brtson 'grus	vīrya
essence of the Tathāgata	de bzhin gshegs pa'i snying po	tathāgatagarbha
ethical discipline	tshul krims	śīla
ethically neutral	lung ma bstan	avyākṛta
ethically neutral obstruction	bsgribs la lung ma bstan	nivṛtavyākaraṇa
evident phenomenon	mngon gyur	abhimukhı
excellence	yon tan	guṇa
excitation	rgod pa	auddhatya
external object	phyi don	bāhyārtha

English	Tibetan	Sanskrit
extrasensory perception	mngon shes	abhijñā
faith	dad pa	śraddhā
fault	nyes pa	ādīnava
feeling	tshor ba	vedanā
force	stobs	bala
formless realm	gzugs med khams	ārūpyadhātu
form realm	gzugs khams	rūpadhātu
foundation consciousness	kun gzhi rnam par shes pa	ālayavijñāna
four immeasurables	tshad med bzhi	catvāryapramānāni
grasping	'dzin pa	graha
great authority	shing rta chen po	mahāratha
great countless eon	grangs med bskal chen	asamkhye-mahākalpa
habituation	goms pa	abhyāsa
hatred	zhe sdang	dvesa
hearing	thos pa	śruta
idea	don spyi	artha-sāmānya†
ideation	rnam rtog	vikalpa
image	rnam pa	ākāra
impartiality	btang snyoms	upeksā
identity	bdag	ātman
identitylessness	bdag med pa	nairātmya
individual liberation	so sor thar pa	prātimoksa
inference	rjes su dpag pa	anumāna
inference by authority	yid ches rjes dpag	āpta-anumāna
inherent nature	rang bzhin	svabhāva
innate ignorance	ma rig pa lhan skyes	sahaja-avidyā
insight	lhag mthong	vipaśyanā
intelligence	shes rab	prajnā
provisional meaning	drang don	neyārtha
intervention	'du byed pa	abhisamskāra
introspection	shes bzhin	samprajanya
investigation	rtog pa	vitarka
joy	bde ba	sukha

English	Tibetan	Sanskrit
knowledge	ye shes	jñāna
latent propensity	bag chags	vāsana
laxity	bying ba	laya
lethargy	rmugs pa	styāna
love	byams pa	maitri
malice	gnod sems	duṣṭacitta
meditation	sgom pa	bhāvanā
meditative absorption	snyoms 'jug	samāpatti
meditative equipoise	mnyam par 'jog pa	samāhita
meditative object	dmigs pa	ālambana
meditative stabilization	bsam gtan	dhyāna
meditative state	bsgoms byung	bhāvanāmaya
melancholy	yid mi bde	durmanas
mental affliction	nyong mongs	kleśa
mental body	yid kyi lus	manomayakāya
mental engagement	yid la byed pa	manaskāra
mental fabrication	kun tu rtog pa	parikalpita
mental non- engagement	yid la mi byed pa	amanasikāra
mental process	sems byung	caitta
mental representation	ming	nāma
mental state	sems	citta
mind	sems	citta
	yid	manas
mind-itself	sems nyid	cittatā
mindfulness	dran pa	smṛti
mind-stream	rgyud	santāna
mirror-like primordial wisdom	me long lta bu'i ye shes	ādarśajkāra
miserable destination	ngan 'gro	durgati
natural misdeed	rang bzhin gyi kha na ma tho ba	prakṛtyavadya
negation	dgag pa	pratiṣedha
negligence	bag med	papramāda
non-ascertaining cognition	snang la ma nges pa'i blo	aniyata- pratibhāsa- mati†
non-composite phenomenon	'du ma byas	asaṅskṛta

English	Tibetan	Sanskrit
non-included phenomenon	ldan min 'du byed	viprayukta-saṃskāra
non-intervention	'du mi byed pa	anabhisaṃskāra
nonresidual nirvāṇa	lhag ma med pa'i myang 'das	niravaśeṣa-nirvāṇa
object	yul	viṣaya
obscuration	sgrib pa	āvaraṇa
ordinary being	so so skye bo	pṛthagjana
paranormal ability	rdzu 'phrul	ṛddhi
partial negation	ma yin dgag	paryudāsa-pratiṣedha
path of accumulation	tshogs lam	saṃbhārmārga
perception	mngon sum	pratyakṣa
perfect enlightenment	yang dag par rdzogs pa'i byang chub	samyaksaṃbodhi
perfection	pha rol tu phyin pa	pāramitā
person of great capacity	skyes bu chen po	mahāpuruṣa
person of medium capacity	skyes bu 'bring	madhyamapuruṣa
person of small capacity	skyes bu chung ngu	adhamapuruṣa
personal identitylessness	gang zag gi bdag med	pudgalanairātmya
phenomenal identitylessness	chos kyi bdag med	dharmanairātmya
pitch	'phang	āroha
plane of meditative affliction	mnyam par bzhag pa'i sa	samāhitabhūmi
pleasure	dga' ba	prīti
pliancy	shin sbyangs	praśrabdhi
positive phenomenon	sgrub pa	vidhi
power	stobs	bala
pride	nga rgyal	māna
primary mental affliction	rtsa ba'i nyon mongs	mūla-kleśa
primordial wisdom of the absolute nature of reality	chos kyi dbyings kyi ye shes	dharmadhātujñāna

English	Tibetan	Sanskrit
primordial wisdom of accomplishment	bya ba sgrub pa'i ye shes	kṛtyānuṣṭhānajñāna
primordial wisdom of discernment	so sor rtog pa'i ye shes	pratyaveksaṇāna-jñāna
primordial wisdom of equality	mnyam pa nyid kyi ye she	samatājñāna
proscribed misdeed	bcas pa'i kha na ma tho ba	pratiksepaṇāvadya
proximate	nyer bsdogs	sāmantaka
quiescence	zhi gnas	śamatha
reality	don	artha
reality	yang dag pa	bhūta
reality-itself	chos nyid	dharmatā
recognition	'du shes	samjñā
referent	don	artha
reflexive awareness	rang rig	svasaṃvedana
remorse	'gyod pa	kaukṛtya
renunciate	rab byung	pravrajita
representation	ming	nāma
residual nirvāṇa	lhag ma dang bcas pa'i myang 'das	sāvaśeṣa-nirvāṇa
sage	drang srong	ṛṣi
secondary mental affliction	nye ba'i nyon mongs	upakleśa
self-cognizing awareness	rang rig	svasaṃvedana
sensual desire	'dod pa la 'dun pa	kāmacchanda
sign	mthsan ma	nimitta
simple negation	med dgag	prasajyapratisedha
sin	sdig pa	pāpa
single-pointed attention	sems rtse gcig pa	ekāgracitta
spirit of awakening	byang chub kyi sems	bodhicitta
spiritual mentor	bla ma	guru
spiritual power	bsod nams	puṇya
spiritual sloth	le lo	kausīdya
stability	gnas pa gnas cha	sthiti

English	Tibetan	Sanskrit
stabilizing meditation	'jog sgom	sthāpanabhāvanā†
stage of completion	rdzogs rim	utpannakrama
stage of generation	bskyed rim	utpattikrama
striving	rtsol ba	vyāyāma
subjective awareness	yul can	viṣayin
supramundane	'jig rten las 'das pa	lokottara
thatness	de kho na nyid	tattva
thinking	bsam pa	cintā
totality	zad pa	kṛtsna
tranquility	rnal du 'bab pa	praśaṭhatā
ultimate truth	don dam bden pa	paramārtha-satya
valid cognition	tshad ma	pramāṇa
very concealed phenomenon	shin tun lkog gyur	atyartha-parokṣa
virtue	dge ba	kuśala
vital energy	rlung	prāṇa
will	sems pa	cetanā
wisdom	shes rab	prajñā
wisdom arising from hearing	thos byung shes rab	srutamayīprajñā
wisdom arising from meditation	bsgom byung shes rab	bhāvanāmayī-prajñā
wisdom arising from thinking	bsam byung shes rab	cintāmayīprajñā
yearning	'dun pa	chanda

Bibliography

Reference Works

Tse tan zhab drung, Dung dkar blo bzang phrin las, and dMu dge bsam gtan. (1984) *Bod rgya tshig mdzod chen mo,* Mi rigs dpe skrun khang (People's Publishing House), 3 vols.

The Century Dictionary and Cyclopedia. New York: The Century Co., 1897.

James Mark Baldwin, ed. (1925) *Dictionary of Philosophy and Psychology.* New York: Macmillan.

Sarat Chandra Das. (1979) *Tibetan-English Dictionary,* Reprint; Kyoto: Rinsen Book Company.

Y.N. Roerich. (1983) *Tibetan-Russian-English Dictionary with Sanskrit parallels.* ed. Y. Parfionovic and V. Dylykova. Moscow: Nauka Publishers, Central Department of Oriental Literature, 10 vols.

Lokesh Chandra. (1982) *Tibetan-Sanskrit Dictionary.* Reprint; Kyoto: Rinsen.

Tsepak Rigzin. (1986) T*ibetan-English Dictionary of Buddhist Terminology.* Dharamsala: Library of Tibetan Works and Archives.

Sources on Western Thought

Saint Augustine (1962). *The Trinity.* trans. Stephen McKenna. Washington D.C.: Catholic University of America Press.

Baars, Bernard (1994). Roger Penrose and the Quest for the Quantum Soul. *Journal of Consciousness Studies: Controversies in Science and the Humanities.* 1, 2, pp. 261–3.

Boutroux, Émile (1911). *Science and Religion in Contemporary Philosophy,* trans. Jonathan Nield. New York: Macmillan.

Burnaby, John (1991). *Amor Dei: A Study of the Religion of St. Augustine.* Norwich: Canterbury Press, first pub. 1938.

Butler, Dom Cuthbert (1967). *Western Mysticism: The Teaching of Augustine, Gregory, and Bernard on Contemplation and the Contemplative Life.* 3rd ed., with Afterthoughts by Prof. David Knowles. London: Constable.

Christian, William A. (1972). *Oppositions of Religious Doctrines: A Study in the Logic of Dialogue among Religions.* London: Macmillan.

Clifford, William K. (1879/1901). *Lectures and Essays by the Late William Kingdom Clifford, F. R. S.* London: Macmillan.

Crick, F.H.C. (1979). Thinking about the Brain. *Scientific American,* Sept.

Crick, F.H.C. (1994). *The Astonishing Hypothesis: The Scientific Search for the Soul.* London: Simon and Schuster.

Danziger, Kurt (1980). The History of Introspection Reconsidered. *Journal of the History of the Behavioral Sciences* 16, pp. 241–262.

Dennett, Daniel C. (1969). *Content and Consciousness*. New York: Routledge.

Dennett, Daniel C. (1991). *Consciousness Explained*. Boston: Little, Brown.

Einstein, Albert (1954). *Ideas and Opinions*. trans. and rev. by Sonya Bangmann. New York: Crown.

Eliade, Mircea (1957). *Myths, Dreams, and Mysteries: The Encounter Between Contemporary Faiths and Archaic Realities*. trans. Philip Mairet. New York: Harper Torchbooks.

Flavell, J.H., and Wellman, H.M. (1977). Metamemory. in R.V. Kail, Jr. and J.W. Hagen (eds.). *Perspectives on the Development of Memory and Cognition*. Hillsdale, NJ: Erlbaum.

Freud, Sigmund (1961). *Civilization and Its Discontents*. trans. and ed. by James Strachey. New York: Norton.

Gadamer, H. (1988). *Truth and Method*. Garrett Barden and John Cumming, trans. New York. Reprint.

Galin, David (1992). Theoretical Reflections on Awareness, Monitoring, and Self in Relation to Anosognosia. *Consciousness and Cognition* I, pp. 152–162.

Gardner, Howard (1985). *The Mind's New Science*. New York: Basic Books.

Geertz, Clifford (1973). *The Interpretation of Cultures*. New York: Basic Books, Inc.

Hameroff, Stuart (1994). Quantum Coherence in Microtubules: A Neural Basis for Emergent Consciousness? *Journal of Consciousness Studies* 1, 1, pp. 91–118.

Harvey, Van (1981). *The Historian and the Believer*. Philadelphia: Westeminster Press.

Heisenberg, Werner (1962). *Physics and Philosophy: The Revolution in Modern Science*. New York: Harper and Row.

Heisenberg, Werner (1971). *Physics and Beyond: Encounters and Conversations*. New York: Harper and Row.

Hodgson, David (1994). Why Searle Has Not Rediscovered the Mind. *Journal of Consciousness Studies*, 1, No. 2, pp. 264–274.

James, Henry, Jr. ed. (1920) *The Letters of William James*. Boston: .Atlantic Monthly Press.

James, William (1890/1950). *The Principles of Psychology*. New York: Dover.

James, William (1899/1958). *Talks to Teachers: On Psychology; and to Students on some of Life's Ideals*. Intro. by Paul Woodring. New York: Norton.

James, William (1902/1982). *The Varieties of Religious Experience: A Study in Human Nature*. New York: Penguin.

James, William (1908). Pluralism and Religion. *Hibbert Journal* 6, pp. 721–728.

James, William (1909/1977). *A Pluralistic Universe*. Cambridge: Harvard University Press.

James, William (1911/1948). Faith and the Right to Believe in *Some Problems of Philosophy.* New York: Longman's. Posthumous, ed. by Henry James, Jr.

Kail, R.V., Jr., and Hagen, J.W. (eds.) (1977). *Perspectives on the Development of Memory and Cognition.* Hillsdale, NJ: Erlbaum.

Katz, Steven T. ed. (1978). *Mysticism and Philosophical Analysis.* New York: Oxford University Press.

Katz, Steven T. (1983). The 'Conservative' Character of Mystical Experience. In *Mysticism and Religious Traditions.* ed. Steven T. Katz. Oxford: Oxford University Press.

Levinson, Henry Samuel (1981). *The Religious Investigations of William James.* Chapel Hill: University of North Carolina Press.

Lyons, William (1986). *The Disappearance of Introspection.* Cambridge, Mass.: MIT Press.

Mackworth, J.F. (1970). *Vigilance and Attention.* Penguin.

Mackworth, N.H. (1950). Medical Research Council Special Report no. 268. London: H.M. Stationary Office.

Maréchal, Joseph, S. J. (1927). *Studies in the Psychology of the Mystics.* trans. Algar Thorold. London: Burns Oates and Washbourne.

Markman, E. M. (1977). "Realizing what you don't understand: A preliminary investigation. *Child Development,* 48, pp. 986–992.

McDermott, John J. ed. (1977). *The Writings of William James: A Comprehensive Edition.* Chicago: University of Chicago Press.

Myers, Gerald E. (1986). *William James: His Life and Thought.* New Haven: Yale University Press.

Nagel, T. (1986). *The View from Nowhere.* Oxford: Oxford University Press.

Penrose, Roger (1994). *Shadows of the Mind: A Search for the Missing Science of Consciousness.* Oxford: Oxford University Press.

Pieper, Josef (1966). *Happiness and Contemplation.* trans. Richard and Clara Winston. Chicago: Henry Regnery.

Posner, Michael I. (1978). *Chronometric Exploration of Mind.* Lawrence Erlbaum Associates.

Posner, Michael I. (1989). *Foundations of Cognitive Science.* Cambridge, Mass: MIT Press.

Prigatano , G. P., and Schacter, D. L. eds. (1991). *Awareness of Deficit after Brain Injury: Clinical and Theoretical Issues.* Oxford: Oxford University Press.

Putnam, Hilary (1987). *The Many Faces of Realism.* La Salle: Open Court.

Putnam, Hilary (1990). *Realism with a Human Face.* ed. James Conant. Cambridge, Mass.: Harvard University. Press.

Ramsey, Bennett (1993). *Submitting to Freedom.* New York: Oxford University Press.

Sanders, A.F. ed. (1970). *Attention and Performance* I. Amsterdam: North-Holland.

Searle, John R. (1994). *The Rediscovery of the Mind.* Cambridge, Mass.: MIT Press.

Smith, Peter and Jones, O.R. (1988). *The Philosophy of Mind: An Introduction.* Cambridge: Cambridge University Press.
Vernon, Jack (1966). *Inside the Black Room: Studies of Sensory Deprivation.* Pelican.
Whitehead, Alfred North (1975). *Science and the Modern World: Lowell Lectures, 1925.* New York: Fontana.
Woodworth, Robert and Schlosberg, Harold (1955). *Experimental Psychology,* 3d ed. New York: Methuen.
Zajonc, Arthur (1993). *Catching the Light: The Entwined History of Light and Mind.* New York: Bantam.

Pāli Sources

Aṅguttara Nikāya
Dhammasaṅgani
Dīgha-Nikāya
Dīgha-Nikāya Commentary
Itivuttaka
Kathāvatthu
Mahāpadāna Sutta
Majjhima-Nikāya
Paramatthamaāyaam
Paṭisambhidā-magga
Sāmasambhidā-magga
Saṃyutta-Nikāya
Saṃyutta sutta
Udāna
Visuddhimagga

Sanskrit and Tibetan Sources

Āryasūra (1946). *Pāramitāsamāsa.* ed. A . Ferrari, in *Annali Lateranensi,* vol. 10. *Pha rol tu phyin pa bsdus pa.* Derge: Khi 217.2
Asaṅga (1907). *Mahāyāna-sūtrālaṃkāra.* ed. and trans. Lévi. Paris: Bibliothèque de l'École des Hautes Études, 159 and 190.
Asaṅga (1936). *Bodhisattvabhūmi,* ed. Unrai Wogihara. Vol. 1. Tokyo. *Byang chub sems pa'i sa.* Derge: Wi 1.2
Asaṅga (1950). *Abhidharmasamuccaya.* ed. Pralhad Pradhan, Santiniketan: Visva-Bharati. *Chos mngon pa kun btus.* Derge: Ri 44.2.
Asaṅga (1957). *Yogācārabhūmi.* ed. Bhattacharya. The *Yogācārabhūmi of Asaṅga,* Part I. Calcutta.
Asaṅga (1970). *Mahāyāna Sūtrālaṃkāra.* ed. S. Bagghi Darbhanga: Mithila Institute.
Asaṅga (1973). *Śrāvakabhūmi.* ed. Karunesha Shukla. Patna. *Nyan thos kyi sa.* Derge: Dzi 1.2 The Tibetan Tripitaka [T.T.]. Peking reprint

edition. Daisetz T. Suzuki, ed. Tokyo: Suzuki Research Foundation, 1962., vol. 110, no. 5537.

Asaṅga *Yogasthāna III*. Bihar MS.

Atīśa (Dīpamkaraśrījñāna) (1983). *Bodhipathapradīpa*. ed. Sarat Chandra Das, "Bodhipathapradīpa" *Journal of the Buddhist Text Society of India*, vol. 1. *Byang chub lam gyi sgron ma*. Derge: Khi 238.1. P.T.T., vol. 103, pp. 20–46.

Bhavya. *Madhyamakahṛdaya, dBu ma'i snying po*. Derge: Dza 1.2.

Candrakīrti (1913). *Prasannapadā*, L. de la Vallée Poussin, ed. Saint Petersburg: Bibliotheca Buddhica IV.

Candragomin. *Deśanāstava. bShags pa'i bstod pa*. Derge: Ka 204.1.

Dharmasaṃgītisūtra, Chos yang dag par sdud pa'i mdo. Derge: Zha 1.2.

Divyāvadāna (1886). ed. Cowell and Neil. Cambridge.

Gaṇḍavyūha (1934). ed. Suzuki and Idzumi. Kyoto.

Jñānagarbha. *Ārya-Saṃdhinirmocana-sutrā-āryamaitreyakevala-parivarta-bhāṣya, 'Phags pa dgongs pa nges par 'grel pa'i mdo las 'phags pa byams pa'i le'u nyi tshe bshad pa*. Derge Bi 318.2.

Kamalaśīla (Jan., 1935). *Third Bhāvanākrama*. ed. E. Obermiller, "A Sanskrit Ms. from Tibet—Kamalaśīla's *Bhāvanākrama*," *The Journal of the Greater Indian Society*.

Kamalaśīla (1958). *First Bhāvanākrama*, ed. G. Tucci, *Minor Buddhist Texts, Part II*, Rome.

Kamalaśīla (1971). *Third Bhāvanākrama*, ed. G. Tucci, *Minor Buddhist Texts, Part III*, Rome.

Kamalaśīla (1979) *The Third Process of Meditative Actualization*. Robert F. Olson and Masao Ichishima. trans. Taishō Daigaku Sōgō Bukkyō Kenkyūsho Nenpō 1.

Kamalaśīla (1985) *Bhāvanākrama of Ācārya Kamalaśīla*, Ācārya Gyaltsen Namdol, ed. and trans. (Tibetan version, Sanskrit Restoration and Hindi Translation), Bibliotheca-Indo-Tibetica-IX, Central Institute of Higher Tibetan Studies, Sarnath, Varanasi, pp. 165–200.

Kamalaśīla. *Bhāvanākrama, sGom pa'i rim pa*. Derge: Ki 55.2.

Kar ma chags med (1984). *Thugs rje chen po'i dmar khrid phyag rdzogs zung 'jug thos ba don ldan*. Bylakuppe: Nyingmapa Monastery.

Kar ma chags med. *Sangs rgyas lag 'chang gi 'grel chen*. Publisher unknown.

Blo bzang rgya mtsho (1974). *Rigs lam che ba blo rigs kyi rnam bzhag nye mkho kun btus*. Dharamsala.

Blo bzang rgya mtsho (1993). *mTha' gnyis dang dral ba'i dbu ma thal 'gyur ba'i blo'i rnam gzhag ches cher gsal bar byed pa blo rigs gong ma*. Dharamsala: Institute of Buddhist Dialectics.

Maitreya [-natha] (1932). *Madhyāntavibhāga*. ed. Battacharya, V.S., and Tucci, G. London: Luzac. Calcutta Oriental Series no. 24. *dBus mtha' rnam 'byed*. Derge: Phi 40.2.

Maitreyanātha. *Mahāyānasūtrālaṃkāra, mDo sde'i rgyan*. Derge: Phi 1.2.

Mātṛceṭa. *Varṇāhavarṇa, bsNgags 'os bsngags bstod*. Derge: Wam 186.2.

Paṇchen blo bzang yes shes. *Byang chub lam gyi rim pa'i dmar khrid thams cad mkhyen par bgrod pa'i myur lam* (Tibetan MS).

Paṇchen blo bzang chos kyi rgyal mtshan (1993). *Phyag rgya cheno po's rtsa ba*. Asian Classics Input Project, Source CD, Release A, S5939F.ACT.

Pratyutpanna-buddha-sammukhāvasthita-samādhi-sūtra, Da ltar gyi sangs rgyas mngon sum du bzhugs pa'i ting nge 'dzin gyi mdo. Derge: Na 1.2.

Ratnameghasūtra, mDo dkon mchog sprin, Derge: Wa 1.2.

Samādhirājasūtra (1961). ed. P.L. *Vaidya. Darbhanga. Ting nge 'dzin rgyal po'i mdo*. Derge: Da 1.2.

Saṃdhinirmocanasūtra (1935). Étienne Lamotte, ed. of Tibetan version and French translation. Paris: Louvain. *dGongs pa nges par 'grel pa'i mdo*. Derge: Ca 1.2.

Saraha. *Dohākoṣa-nāma-caryāgīti, Do-hā mdzod ces bya ba spyod pa'i glu* bsTan 'gyur. Derge ed.: rGyud 'grel, Vol. zhi, fols. 26b–28b. Peking ed. 31b–34a.

Saraha. *Dohākoṣa-upadeśa-gīti, Mi zad pa'i gter mdzod man ngag gi glu* bsTan 'gyur. Derge ed.: fols. 28b–33b. Peking ed.: fols. 34a–39b.

Saraha. *Dohākoṣagīti, Do ha mdzod kyi glu*. Derge: Wi 70.2.

Saraha. *Dohākoṣagīti, Do ha mdzod kyi glu*. Derge: Wi 73.1.4.

Sthiramati. *Madhyāntavibhāgaṭīkā, dBus mtha' rnam 'byed pa'i 'grel pa*. Derge: Bi 189.2.

Śāntideva. *Bodhicaryāvatāra, Byang chub sems dpa'i spyod pa la 'jug pa*. Derge: La 1.2.

Śāntideva (1961). *Śikṣāsamuccaya of Śāntideva*. ed. P. L. Vaidya. Buddhist Sanskrit texts, vol. 11. Darbhanga: Mithila Institute.

Śāntipa. *Prajñāpāramitopadeśa*, Sher phyin man ngag. Derge: Ju 246.2.

Tattvasaṃgraha (1968). ed. D. Shastri. Varanasi: Bauddhabharati.

gTer ston las rab gling pa. *rDzogs pa chen po man ngag sde'i bcud phur man ngag thams cad kyi rgyal po klong lnga'i yi ge dum bu gsum pa lce btsun chen po'i vı ma la'i zab tig gi bshad khrid chu 'babs su bkod pa snying po'i bcud dril ye shes thig le*, ed. Ven Taklung Tsetrul Pema Wangyal. Darjeeling: Orgyan Kunsang Chokhor Ling.

Tsong kha pa (1972). *Lam rim mchan bzhi sbrags ma*. New Delhi. 2 vols.

Tsong kha pa. *dBu ma 'jug pa'i rnam bshad dgongs pa rab gsal*. Collected Works, Vol. Ma.

Tsong kha pa. *dBu ma rtsa ba'i tshig le'ur byas pa'i rnam bshad rigs pa'i rgya mtsho*. Collected Works, Vol. Ba.

Tsong kha pa. *Byang chub kyi sems pa'i tshul khrim kyi rnam bshad byang chub gzhung lam*. Collected Works, Vol. Ka.

Tsong kha pa. *Byang chub lam rim che ba*. Collected Works, Vol. Pa.

Tsong kha pa. *Byang chub lam gyi rim pa chung ba*. Collected Works, Vol. Pha.

Tsong kha pa. *bDe ba can gyi zhing du skye ba 'dzin pa'i smon lam zing mchog sgo 'byed*. Collected Works, Vol. Kha, in *bKa' 'bum thor bu ba*. pp. 85a–100a.

Tsong kha pa. *Drang ba dang nges pa'i don rnam par phe ba'i bstan bcos legs bshad snying po*. Collected Works, Vol. Pha.

Tsong kha pa. *rGyal ba khyab bdag rdo rje 'chang chen po'i lam gyi rim pa gsang ba kun gyi gnad rnam par phye ba.* Collected Works, Vol. Ga.

Tsong kha pa. *rGyal tshab chos rjes rje'i drung du gsan pa'i mngon sum le'u'i brjed byang.* Collected Works, Vol. Ba.

Tsong kha pa. *rGyal tshab chos rje'i drung du gsan pa'i shes rab le'u'i zin bris.* Collected Works, Vol. Pha.

Tsong kha pa. *Lam gyi gtso bo rnam gsum gyi rtsa ba.* Collected Works, Vol. *Kha, in bKa' 'bum thor bu ba.* pp. 193b–194b.

Tsong kha pa. *mNgon sum le'u'i tikka rje'i gsung bzhin mdzad pa.* Collected Works, Vol. Ma.

Tsong kha pa. *bSam gtan gzugs med kyi bstan bcos.* Collected Works, Vol. Tsha.

Tsong kha pa. *gSang sngags kyi tshul khrims kyi rnam bshad dngos grub kyi sne ma.* Collected Works, Vol. Ka.

Tsong kha pa. *Shes rab kyi pha rol tu phyin pa'i man ngag gi bstan bcos mngon par rtogs pa'i rgyan 'grel pa dang bcas pa'i rgya cher bshad pa'i legs bshad gser gyi phreng ba.* Collected Works, Vols. Tsa and Tsha.

Tsong kha pa. *Yid dang kun gzhi'i dka' gnas rgya cher 'grel pa legs bshad rgya mtsho.* Collected Works, Vol. Tsha.

Tsong kha pa. *Zab lam na ro'i chos drug gyi khrid rim yid ches gsum ldan.* Collected Works, Vol. Ta.

Tsong kha pa. *Zhi lhag gnyis kyi dka' gnad rgyal ba'i dgongs pa bzhin bshad pa.* Collected Works, Vol. Pha.

Tsong kha pa. *Zhugs pa dang gnas pa'i skyes bu chen po rnams kyi rnam par bzhag pa blo gsal bgrod pa'i them skas.* Collected Works, Vol. Tsha.

Vasubandhu (1923–31). *Abhidharmakośa.* ed. and trans. La Vallée-Poussin, Louis de, Paris: P. Geuthner.

Vasubandhu (1981). *Abhidharmakośa,* Dwārikādās Śāstrī, ed., *Abhidharmakośa and Bhāsya* of Ācārya Vasubandhu. Varanasi: Bauddha Bharati.

Vasubandhu (1964). *Madhyāntavibhāga-bhāsya.* ed. Gadjin M. Nagao Yamaguchi. Tokyo: Suzuki Research Foundation. *dBus mtha' rnam 'byed pa'i 'grel pa.* Derge: Bi 1.2.

Vasubandhu. *Abhidharmakośakārikā.* T. T. vol. 115, no 5590.

Vasubandhu. *Abhidharmakośabhāsyam, Chos mngon pa'i mdzod kyi bshad pa.* Derge: Ku 26.2.

Vasubandhu. *Sūtrālaṃkāravyākhyā, mDo sde'i rgyan gyi bshad pa.* Derge: Phi 129.2

Yongs 'dzin ye shes rgyal mtshan (1974). *sNyan rgyud lam bzang gsal ba'i sgron me.* Included in *The Collected Works of Tshe-mchog gling Yongs-'dzin Ye-shes-rgyal-mtshan.* New Delhi: Tibet House Library.

Translations and Secondary Sources

Almond, Philip C. (1988). *The British Discovery of Buddhism.* Cambridge: Cambridge University Press.

Asaṅga and Tsong-Kha-Pa (1986). Asaṅga's Chapter on Ethics with the Commentary of Tsong-Kha-Pa, *The Basic Path to Awakening, The Complete Bodhisattva.* trans. Mark Tatz. Lewiston: Edwin Mellen Press. Studies in Asian Thought and Religion, Vol. 4.

Atīśa (1983). *A Lamp for the Path and Commentary.* trans. Richard Sherbourne, S.J. London: Allen and Unwin.

Berzin, Alex, trans. (1978). *The Mahāmudrā Eliminating the Darkness of Ignorance.* Dharamsala: Library of Tibetan Works and Archives.

Buddhaghosa (1979). *The Path of Purification,* trans. by Bhikkhu Ñāṇamoli. Kandy: Buddhist Publication Society.

Buswell, Robert E., Jr. and Gimello, Robert M., eds. (1992). *Paths to Liberation: The Mārga and Its Transformations in Buddhist Thought.* Honolulu: University of Hawaii Press, Studies in East Asian Buddhism 7.

Chattopadhyaya, Alaka (1967). *Atīśa and Tibet.* Calcutta.

Chi, Chang Chen, trans. (1992). C.A. Musès, ed. *Esoteric Teachings of Tibetan Tantra.* York Beach: Samuel Weiser.

Conze, Edward., trans. (1975). *The Large Sutra on Perfect Wisdom.* Berkeley: University of California Press.

Cox, Collett (1992). Mindfulness and Memory: The Scope of Smṛti from Early Buddhism to the Sarvāstivādin Abhidharma. *In the Mirror of Memory: Reflections on Mindfulness and Remembrance in Indian and Tibetan Buddhism,* Janet Gyatso, ed. Albany: State University of New York, pp. 67–107.

Cozort, Daniel (1986). *Highest Yoga Tantra.* Ithaca: Snow Lion.

H.H. the Dalai Lama, Tsongkhapa, and Jeffrey Hopkins (1977). *Tantra in Tibet.* Ithaca: Snow Lion.

H.H. the Dalai Lama, Tenzin Gyatso (1988). *Transcendent Wisdom: A Commentary on the Ninth Chapter of Shantideva's* Guide to the Bodhisattva Way of Life, trans. and ed. by B. Alan Wallace. Ithaca: Snow Lion.

de Jong, J.W. (1974). The Study of Buddhism: Problems and Perspectives. *Studies in Indo-Asian Art and Culture* 4 *(Vira Commemorative Volume)* pp. 13–26.

Evans, David W. (1992). *Discourses of Gotama Buddha: Middle Collection.* London: Janus.

Fenner, Peter (1990). *The Ontology of the Middle Way.* Dordrecht: Kluwer.

Gómez, L.O. (1972). Ultimo Tratado del Cultivo Graduado. *Diálogos.* Revista del Departamento de Filosofia, Universidad de Puerto Rico, VIII 23, pp. 85–137.

Gómez, L.O. (1977). Primer Tratado del Cultivo Graduado. *Diálogos.* Revista del Departamento de Filosofia, Universidad de Puerto Rico, XII 29–30, pp. 177–224.

Gos lo tsva ba gzon nu dpal (1988). *The Blue Annals,* trans. George Roerich. Delhi: Motilal Banarsidass.

Griffiths, Paul J. (1981). Buddhist Hybrid English: Some Notes on Philology and Hermeneutics for Buddhologists. *Journal of the International Association of Buddhist Studies* 4, pp. 17–32.

Griffiths, Paul J. (1986). *On Being Mindless: Buddhist Meditation and The Mind-Body Problem.* La Salle: Open Court.

Griffiths, Paul J. (1992). Memory in Classical Yogācāra. *In the Mirror of Memory: Reflections on Mindfulness and Remembrance in Indian and Tibetan Buddhism,* Janet Gyatso, ed. Albany: SUNY Press, pp. 109–132.

Guenther, Herbert V., and Kawamura, Leslie S. (1975). *Mind in Buddhist Psychology.* Emeryville: Dharma.

Guenther, Herbert V. (1989). Buddhism in Tibet, in *Buddhism and Asian History.* Joseph M. Kitigawa and Mark D. Cummings, ed. New York: Macmillan pp. 175–187.

Guenther, Herbert V. (1989), *From Reduction to Creativity: rDzogs-chen and the new Sciences of the Mind.* Boston and Shaftsbury: Shambhala.

Guenther, Herbert V. (1993). *Ecstatic Spontaneity: Saraha's Three Cycles of Dohā.* Berkeley: Asian Humanities Press.

Gunaratana, Henepola (1985). *The Path of Serenity and Insight: An Explanation of the Buddhist Jhānas.* Columbia, Missouri: South Asia Books.

Gyatrul Rinpoche (1993). *Ancient Wisdom: Nyingma Teachings on Dream Yoga, Meditation and Transformation,* trans. B. Alan Wallace and Sangye Khandro. Ithaca: Snow Lion.

Gyatso, Janet, ed. (1992). *In the Mirror or Memory: Reflections on Mindfulness and Remembrance in Indian and Tibetan Buddhism.* Albany: State University of New York.

Harrison, Paul (1992). Commemoration and Identification in *Buddhānusmṛti.* In *In the Mirror of Memory: Reflections on Mindfulness and Remembrance in Indian and Tibetan Buddhism,* Janet Gyatso, ed. Albany: State University of New York, pp. 220–238.

Harvey, Peter (1989). Consciousness Mysticism in the Discourses of The Buddha. In *The Yogi and the Mystic: Studies in Indian and Comparative Mysticism,* ed. Karel Werner. London: Curzon Press.

Harvey, Peter (1992). The Mind-Body Relationship in Pāli Buddhism: A Philosophical Investigation," in *Asian Philosophy,* Vol. 3, no. 1.

Hatter, M. (1968). *Dignāga on Perception.* Cambridge: Harvard University Press.

Hopkins, Jeffrey (1980). *Compassion in Tibetan Buddhism.* Ithaca: Snow Lion Publications.

Hopkins, Jeffrey (1983). *Meditation on Emptiness.* London: Wisdom Publications.

Hopkins, Jeffrey (1984). *The Tantric Distinction.* London: Wisdom Publications.

Hopkins, Jeffrey (1987). *Emptiness Yoga.* Ithaca: Snow Lion.

Huntington, C.W. (1989). *The Emptiness of Emptiness: An Introduction to Early Indian Mādhyamika,* with Geshé Namgyal Wangchen. Honolulu: University of Hawaii Press.

Jaini, S. (1959). Origin and Development of the Theory of viprayukta-samskāras. *Bulletin of the School of Oriental and African Studies,* University of London 22/3. pp. 531-547.

Jayatilleka, K. N. (1963). *Early Buddhist Theory of Knowledge.* London: Allen and Unwin.

Kalupahana, David J. (1987). *The Principles of Buddhist Psychology.* Albany: State University of New York Press.

Karma Chagmé (1997). *Spacious Path to Freedom: Practical Instructions on the Union of Mahāmudrā and Atiyoga.* Gyatrul Rinpoche, comm., B. Alan Wallace, trans. and ed. Ithaca: Snow Lion.

mKhas grub dGe legs dpal bzang (1992). *A Dose of Emptiness.* trans. José Cabezón. Albany: SUNY.

Kheminda Thera. *The Way of Buddhist Meditation.* Photocopy, publication unknown.

King, Winston L. (1980). *Theravāda Meditation: The Buddhist Transformation of Yoga.* University Park: Pennsylvania State University Press.

Kiyota, Minoru, ed. (1978). *Mahāyāna Buddhist Meditation: Theory and Practice.* Honolulu: The University Press of Hawaii.

Klein, Anne C. (1986). *Knowledge and Liberation.* Ithaca: Snow Lion.

Klein, Anne C. (1992). Mental Concentration and the Unconditioned: A Buddhist Case for Unmediated Experience. In Robert E. Buswell, Jr. and Robert M. Gimello, ed. *Paths to Liberation: The Mārga and Its Transformations in Buddhist Thought.* Honolulu: University of Hawaii Press, Studies in East Asian Buddhism 7, pp. 269–308.

Klein, Anne C. (1994). *Path to the Middle: Oral Mādhyamika Philosophy in Tibet.* Albany: SUNY.

Klein, Anne C. (1995). *Meeting the Great Bliss Queen: Buddhists, Feminists, and the Art of the Self.* Boston: Beacon Press.

Kritzer, Robert (1981). Review of Alex Wayman, *Calming the Mind and Discerning the Real:* Buddhist Meditation and the Middle View. *Philosophy East and West* 31, pp. 380–82.

Kritzer, Robert (1995). Pratītyasamutpāda—The Discussion in the Abhidharma-samuccaya, *Together with the Commentary of the* Abhidharmasamuccaya-bhāṣya. Berkeley: University of California Press.

Lamotte, E. (1952). Le troisième Bhāvanākrama de Kamalaśīla." Traduction de la version tibétain. Demiéville, pp. 336–353.

Lamrimpa, Gen (1992). *Śamatha Meditation.* trans. B. Alan Wallace. Ithaca: Snow Lion.

Lati Rinbochay (1980). *Mind in Tibetan Buddhism.* trans. and ed. Elizabeth Napper. New York: Valois/Snow Lion.

Lati and Lochö Rinbochays, Zahler L., and Hopkins, J. (1983). *Meditative States in Tibetan Buddhism: The Concentrations and Formless Absorptions.* London: Wisdom.

Lhalungpa, Lobsang (1984). *The Life of Milarepa.* Boulder: Shambhala.

Lodrö, Geshe Gedün (1992). *Walking Through Walls: A Presentation of Tibetan Meditation.* trans. and ed. Jeffrey Hopkins. Ithaca: Snow Lion.

Maxwell, Natalie (1975). *Compassion: The True Cause of Bodhisattvas* (unpublished dissertation, University of Wisconsin.

McDermott, Charlene (1978). Yogic Direct Awareness as Means of Valid Cognition in Dharmakīrti and Rgyal-tshab. In *Mahāyāna Meditation: Theory and Practice.* Minoru Kiyota, ed. Honolulu: University of Hawaii Press, pp. 144–166.

Nāgārjuna and Rendawa Zhön-nu Lo-drö (1979). trans. Geshe Lobsang Tharchin and Artemus B. Engle, Artemus B. *Nāgārjuna's Letter:* Nāgārjuna's "Letter to a Friend" with a commentary by the Venerable Rendawa Zhön-nu Lo-drö. Dharamasala: Library of Tibetan Works and Archives.

Namgyal, Takpo Tashi (1986). *Mahāmudrā: The Quintessence of Mind and Meditation,* trans. Lobsang P. Lhalungpa. Boston: Shambhala.

Napper, Elizabeth (1989). *Dependent-Arising and Emptiness.* Boston: Wisdom.

Norbu, Namkhai (1992). *Dream Yoga: The Practice of the Natural Light.* Ithaca: Snow Lion.

Nyanaponika Thera (1973). *The Heart of Buddhist Meditation.* New York: Samuel Weiser.

Olson, R.F. and Ichishima, M. (1979). The Third Process of Meditative Actualization by Kamalaśīla. *Taishô Daigaku Sôgô Bukkyô Kenkyûsho Nenpô* 1, pp. 17–53.

Padmasambhava (1997). *Natural Liberation: Padmasambhava's Teachings on the Six Bardos.* Gyatrul Rinpoche, comm., B. Alan Wallace, trans. and ed. Boston: Wisdom.

Pensa, C. (1964). Terzo Bhāvanākrama di Kamalaśīla. Rivista Degli Studi Orientali XXXIX, pp. 211–242.

Perdue, Daniel (1992). *Debate in Tibetan Buddhism.* Ithaca: Snow Lion.

Poussin, Louis de La Vallée (1917). The way to *Nirvāṇa : Six Lectures on Ancient Buddhism as a Discipline of Salvation.* Cambridge: Cambridge University Press.

Powers, John (1992). *Two Commentaries on the* Samdhinirmocana-sūtra *by Asaṅga and Jñānagarbha.* Lewiston: Edwin Mellen Press, in *Studies in Asian Thought and Religion,* Vol. 13.

Rabten, Geshe (1979). *The Mind and Its Functions,* Stephen Batchelor, trans. Mont. Pèlerin: Tharpa Choeling.

Rabten, Geshe (1986). *Echoes of Voidness,* Stephen Batchelor, trans. and ed. London: Wisdom.

Rahula, Walpola (1974). *What the Buddha Taught,* Rev. ed. New York: Grove Weidenfeld.

Ruegg, David Seyfort (1989). *Buddha-Nature, Mind, and the Problem of Gradualism in a Comparative Perspective: On the Transmission and Reception of Buddhism in India and Tibet.* London: School of Oriental and African Studies.

Saraha (1954). Saraha's Treasury of Songs. trans. D.L. Snellgrove in E. Conze, ed. *Buddhist Texts through the Ages.* Oxford: Cassirer.

Śāntideva (1981). *Śikṣā-samuccaya,* trans. Cecil Bendall and W.H.D. Rouse. Delhi: Motilal Banarsidass.

Shantideva (1981). *A Guide to the Bodhisattva's Way of Life.* trans. Stephen Batchelor. Dharamsala: LTWA.

Śāntideva (1990). *Śāntideva's Bodhicharyāvatāra.* trans. Parmananda Sharma Parmananda. New Delhi: Aditya Prakashan.

Śāntideva (1997). *A Guide to the Bodhisattva Way of Life.* Vesna A. Wallace and B. Alan Wallace, ed. Ithaca: Snow Lion.

Shaw, Miranda (1994). *Passionate Enlightenment: Women in Tantric Buddhism.* Princeton: Princeton University Press.

Snellgrove, David, and Richardson, Hugh (1986). *A Cultural History of Tibet.* Boston: Shambhala.

Sopa, Geshe Lhundup, and Hopkins, Jeffrey (1976). *Practice and Theory of Tibetan Buddhism.* New York: Grove Press.

Sopa, Geshe (1980a). Some Comments on Tsong kha pa's *Lam rim chen mo* and Professor Wayman's *Calming the Mind and Discerning the Real. Journal of the International Association of Buddhist Studies,* 3, pp. 68–92

Sopa, Geshe (1980b). Geshe Sopa Replies to Alex Wayman. In *Journal of the International Association of Buddhist Studies,* 3 pp. 98–100.

Staal, Frits (1975). *Exploring Mysticism: A Methodological Essay.* Berkeley: University of California Press.

Steinkellner, E. and Tauscher, H., eds. (1981). *Contributions of Tibetan and Buddhist Religion and Philosophy: Proceedings of the Csoma de Koros Symposium.* Vienna: Arbeitskreis für Tibetologie und Buddhistische Studien Universität Wien.

Sthiramati. (1937) *Madhyāntavibhāgaṭīkā: Analysis of the Middle Path and the Extremes,* trans. David Lasar Friedmann. Uthrecht.

Takasaki, Jikido (1966). *A Study of the Ratnagotravibhāga.* Rome: Istituto Italiano Per Il Medio ed Estremo Oriente.

Tauscher, Helmut (1981). Candrakīrti. Vienna: Arbeitskreis für Tibetische und Buddhistische Studien, Universität Wien.

Tauscher, Helmut (1989). Verse-Index of Candrakīrti's Madhyamakāvatāra (Tibetan Versions). Vienna: Arbeitskreis für Tibetische und Buddhistische Studien, Universität Wien.

Thurman, Robert A.F., ed. (1979). *The Life and Teachings of Tsong Khapa.* Dharamsala: LTWA.

Tsogyal, Yeshe (1993). *The Lotus-Born: The Life Story of Padmasambhava,* trans. Erik Pema Kunsang. Boston: Shambhala.

Tsong-kha-pa (1981). *The Yoga of Tibet: The Great Exposition of Secret Mantra—Volumes II and III,* trans. and ed. Jeffrey Hopkins. London: Unwin Hyman.

Tsong Khapa (1984). *Tsong Khapa's Speech of Gold in the Essence of True Eloquence: Reason and Enlightenment in the Central Philosophy of Tibet,* trans. Robert A.F. Thurman. Princeton: Princeton University Press.

Tsong-kha-pa (1987). *Tantra in Tibet: The Great Exposition of Secret Mantra, Volume I,* trans. and ed. Jeffrey Hopkins. London: Unwin Hyman.

Tsongkapa (1988). *The Principle Teachings of Buddhism*, trans. Geshe Lobsang Tharchin with Michael Roach. Howell, NJ: Mahayana Sutra and Tantra Press.

Tucci, G. (1956) (1958) (1971). *Minor Buddhist Texts*. Rome: Instituto Italiano per il Medro ed Estremo Oriente, Part I, 1956; Part II, 1958; Part III, 1971.

Tulku Thondup Rinpoche (1989). *Buddha Mind: An Anthology of Longchen Rabjam's Writings on Dzogpa Chenpo*. Ithaca: Snow Lion.

Vajirañāṇa, Paravahera (1975). *Buddhist Meditation in Theory and Practice*. Kuala Lumpur, Malaysia: Buddhist Missionary Society.

Van den Broeck, J. (1977). *La progression dans la meditation (Bhāvanākrama de Kamalaśīla)*. traduit du sanscrit et du tibétain. Bruxelles: Publications de l'Institut Belge des Hautes Ètudes Bouddhiques, Série "Ètudes et Textes" no. 6.

Vasubandhu (1991). *Abhidharmakośabhāsyam*. trans. Louis de La Vallée Poussin, English trans. Leo M. Pruden. Berkeley: Asian Humanities Press.

Wallace, B. Alan, trans. and ed. (1980). *The Life and Teaching of Geshé Rabten*. London: Allen and Unwin.

Wallace, B. Alan (1996). *Choosing Reality: A Buddhist View of Physics and the Mind*. Ithaca: Snow Lion.

Wallace, B. Alan (1992). *A Passage from Solitude*, ed. Zara Houshmand. Ithaca: Snow Lion.

Wallace, B. Alan (1993). *Tibetan Buddhism From the Ground Up*. with Steven Wilhelm. Boston: Wisdom.

Walshe, Maurice, trans. (1987). *Thus Have I Heard: The Long Discourses of the Buddha (Dīgha Nikāya)*. London: Wisdom.

Wayman, Alex (1952). Introduction to Tsoṅ kha pa's Lam rim chen mo. *Phi Theta Annual*, Vol. 3, Berkeley, pp. 51–82.

Wayman, Alex (1961). *Analysis of the Śrāvakabhūmi Manuscript*. Berkeley: University of California Press.

Wayman, Alex (1978). *Calming the Mind and Discerning the Real: Buddhist Meditation and the Middle View*. New York: Columbia University Press.

Wayman, Alex (1980). Alex Wayman Replies to Geshe Sopa. *Journal of the International Association of Buddhist Studies* 3, pp. 93–97.

Willis, Janice D. (1995). *Enlightened Beings: Life Stories from the Ganden Oral Tradition*. Boston: Wisdom.

Zangpo, Tsering Lama Jampal (1988). *A Garland of Immortal Wish-fulfilling Trees*. trans. Sangye Khandro. Ithaca: Snow Lion.

Index